MoMA Highlights

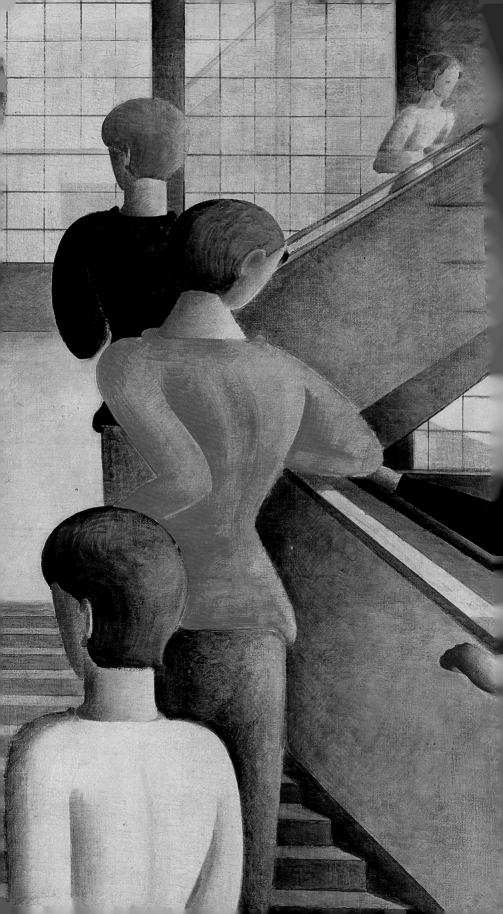

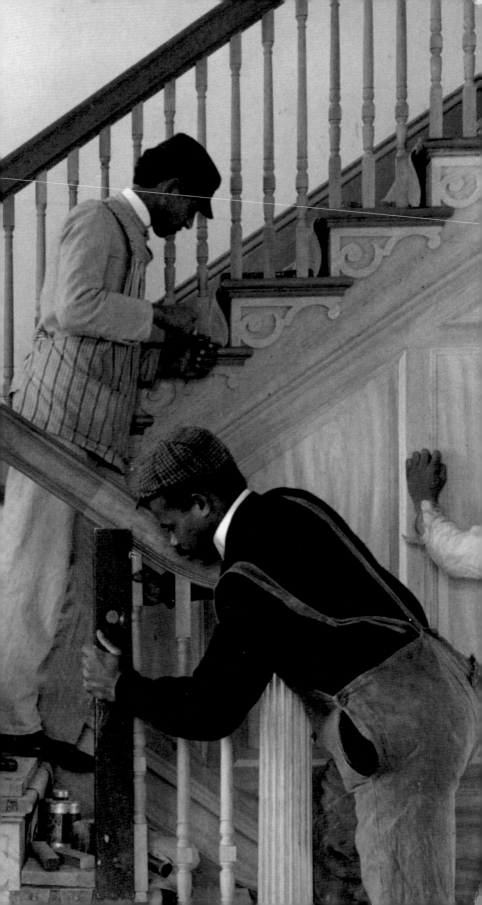

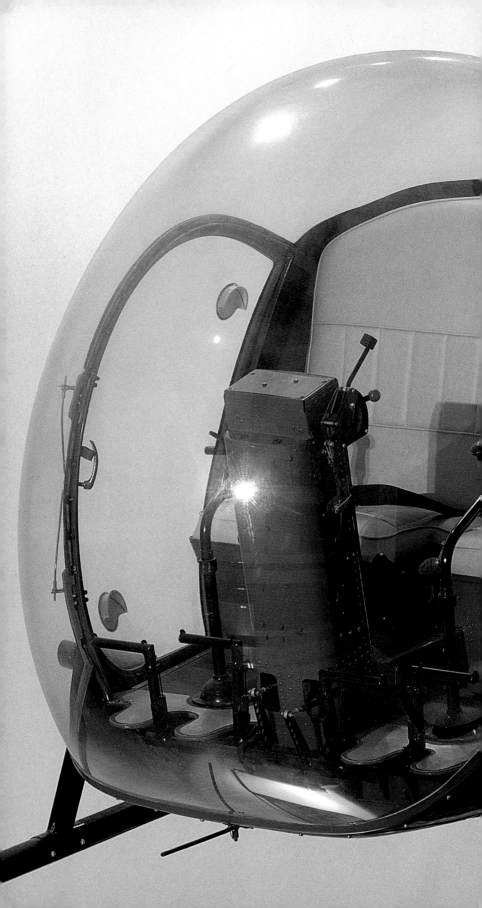

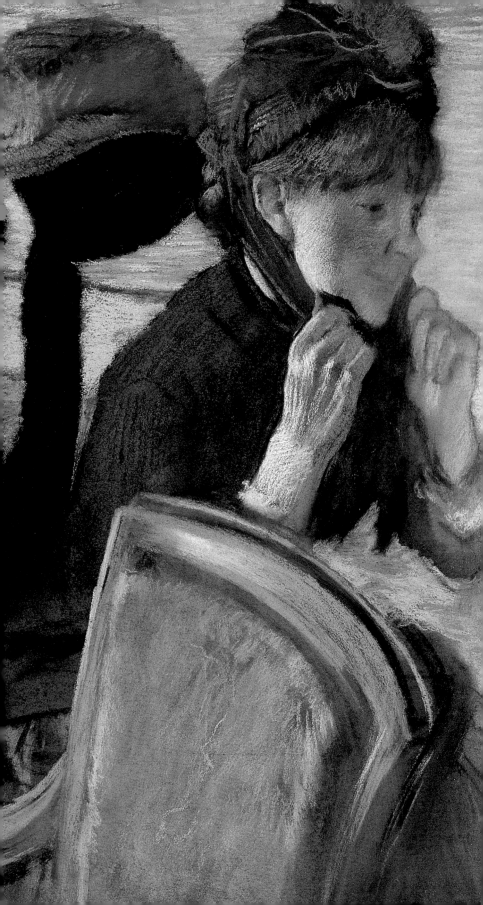

MoMA Highlights

350 Works from
The Museum of Modern Art
New York

The Museum of Modern Art, New York

Produced by the Department of Publications
The Museum of Modern Art, New York

Editors
Harriet Schoenholz Bee; Cassandra Heliczer
Design
Antony Drobinski, Emsworth Design, Inc.;
Amanda Washburn
Production
Christopher Zichello; Christina Grillo
Color separations
Professional Graphics, Inc.,
Rockford, Illinois;
C S Graphics Pte Ltd, Singapore
Printer
C S Graphics Pte Ltd, Singapore

Second edition 2004.
Reprinted 2005, 2007, 2008

Library of Congress Catalogue
Card Number: 2004106189
ISBN 978-0-87070-490-1

Published by The Museum of Modern Art
11 West 53 Street, New York, NY 10019-5497
www.moma.org

Distributed in the United States and Canada
by D.A.P./Distributed Art Publishers, Inc.,
New York

Distributed outside the United States and
Canada by Thames & Hudson, Ltd, London

Printed in Singapore

Pages 2–11, details: Oskar Schlemmer, *Bauhaus
Stairway* (p. 118); Frances Benjamin Johnston,
*Stairway of Treasurer's Residence: Students at
Work. Hampton Institute, Hampton, Virginia*
(p. 57); Arthur Young, Bell-47D1 Helicopter
(p. 203); Robert Motherwell, *Elegy to the
Spanish Republic, 108* (p. 244), Clint Eastwood,
Unforgiven (p. 340); Felix Gonzalez-Torres,
"Untitled" (Death by Gun) (p. 344); Hilaire-
Germain-Edgar Degas, *At the Milliner's* (p. 42);
Josef von Sternberg, *The Blue Angel* (p. 135);
Jan Groover, Untitled (p. 332); Juan Gris,
Breakfast (p. 76)

Front cover: See p. 238

Part-title page, details, clockwise: See pp. 291,
227, 125, 210, 225

Opposite title page, details, clockwise:
See pp. 253, 258, 228, 240, 218

Back cover, clockwise: See pp. 335, 155, 65,
295, 353

Contents

What is The Museum of Modern Art? At first glance, this seems like a relatively straightforward question. But the answer is neither simple nor straightforward, and any attempt to answer it almost immediately reveals a complex institution that, from its inception, has engendered a variety of meanings. For some, the Museum is a cherished place, a sanctuary in the heart of midtown Manhattan. For others, it is an idea represented by its collection and amplified by its exhibition program. For still others, the Museum is a laboratory of learning, a place where the most challenging and difficult art of our time can be measured against the achievements of the immediate past.

The Museum of Modern Art is, of course, all of this and more. Yet, in 1929, its founders dreamed, and its friends, trustees, and staff have dreamed since, that its multiple meanings and potential would ultimately be resolved into some final, fully formed equilibrium. In 1939, for instance, in his preface to the catalogue of the Museum's tenth anniversary exhibition, the Museum's president, A. Conger Goodyear, proudly proclaimed that the institution had finally reached maturity. As we now realize, in spite of the achievements of the Museum's initial years, he could not have anticipated the challenges to come. The Museum was still at the beginning of an adventure, an evolution that continues to unfold more than half a century later. At the age of ten the Museum was (and at more than seven times ten moves onward as) an exploratory enterprise whose parameters and possibilities remain open.

From small temporary quarters at 730 Fifth Avenue to its new building occupying most of a city block at 11 West 53 Street, from a single curatorial department to seven (six of which are collecting departments), and from a program without a permanent collection to a collection of over 100,000 objects, The Museum of Modern Art has grown, changed, and rethought itself on a regular basis. In doing so, it has undergone seven major architectural expansions and renovations since the completion of its first building in 1939—with its most recent expansion, designed by the celebrated Japanese architect Yoshio Taniguchi, finished in late 2004. This virtually continuous process of physical growth reflects the institution's ongoing efforts to honor its own changing programmatic and intellectual needs by constantly adjusting, and frequently rethinking, the topography of its space. Each evolution of the Museum has opened up the possibility for the next iteration of the institution, creating a kind of permanent self-renewing debate within The Museum of Modern Art about its future as well as its relationship to the past. With each change have come new expectations and challenges for the Museum, and this is especially true today as the Museum enters a new millennium.

The Museum of Modern Art is predicated on a relatively simple proposition, that the art of our time—modern art—is as vital and important as the art of the past. A corollary of this proposition is that the aesthetic and intellectual interests that shape modern art can be seen in mediums as different as painting and sculpture, film and media, photography, architecture and design, prints and illustrated books, and drawings—the current curatorial departments of the Museum.

From the outset, The Museum of Modern Art has been a laboratory for the study of the ways in which modernity has manifested itself in the visual arts. There has been, of course, and there will continue to be, a great deal of debate over what is actually meant by the term *modern*. Does it connote a moment in time, an idea, or a particular set of values? Whatever definition is favored, it seems clear that any discussion of the concept must take into account the role The

Museum of Modern Art has played in attempting to define, by its selective focus and the intellectual arguments of its staff, a canon of modern and contemporary art. These efforts at definition have often been controversial, as the Museum has sought to navigate between the interests of the avant-garde, which it seeks to promote, and the general public, which it seeks to serve.

The story of how The Museum of Modern Art came to be so intimately associated with the history of modern art forms a rich narrative that, over time, has acquired the potency of a founding myth. Like all such myths, it is part truth and part fiction, built upon the reality of the Museum's unparalleled collection. Various accounts—from Russell Lynes's book of 1973, *Good Old Modern*, to the Museum's own volume of 1984, *The Museum of Modern Art, New York: The History and the Collection*—give the details of The Museum of Modern Art's story at length, and this is not the place to repeat or enlarge upon it. What is worth considering, however, is that seventy-five years after the Museum first opened its doors in 1929, many of those associated with the beginnings of the Museum—Abby Aldrich Rockefeller, a founding trustee; Alfred H. Barr, Jr., the first director; Philip Johnson, who established the department of architecture and design; and Dorothy C. Miller, one of the Museum's first curators, to name only a few—remain vivid figures whose ideas and personalities continue to reverberate throughout the institution. This is true, in part, because there are still many people involved with the Museum who knew them, and have preserved and burnished their memories, but it is also because they are such fascinating figures, whose vision and drive gave birth to an institution that was the first, and rapidly became the foremost, museum of its kind in the world.

Given the resonance of this founding legacy, the challenge for The Museum of Modern Art today is to build upon this past without being delimited or constrained by it. This is by no means a simple task. To keep the Museum open to new ideas and new possibilities also means reevaluating and changing its perception of its past. As The Museum of Modern Art has become increasingly successful, established, and respected, its sense of responsibility to its own prior achievements has grown. In many ways, the Museum has become an agent implicated in the growth of the very tradition it seeks to explore and explicate: through its pioneering exhibitions, often based upon the Museum's permanent collection; its International Program, which has helped promote modern art around the world by circulating exhibitions to Europe, South America, and Asia; and through its acquisitions, publications, and public programs. Thus, it must constantly seek an appropriate critical distance, one that allows it to be an observer as well as the observed. While this distance may, in fact, be impossible to achieve fully, the effort to do so has resulted in a commitment to an intense internal debate, and an openness to sharing ideas with the public in a quest to promote an ever deeper engagement with modern art for the largest possible audience.

Any understanding of The Museum of Modern Art must begin with the recognition that the very idea of a museum of modern art implies an institution that is forever willing to take risks and court controversy. The challenge for the Museum is to periodically reinvent itself, to map new space, metaphorically as well as practically; to do this it must be its own severest critic. Programmed, therefore, into the Museum and its history—and by implication its future—are a series of contradictions and conflicts. These have often given rise to fierce divisions

within, as well as outside, the Museum, over such diverse issues, for example, as the importance of abstract art, how to deal with the representation of alternative modernisms within the collection, and whether the Museum should continue to collect contemporary art. But, rather than resolve such divisions, the Museum has had the strength to live with them. This has insured that the Museum remains an extremely lively place, where issues and ideas are argued over with an often startling intellectual intensity.

Working within its current configuration of six curatorial departments that collect, the Museum has built an unparalleled collection of art that now spans more than 150 years, from the mid-nineteenth century to the present. Defined by their focus on different mediums, the curatorial departments reflect the Museum's interest in examining the various ways modern ideas and ideals have manifested themselves across different disciplines. While the roles of the departments were initially relatively fluid, during the late 1960s and 1970s they became more codified, as each department became responsible for developing its collection independently of the other departments.

This approach has enabled The Museum of Modern Art to study and organize the vast array of art that it owns. It has led, as well, to the layout of the Museum's galleries in recent times by department. But this fundamentally taxonomic approach has resulted, in many instances, in a relatively static reading of modern art by the Museum, with a clearly defined set of physical and conceptual paths through the collection. Over the last fifteen years, however, the Museum has become increasingly aware of the importance of interdisciplinary approaches to the presentation of its collection. The division of the galleries into discrete departmental spaces is gradually being balanced by a more synthetic and inclusive reading of the collection that complicates, rather than simplifies, relationships among works of art.

The growth of the Museum's collection has been steady and, at times, dramatic. The first works of art entered the Museum's collection in 1929, the year the Museum was established, and included Aristide Maillol's sculpture *Ile de France*. However, it was not until 1931, after founding trustee Lillie P. Bliss bequeathed to the Museum a superb group of 116 paintings, prints, and drawings, including Paul Cézanne's *The Bather, Pines and Rocks*, and *Still Life with Apples*, and Paul Gauguin's *The Moon and the Earth*, that the collection really began to develop. By 1940, the Museum's collection had grown to 2,590 objects, including 519 drawings, 1,466 prints, 436 photographs, 169 paintings, and 1,700 films. Twenty years later, the collection had expanded to over 12,000 objects, and by 1980 it exceeded 52,000. Today, the Museum owns over 6,000 drawings, 50,000 prints and illustrated books, 25,000 photographs, 3,200 paintings and sculptures, 24,000 works of architecture and design, and 20,000 films, videos, and other media works.

Many of the most important works of art in the collection entered the Museum during and immediately after World War II: among them are Pablo Picasso's *Les Demoiselles d'Avignon*, Henri Matisse's *Blue Window*, Vincent van Gogh's *The Starry Night*, and Piet Mondrian's *Broadway Boogie Woogie*. There were many reasons for this, but among the most important were the Nazis' selling of so-called degenerate art from state collections; the economic might of the United States, especially immediately after the end of the war; and the emigration of collectors and artists to the United States and elsewhere, as they sought refuge from the deprivations of the war. Having helped introduce an American audience

to avant-garde European art throughout the 1930s, The Museum of Modern Art became a haven for art, artists, and collectors—all victims of Nazi persecution.

Collections, of course, are complex entities that grow and evolve in different ways. They are all the result, however, of discrete decisions made by individuals. In the case of The Museum of Modern Art, these decisions rest with the director and chief curators. In addition, each curatorial department has a working committee, authorized by the Board of Trustees, to act on its behalf in the acquisition process. Since the development of The Museum of Modern Art's collection, like that of most museums, has occurred over time, each generation's choices are woven into the fabric of the collection so that a continuous thread of ideas and interests emerges. The result of this reflects the unfolding pattern of the Museum's history in a highly nuanced collection that is inflected and altered by the particular tastes and ideas of individual directors and curators, and the responses those tastes and ideas engender in their successors, as holes are filled in the collection and areas of overemphasis are modified.

The vast majority of objects in The Museum of Modern Art's collection have been acquired as gifts and bequests, which are often the fruit of relationships nurtured through the years, from generous donors and friends. The Museum's trustees have played a particularly important role in this regard, and the recent bequests of Louise Reinhardt Smith and Florene May Schoenborn, and the gifts of David and Peggy Rockefeller, Philip Johnson, Elaine Dannheisser, Agnes Gund, Ronald S. Lauder, and the Woodner Family are among the most recent examples of a tradition that includes such extraordinary bequests as those of Lillie P. Bliss, William S. Paley, and Gordon Bunshaft. In addition, major gifts from such close friends of the Museum as Sidney and Harriet Janis, Mary Sisler, and Mr. and Mrs. John Hay Whitney, among many others, have also strengthened the collection.

The Museum also purchases works of art, and it occasionally deaccessions an object in order to refine and enhance its collection. Perhaps the most celebrated instance of this was the sale of an Edgar Degas, along with several other works from the Lillie P. Bliss bequest, which enabled the Museum to acquire Picasso's *Les Demoiselles d'Avignon*, one of the most important paintings of the twentieth century and a cornerstone of the Museum's collection. Deaccessioning also permitted the Museum to acquire, in 1989, van Gogh's *Portrait of Joseph Roulin*, as well as, in 1995, Gerhard Richter's celebrated group of fifteen works, *October 18, 1977*, and, in 2003, Jasper Johns's *Diver*, among other important works of art. The principal reason the Museum has the most comprehensive collection of modern art in the world is because from the outset it has accepted only unconditional gifts, with very few exceptions. This has allowed it periodically to reassess the relative importance of any work of art in its collection, but it has come at the price of occasionally seeing works of art go to other institutions (such as the Walter and Louise Arensberg Collection, which was given to the Philadelphia Museum of Art when The Museum of Modern Art was unable to accept the conditions imposed by the donors). Nevertheless, it has also provided The Museum of Modern Art with the ability to reconsider and revise its collection, allowing it to exist in what Alfred Barr would have called a metabolic state of self-renewal. An additional consequence of the Museum's policy concerning gifts is that the institution has been free to integrate works of art into its collection in an unrestricted

way that has permitted development of a coherent and relatively unencumbered presentation of its collection, confined only by the limitations of its space.

Given that great collections are inevitably mosaics that shift and change over time, the cumulative result of individual tastes and idiosyncrasies, as well as the vagaries of historical opportunities, it is through the ordering and presentation of their collections that museums encode their ideas and narratives. In the case of The Museum of Modern Art, this is especially true, as the collection is the principal means by which it argues for its reading of modern art. Thus, the publication of this second edition of *MoMA Highlights* celebrates the richness of the Museum's collection and the variety of issues and ideas it embraces. It is not meant to be comprehensive, nor is it meant to provide a definitive statement about the Museum's collection. On the contrary, it is intended to be provocative, one of many such publications to come designed to explore the complexity and variety of possibilities that exist within the collection. Our goal is also to suggest new and imaginative ways of understanding the different works of art that constitute the Museum's collection. Organized in a general, but not rigid, chronological order, it endeavors to juxtapose works from different parts of the collection in surprising, revealing, and sometimes arbitrary ways. For example, both Cézanne's painting *The Bather* of 1885 and Étienne-Jules Marey's untitled photograph of 1890–1900 are about the male figure in space. But Cézanne presents us with a monumental, yet awkward, figure arrested in the act of putting his foot in water, while Marey shows us a well-muscled and sleek figure in the process of accelerating from a starting position. Where Cézanne invokes classical and Renaissance models to create a timeless image, Marey uses the relatively new medium of photography to document the time elapsed as a body moves through space. In another example, compare Pierre Bonnard's *Nude in a Bathroom* and Picasso's *Girl Before a Mirror*, both painted in 1932. Each, in a very different way, explores questions of intimacy and introspection, Bonnard by examining his wife as she dries herself off after a bath, Picasso by studying his mistress Marie-Thérèse Walter as she contemplates herself in a mirror. Bonnard, known for his optical acuity and coloristic effects, reveals himself here to be a master of subtle psychological probing, while Picasso uses his prodigious talent to examine the complex boundary between mystery and Eros, developing a rich and powerful image built of flat, bold colors surrounded by thick black contours that gives his painting an almost iconic quality.

Other pairings, such as Oskar Schlemmer's *Bauhaus Stairway* of 1932 and Wilhelm Wagenfeld's Table Lamp of 1923–24 or Stuart Davis's *Odol* of 1924 and Sven Wingquist's Self-Aligning Ball Bearing of 1929, examine the aesthetic vocabulary of the Bauhaus, on the one hand, and the rising impact of industrial design and consumerist society, on the other hand. Still others, such as Andy Warhol's film *Empire* and his *Gold Marilyn Monroe* of 1962, explore how an artist's fascination with famous landmarks manifests itself through different mediums.

Not every juxtaposition is meant to be read as a comparison or confrontation. Some are simply the result of two interesting works of art brought together for consideration on facing pages. In preparing this volume, we have tried to demonstrate that The Museum of Modern Art's collection is the result of considered, careful research and fortuitous opportunities that have allowed us to assemble often disparate works of art in new and intriguing relationships.

Modern art began as a great experiment, and it continues to be one today.

Much of the early effort of The Museum of Modern Art was given over to trying to make order out of the seemingly confused, and at times baffling, nature of this art. While these efforts helped to explain the complicated relationships among different movements and counter-movements (such as Cubism, Suprematism, Dada, Conceptual art, Minimalism, to name a few), they also, inadvertently, tended to simplify and reconcile competing and contradictory ideas. The positivist assertion of the first decades of the Museum's existence, that modern art forms a single, coherent narrative that can be reflected in the Museum's galleries, needs to be tempered by the recognition that the very ideas of modern and contemporary art imply the possibility of multiple, even contradictory, narratives. To a large degree, of course, the founders of the Museum were aware of the richness of this tradition, and their pioneering efforts initially embraced a broad range of interests, including tribal, naïve, and folk art. But the relatively limited space of the galleries and their linear configuration, compounded by their dramatic growth, inevitably led to a reductivist approach.

Today, contemporary artists challenge us in many of the same ways as artists of the avant-garde of forty years ago (many of whom are now regarded as modern masters) challenged viewers of their day. That we have come to accept the achievements of Picasso and Matisse, Mondrian and Jackson Pollock, does not necessarily mean that their work is either fully understood or that this acceptance is universal. For The Museum of Modern Art, this means that its collection must be a laboratory where the public can explore the relationship between contemporary art and the art of the immediate past, in an ongoing effort to continue to define modern art. By locating objects and people in time as well as space, the Museum is constantly mapping relationships between works of art and their viewers, so that the space of the Museum becomes a site of narration where many individual stories can be developed and realized. This process of experimentation and narration also allows us to create a dialogue between artists (and ideas) of the first years of the twentieth century and those of the century's final years. To do this successfully, the Museum is committed to developing new ways of understanding and presenting its collection. The first edition of this handbook, with its multidisciplinary approach, was one of the first steps in this process. Another was the Museum's yearlong project of three cycles of exhibitions presented in celebration of the millennium, from fall 1999 through early 2001, which examined its permanent collection in new ways that parallel many of the themes developed in this volume. The opening of the new Museum of Modern Art, in November 2004, with its expanded galleries and new layout, continues this process of exploring the richness and complexity of the Museum's diverse holdings.

This process of reconsidering our understanding of modern art has been realized with the completion of the Museum's new building. It has enabled the Museum to create numerous suites of galleries, allowing for a more layered presentation of the collection. This will both complicate and enrich the story of modern art. This volume of highlights of the Museum's collection may thus be taken as an initial chapter in that story and as both a record of the Museum's past and a statement in anticipation of an exciting future.

Glenn D. Lowry, *Director*

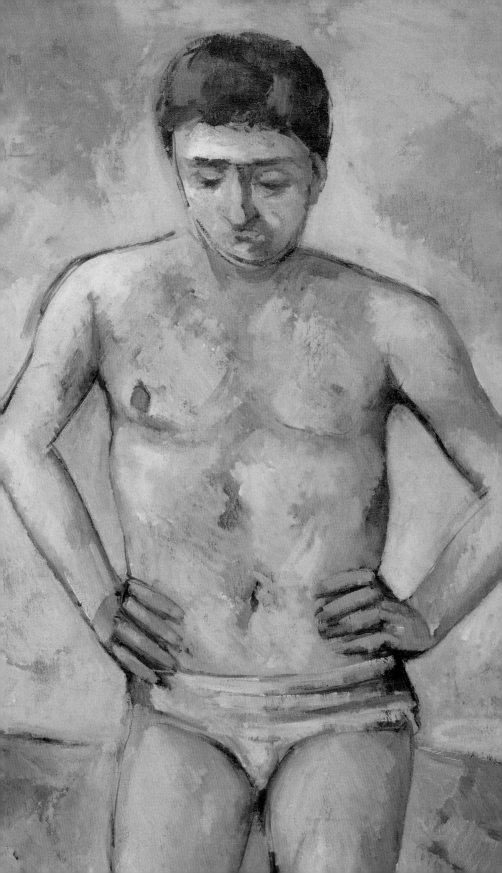

The Bather. c. 1885
Oil on canvas, 50 × 38⅛" (127 × 96.8 cm)
Lillie P. Bliss Collection

The Bather is one of Cézanne's most evocative paintings of the figure, although the unmuscled torso and arms have no heroic pretensions, and the drawing, in traditional, nineteenth-century terms, is awkward and imprecise. The bather's left, forward leg is placed firmly on the ground, but his right leg trails and carries no weight. The right side of his body is pulled higher than the left, the chin curves lopsidedly, and the right arm is elongated and oblique. The landscape is as bare as a desert, but its green, violet, and rose coloration refuses that name. Its dreaming expanse matches the bather's pensiveness. Likewise, the shadows on the body, rather than shifting to black, share the colors of the air, land, and water; and the brushwork throughout is a network of hatch-marks and dapples, restless yet extraordinarily refined. The figure moves toward us but does not meet our gaze.

These disturbances can be characterized as modern: they indicate that while Cézanne had an acute respect for much of traditional art, he did not represent the male nude the way the classical and Renaissance artists had done. He wanted to make an art that was "solid and durable like the art of the museums" but that also reflected a modern sensibility incorporating the new understanding of vision and light developed by the Impressionists. He wanted to make an art of his own time that rivaled the traditions of the past.

Étienne-Jules Marey | French, 1830–1904
or **Georges Demenÿ** | French, 1850–1917

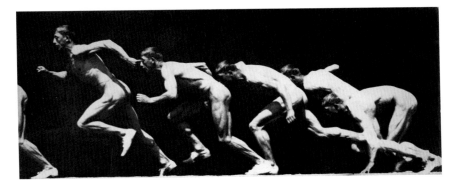

Untitled. c. 1890–1900
Gelatin silver print, 6 1/16 × 14 5/8" (15.4 × 37.2 cm)
Gift of Paul F. Walter

Marey, a physiologist, had been studying motion for two decades when the work of the American photographer Eadweard Muybridge led him to try photography in 1881. Unlike Muybridge, who used a battery of cameras to make a sequence of separate frames (like the frames in a movie), Marey recorded the successive phases of motion on single plate. Thus, his studies at once analyze motion and present a virtual image of its course.

Photography has radically enhanced our ability to study the world around us (and the skies beyond) by making visible what once had been too distant, too small, too fast, or otherwise too difficult to see. Many such pictures were made in the service of science, but their impact often has been much broader than their original scientific function. The influence of Marey's pictures on the Futurist painters, such as Giacomo Balla and Gino Severini, who sought to evoke dynamic motion in their work, is only the most familiar example.

Demenÿ worked as Marey's assistant from 1881 to 1893 and then applied Marey's method to the physical training program of the French army. This picture, whose successive exposures were timed to match the strides of the runner, may have been made by him.

Monument to Balzac. 1897–98

Bronze (cast 1954), 9' 3" × 48¼" × 41"
(282 × 122.5 × 104.2 cm)
Presented in memory of Curt Valentin
by his friends

Commissioned to honor one of France's greatest novelists, Rodin spent seven years preparing for *Monument to Balzac*, studying the writer's life and work, posing models who resembled him, and ordering clothes to his measurements. Ultimately, though, Rodin's aim was less Honoré de Balzac's physical likeness than an idea or spirit of the man, and a sense of his creative vitality: "I think of his intense labor, of the difficulty of his life, of his incessant battles and of his great courage. I would express all that."

Several studies for the work are nudes, but Rodin finally clothed the figure in a robe inspired by the dressing gown that Balzac often wore when writing. (He liked to work at night.) The effect is to make the figure a monolith, a single, phallic, upward-thrusting form crowned by the craggy ridges and cavities that define the head and face. *Monument to Balzac* is a visual metaphor for the author's energy and genius, yet when the plaster original was exhibited in Paris in 1898, it was widely attacked. Critics likened it to a sack of coal, a snowman, a seal, and the literary society that had commissioned the work dismissed it as a "crude sketch." Rodin retired the plaster model to his home in the Paris suburbs. It was not cast in bronze until years after his death.

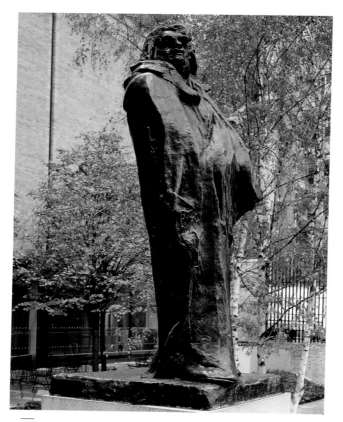

The Great Train Robbery. 1903
35mm film, black and white with color tinting,
silent, 11 minutes (approx.)
Preserved with funding from the Celeste Bartos
Film Preservation Fund
George Barnes

The Great Train Robbery is not the earliest film in which the former showman and film exhibitor, Porter, told a story through the editing together of images in sequence, nor is it the first Western. Nevertheless, it is a milestone in American film history for combining these two elements into what was, for 1903, an exceptionally long film at eleven minutes and one that captured the imagination of the movie-going public worldwide. In the film, bandits hold up a train and rob passengers. After an escape and chase on horseback, the bandits are caught. The outlaw fires at the viewers as if they are the passengers, in an extra shot that, Porter noted, could be shown at the beginning or the end of the film.

With *The Great Train Robbery* Porter pulled the American film business out of its early doldrums, using cameras mounted on moving trains, special optical effects, hand-colored images of gunshots and explosions, and trick photography—all to tell a story drawn blatantly from the popular dime novels of the day.

Porter had begun his career at the turn of the century as a designer and builder of cameras for the Edison Company factory in West Orange, New Jersey, and eventually became a cameraman and director in charge of all work turned out by the Edison Studio in New York City. This is his best-known film.

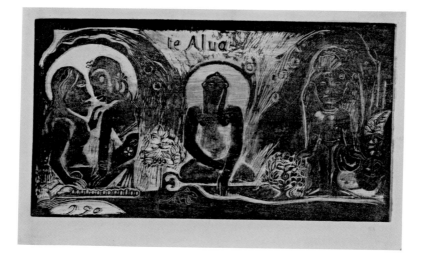

The Gods (Te Atua) from the series Noa Noa. 1893–94
Woodcut, comp.: 8 × 13⅞" (20.5 x 35.2 cm)
Publisher: the artist. Edition: proof before edition of 35
Gift of Abby Aldrich Rockefeller

The imposing idols seen here reflect the figural style of Oceanic sculptures that Gauguin had seen during his travels. To create these prints, the artist first cut his composition into a block of hard wood, delineating the figures with abrupt, gouged lines. Then he selectively inked and wiped the block before printing the image on a sheet of paper. The dark and mysterious areas of the composition create an aura of the exotic and the spiritual.

The Gods (Te Atua) is one of ten woodcuts executed by Gauguin after his return to Paris from Tahiti in 1893. They were intended as illustrations to a text that he planned to publish about his experiences in the South Seas. With this book, which he titled *Noa Noa* (the Tahitian word for fragrance), he hoped to provide a background for the public's understanding of his new Symbolist paintings.

Gauguin had left for Tahiti in 1891 to escape the pressures of modern-day life and to seek an unspoiled society in tune with nature. There he painted a number of important canvases inspired by his Tahitian experiences. He made his second trip to the South Seas in 1894; but the *Noa Noa* project was never realized as the book he had planned. He died in the Marquesas Islands in 1903.

Henri Rousseau | French, 1844–1910

The Sleeping Gypsy. 1897
Oil on canvas, 51" × 6' 7" (129.5 × 200.7 cm)
Gift of Mrs. Simon Guggenheim

As a musician, the gypsy in this painting is an artist; as a traveler, she has no clear social place. Lost in the self-absorption that is deep, dreaming sleep, she is dangerously vulnerable—yet the lion is calmed and entranced.

The Sleeping Gypsy is formally exacting—its contours precise, its color crystalline, its lines, surfaces, and accents carefully rhymed. Rousseau plays delicately with light on the lion's body. A letter of his describes the painting's subject: "A wandering Negress, a mandolin player, lies with her jar beside her (a vase with drinking water), overcome by fatigue in a deep sleep. A lion chances to pass by, picks up her scent yet does not devour her. There is a moonlight effect, very poetic. The scene is set in a completely arid desert. The gypsy is dressed in oriental costume."

A sometime *douanier* (toll collector) for the city of Paris, Rousseau was a self-taught painter, whose work seemed entirely unsophisticated to most of its early viewers. Much in his art, however, found modernist echoes: the flattened shapes and perspectives, the freedom of color and style, the subordination of realistic description to imagination and invention. As a consequence, critics and artists appreciated Rousseau long before the general public did.

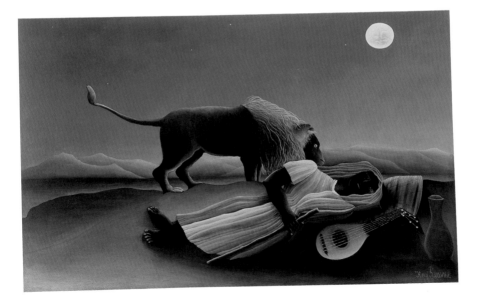

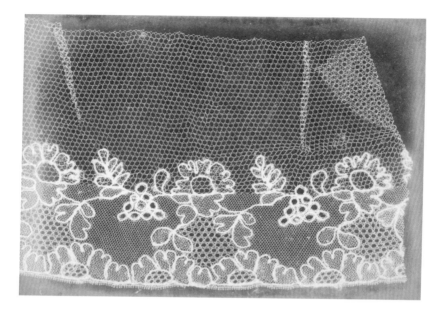

Lace. 1845
Salted paper print, 6½ × 8¾" (16.5 × 22.3 cm)
Gift of Dr. Stefan Stein

To make this picture, Talbot laid a piece of lace on chemically sensitized paper and allowed the light of the sun gradually to fix its negative image precisely, down to the smallest fold or imperfection. This simple operation had never been possible before photography was invented.

The invention was made public in January 1839, when France announced the daguerreotype as its gift to the world. Talbot, who independently had invented another form of photography several years earlier, then quickly stated his own claim. His process, in which any number of positive paper prints could be made from a single negative, soon triumphed over the daguerreotype process, which produced unique pictures on metal.

Talbot's *Lace* is not merely a copy of unprecedented ease and fidelity. It is also a picture, which transposed the lace from the realm of objects to the realm of pictures, where it has enjoyed a new and unpredictable life.

Édouard Vuillard | French, 1868–1940

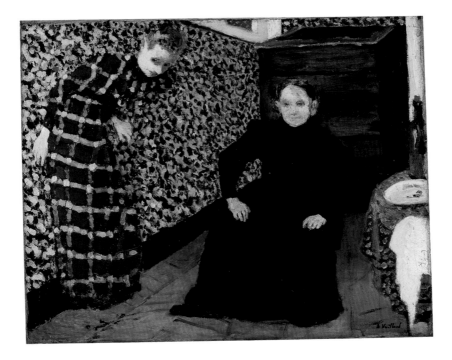

Mother and Sister of the Artist. c. 1893

Oil on canvas, 18¼ × 22¼" (46.3 × 56.5 cm)
Gift of Mrs. Saidie A. May

In this painting, Vuillard's mother and sister are depicted at home. A widow who had supported her family by running her own business, his mother commands a powerful presence. Her pose is solid and stable, her dress is the painting's largest unbroken form, and her face and hands stand out against browns and blacks, and against the extraordinary trapezoid of mottled color that describes the room's wallpaper. Her daughter, by contrast, almost disintegrates into this surface, as if its dots had temporarily organized themselves into the checkered pattern of her dress. Pressing herself awkwardly against the wall, she bends her head and shoulders, apparently greeting a visitor but also, it seems, forced to bow if she is to fit in the picture's frame.

Intimate in scale, this scene is deceptively casual. Relying on imaginative insight as well as on the direct observation prized by the Impressionists, Vuillard constructs a psychologically suggestive space: the table, the bulky chest of drawers, the overactive wallpaper, and the steeply rising perspective of the floor make a crowded container for the figures, and the claustrophobia this suggests is heightened by slightly leaning angles, an imperfectly centered composition, and the daughter's off-balance posture. The whole space seems apt to fall inward at Mme. Vuillard—a dominating, even oppressive force in the room (and, we suspect, in the family); she is also the gravitational principle that prevents a collapse.

Claret Pitcher. c. 1880

Glass, silverplate, and ebony, 16⅝ × 9¹⁵⁄₁₆ × 4"
(42.2 × 25.2 × 10.2 cm)
Gift of Mrs. John D. Rockefeller, 3rd

The simple geometry of this elongated claret pitcher is characteristic of Dresser's designs, which stand in stark contrast to the heavily ornamented styles of his time. Dresser had studied Japanese decorative arts, which influenced his own designs and those of his more progressive contemporaries. In this pitcher, the long, vertical ebony handle is almost a direct quotation of the bamboo handles on Japanese vessels. As in many of his designs for metalwork, the fittings on the claret pitcher are made from electroplated metal, a technological innovation that made silverware available to a growing middle class before the turn of the century. The exposed rivets and joints presage the enthusiasm for the machine aesthetic in industrial design of several decades later.

A trained botanist as well as a designer, Dresser was strongly inspired by the underlying structures of natural forms and by his interest in technological progress. While he shared some of the theories of the English Arts and Crafts movement, which sought to replace the often shoddy design of mass-produced goods with skilled handcraftsmanship, Dresser was completely committed to quality design for machine production, and is one of the world's first industrial designers.

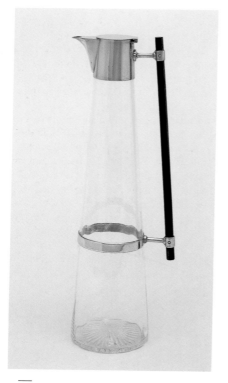

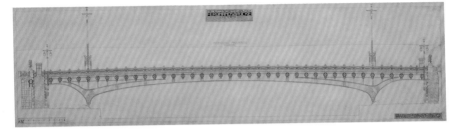

Ferdinandsbrücke, Vienna.
Preliminary version, c. 1896
Elevation: ink on paper with collaged text,
19⅛ × 66 ½" (48.6 × 168.9 cm)
Promised gift of Jo Carole and Ronald S. Lauder

In 1895 Otto Wagner, the leading Viennese architect of his time, declared: "The only possible point of departure for our artistic creation is modern life." As shown in this drawing, Wagner's design for the Ferdinandsbrücke, a bridge named in honor of Archduke Francis Ferdinand, is one of his frankest expressions of the techniques of modern engineering. The bridge's steel truss spans the Danube Canal in a low, broad arch. Decorating the naked steel structure are imperial emblems—coats of arms, wreaths, and garlands—particularly appropriate for Vienna, which was the capital of the Austro-Hungarian empire at the turn of the century.

Wagner argued for simplicity and a new "realist" style, which implied that designers should use modern materials and clear methods of construction. He gave shape to his ideas in the many buildings and projects he designed in Vienna, as the city expanded outside its medieval boundaries. Although the Ferdinandsbrücke was not built according to his design, Wagner's prolific output and progressive ideas influenced an entire generation and firmly established him as one of the forefathers of modern architecture.

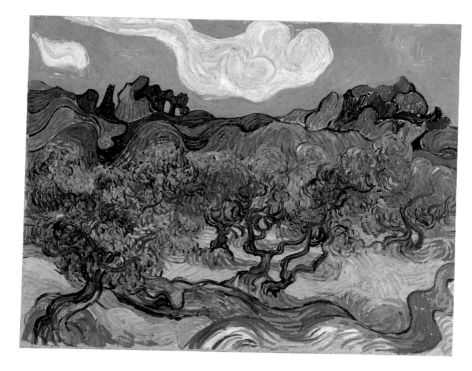

The Olive Trees. 1889
Oil on canvas, 28⅝ × 36" (72.6 × 91.4 cm)
Mrs. John Hay Whitney Bequest

In the blazing heat of this Mediterranean afternoon, nothing rests. Against a ground scored as if by some invisible torrent, intense green olive trees twist and crimp, capped by the rolling, dwindling hillocks of the distant Alps, beneath a light-washed sky with a bundled, ectoplasmic cloud.

After van Gogh voluntarily entered the asylum at Saint-Rémy in the south of France in the spring of 1889, he wrote his brother Theo: "I did a landscape with olive trees and also a new study of a starry sky." Later, when the pictures had dried, he sent both of them to Theo in Paris, noting: "The olive trees with the white cloud and the mountains behind, as well as the rise of the moon and the night effect, are exaggerations from the point of view of the general arrangement; the outlines are accentuated as in some old woodcuts."

Van Gogh's letters make it clear that he created this particular intense vista of the southern French landscape as a daylight partner to the visionary nocturne of his more famous canvas, *The Starry Night*. He felt that both pictures showed, in complementary ways, the principles he shared with his fellow painter Paul Gauguin, regarding the freedom of the artist to go beyond "the photographic and silly perfection of some painters" and intensify the experience of color and linear rhythms.

Vincent van Gogh | Dutch, 1853–1890

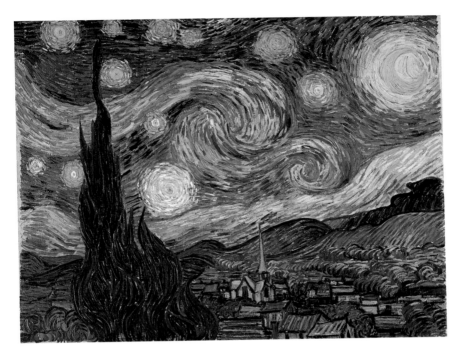

The Starry Night. 1889

Oil on canvas, 29 × 36¼" (73.7 × 92.1 cm)
Acquired through the Lillie P. Bliss Bequest

Van Gogh's night sky is a field of roiling energy. Below the exploding stars, the village is a place of quiet order. Connecting earth and sky is the flamelike cypress, a tree traditionally associated with graveyards and mourning. But death was not ominous for van Gogh. "Looking at the stars always makes me dream," he said, "Why, I ask myself, shouldn't the shining dots of the sky be as accessible as the black dots on the map of France? Just as we take the train to get to Tarascon or Rouen, we take death to reach a star."

The artist wrote of his experience to his brother Theo: "This morning I saw the country from my window a long time before sunrise, with nothing but the morning star, which looked very big." This morning star, or Venus, may be the large white star just left of center in *The Starry Night*. The hamlet, on the other hand, is invented, and the church spire evokes van Gogh's native land, the Netherlands. The painting, like its daytime companion, *The Olive Trees*, is rooted in imagination and memory. Leaving behind the Impressionist doctrine of truth to nature in favor of restless feeling and intense color, as in this highly charged picture, van Gogh made his work a touchstone for all subsequent Expressionist painting.

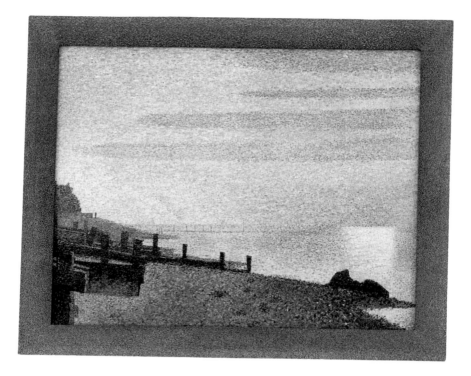

Evening, Honfleur. 1886

Oil on canvas, 25¾ × 32" (65.4 × 81.1 cm)
Gift of Mrs. David M. Levy

Seurat spent the summer of 1886 in the resort town of Honfleur, on the northern French coast, a region of turbulent seas and rugged shorelines to which artists had long been attracted. But Seurat's evening scene is hushed and still. Vast sky and tranquil sea bring a sense of spacious light to the picture, yet also have a peculiar visual density. Long lines of cloud echo the breakwaters on the beach—signs of human life and order.

Seurat had used his readings of optical theory to develop a systematic technique, known as pointillism, that involved the creation of form out of small dots of pure color. In the viewer's eye, these dots can both coalesce into shapes and remain separate particles, generating a magical shimmer. A contemporary critic described the light in

Evening, Honfleur and related works as a "gray dust," as if the transparency of the sky were filled with, or even constituted by, barely visible matter—a sensitive response to the paint's movement between illusion and material substance, as the dots both merge to describe the scene and break into grains of pigment.

Seurat paints a frame around the scene—buffering a transition between the world of the painting and reality; and, at the upper right, the dots on the frame grow lighter, lengthening the rays of the setting sun.

Paul Gauguin | French, 1848–1903

The Seed of the Areoi
(Te aa no areois). 1892
Oil on burlap, 36¼ × 28⅜" (92.1 × 72.1 cm)
The William S. Paley Collection

The Polynesian goddess sits on a blue-and-white cloth. Gauguin's style fuses various non-European sources: ancient Egyptian (in the hieratic pose), Japanese (in the relative absence of shadow and modeling, and in the areas of flat color), and Javanese (in the position of the arms, influenced by a relief in the temple of Borobudur). But there are also signs of the West, specifically through aspects of the pose derived from a work by the French Symbolist painter Pierre Puvis de Chavannes. The color, too, is eclectic: although Gauguin claimed to have found his palette in the Tahitian landscape, the exquisite chromatic chords in *The Seed of the Areoi* owe more to his compositional eye than to the island's visual realities.

In the origin myth of the Areoi, a Polynesian secret society, a male sun god mates with the most beautiful of all women, Vaïraümati, to found a new race. By painting his Tahitian mistress Tehura as Vaïraümati, Gauguin implied a continuity between the island's past and its life during his own stay there. In fact, Tahiti had been profoundly altered by colonialism (the Areoi society itself had disappeared), but Gauguin's anachronistic vision of the place gave him an ideal model for his painting. This vision was particularly powerful for him in its contrast with the West, which, he believed, had fallen into "a state of decay."

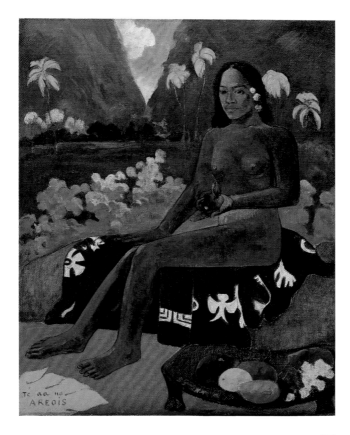

Child's Cradle. c. 1895

Ebonized bentwood, 6' 8¼" × 56¼" × 25⁷⁄₁₆"
(203.8 × 142.9 × 64.6 cm)
Manufacturer: J. & J. Kohn, Austria
Gift of Barry Friedman

This elaborate bentwood cradle was lined with thick cushions to create a soft, sheltered, egg-shaped bed for an infant. The sinuous and sensual design, with the elegant, curved forms of the cradle and the long vertical arm that supported draped netting, reflects the popular Art Nouveau style of the time. Such cradles could be found in stylish, bourgeois homes all over Europe.

Bentwood designs became ubiquitous as seating for cafés and gardens and later as elaborate, upholstered domestic furnishings. Inexpensive, durable, light, and ideal for export because components could be assembled after shipping, pieces such as J. & J. Kohn's cradle became perfect symbols of the new industrial age. The bentwood process had been developed by the German designer Michael Thonet in the mid-nineteenth century in order to make appealing functional furniture efficiently and economically. In 1867 the manufacturer J. & J. Kohn became Thonet's chief competitor, opening factories in several international locations.

Bentwood furniture was made by steaming lengths of wood and then bending them and placing them in metal molds to dry. The resulting standardized sections were assembled with hardware instead of the traditional hand-carved joints. The idea of standardized elements revolutionized the principles of furniture production.

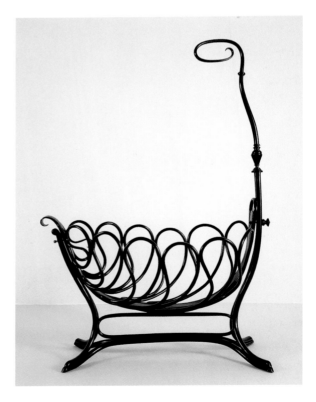

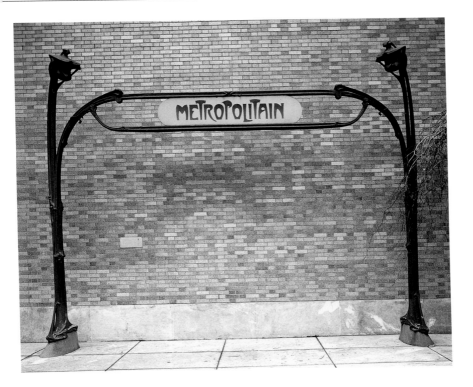

Entrance Gate to Paris Subway (Métropolitain) Station. c. 1900

Painted cast iron, glazed lava, and glass,
13' 11" × 17' 10" × 32" (424 × 544 × 81 cm)
Gift of Régie Autonome des Transports Parisiens

The emergence of the Art Nouveau style toward the end of the nineteenth century resulted from a search for a new aesthetic that was not based on historical or classical models. The sinuous, organic lines of Guimard's design and the stylized, giant stalks drooping under the weight of what seem to be swollen tropical flowers, but are actually amber glass lamps, make this a quintessentially Art Nouveau piece. His designs for this famous entrance arch and two others were intended to visually enhance the experience of underground travel on the new subway system for Paris.

Paris was not the first city to implement an underground system (London already had one), but the approaching Paris Exposition of 1900 accelerated the need for an efficient and attractive means of mass transportation. Although Guimard never formally entered the competition for the design of the system's entrance gates that had been launched by the Compagnie du Métropolitain in 1898, he won the commission with his avant-garde schemes, all using standardized cast-iron components to facilitate manufacture, transport, and assembly.

While Parisians were at first hesitant in their response to Guimard's use of an unfamiliar vocabulary, his Métro gates, installed throughout the city, effectively brought the Art Nouveau style, formerly associated with the luxury market, into the realm of popular culture.

Louis Lumière | French, 1864–1948

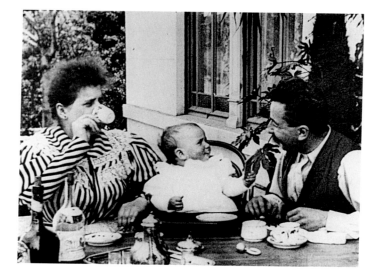

Feeding the Baby
(Repas de bébé). 1895
35mm film, black and white, silent,
45 seconds (approx.)
*Auguste Lumière, Mrs. Auguste Lumière,
and their daughter*

Feeding the Baby is one of the films that
mark the official birth of cinema as a
theater-going experience, on December
28, 1895. On that date, Lumière and his
brother Auguste projected a program of
short films to a paying audience at the
Grand Café on the Boulevard des
Capucines in Paris. Filmed by Louis
and less than a minute long, it shows
Auguste and his wife having a meal with
their child. While this is presented as a
documentary, the film shows a domestic
scene arranged for the camera; as such,
it falls somewhere between the
Lumières' usual strict recordings of
actual events and their staged comedies.

The Lumière brothers were already
well-established photographers and
manufacturers of photographic equip-
ment when, in 1894, they witnessed a
demonstration of Thomas Edison's
Kinetoscope in Paris. The American
invention was a peepshow device,
accommodating only one viewer at a
time. The Lumières quickly set out to
create a combination camera and projec-
tor. Their new, simplified, and portable
apparatus, which they called the Ciné-
matographe, was the leap of technical
imagination needed for a cinematic cul-
ture to emerge from Edison's novelty.

Henri de Toulouse-Lautrec | French, 1864–1901

Divan Japonais. 1893
Lithographed poster, comp.: 31⅝ × 23⅞"
(80.3 × 60.7 cm)
Publisher: Édouard Fournier, Paris
Abby Aldrich Rockefeller Fund

The Divan Japonais, a cabaret in Montmartre, an artists' quarter in Paris, was newly redecorated in 1893 with fashionable Japanese motifs and lanterns. Its owner, Édouard Fournier, commissioned this poster—depicting singers, dancers, and patrons—from Toulouse-Lautrec to attract customers to the opening of his nightclub. In the immediate foreground, Toulouse-Lautrec depicts two of his good friends in the audience: on the right, Édouard Dujardin, an art critic and founder of the literary journal *Revue wagnérienne*, and, at the center, the famous cancan dancer Jane Avril,

whose elegant black silhouette dominates the scene. In the background, another well-known entertainer of the period, the singer Yvette Guilbert, performs on stage. Although her head is abruptly cropped in this composition—reflecting the influence of photography and Japanese prints—Guilbert was immediately known to contemporary patrons by the dramatic gesture of her signature long black gloves.

Lithographed posters proliferated during the 1890s due to technical advances in color printing and the relaxation of laws restricting the placement of posters. Dance halls, *café-concerts,* and festive street life invigorated nighttime activities. Toulouse-Lautrec's brilliant posters, made as advertisements, captured the vibrant appeal of the prosperous *Belle Époque.*

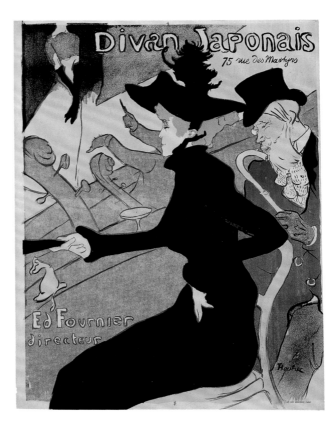

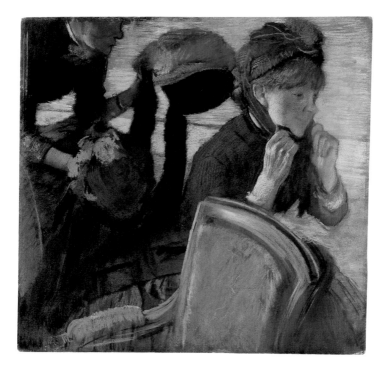

At the Milliner's. c. 1882

Pastel on paper, 27 5/8 × 27 3/4" (70.2 × 70.5 cm)
Gift of Mrs. David M. Levy

This cameo of nineteenth-century life maintains its intimacy through Degas's use of pastel, whose chalky texture quiets the scene in multiple veils of color. Pastel, an important drawing medium at the end of the nineteenth century due in part to a new preoccupation with color, appropriately expresses, through its inherent fragility, the ephemeral encounter between two women of different milieus that lies at the heart of Degas's composition.

Degas often accompanied his female friends to the dressmaker's and the milliner's. Here, one of them, the American artist Mary Cassatt, serves as the model and tries on hats while an attendant waits expectantly behind her. Cassatt's expression of contented self-assurance contrasts sharply with the apprehensive posture of the shopgirl, a figure obscured by cropping and the lack of delineation of her facial features.

In this daring nuanced composition about modern life—the subject is the fleeting encounter rather than the women themselves—Degas heeded the advice of the critic Edmond Duranty, who, in his 1876 pamphlet, *The New Painting*—about the art that came to be known as Impressionism—wrote: "Let us take leave of the stylized human body, which is treated like a vase. What we need is the characteristic modern person in his clothes, in the midst of his social surroundings, at home or out in the street."

Pablo Picasso | Spanish, 1881–1973

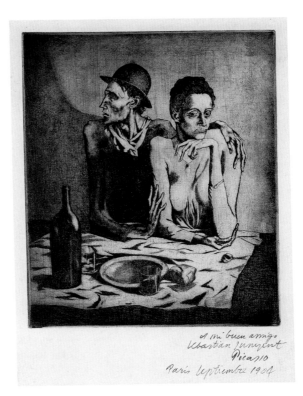

The Frugal Repast. 1904
Etching, plate: 18 ³⁄₁₆ × 14 ⅞" (46.2 × 37.8 cm)
Publisher: Ambroise Vollard, Paris. Edition:
proof before edition of 250
Gift of Thomas T. Solley with Mary Ellen
Meehan, purchase through the Vincent d'Aquila
and Harry Soviak Bequest, and with contri-
butions from Lily Auchincloss, The Associates
Fund, The Philip and Lynn Straus Foundation
Fund, and John S. Newberry (by exchange)

This gaunt, nearly emaciated couple sit at
a bleak table on which only a few scraps
of bread and a bit of wine remain.
Although the man's elongated fingers
tenderly clasp the woman, he, thought
to be blind, turns away from her, his
anguished face, with lips slightly parted,
suggesting grief. Seemingly more
resigned, the woman appears lost in
thought as she rests her chin on her hand.

This etching was executed early in
Picasso's career, when he was a strug-
gling 23-year-old artist and had recently
returned from his native Spain to Paris
and settled in Montmartre. *The Frugal
Repast* reveals the artist's feeling for
humanity, especially for the poor and
others on the fringes of society.
Haunted, lonely people, often itinerant
circus workers, populate the artist's
compositions during this period.

Although it is only the second etch-
ing Picasso made, *The Frugal Repast*
demonstrates an astonishing mastery of
the medium as the artist deftly captured
nuances of light and form purely with
line. The soft residue of ink he allowed
to remain on the plate's surface creates
evocative shadows, which add to the
somber mood.

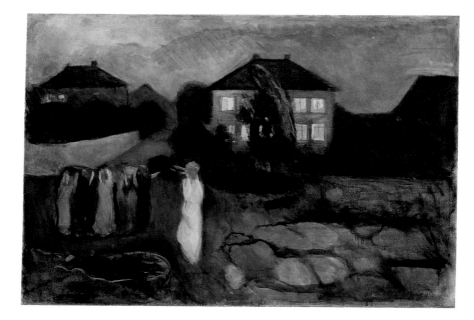

The Storm. 1893
Oil on canvas, 36⅛ × 51½" (91.8 × 130.8 cm)
Gift of Mr. and Mrs. H. Irgens Larsen and
acquired through the Lillie P. Bliss and Abby
Aldrich Rockefeller Funds

Munch painted *The Storm* in Aasgaard-
strand, a small Norwegian seaside resort
where he often stayed. There had indeed
been a violent storm there that summer,
but the painting does not appear to show
it, or even its physical aftermath; the
storm here is an inner one, a psychic
distress. Standing near the water, in an
eerie blue half-light, half-dark Scandi-
navian summer night, a young woman
clasps her hands to her head. Other
women, standing apart from her, make
the same anguished gesture—to what
end we are not sure. The circle in which
they stand, and the protagonist's white
dress, give to the scene the feeling of
some ancient pagan ritual, even while

the solid house in the background, its lit
windows shining in the dark, suggests
some more regular life from which these
women are excluded—or perhaps that
they find intolerable.

Munch's art suggests a transfor-
mation of personal memories and
emotions into a realm of dream, myth,
and enigma. His exposure to French
Symbolist poetry during a stay in Paris
had convinced him of the necessity for
a more subjective art; there was no
need, he said, for more paintings of
"people who read and women who
knit." Associated with the international
development of Symbolism in the
1890s, he is also recognized as a pre-
cursor of Expressionism.

Moonrise, Mamaroneck, New York. 1904

Platinum and ferroprussiate print, 15 5/16 × 19"
(38.9 × 48.2 cm)
Gift of the artist

The colors in this photograph were not captured in the camera but were concocted later by Steichen in the darkroom, where he also sketched the reeds and grasses in the foreground. These marks of the artist's hand were the young photographer's way of showing that the picture was not an ordinary photograph but a work of art.

Raised in Wisconsin, Steichen made his way in 1900 to New York, where he met the older and more seasoned photographer Alfred Stieglitz, and soon joined him in a vigorous campaign to establish photography as a fine art. Although they failed at first to impress a broad public, they encouraged many talented young photographers to think of themselves as artists and so initiated a rich tradition that flourished for more than half a century.

For Stieglitz and Steichen, pursuing the artistic potential of photography meant rejecting its practical functions in the modern industrialized world. They retreated into an aesthetic world of refinement and comforting values, such as the purity of nature. Pure as it was, however, the nature that they photographed was rarely wild. Mamaroneck surely was more peaceful a century ago than it is today, but it was already a suburb of New York to which Steichen often went to escape from the rigors of city life.

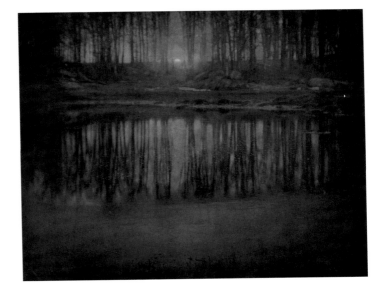

Madonna. 1895–1902
Lithograph and woodcut, comp.: 23¾ × 17½"
(60.5 × 44.5 cm)
Publisher: the artist. Edition: approx. 250
The William B. Jaffe and Evelyn A. J. Hall
Collection

Alluring and inviting, disturbing and
threatening, Munch's *Madonna* is above
all mysterious. This erotic nude appears
to float in a dreamlike space, with
swirling strokes of deep black almost
enveloping her. An odd-looking, small
fetuslike figure or just-born infant hov-
ers at the lower left with crossed skeletal
arms and huge frightened eyes. Forms
resembling sperm pervade the sur-
rounding border of this print. Little
about the *Madonna* seems to conform to
her holy title, save for a narrow dark
gold band atop her head. This haunting
apparition reflects Munch's alliance with
Symbolist artists and writers.

Woman, in varying roles from
mother-protector to sexual partner to
devouring vampire and harbinger of
death, serves as the chief protagonist in
a series of paintings and corresponding
prints about love, anxiety, and death that
Munch grouped together under enig-
matic headings. *Madonna* was first exe-
cuted as a black-and-white lithograph in
1895. During the next seven years,
Munch hand-colored several impres-
sions. Finally, the image was revised in
1902, using additional lithographic
stones for color and a woodblock for the
textured blue sky. Self-trained in print-
making, Munch often used its mediums
in experimental ways, such as the
unusual composition of woodcut and
lithography seen here.

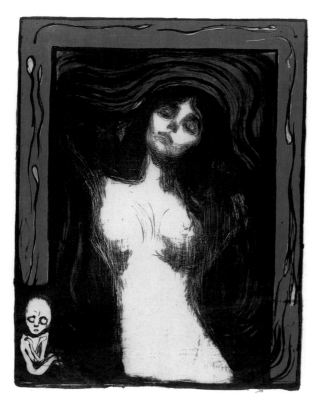

Odilon Redon | French, 1840–1916

Roger and Angelica. c. 1910
Pastel on paper, 36½ × 28¾" (92.7 x 73 cm)
Lillie P. Bliss Collection

In this evocation of a scene from the sixteenth-century romance *Orlando Furioso*, the knight Roger appears on his fiery steed to save the maiden Angelica from a horrible fate: the dragon, with its evil inner glow, is looming at the lower left. Tendrils of threatening mist curling up from below menace the maiden, while angry storm clouds hover above. The figures themselves are small and sketchily rendered; it is the picture's atmospheric effects, conveyed with light-and-dark contrasts and shots of dazzling color—including those of the imposing crag on which Angelica is stranded—that create the high drama of this tension-ridden scene.

The young Redon is said to have watched the clouds scudding over the flat Bordeaux landscape where he was raised and imagined in them the fantastic beings that he would later conjure up in his paintings, drawings, lithographs, and pastels. *Roger and Angelica*, executed in the last period of his career, when color had bewitched him, exemplifies Redon's consummate ability to imbue his wildly imaginative fantasies with color, light, and shadow, using the mere strokes of a crayon.

Although this work was created in the twentieth century, it reflects the Romanticism of the nineteenth century, in which feeling triumphed over form, and color was the primary vehicle of expression.

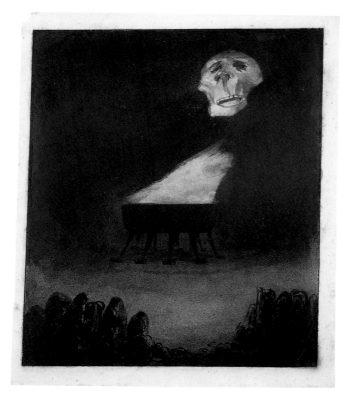

Untitled (The Eternal Flame).

c. 1900
Gouache and ink on paper, 13 × 10¾" (32.9 ×
27.2 cm)
John S. Newberry Collection

This drawing is related to a later series
of Kubin's works, *The Eternal Flame,*
based on German folktales and myths.
A flaming cauldron placed in the center
of the composition is a recurring motif
in the series. The feeling of horror and
mystery of this image is created through
a subtle play of light and dark that
envelops the foreground figures in an
enigmatic veil. Light dramatizes and
brings forth from the shadows both the
flame and the floating skull, thus height-
ening the effect of a hallucinatory vision.

Most of Kubin's drawings evoke a
fantastic nightmarish mood, high drama,
and mystery. The eerie, unreal quality

characteristic of his work may possibly
be related to his early apprenticeship to
a photographer, since Kubin's images
seem to emerge out of the darkness,
much as negatives develop in a darkroom.

Although most of Kubin's adult life
falls within the twentieth century, his
art—primarily drawings—belongs to
the Austrian Symbolism of the end of
the nineteenth century. The graphic
work of Francisco Goya, James Ensor,
Max Klinger, Odilon Redon, and partic-
ularly Hieronymus Bosch offered him
stylistic inspiration, while his subject
matter was steeped in the incompatible
philosophies of Friedrich Nietzsche and
Arthur Schopenhauer.

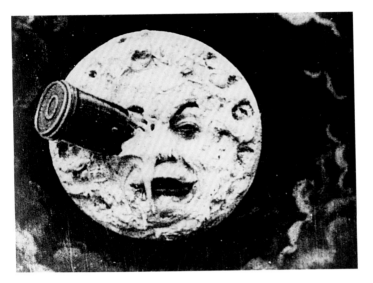

A Trip to the Moon
(Le Voyage dans la lune). 1902
35mm film, black and white, silent, 11 minutes
(approx.)
Bluette Bernon

A Trip to the Moon is a satire in which
the innate conservatism of the scientific
community is overcome by the convic-
tions of a lone charismatic figure (played
by the filmmaker himself). This one-reel
film spared no effect or expense in
bringing to life Méliès's intensely per-
sonal vision. Astronauts prepare for a
rocket-launching, take off, land on the
moon (hitting it in the eye), and finally
splash down back on earth.

Perhaps the greatest tribute paid to
Méliès by his peers was the fact that,
rather than attempting to duplicate the
marvels contained in *A Trip to the Moon*,
they simply stole it and released it under
their own names, particularly in the
United States. Méliès produced hundreds
of films over the next decade. He had
been a renowned magician and show-
man, who first became fascinated with
projected images when he incorporated
magic lanterns (early slide projectors)
into his stage presentations at the
Théâtre Robert-Houdin in Paris.
Inspired by the work of the Lumière
brothers, Méliès went on to build Europe's
first true film studio, at Montreuil, and
began to make films indoors in a stage-
like space with artificial lighting. He
produced action shorts, fictional tales,
and spectacles; but he was most success-
ful with his fantasy works, the most
famous of which is *A Trip to the Moon*.

Foliage. 1895–1900
Watercolor and pencil on paper, 17 ⅝ × 22 ⅜"
(44.8 × 56.8 cm)
Lillie P. Bliss Collection

At first glance, this work might strike the viewer as unfinished, given the blank areas left on the paper. But Cézanne meant *Foliage* to be a study in color and line depicting the rhythms of rustling leaves, which appear to move across the page. His brushstrokes deliver deposits of pigment that create the illusion of light and shadow. Nature is evoked in the lightness and transparency of the medium, in the placement of the subject, and in the inferred movement.

Cézanne's late watercolors, of which this is a superb example, "are acts of construction in color." Here he applied discrete unblended lines and patches of color around lightly sketched pencil contours and built depth from color by translating dark-light gradations into cool-warm ones. In this mosaic, colored lines and planes and overlapping shades together fix the depth of the subject to the surface of the paper—the white surface that is the final arbiter of pictorial coherence.

In this way Cézanne redefined modern drawing according to color "modulation," his term for that which enabled him not only to capture the light of southern France, where he lived and worked, but also to approach abstraction.

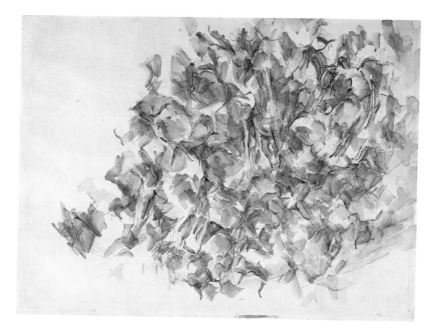

André Derain | French, 1880–1954

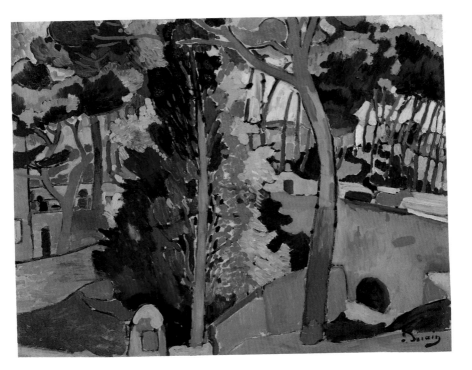

Bridge over the Riou. 1906
Oil on canvas, 32 ½ × 40" (82.5 × 101.6 cm)
The William S. Paley Collection

Although *Bridge over the Riou* describes a place in the south of France, its complexly patterned composition suggests a gradual reworking and reshaping rather than a quick and fluid response to what Derain saw there. From the foreground bank, over the riverbed, to the higher ground beyond, the space is compressed and flattened, but the scene can still be identified—the bridge at the lower right, a cabin down in the ravine, the beehive form of a covered well. Houses appear beyond the river, behind the trees.

In 1905 Derain and his peers in the Fauvist group had created a *succès de scandale* through their radical use of color, but they still accepted from Impressionism the idea that a painting should follow nature, and should try to capture the passing moment of contemporary life. By 1906, however, Derain wanted to create images that would "belong to all time" as well as to his own period, and the separate strokes of color seen in his paintings of 1905 are here subsumed into larger colored shapes, some of them outlined in exotic blues or lavenders, or an indian red or pink, say, for a tree trunk. This emotionally high-keyed color relates to the intensity of the light in the south of France, yet belongs less to nature than to art.

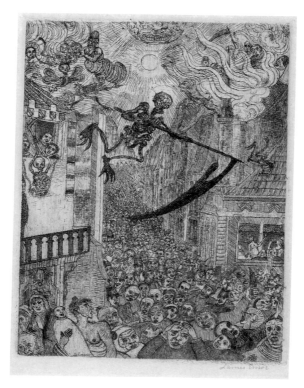

Death Chasing the Flock of Mortals. 1896

Drypoint and etching, plate: 9 7/16 × 7 3/16"
(23.9 × 18.2 cm)
Publisher: the artist
Purchase Fund

A large skeletal flying figure of Death with reptilelike feet brandishes an enormous, menacing scythe over the swarming mob of people jamming the streets below. The figures, most of whom are portrayed only by grimacing masklike faces, flee the oncoming catastrophe. In the building at the right we glimpse a nude woman toasting her companions—a hint of the debauchery, cruelty, and indifference that Ensor perceived in society. Overhead a radiating sun, centered between winged, haloed beings and frightened figures engulfed in flames, suggests heaven, hell, and the Day of Judgment.

Ensor's nightmarish, satiric visions, which reveal a preoccupation with the macabre and with death, were influenced by earlier Flemish art of the fifteenth and sixteenth centuries, specifically that of Hieronymus Bosch and Pieter Bruegel. Ensor's obsession with death and impermanence led him to printmaking. As he stated, "I dread the fragility of painting. I want to survive and I think of solid copper plates, of unalterable inks ... of faithful printing, and I am adopting etching as a means of expression." Indeed, between 1886 and 1905 Ensor was a prolific printmaker, who executed 134 prints.

Prophet. 1912

Woodcut, comp.: 12 ⅝ × 8 ¾" (32.1 × 22.2 cm)
Publisher: the artist. Edition: 20–30
Given anonymously (by exchange)

This brooding face confronts the viewer with an immediacy and deep emotion that leave no doubt about the prophet's spirituality. His hollow eyes, furrowed brow, sunken cheeks, and solemn countenance express his innermost feelings. Three years before Nolde executed this print, he had experienced a religious transformation while recovering from an illness. Following this episode, he began depicting religious subjects in paintings and prints, such as the image seen here.

Nolde had joined the German Expressionist group *Die Brücke* (The Bridge) in 1906, participating in its exhibitions and in its exchange of ideas and techniques. He taught etching to his fellow members, and they introduced him to woodcuts. During the 1890s, woodcuts had undergone a resurgence and revamping, when artists such as Paul Gauguin and Edvard Munch used them to create bold images that expressed strong emotional content. In *Prophet*, Nolde also exploits the characteristics inherent to the medium. Coarsely gouged-out areas, jagged lines, and the textured grain of the wood effectively combine in this portrayal of a fervent believer—a quintessential German Expressionist print.

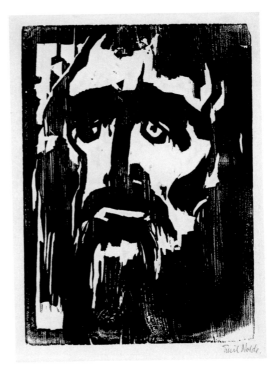

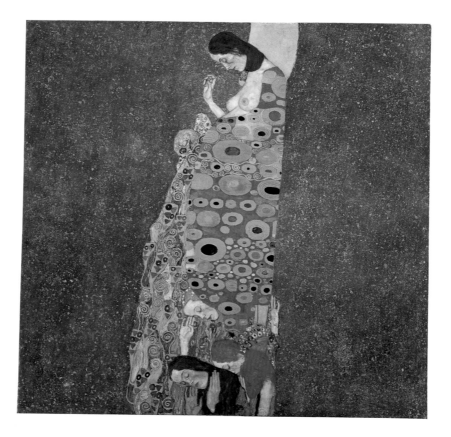

Hope, II. 1907–08
Oil, gold, and platinum on canvas, 43 ½ × 43 ½"
(110.5 × 110.5 cm)
Jo Carole and Ronald S. Lauder and Helen
Acheson Funds, and Serge Sabarsky

A pregnant woman bows her head and closes her eyes, as if praying for the safety of her child. Peeping out from behind her stomach is a death's head, sign of the danger she faces. At her feet, three women with bowed heads raise their hands, presumably also in prayer—although their solemnity might also imply mourning, as if they foresaw the child's fate.

Why, then, the painting's title? Although Klimt himself called this work *Vision*, he had called an earlier, related painting of a pregnant woman *Hope*. By association with the earlier work, this one has become known as *Hope, II*. There is, however, a richness here to balance the women's gravity.

Klimt was among the many artists of his time who were inspired by sources not only within Europe but far beyond it. He lived in Vienna, a crossroads of East and West, and he drew on such sources as Byzantine art, Mycenean metalwork, Persian rugs and miniatures, the mosaics of the Ravenna churches, and Japanese screens. In this painting the woman's gold-patterned robe—drawn flat, as clothes are in Russian icons, although her skin is rounded and dimensional—has an extraordinary decorative beauty. Here, birth, death, and the sensuality of the living exist side by side suspended in equilibrium.

Girl with Black Hair. 1911

Watercolor and pencil on buff paper, 22⅛ × 14½" (56.2 × 36.7 cm)

Gift of the Galerie St. Etienne, New York, in memory of Dr. Otto Kallir; promised gift of Jo Carole and Ronald S. Lauder; and purchase

Girl with Black Hair is one of two erotic watercolors of the same subject, both of which are closely related compositionally. Here the young woman, in a half-seated, half-reclining pose, displays her genitalia unashamedly; her partly closed eyes do not confront the artist or the viewer but stare into space with detachment and boredom. Her black skirt, bunched up around her waist, reflects the form of her abundant black hair.

The pose of the girl suggests that the work was executed from a vantage point above the figure. Reportedly, Schiele's favorite mode of working was to observe his models from above (using a stool or ladder) while they reclined on a low couch expressly built by him for this purpose.

Young women in various stages of undressing or nude constituted one of Schiele's favorite subjects. His models were often pubescent girls of working-class background or even young prostitutes, since the artist, having been cut off from any financial support by his family, could not afford to hire professional models. During 1911–12 he executed some of his most provocative depictions of female nudes—often in contorted and unnatural poses: standing, sitting, reclining, or kneeling. Such drawings, exhibiting a bold expressiveness of body language and a masterful handling of the watercolor medium, were in great demand among Schiele's Viennese patrons.

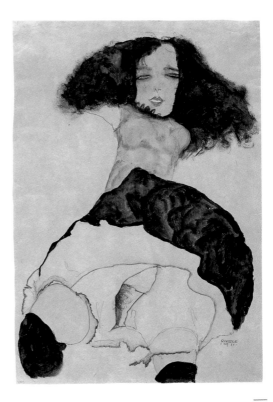

Sitzmaschine Chair with Adjustable Back. c. 1905

Bent beechwood and sycamore panels,
43½ × 28¼ × 32" (110.5 x 71.8 x 81.3 cm)
Manufacturer: J. & J. Kohn, Austria
Gift of Jo Carole and Ronald S. Lauder

The *Sitzmaschine,* that is, the "machine for sitting," was originally designed by Hoffmann for his Purkersdorf Sanatorium in Vienna. The sanatorium was one of the first important commissions given to the Wiener Werkstätte, a collaborative founded in 1903 by Hoffmann and Koloman Moser espousing many of the English Arts and Crafts movement's tenets of good design and high-quality craftsmanship. It represents one of Hoffmann's earliest experiments in unifying a building and its furnishings as a total work of art.

The *Sitzmaschine* makes clear reference to an adjustable-back English Arts and Crafts chair known as the Morris chair, designed by Philip Webb around 1866. It also stands as an allegorical celebration of the machine. This armchair, with its exposed structure, demonstrates a rational simplification of forms suited to machine production. Yet, at the same time, the grid of squares piercing the rectangular back splat, the bentwood loops that form the armrests and legs, and the rows of knobs on the adjustable back illustrate the fusion of decorative and structural elements typical of the Wiener Werkstätte style. J. & J. Kohn produced and sold this chair in a number of versions, most of which had cushions on the seat and back, until at least 1916. The Kohn firm produced many designs by Hoffmann, forming one of the first successful alliances between a designer and industry in Vienna.

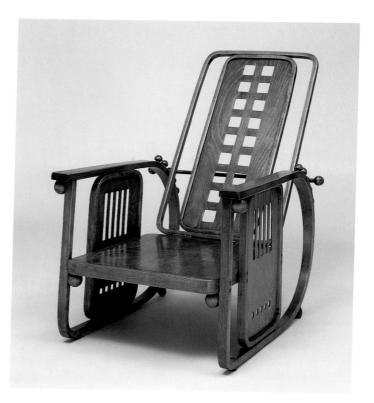

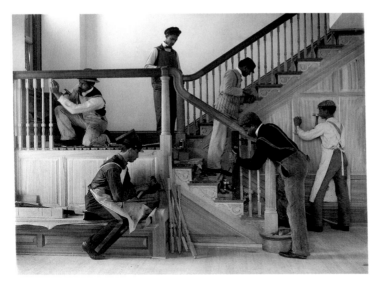

Stairway of Treasurer's Residence: Students at Work. Hampton Institute, Hampton, Virginia. 1899–1900

Platinum print, 7⁹⁄₁₆ × 9⁹⁄₁₆" (19.2 × 24.3 cm)

Gift of Lincoln Kirstein

Johnston was a professional photographer, noted for her portraits of Washington politicians and her photographs of coal miners, iron workers, and women workers in the New England textile mills. In 1899 Hampton Institute commissioned her to make photographs at the school for an exhibition about contemporary African American life at the Paris Exposition of 1900. This picture exemplifies Johnston's classical sense of composition and her practice of care-

fully arranging her subjects. Her complete control over the scene is readily apparent, yet the grace of the men's poses—evenly bathed in natural light—seems to justify her artifice.

Hampton Institute had been established in 1868, three years after the Civil War ended, when the educator and philanthropist Samuel C. Armstrong persuaded the American Missionary Association to fund a school for the vocational training of African Americans. Armstrong admired the "excellent qualities and capacities" of the freed black soldiers who had fought in the War under his command, and he believed that education was essential to them if they were to achieve productive independence.

Fränzi Reclining. 1910

Woodcut, comp.: 8¹⁵⁄₁₆ × 16⁹⁄₁₆" (22.6 × 42.1 cm)
(irreg.)
Publisher: the artist
Gift of Mr. and Mrs. Otto Gerson

Fränzi, shown here at the age of twelve, posed frequently for Heckel and other German Expressionists, who were drawn to the natural, yet awkward, positions that she assumed because they were so unlike the artificial stances of professional models. The woodcut medium was a perfect vehicle to express thick, angular outlines for her figure, with its distorted arm and jagged fingers, and exaggerated masklike features for her face. This bold new imagery found its source in African sculptures that Heckel had studied in the Dresden Ethnological Museum.

Heckel also took a cue from Edvard Munch, the Norwegian painter much admired by *Die Brücke* artists, and employed one of his unusual printing techniques. Like Munch, he sawed the woodblock into pieces, cutting out the three red background areas, inking the components separately, and then reassembling them like a jigsaw puzzle before printing.

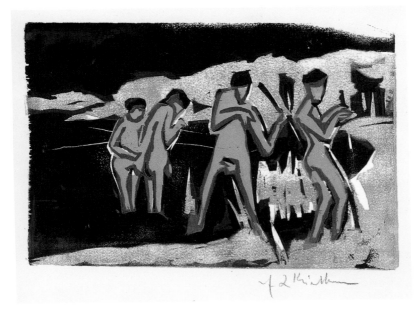

Bathers Throwing Reeds from the portfolio **E L Kirchner (Brücke V).**
1909–10
Woodcut, comp.: 7⅞ × 11½" (20 × 29.2 cm)
Publisher: Brücke, Dresden. Edition: approx. 68
Riva Castleman Endowment Fund, The Philip and Lynn Straus Foundation Fund, Frances R. Keech Fund, and by exchange: Nina and Gordon Bunshaft Bequest, Gift of James Thrall Soby, anonymous, J. B. Neumann, Victor S. Riesenfeld, Lillie P. Bliss Collection, and Abby Aldrich Rockefeller Fund

The four nudes in this simplified green landscape, seemingly unaware that they are being observed, enjoy an unspoiled natural environment as they play and wade in the water. This subject, a frequent one in German Expressionist art, reflects the philosophy of *Die Brücke*, whose members opposed materialistic and bourgeois aspects of society and wanted to create a "bridge" that would lead to an authentic community of spirituality, freedom, and creativity. The flat, angular style of *Bathers Throwing Reeds* is directly influenced by Oceanic, African, and Eskimo sculptures that Kirchner had seen and copied in museums. It also reflects the German Expressionists' interest in and admiration for tribal and ethnological arts in general.

Kirchner founded *Die Brücke* in Dresden in 1905 with fellow students Karl Schmidt-Rottluff, Erich Heckel, and Fritz Bleyl, all of whom rejected the oppressive traditions and official exhibitions of the art academies. From 1906 until its dissolution in 1913, *Die Brücke* organized numerous exhibitions and published annual portfolios of prints made by its members.

Street, Dresden. 1908 (dated 1907)
Oil on canvas, 59¼" × 6' 6⅞" (150.5 × 200.4 cm)
Purchase

Street, Dresden is Kirchner's bold, discomfiting attempt to render the jarring experience of modern urban bustle. The scene radiates tension. Its packed pedestrians are locked in a constricting space; the plane of the sidewalk, in an unsettlingly intense pink (part of a palette of shrill and clashing colors), slopes steeply upward, and exit to the rear is blocked by a trolley car. The street—Dresden's fashionable Königstrasse—is crowded, even claustrophobically so, yet everyone seems alone. The women at the right, one clutching her purse, the other her skirt, are holding themselves in, and their faces are expressionless, almost masklike. A little girl is dwarfed by her hat, one in a network of eddying, whorling shapes that entwine and enmesh the human figures.

Developing in parallel with the French Fauves, and influenced by them and by the Norwegian painter Edvard Munch, the German artists of *Die Brücke* explored the expressive possibilities of color, form, and composition in creating images of contemporary life. *Street, Dresden* is a bold expression of the intensity, dissonance, and anxiety of the modern city. Kirchner later wrote, "The more I mixed with people the more I felt my loneliness."

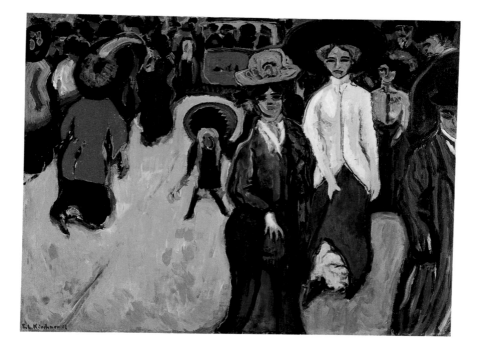

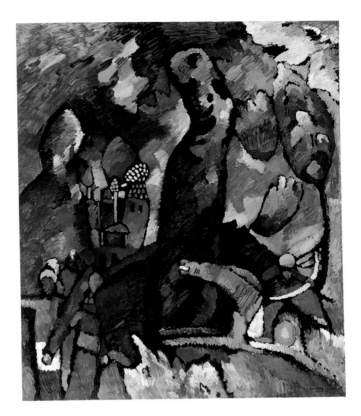

Picture with an Archer. 1909
Oil on canvas, 68⅞ × 57⅜" (175 × 144.6 cm)
Gift and bequest of Mrs. Bertram Smith

The color in *Picture with an Archer* is vibrantly alive—so much so that the scene is initially hard to make out. The patchwork surface seems to be shrugging off the task of describing a space or form. Kandinsky was the first modern artist to paint an entirely abstract composition; at the time of *Picture with an Archer*, that work was just a few months away.

Kandinsky took his approach from Paris—particularly from the Fauves—but used it to create an Eastern landscape suffused with a folktale mood. Galloping under the trees of a wildly radiant countryside, a horseman turns in his saddle and aims his bow. In the left foreground stand men in Russian dress; behind them are a house, a domed tower, and two bulbous mountainy pinnacles, cousins of the bent-necked spire in the picture's center. Russian icons show similar rocks, which do exist in places in the East, but even so have a fantastical air. The lone rider with his archaic weapon, the traditional costumes and buildings, and the rural setting intensify the note of fantasy or poetic romance.

There is a nostalgia here for a time or perhaps for a place: in 1909 Kandinsky was living in Germany, far from his native Russia. But in the glowing energy of the painting's color there is also excitement and promise.

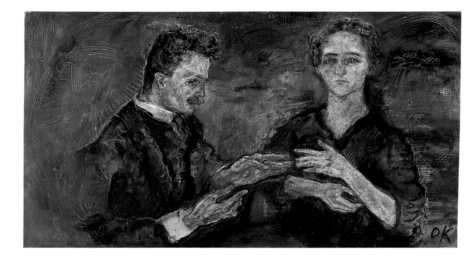

Hans Tietze and
Erica Tietze-Conrat. 1909
Oil on canvas, 30⅛ × 53⅝" (76.5 × 136.2 cm)
Abby Aldrich Rockefeller Fund

The Tietzes were socially prominent art historians, but Kokoschka ignores their public personas to find a mysterious delicacy in their private relationship. Erica gazes out toward us; Hans looks at Erica's hand, and reaches for it without touching it, so that his hands and her left arm form an arch that is broken at its summit by a narrow gap, a space with a psychic charge. The couple emerge from a shimmering ground of russets and dim blues into which their outlines seem to melt in places. Scratches in the thin oil—made, according to Erica Tietze-Conrat, with the artist's fingernails—create a texture of ghostly halfmarks around the figures, a subtle halo of crackling energy.

Like his Viennese compatriot Egon Schiele, Kokoschka tried to transcend academic formulas with an art of emotional and physical immediacy—an art, in his words, "to render the vision of people being alive." *Hans Tietze and Erica Tietze-Conrat* is one of his "black portraits," in which he tried to penetrate his subjects' "closed personalities so full of tension." (His Vienna was also the home of Sigmund Freud.)

I and the Village. 1911

Oil on canvas, 6' 3⅝" × 59⅝" (192.1 × 151.4 cm)
Mrs. Simon Guggenheim Fund

Painted the year after Chagall came to Paris, *I and the Village* evokes his memories of his native Hasidic community outside Vitebsk. In the village, peasants and animals lived side by side, in a mutual dependence here signified by the line from peasant to cow, connecting their eyes. The peasant's flowering sprig, symbolically a tree of life, is the reward of their partnership. For Hasids, animals were also humanity's link to the universe, and the painting's large circular forms suggest the orbiting sun, moon (in eclipse at the lower left), and earth.

The geometries of *I and the Village* are inspired by the broken planes of Cubism, but Chagall's is a personalized version. As a boy he had loved geometry: "Lines, angles, triangles, squares," he would later recall, "carried me far away to enchanting horizons." Conversely, in Paris he used a disjunctive geometric structure to carry him back home. Where Cubism was mainly an art of urban avant-garde society, *I and the Village* is nostalgic and magical, a rural fairy tale: objects jumble together, scale shifts abruptly, and a woman and two houses, at the painting's top, stand upside-down. "For the Cubists," Chagall said, "a painting was a surface covered with forms in a certain order. For me a painting is a surface covered with representations of things ... in which logic and illustration have no importance."

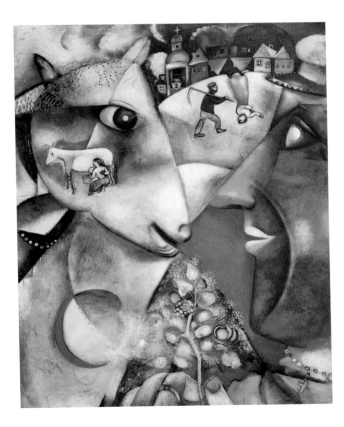

Pablo Picasso | Spanish, 1881–1973

Les Demoiselles d'Avignon.

1907
Oil on canvas, 8' × 7' 8" (243.9 × 233.7 cm)
Acquired through the Lillie P. Bliss Bequest

Les Demoiselles d'Avignon is one of the most important works in the genesis of modern art. The painting depicts five naked prostitutes in a brothel; two of them push aside curtains around the space where the other women strike seductive and erotic poses—but their figures are composed of flat, splintered planes rather than rounded volumes, their eyes are lopsided or staring or asymmetrical, and the two women at the right have threatening masks for heads. The space, too, which should recede, comes forward in jagged shards, like broken glass. In the still life at the bottom, a piece of melon slices the air like a scythe.

The faces of the figures at the right are influenced by African masks, which Picasso assumed had functioned as magical protectors against dangerous spirits: this work, he said later, was his "first exorcism painting." A specific danger he had in mind was life-threatening sexual disease, a source of considerable anxiety in Paris at the time; earlier sketches for the painting more clearly link sexual pleasure to mortality. In its brutal treatment of the body and its clashes of color and style (other sources for this work include ancient Iberian statuary and the work of Paul Cézanne), *Les Demoiselles d'Avignon* marks a radical break from traditional composition and perspective.

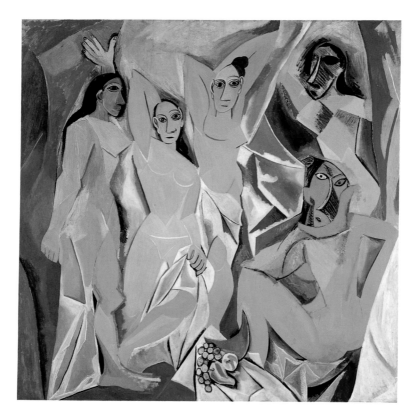

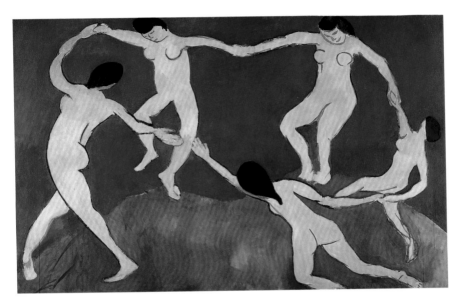

Dance (first version). 1909
Oil on canvas, 8' 6½" × 12' 9½" (259.7 × 390.1 cm)
Gift of Nelson A. Rockefeller in honor of
Alfred H. Barr, Jr.

A monumental image of joy and energy,
Dance is also strikingly daring. Matisse
made the painting while preparing a
decorative commission for the Moscow
collector Sergei Shchukin, whose final
version of the scene, *Dance (II)*, was
shown in Paris in 1910. Nearly identical
in composition to this work, its simplifi-
cations of the human body were
attacked as inept or willfully crude. Also
noted was the work's radical visual flat-
ness: the elimination of perspective and
foreshortening that makes nearer and
farther figures the same size, and the sky
a plane of blue. This is true, as well, of
the first version.

Here, the figure at the left moves
purposefully; the strength of her body is
emphasized by the sweeping unbroken
contour from her rear foot up to her
breast. The other dancers seem so light
they nearly float. The woman at the far
right is barely sketched in, her foot

dissolving in runny paint as she reels
backward. The arm of the dancer to her
left literally stretches as it reaches
toward the leader's hand, where momen-
tum has broken the circle. The dancers'
speed is barely contained by the edges of
the canvas.

Dance (II) is more intense in color
than this first version, and the dancers'
bodies—there deep red—are more
sinewy and energetic. In whatever can-
vas they appear, these are no ordinary
dancers, but mythical creatures in a
timeless landscape. Dance, Matisse once
said, meant "life and rhythm."

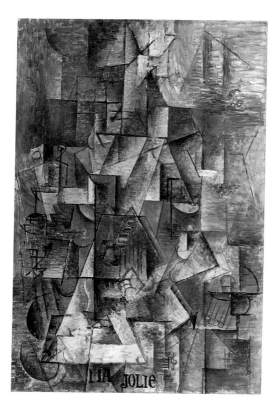

"Ma Jolie." 1911–12

Oil on canvas, 39⅜ × 25¾" (100 × 65.4 cm)
Acquired through the Lillie P. Bliss Bequest

Numerous elusive clues connect "*Ma Jolie*" to reality: a triangular form in the lower center, strung like a guitar or zither; below the strings, four fingers, with an angular elbow to the right; and in the upper half, perhaps a floating smile. Together these elements suggest a woman holding a musical instrument, but the picture hints at reality only to deny it. Planes, lines, spatial cues, shadings, and other traces of painting's language of illusion are abstracted from descriptive uses; the figure almost disappears into a network of flat, straight-edged, semitransparent planes.

Yet "*Ma Jolie*," an example of high Analytic Cubism, is actually a painting on a very traditional theme—a woman holding a musical instrument. The palette of brown and sepia is reminiscent of the work of Rembrandt, and Picasso emphasizes the handmade nature of the brushstrokes, underlining the artist's human presence. At the bottom of the canvas Picasso also inscribes a treble clef and the words "*Ma Jolie*," (my pretty one)—both a line from a popular song and a reference to his lover Marcelle Humbert. A kind of stand-in for the woman who can barely be seen, the phrase "Ma Jolie" is clear, legible, colloquial, and suggests conventional prettiness—although this was one of the most complex, abstract, and esoteric images of its day.

Piet Mondrian | Dutch, 1872–1944

Pier and Ocean 5
(Sea and Starry Sky). 1914
Charcoal and gouache on buff paper, 34⅝ × 44"
(87.9 × 111.2 cm)
Mrs. Simon Guggenheim Fund

At first glance, this drawing appears to
be totally abstract, despite its descrip-
tive title. In fact, the vertical lines at the
base of the oval represent a pier that
stretches into an ocean of short hori-
zontal and vertical lines above and
around it. At times crossing or lying
perpendicular to one another, these lines
reflect the rhythmic ebb and flow of the
sea, and, with the areas of white paint,
the reflected starlight overhead.

Mondrian had begun to experi-
ment with abstraction before 1912,
when he left for Paris, where for two
years he was exposed to Cubism. He
returned to the Netherlands with
renewed determination to create a purer
abstract form at the expense of more
illustrative elements. His highly individ-
ual version of Cubism simplified it into
a vertical-horizontal grid, in which
shading was flattened to the surface to
form areas of muted color.

In the Pier and Ocean series of
1914–15, color is eliminated, and the
grid opens to form a cluster of "plus-
and-minus" signs within a Cubist oval.
The reduction to vertical and horizontal
generalizes the artist's sources in nature
into a symbolic structure representing
what Mondrian saw as a cosmic dualism
between the masculine and spiritual
(vertical) and the feminine and material
(horizontal). His system of cruciform
signs here speaks to flickering light and
movement on water and also to a spiri-
tual structure within nature itself—in
his words, "a true vision of reality."

Guitar. 1912–13
Construction of sheet metal and wire, 30½ ×
13¾ × 7⅝" (77.5 × 35 × 19.3 cm)
Gift of the artist

Before the twentieth century, sculpture
often described the human form, and
was principally an art of carving and
modeling solids. In *Guitar* Picasso broke
with these age-old traditions, examining
an everyday object and initiating a new
type of sculptural construction: built up
from sheet metal, *Guitar* has no solid
center but is open to space. A shallow
arrangement of planes to be viewed from
the front, it seems pictorial as well as
sculptural, and relates to Picasso's Cubist
collages of newspaper clippings and the
like. This points to another departure
from tradition: whereas ambitious sculp-
tors of the period might work in bronze
or marble, Picasso used sheet metal and
wire—common, everyday materials, like
the newspapers of the collages.

Picasso's guitar sculpture is the
same size and shape as the real thing,
but he shatters its form. If the front of a
guitar is a plane concealing a volume, he
cuts that plane away, opening up the
interior as an empty box. If the sound
hole is ordinarily a void, he gives it sub-
stance, turning it into a projecting cylin-
der (a device, Picasso said, inspired by
the tubular eyes in an African Grebo
mask). Viewed frontally, the cylinder's
open rim becomes a line drawing of the
sound hole. Here, Picasso has opened up
the central core of sculpture, allowing us
to see into and through it.

Georges Braque | French, 1882–1963

Still Life with Tenora. 1913

Cut-and-pasted papers and newspaper, charcoal, chalk, watercolor, and oil on canvas, 37½ × 47⅜" (95.2 × 120.3 cm)
Nelson A. Rockefeller Bequest

Still Life with Tenora is a consummate example of Braque's *papier collé* (literally, pasted paper) style. The bold geometric fragments of contrasting types of paper interlaced with the figurative motifs drawn in charcoal evoke the structure of a fugue, in which two distinct melodies intertwine in a rich, sonorous composition, each acting as a foil to the other's reality.

The invention of the *papier collé* in 1912 by Braque and Pablo Picasso introduced a revolution in Western painting, whose repercussions are still being felt today. By pasting fragments of paper (newspaper, wallpaper, and wood-grained paper) onto their still-life compositions, they introduced real materials and textures into an art hitherto based on illusionistic renderings.

The significance of this breakthrough cannot be overestimated because through this technique these artists declared the autonomy of the painted or drawn image, and radically severed it from any attempt at representation. The fragments attached to the picture's surface rarely followed the contours or silhouettes of the drawn motifs (glasses, bottles, or musical instruments), but, paradoxically, contradicted them. Thus, they countered the conventional devices of modeling and depth perspective, and drew attention to the absolute flatness of the two-dimensional plane.

Unique Forms of Continuity in Space. 1913

Bronze (cast 1931), 43⅞ × 34⅞ × 15¾" (111.2 × 88.5 × 40 cm)

Acquired through the Lillie P. Bliss Bequest

In *Unique Forms of Continuity in Space*, Boccioni puts speed and force into sculptural form. The figure strides forward. Surpassing the limits of the body, its lines ripple outward in curving and streamlined flags, as if molded by the wind of its passing. Boccioni had developed these shapes over two years in paintings, drawings, and sculptures, exacting studies of human musculature. The result is a three-dimensional portrait of a powerful body in action.

In the early twentieth century, the new speed and force of machinery seemed to pour its power into radical social energy. The new technologies and the ideas attached to them would later reveal threatening aspects, but for Futurist artists like Boccioni, they were tremendously exhilarating. Innovative as Boccioni was, he fell short of his own ambition. In 1912, he had attacked the domination of sculpture by "the blind and foolish imitation of formulas inherited from the past," and particularly by "the burdensome weight of Greece." Yet *Unique Forms of Continuity in Space* bears an underlying resemblance to a classical work over 2,000 years old, the *Nike of Samothrace.* There, however, speed is encoded in the flowing stone draperies that wash around, and in the wake of, the figure. Here the body itself is reshaped, as if the new conditions of modernity were producing a new man.

Gino Severini | Italian, 1883–1966

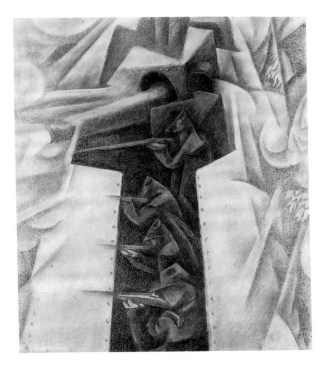

Armored Train in Action. 1915
Charcoal on paper, 22½ × 18¾" (56.9 × 47.5 cm)
Benjamin Scharps and David Scharps Fund

This study for the most famous of the Futurist war paintings, *The Armored Train* (1915), incorporates an unusual aerial perspective in its depiction of a train filled with armed soldiers. Severini enjoyed a unique vantage point—his Paris studio overlooked the Denfert-Rochereau station, from which he was able to observe the constant movement of trains filled with soldiers, supplies, and weaponry. Although Severini remained a noncombatant during World War I, he took the advice of fellow Futurist artist Filippo Tommaso Marinetti to "try to live the war pictorially, studying it in all its marvelous mechanical forms."

The Futurists glorified modern technology, and World War I, the first war of the twentieth century to employ the technological achievements of the industrial age in a program of mass destruction, was for them the most important spectacle of the modern era. Their admiration for speed—made possible by machinery—is represented here by the fractured landscape, which accentuates the train's force and momentum as it cuts through the countryside.

Armored Train in Action foreshadows a fundamental principle of Severini's later art: the "image-idea," in which a single image expresses the essence of an idea. Through a depiction of the plastic realities of war—a train, canon, guns, and soldiers—he provides a pictorial vocabulary necessary to grasp its deeper symbolism.

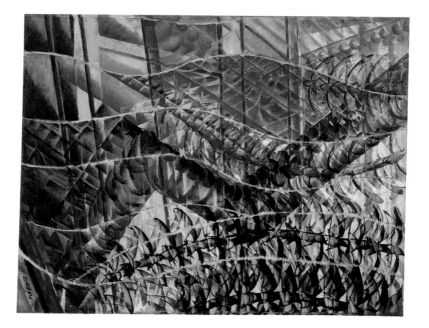

Swifts: Paths of Movement + Dynamic Sequences. 1913
Oil on canvas, 38⅛ × 47¼" (96.8 × 120 cm)
Purchase

"All things move, all things run, all things are rapidly changing," wrote the Futurists, one of them Balla, in 1910. Elaborating on Cubism's experiment in fracturing forms into planes, the Futurists further tried to make painting answer to movement: while the Cubists were concentrating on still lifes and portraits—in other words, were examining stationary bodies—the Futurists were looking at speed. They said: "The gesture which we would reproduce on canvas shall no longer be a fixed *moment* in universal dynamism. It shall simply be the dynamic sensation itself."

The backdrop to this painting is fixed architecture—a window, a drainpipe, a balcony—but the arcs that snake across the foreground are pure rush. The shapes of the swifts (are there four or forty of them?) repeat in stuttering bands, but their substance seems to evaporate: melting into light, the birds are lost in the paths of their own swooping soar. "Dynamic sensation," in Balla's time, was newly susceptible to scientific and visual analysis. Balla knew the photography of Étienne-Jules Marey, which described the movements of animals—including birds—through closely spaced sequences of images; *Swifts* emulates Marey's scientific visual analysis, which, in Balla's time, subjected "dynamic sensation to scrutiny," but adds to it a sense of exhilarated pleasure.

Panel for Edwin R. Campbell No. 4. 1914
Oil on canvas, 64¼ × 48¼" (163 × 122.5 cm)
Nelson A. Rockefeller Fund (by exchange)

This painting is one of a lush and vibrant suite of four canvases produced at a time when artists in several countries were beginning to explore what Kandinsky, a pioneer of abstract art, called "nonobjective" painting—painting that showed no immediately recognizable objects. Instead, Kandinsky wanted each of his works to be "a graphic representation of a mood." Studies for one of these paintings suggest that he had a landscape in mind when he conceived it, and we might still see in all four works a field, a mountain, or a cloud; but they are much trans-formed. Similarly, if these works do indeed describe the four seasons, as one scholar has guessed, then their colors and abstract shapes respond to some quality sensed in the year's phases, rather than to any specific scene.

Edwin R. Campbell, who commissioned the series, was an automobile executive, who had the works made to fit the walls in the entrance hall of the New York apartment he shared with his wife, Margery. Unfortunately, the couple separated in 1921, and the paintings separated too, being divided into pairs, and passing through several different collections; they were permanently reunited at The Museum of Modern Art in 1982.

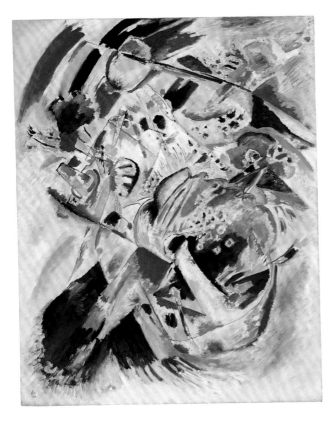

The Song of Love. 1914

Oil on canvas, 28¾ × 23⅜" (73 × 59.1 cm)
Nelson A. Rockefeller Bequest

"M. Giorgio de Chirico has just bought a red rubber glove"—so wrote the French poet Guillaume Apollinaire in July of 1914, noting the purchase because, he went on to say, he knew the glove's appearance in de Chirico's paintings would add to their uncanny power. Implying human presence, as a mold of the hand, yet also inhuman, a clammily limp fragment distinctly unfleshlike in color, the glove in *The Song of Love* has an unsettling authority. Why, too, is this surgical garment pinned to a board or canvas, alongside a plaster head copied from a classical statue, relic of a noble vanished age? What is the meaning of the green ball? And what is the whole ensemble doing in the outdoor setting insinuated by the building and the passing train?

Unlikely meetings among dissimilar objects were to become a strong theme in modern art (they soon became an explicit goal of the Surrealists), but de Chirico sought more than surprise: in works like this one, for which Apollinaire used the term "metaphysical," he wanted to evoke an enduring level of reality hidden beyond outward appearances. Perhaps this is why he gives us a geometric form (the spherical ball), a schematic building rather than a specific one, and inert and partial images of the human body rather than a living, mortal being.

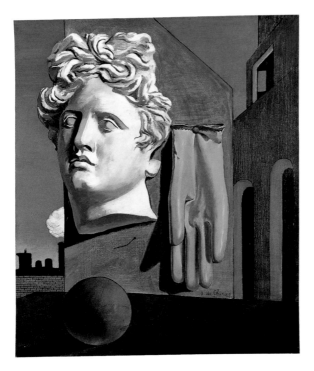

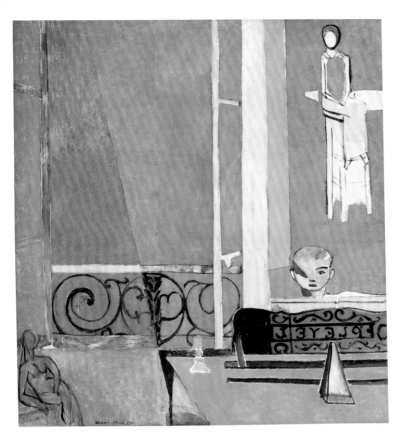

Piano Lesson. 1916
Oil on canvas, 8' ½" × 6' 11 ¾" (245.1 × 212.7 cm)
Mrs. Simon Guggenheim Fund

The little boy so seriously playing the piano is Matisse's son Pierre. The woman who might be his teacher, apparently watching him from behind, is actually a figure in a painting, Matisse's *Woman on a High Stool (Germaine Raynal)*, which hangs on the wall by the window. Similarly the sensually posed nude at bottom left would be an unlikely class auditor were not this another artwork in Matisse's living room, his own bronze *Decorative Figure*.

Piano Lesson treats two unlike spaces—a view through a window into air and the flat and tangible canvas of *Woman on a High Stool*—as if they were quite equivalent. Matisse is addressing issues both formal and philosophical. In describing the playing of music he also takes art-making as his subject, and the filigree bar of curves supplied by the music stand and balcony ironwork—a lovely touch amid the painting's interlocking triangles and rectangles—might almost be a visual version of music's curling notes.

Those flat planes of muted color create a system of geometric compartments that link the painting to Cubism, whose radical inventions Matisse had observed over the preceding few years without ever committing himself to the style. Works like this one show him examining Cubist ideas about pictorial structure while also producing an image utterly personal to him.

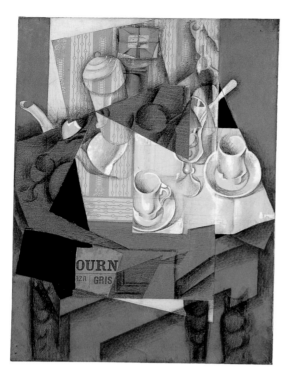

Breakfast. 1914

Cut-and-pasted papers and newspaper, color crayons, charcoal, gouache, and oil on canvas, 31⅞ × 23½" (80.9 × 59.7 cm)
Acquired through the Lillie P. Bliss Bequest

The *papier collé*, invented by Georges Braque and Pablo Picasso in 1912, found a rich and complex expression in the 1914 works of Gris. In conception, his *papiers collés* are closer to paintings than are the sparely drawn compositions of his forerunners; unlike them Gris covers the whole surface with pasted papers and paint. In works such as *Breakfast*, Gris's use of printed papers is more literal than theirs: the wood-grained fragments usually follow some of the contours of a table and are therefore integral to the composition; and his perspectival cues are relatively legible and precise. His superimposed drawings of domestic objects, fragmented yet softly modeled and most often seen from above, combine to create a more representational pictorial composition than those of Braque and Picasso.

Despite these observations, *Breakfast* is full of troubling contradictions. The striped wallpaper background spills across the table; certain objects (a glass on the left, a bottle in the upper right) appear as ghostly presences; the coffeepot is disjointed; the tobacco packet is painted and drawn in photographically realistic trompe l'oeil, but its label is real. Thus, while aspects of domestic comfort are captured in this image, Gris also raises many subjective and objective questions about how reality is perceived.

The Red Studio. 1911

Oil on canvas, 71 ¼" × 7' 2 ¼" (181 × 219.1 cm)
Mrs. Simon Guggenheim Fund

"Modern art," said Matisse, "spreads joy around it by its color, which calms us." In this radiant painting he saturates a room—his own studio—with red. Art and decorative objects are painted solidly, but furniture and architecture are linear diagrams, silhouetted by "gaps" in the red surface. These gaps reveal earlier layers of yellow and blue paint beneath the red; Matisse changed the colors until they felt right to him. (The studio was actually white.)

The studio is an important place for any artist, and this one Matisse had built for himself, encouraged by new patronage in 1909. He shows in it a carefully arranged exhibition of his own works. Angled lines suggest depth, and the blue-green light of the window intensifies the sense of interior space, but the expanse of red flattens the image. Matisse heightens this effect by, for example, omitting the vertical line of the corner of the room.

The entire composition is clustered around the enigmatic axis of the grandfather clock, a flat rectangle whose face has no hands. Time is suspended in this magical space. On the foreground table, an open box of crayons, perhaps a symbolic stand-in for the artist, invites us into the room. But the studio itself, defined by ethereal lines and subtle spatial discontinuities, remains Matisse's private universe.

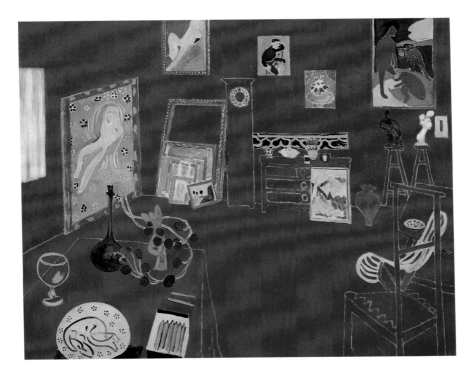

The Back, III. 1916

Bronze, 6'2½" × 44" × 6" (189.2 × 111.8 × 15.2 cm)
Edition: 1/10
Mrs. Simon Guggenheim Fund

"Fit your parts into one another and build up your figure as a carpenter does a house. Everything must be constructed —built up of parts that make a unit; a tree like a human body, a human body like a cathedral." So Matisse believed the sculptor should proceed, and the credo can be sensed in this work and throughout the group of four relief sculptures to which it belongs, with its progressive stability and simplicity. Matisse did not conceive The Backs as a series, but occasionally returned to the theme over the years. Even so, these reliefs—his largest sculptures—present a coherent progress, from a relatively detailed naturalism toward a near-abstract monumentality.

This work is the third in the series, and it is more vertical and less sinuous than its precursors. The first work in the series (1909) has a dynamic tension, and an arabesque line flows through it; in the second (1913), the body is more erect, less fluid. The left leg has become a thick pillar; making the figure more solid. The third work leads to the fourth (1931), where Matisse suppresses physical detail, making the contours more fluid, the surface more homogeneous. But if he surrenders expressiveness in the sculpture's parts, he regains it in the symmetrical harmony of the work as a whole.

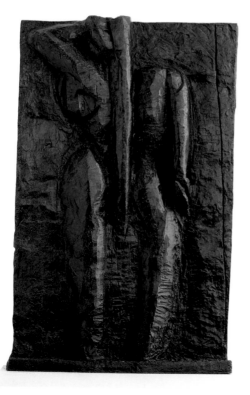

The Moroccans. 1915–16

Oil on canvas, 71⅜" × 9' 2" (181.3 × 279.4 cm)
Gift of Mr. and Mrs. Samuel A. Marx

The Moroccans marvelously evokes tropical sun and heat even while its ground is an enveloping black, what Matisse called "a grand black, ... as luminous as the other colors in the painting." Utterly dense, this black evokes a space as tangible as any object, and allows a gravity and measured drama without the illusion of depth once necessary to achieve this kind of grandeur.

The painting, which Matisse described as picturing "the terrace of the little café of the casbah," is divided into three: at the upper left, an architectural section showing a balcony with flowerpot and the dome of a mosque behind; a still life, of four green-leafed yellow melons at the lower left; and a figural scene in which an Arab sits with his back to us. To his right is an arched doorway, and windows above contain vestigial figures. The form to his left is hard to decipher, but has been interpreted as a man's burnoose and circular turban.

During his visit to Morocco in 1912–13, Matisse had been inspired by African light and color. At the same time, he faced the challenge of Cubism, the leading avant-garde art movement of the period, and *The Moroccans* summarizes his memories of Morocco while also combining the intellectual rigor of Cubist syntax with the larger scale and richer palette of his own art.

Fugue in Two Colors. 1912
Gouache and ink on paper, 8½×9" (21.3×
22.8 cm)
Gift of Mr. and Mrs. František Kupka

This small study for a large painting,
Amorpha, Fugue in Two Colors (1912), is
one of twenty-seven such studies in the
collection of The Museum of Modern
Art. It shows a late interpretation of this
theme, the fugue, in which the irregu-
larly shaped and patterned panes recall
the complexity and translucency of
stained-glass windows. In the final
painting, Kupka simplified the compo-
sition into broader planes of color that
constitute a single monumental
arabesque.

The painting was exhibited at the
Salon d'Automne in Paris in 1912,
where it provoked general consterna-
tion. Whereas Kupka's original motifs
had been inspired by nature, his final
gouache studies and the painting itself
were totally abstract and distilled to

two colors, red and blue. These were
intended to represent the interlacing
voices of a fugue, in which, as he himself
wrote, "the sounds evolve like veritable
physical entities, intertwine, come and go."

Born in a small city in eastern
Bohemia, Kupka studied in Prague and
Vienna and then settled permanently in
Paris in 1896. By 1912 his painting had
evolved to a radically abstract style, estab-
lishing him as one of the earliest pioneers
of abstraction in European painting.

La Prose du Transsibérien et de la petite Jehanne de France by Blaise Cendrars. 1913

Illustrated book with pochoir, 6' 9⅝" × 14¼"
(207.4 × 36.2 cm)
Publisher: Éditions des Hommes Nouveaux
(Blaise Cendrars). Edition: 150 announced;
60–100 printed
Purchase

Brilliant swirls of color cascade down
the left side of this elongated composi-
tion, ending with a simplified represen-
tation of a red Eiffel Tower. Juxtaposed
on the right, in a parallel arrangement,
are the words of the poet Cendrars,
which end with the text "O Paris." Col-
ors and words drift in a nonlinear fash-
ion similar to a stream of consciousness,
a state in which time and location are
irrelevant. Delaunay-Terk's hues and
Cendrars's prose interact on a simulta-
neous journey, producing synchronized
rhythms of art and poetry.

The text of *La Prose du Trans-
sibérien et de la petite Jehanne de France*
(Prose of the Trans-Siberian and of
little Jeanne of France) contains
Cendrars's sporadic flashbacks and
flash-forwards to other times and
places, and recounts his railroad jour-
ney from Moscow to the Sea of Japan
in 1904. It also includes recollections
of a train ride with his young French
mistress, the "petite Jehanne" of the
title, who repeatedly asked, "Are we
very far from Montmartre?"

Calling their creation "the first
simultaneous book," Delaunay-Terk and
Cendrars drew on the artistic theory of
simultaneity, espoused by the artist's
husband, the painter Robert Delaunay,
and modern poets.

Robert Delaunay | French, 1885–1941

Simultaneous Contrasts: Sun and Moon. 1913 (dated 1912)
Oil on canvas, 53" (134.5 cm) diam.
Mrs. Simon Guggenheim Fund

Delaunay was fascinated by how the interaction of colors produces sensations of depth and movement, without reference to the natural world. In *Simultaneous Contrasts* that movement is the rhythm of the cosmos, for the painting's circular frame is a sign for the universe, and its flux of reds and oranges, greens and blues, is attuned to the sun and the moon, the rotation of day and night. But the star and planet, refracted by light, go undescribed in any literal way. "The breaking up of form by light creates colored planes," Delaunay said. "These colored planes are the structure of the picture, and nature is no longer a subject for description but a pretext." Indeed, he had decided to abandon "images or reality that come to corrupt the order of color."

The poet Guillaume Apollinaire christened Delaunay's style "Orphism," after Orpheus, the musician of Greek legend whose eloquence on the lyre is a mythic archetype for the power of art. The musicality of Delaunay's work lay in color, which he studied closely. In fact, he derived the phrase "Simultaneous Contrasts" from the treatise *On the Law of the Simultaneous Contrast of Colors*, published in 1839 by Michel-Eugène Chevreul. Absorbing Chevreul's scientific analyses, Delaunay has here gone beyond them into a mystical belief in color, its fusion into unity symbolizing the possibility for harmony in the chaos of the modern world.

Two Clerestory Windows from Avery Coonley Playhouse, Riverside, Illinois. 1912

Color and clear glass, leaded, each $18\frac{5}{16} \times 34\frac{3}{16}$"
(46.5×86.8 cm)
Joseph H. Heil Fund

To enliven the interior of his Avery Coonley Playhouse, a kindergarten in the suburbs of Chicago for a private client, Frank Lloyd Wright designed stained-glass clerestory windows, which formed a continuous band around the top of the playroom. Each window in the series was composed of lively combinations of simple geometric motifs in bright colors. The windows were inspired by the sights of a parade, and their shapes abstracted from balloons, confetti, and even an American flag.

Wright designed the interior furnishings for almost all of his buildings, thereby creating an organic unity of the whole and its parts. Art glass was integral to the architectural fabric of many of his early works. The arranging of shapes into patterns in the Coonley Playhouse windows relates to the formal strategies Wright adopted in his architecture. His belief in the universality of fundamental geometric forms was as much a response to rational methods of modern machine production as an intuitive understanding that abstract forms carried shared spiritual values. Geometric forms had played a role in Wright's own childhood education through a German system of educational toys, the Froebel blocks, which he later credited as a major influence on his ideas about architecture.

Painterly Architectonic. 1917
Oil on canvas, 31 ½ × 38 ⅝" (80 × 98 cm)
Philip Johnson Fund

In *Painterly Architectonic*, one of a series of works by this title, Popova arranges areas of white, red, black, gray, and pink to suggest straight-edged planes laid one on top of the other over a white ground, like differently shaped papers in a collage. The space is not completely flat, however, for the rounded lower rim of the gray plane implies that this surface is arching upward against the red triangle. This pressure finds matches in the shapes and placements of the planes, which shun both right angles and vertical or horizontal lines, so that the picture becomes a taut net of slants and diagonals. The composition's orderly spatial recession is energized by these dynamic vectors, along which the viewer's gaze alternately slides and lifts.

Influenced by her long visits to Europe before World War I, Popova helped to introduce the Cubist and Futurist ideas of France and Italy into Russian art. But, no matter how abstract European Cubism and Futurism became, they never completely abandoned recognizable imagery, whereas Popova developed an entirely nonrepresentational idiom based on layered planes of color. The catalyst in this transition was Kazimir Malevich's Suprematism, an art of austere geometric shapes. But where Suprematism was infused with the desire for a spiritual or cosmic space, Popova's concerns were purely pictorial.

Suprematist Composition: White on White. 1918
Oil on canvas, 31 ¼ × 31 ¼" (79.4 × 79.4 cm)

A white square floating weightlessly in a white field, *Suprematist Composition: White on White* was one of the most radical paintings of its day: a geometric abstraction without reference to external reality. Yet the picture is not impersonal: we see the artist's hand in the texture of the paint, and in the subtle variations of the whites. The square is not exactly symmetrical, and its lines, imprecisely ruled, have a breathing quality, generating a feeling not of borders defining a shape but of a space without limits.

After the Revolution, Russian intellectuals hoped that human reason and modern technology would engineer a perfect society. Malevich was fascinated with technology, and particularly with the airplane, instrument of the human yearning to break the bounds of earth. He studied aerial photography, and wanted *White on White* to create a sense of floating and transcendence. White was for Malevich the color of infinity, and signified a realm of higher feeling.

For Malevich, that realm, a utopian world of pure form, was attainable only through nonobjective art. Indeed, he named his theory of art Suprematism to signify "the supremacy of pure feeling or perception in the pictorial arts"; and pure perception demanded that a picture's forms "have nothing in common with nature." Malevich imagined Suprematism as a universal language that would free viewers from the material world.

Red Blue Chair. c. 1923
Painted wood, 34⅛ × 26 × 33" (86.7 × 66 × 83.8 cm)
Gift of Philip Johnson

In the Red Blue Chair, Rietveld manipulated rectilinear volumes and examined the interaction of vertical and horizontal planes, much as he did in his architecture. Although the chair was originally designed in 1918, its color scheme of primary colors (red, yellow, blue) plus black—so closely associated with the de Stijl group and its most famous theorist and practitioner Piet Mondrian—was applied to it around 1923. Hoping that much of his furniture would eventually be mass-produced rather than hand-crafted, Rietveld aimed for simplicity in construction. The pieces of wood that comprise the Red Blue Chair are in the standard lumber sizes readily available at the time.

Rietveld believed there was a greater goal for the furniture designer than just physical comfort: the well-being and comfort of the spirit. Rietveld and his colleagues in the de Stijl art and architecture movement sought to create a utopia based on a harmonic human-made order, which they believed could renew Europe after the devastating turmoil of World War I. New forms, in their view, were essential to this rebuilding.

Bicycle Wheel. 1951 (third version, after lost original of 1913)
Assemblage: metal wheel, 25½" (63.8 cm) diam., mounted on painted wood stool, 23¾" (60.2 cm) high; overall, 50½ × 25½ × 16⅝" (128.3 × 63.8 × 42 cm)
The Sidney and Harriet Janis Collection

Bicycle Wheel is Duchamp's first Ready-made, a class of artworks that raised fundamental questions about artmaking and, in fact, about art's very definition. This example is actually an "assisted Readymade": a common object (a bicycle wheel) slightly altered, in this case by being mounted upside-down on another common object (a kitchen stool). Duchamp was not the first to kidnap everyday stuff for art; the Cubists had done so in collages, which, however, required aesthetic judgment in the shaping and placing of materials. The Readymade, on the other hand, implied that the production of art need be no more than a matter of selection—of choosing a preexisting object. In radically subverting earlier assumptions about what the artmaking process entailed, this idea had enormous influence on later artists, particularly after the broader dissemination of Duchamp's thought in the 1950s and 1960s.

The components of *Bicycle Wheel*, being mass-produced, are anonymous, identical or similar to countless others. In addition, the fact that this version of the piece is not the original seems inconsequential, at least in terms of visual experience. (Having lost the original *Bicycle Wheel*, Duchamp simply remade it almost four decades later.) Duchamp claimed to like the work's appearance, "to feel that the wheel turning was very soothing." Even now, *Bicycle Wheel* retains an absurdist visual surprise. Its greatest power, however, is as a conceptual proposition.

The Hat Makes the Man. 1920

Gouache, pencil, ink, and cut-and-pasted
collotypes on buff paper, 14 × 18" (35.6 ×
45.7 cm)
Purchase

Pictures of ordinary hats cut out of a
catalogue are stacked one atop the other
in constructions that resemble both
organic, plantlike forms and anthropo-
morphic phalluses. With the inscription,
"seed-covered stacked-up man seedless
waterformer ('edelformer') well-fitting
nervous system also tightly fitted nerves!
(the hat makes the man) (style is the tai-
lor)," Ernst incorporates verbal humor
into this subversive visual pun.

The artist was a major figure of the
Dada group, which embraced the con-
cepts of irrationality and obscure mean-
ing. *The Hat Makes the Man* illustrates
the use of mechanical reproductions to
record Ernst's own hallucinatory, often
erotic visions. The origin of this collage
is a sculpture made from wood hat
molds that Ernst created in 1920 for a
Dada exhibition in Cologne. The repeti-
tion of the hat, indicative of part of the
bourgeois uniform, suggests the Dadaist
view of modern man as a conformist
puppet. Thus, in true Dada fashion,
Ernst combines the contradictory ele-
ments of an inanimate object with refer-
ences to man and to nature; symbols of
social conventionality are equated with
sexually charged ones.

The Engineer Heartfield. 1920

Watercolor, pasted postcards, relief halftone,
and pencil on paper, 16½ × 12" (41.9 × 30.5 cm)
Gift of A. Conger Goodyear

In this work Grosz combines traditional, delicately hued watercolor with pasted photomechanical reproductions in an unreal space, inspired by the work of the Italian painter Giorgio de Chirico. These pictorial devices convey the satirical ideology that Grosz shared with his subject, John Heartfield, a friend, a fellow Berlin Dada artist, and a frequent collaborator. Heartfield is depicted as bald, grim-faced, and with clenched fists and a machine heart—the personification of the politically defiant anti-authoritarian, which was a stance that infused Heartfield's own art.

His uniform and the drab walls and floor suggest a prisoner in his cell, and the segmented view of a building in the distance, as if glimpsed through a narrow window, bears the mordant inscription: "Lots of luck in your new home." The mechanical gears indicate Heartfield's identity as an engineer or constructor *(monteur)* of photomontages. In fact, Heartfield called himself a *monteur-dada*, rather than an artist, and conceived of his own assembled works as images intended only for mass reproduction in magazines and on book covers and posters.

Collage Arranged According to the Laws of Chance. 1916–17

Torn-and-pasted papers on gray paper,
19⅛ × 13⅝" (48.6 × 34.6 cm)
Purchase

This elegantly composed collage of torn-and-pasted paper is a playful, almost syncopated composition in which uneven squares seem to dance within the space. As the title suggests, it was created not by the artist's design, but by chance. In 1915 Arp began to develop a method of making collages by dropping pieces of torn paper on the floor and arranging them on a piece of paper more or less the way they had fallen. He did this in order to create a work that was free of human intervention and closer to nature. The incorporation of chance operations was a way of removing the artist's will from the creative act, much as his earlier, more severely geometric collages had substituted a paper cutter for scissors, so as to divorce his work from "the life of the hand."

Arp was a founding member of the first Dada group that coalesced in Zurich in 1916 around the Cabaret Voltaire of Hugo Ball, the poet and performer. Dada—its name a nonsensical word chosen at random from the dictionary—was formed to prove the bankruptcy of existing styles of artistic expression rather than to promote a particular style itself. "Dada," wrote Arp, "wished to destroy the hoaxes of reason and to discover an unreasoned order." While this work is far less violent than some of the rhetoric of Dada, Arp's exemplary use of serendipitous composition here perfectly embodies what has been called the heart of Dada practice—the gratuitous act.

3 Standard Stoppages. 1913–14

Assemblage: three threads glued to three painted canvas strips, each 5¼ × 47¼" (13.3 × 120 cm), each mounted on a glass panel, 7¼ × 49⅜ × ¼" (18.4 × 125.4 × .6 cm); three wood slats, 2½ × 43 × ⅛" (6.2 × 109.2 × .2 cm), 2½ × 47 × ⅛" (6.1 × 119.4 × .2 cm), and 2½ × 43¼ × ⅛" (6.3 × 109.7 × .2 cm), shaped along one edge to match the curves of the threads; the whole fitted into a wood box, 11⅛ × 50⅞ × 9" (28.2 × 129.2 × 22.7 cm)
Katherine S. Dreier Bequest

A working note of Duchamp's describes his idea for this enigmatic work: "A straight horizontal thread one meter long falls from a height of one meter onto a horizontal plane twisting *as it pleases* and creates a new image of the unit of length." Here, three such threads, each fixed to its own canvas with varnish, and each canvas glued to its own glass panel, are enclosed in a box, along with three lengths of wood (draftsman's straightedges) cut into the shapes drawn by the three threads.

Duchamp later said that *3 Standard Stoppages* opened the way "to escape from those traditional methods of expression long associated with art," such as what Duchamp called "retinal painting," art designed for the luxuriance of the eye. This required formal intelligence and a skillful hand on the part of the artist. The Stoppages, on the other hand, depended on chance—which, paradoxically, they at the same time fixed and "standardized." (Duchamp used the phrase "canned chance.") Subordinating art both to accident and to something approximating the scientific method (which they simultaneously parodied), *3 Standard Stoppages* advanced a conceptual approach, an absurdist strain, and a way of commenting on both art and the broader culture that inspired countless later artists of many different kinds.

I See Again in Memory My Dear Udnie. (1914, perhaps begun 1913)

Oil on canvas, 8' 2½" × 6' 6¼" (250.2 × 198.8 cm)
Hillman Periodicals Fund

Like the Futurists and like his friend Marcel Duchamp, Picabia recognized the importance of the machine in the dawning technological age. The hard-edged, evenly rounded shapes of *I See Again in Memory My Dear Udnie*, some of them in metallic grays, parallel fusions of the mechanical and the organic in Duchamp's painting, and anticipate more overt references of this kind in Picabia's later work. Perspective lines at the painting's sides suggest a space around this fragmented body, which seems to stand on a kind of stage. Segmented tubes among the curling forms may have a sexual subtext, and

Picabia himself described his art of this period as trying "to render external an internal state of mind or feeling."

The "Udnie" of this work's title was surely a certain Mlle. Napierskowska, a professional dancer whom Picabia met on the ocean liner that took him to the United States to participate in the famous Armory Show of 1913. Fascinated by Napierskowska's performances (which were suggestive enough to provoke her arrest during her American tour), Picabia began to produce gouaches and watercolors inspired by her even before landing in New York. Over the following year, he extended this imagery in paintings, titling one of them *Udnie (Young American Girl)*— and thus suggesting that the abstract planes of these works relate to the human form.

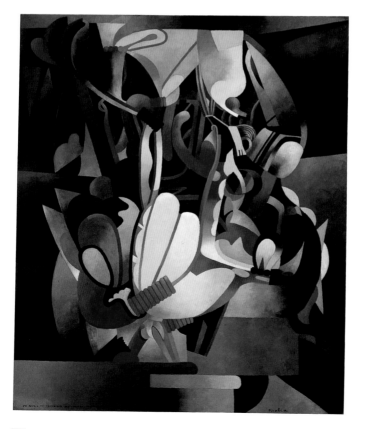

Lois Weber | American, 1882–1939
Phillips Smalley | American, 1875–1939

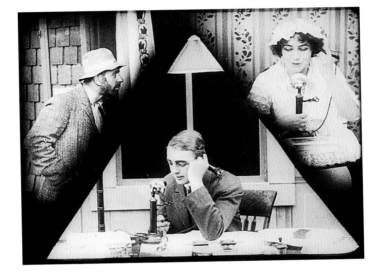

Suspense. 1913

35mm film, black and white, silent, 12 minutes
(approx.)
National Film and Television Archive, British
Film Institute (by exchange)
Sam Kaufman, Valentine Paul, Lois Weber

The story of *Suspense*, a one-reel thriller,
is a simple one—a tramp threatens a
mother and child, while the father races
home to their rescue—but the tech-
niques used to tell it are complex. Weber
and Smalley employ a dizzying array of
formal devices. The approach of an
automobile is shown reflected in another
car's side-view mirror. We catch our first
glimpse of the menacing burglar from
the same angle as the wife does—from
directly over him while he glares straight
up. Three simultaneous actions are
shown, not sequentially but as a triptych
within one frame.

Smalley and Weber began their film
careers as a husband-and-wife team act-
ing under the direction of Edwin S.

Porter at the Rex Company, one of the
many early independent film studios
established to combat the power of the
Motion Picture Patents Company, a con-
glomeration of the major producers and
distributors in the United States. By the
time Porter left Rex, in 1912, Smalley
and Weber had graduated to directing
and were fully responsible for the small
studio's output. *Suspense* is one of the
very few films made at Rex that survives,
and its staggering originality raises a
tantalizing question: is it a fascinating
anomaly or a representative sample of
the studio's overall production?

Fifth Avenue, New York. 1915
Platinum print, 12¼ × 8¼" (31.2 × 20.8 cm)
Gift of the artist

The shallow composition, as in a Japanese print, empty at the center and crowded at the edges; the muted tones, as in a print by James MacNeill Whistler; and the elegant shape made by the tethered flag, which rhymes with the spires of the church: these are survivals of photography's aesthetic movement at the turn of the century.

Strand's momentary glimpse of individual pedestrians strolling near a specific church—St. Patrick's Cathedral—on a particular stretch of Fifth Avenue in New York hints of concrete experience and points toward the challenges that the art of photography faced as it emerged from its aesthetic cloister. A woman in the foreground makes eye contact with the photographer. As a result, she is transformed from an element in a decorative frieze into a person with a mind of her own.

Brooklyn Bridge (Mosaic). 1913

Etching and drypoint, plate: 11¼ × 8⅞"
(28.6 × 22.5 cm)
Publisher: Alfred Stieglitz at "291," New York.
Edition: approx. 20
Gift of Abby Aldrich Rockefeller

The Brooklyn Bridge, a world-renowned symbol of New York City and an icon of technological achievement, has been an attractive subject for artists since its completion in 1883. Marin's etched image presents its pointed cathedral-like arches and strong, steel suspension cables in a bold and heroic fashion. At the same time, the work generates a sense of the hustle and bustle of city life through the dynamic groupings of lines that break up the composition.

Brooklyn Bridge (Mosaic) was created two years after Marin returned to New York from Paris, and is an example of how much this American city energized the artist, who found the people, the skyscrapers, and the bridges "alive" and, in their interaction, playing "great music." It is one of a group of six New York etchings made by Marin and published by the photographer and art dealer Alfred Stieglitz. They were shown at his gallery at 291 Fifth Avenue. Stieglitz championed a circle of young American artists and was particularly supportive of Marin.

Intolerance. 1916
35mm film, black and white and color-tinted,
silent, 196 minutes (approx.)
Acquired from the artist; preserved with
funding from the Celeste Bartos Film
Preservation Fund

Intolerance is one of the cinema's earliest
formal masterpieces. Its ambitious scale
and lavish production—exemplified by
the enormous, if historically inaccurate,
set for the court of Babylon—were
unprecedented at the time. The film was
to serve as a mighty sermon against the
hideous effects of intolerance; in it,
Griffith proposed his view of history
and myth. *Intolerance* interweaves his
unfinished work, "The Mother and the
Law," a contemporary melodrama about
the hypocrisy of well-off do-gooders set
in the United States, with three parallel
stories of earlier times: Christ at Calvary,
the razing of Babylon by Persians, and

the persecution of the Huguenots in
France. Griffith explained the film:
"The stories begin like four currents
looked at from a hilltop. At first the four
currents flow apart, slowly and quietly.
But as they flow, they grow nearer and
nearer together, and faster and faster,
until in the end, in the last act, they
mingle in one mighty river of expressed
emotion."

The scale and extravagance of
Intolerance brought Hollywood to the
fore as the center for American film
production. The film also exercised
enormous international influence, par-
ticularly in post-Revolutionary Russia,
where Lenin commended the scope and
purpose of the film. But the complexity
of the structure seemed to baffle early
audiences, and *Intolerance* was a box-
office failure, although Griffith's previ-
ous film, *The Birth of a Nation* (1915),
had been a great success.

Water Lilies. c. 1920
Oil on canvas, left panel of triptych, each panel
6' 6" × 14' (200 × 425 cm)
Mrs. Simon Guggenheim Fund

Visitors to Monet's Giverny studio in
1918 found "a dozen canvases placed in
a circle on the floor … [creating] a
panorama made up of water and lilies,
of light and sky. In that infinitude, water
and sky have neither beginning nor
end." What they had seen was a group
of paintings that Monet planned to
install abutting each other in an oval,
encompassing the viewer in a sensually
enveloping space. The aim, he said, was
to supply "the illusion of an endless
whole, of water without horizon or
bank." The *Water Lilies* triptych comes

from this series, which describes a scene
Monet not only showed in art but shaped
in life: the pond in his own garden.

Like his fellow Impressionists,
Monet, when young, had attempted a
faithfulness to perceived reality, trying
to capture the constantly changing qual–
ity of natural light and color. The *Water
Lilies*, though, seem nearly abstract, for
their scale and allover splendor so
immerse us in visual experience that
spatial cues dissolve: above and below,
near and far, water and sky commingle.
Perhaps this was the quality that led
Monet's visitors to say, "We seem to be
present at one of the first hours in the
birth of the world." Yet Monet's desire
that the installation create "the refuge of
a peaceful meditation" seems equally just.

Joan Miró | Spanish, 1893–1983

The Birth of the World. 1925
Oil on canvas, 8' 2¾" × 6' 6¾" (250.8 × 200 cm)
Acquired through an anonymous fund, the Mr.
and Mrs. Joseph Slifka and Armand G. Erpf
Funds, and by gift of the artist

According to the first Surrealist mani-
festo of 1924, "the real functioning of
the mind" could be expressed by a "pure
psychic automatism," "the absence of
any control exercised by reason." Miró
was influenced by Surrealist ideas, and
said, "Rather than setting out to paint
something, I begin painting and as I
paint, the picture begins to assert
itself.... The first stage is free, uncon-
scious." But, he added, "The second
stage is carefully calculated."

The Birth of the World reflects just
this combination of chance and plan.
Miró primed the canvas unevenly, so
that paint would here sit on the surface,
there soak into it. His methods of apply-
ing paint allowed varying degrees of
control—pouring, brushing, flinging,
spreading with a rag. The biomorphic
and geometric elements, meanwhile, he
drew deliberately, working them out in a
preparatory drawing.

Miró's works in this vein suggest
something both familiar and unidentifi-
able, yet even at his most ethereal, Miró
never loses touch with the real world: we
see a bird, or a kite; a shooting star, a
balloon on a string, or a spermatozoa; a
character with a white head. *The Birth of
the World* is the first of many Surrealist
works that deal metaphorically with
artistic creation through an image of the
creation of a universe. In Miró's words,
it describes "a sort of genesis."

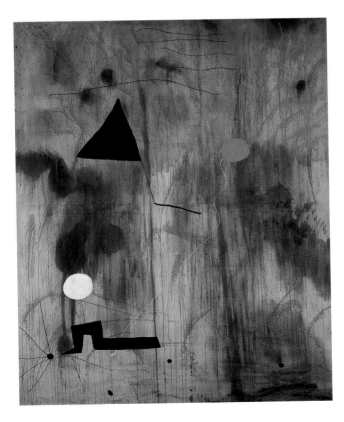

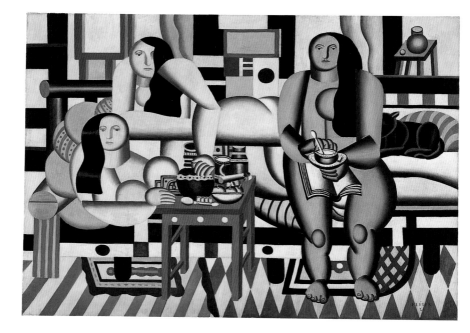

Three Women. 1921

Oil on canvas, 6' ¼" × 8' 3" (183.5 × 251.5 cm)
Mrs. Simon Guggenheim Fund

In *Three Women*, Léger translates a common theme in art history—the reclining nude—into a modern idiom, simplifying the female figure into a mass of rounded and somewhat dislocated forms, the skin not soft but firm, even unyielding. The machinelike precision and solidity that Léger gives his women's bodies relate to his faith in modern industry, and to his hope that art and the machine age would together remake the world. The painting's geometric equilibrium, its black bands and panels of white, suggest his awareness of Mondrian, an artist then becoming popular. Another stylistic trait is the return to variants of classicism, which was widespread in French art after the chaos of World War I. Though buffed and polished, the simplified volumes of Léger's figures are, nonetheless, in the tradition of classicists of the previous century.

A group of naked women taking tea, or coffee, together may also recall paintings of harem scenes, for example, by Jean-Auguste-Dominique Ingres, although there the drink might be wine. Updating the repast, Léger also updates the setting—a chic apartment, decorated with fashionable vibrancy. And the women, with their flat-ironed hair hanging to one side, have a Hollywood glamour. The painting is like a beautiful engine, its parts meshing smoothly and in harmony.

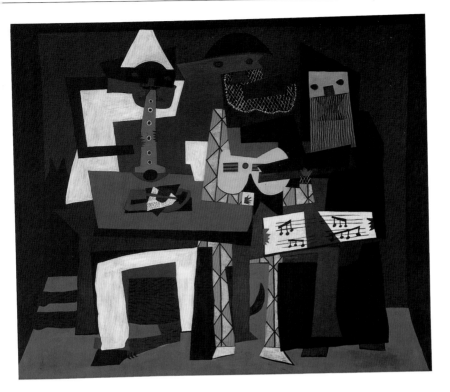

Three Musicians. 1921
Oil on canvas, 6' 7" × 7' 3¾" (200.7 × 222.9 cm)
Mrs. Simon Guggenheim Fund

At the left of a bare and boxlike space, a masked Pierrot plays the clarinet. At the right, a singing monk holds sheet music. And in the center, strumming a guitar, is a Harlequin, in Picasso's art a recurring stand-in for the artist himself.

Pierrot and Harlequin are stock characters in the old Italian comic theater known as commedia dell'arte, a familiar theme in Picasso's work. The painting, then, has a whimsical side, epitomized by the near-invisible dog: its head is about halfway up the canvas on the left, one of several subtle browns, and we can also make out front paws, a hind leg, and a jaunty tail popping up between Harlequin's legs. Overall, though, the work's somber background and large size make the musicians a solemn, even majestic trio.

The intricate, jigsaw-puzzle-like composition sums up the Synthetic Cubist style, the flat planes of unshaded color recalling the cutout and pasted paper forms with which the style began. These overlapping shapes are at their most complex at the center of the picture, which is also where the lightest hues are concentrated, so that an aura of darkness surrounds a brighter center. Along with the frontal poses of the figures, this creates a feeling of gravity and monumentality, and gives *Three Musicians* a mysterious, otherworldly air.

The Passion of Joan of Arc (La Passion de Jeanne d'Arc).

1928
35mm film, black and white, silent, 89 minutes (approx.)
Cinémathèque Française (by exchange)
Renée (Maria) Falconetti

Made at the end of the silent-film era, Dreyer's version of the trial and execution at the stake of Joan of Arc, her ecstasy, and above all her suffering, is the filmmaker's great work. The setting is austere, the architecture grim, as the film's physical imagery heightens the sense of tragedy during the long interrogation of the maid of Orleans. Huge close-ups of faces dominate the drama; many appear without the context of establishing shots. Oblique camera angles and distorting facial expressions are used for expressive effect. The film's pace is measured and the conclusion inexorable.

Dreyer based the chronicle of Joan's demise on contemporary court documents of her trial but reduced days of questioning into one and offered little historical context in the film's intertitles, which provide the dialogue of the interrogation. Although the rare appearance on film of the French dramatist and poet Antonin Artaud (as a prosecutor) is of historical interest, it is Falconetti, as Joan, who gives one of the most intense performances in the history of cinema, heightening the work's transcendental power.

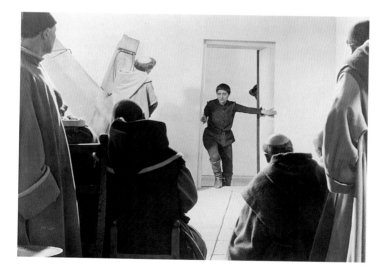

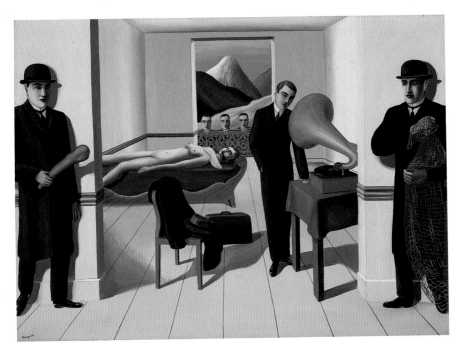

The Menaced Assassin. 1926

Oil on canvas, 59¼" × 6' 4⅞" (150.4 × 195.2 cm)
Kay Sage Tanguy Fund

A woman's naked body, blood trickling from her mouth, lies on a couch. The well-dressed man who is presumably her killer—the assassin of the painting's title—stands ready to leave, his coat and hat on a chair and his bag adjoining, but he is delayed by the sound of music: languidly relaxed, he listens to a gramophone. Meanwhile two men (agents of the law?), oddly alike, wait in the foyer to ambush him, armed with club and net. And behind him three more men, triplets to the others' twins, watch from over the balcony, witnesses outside the action's frame—like reflections of the painting's viewers, peering in from the other direction.

Magritte's Belgian brand of Surrealism deals in clear visions with unclear meanings. Unlike the fantastic dreamscapes of Paris Surrealists such as Salvador Dalí, his settings are strangely normal, and his protagonists are bourgeois gentlemen in ties and bowler hats. Yet he specialized in permanent irresolution, in mysteries without a key. *The Menaced Assassin* must be rooted in detective novels and movies, which fascinated Magritte, but its studied frozen quality, the impassivity of its actors, puts it in another dimension from the dime thriller.

Disturbingly, the gaze of the three men at the back meets the viewers' own. The murderer himself is menaced; the viewers themselves are viewed.

Parole in libertà futuriste, tattili-termiche olfattive

by Filippo Tommaso Marinetti. 1932–34
Illustrated book with 26 lithographs on metal,
page: 9³/₁₆ × 8¹¹/₁₆" (23.3 x 22 cm)
Publisher: Edizioni Futuriste di Poesia, Rome.
Edition: approx. 25
Gift of The Associates of the Department of
Prints and Illustrated Books and of Elaine
Lustig Cohen in memory of Arthur A. Cohen

This extraordinary book, with its cover and bound pages made completely of metal, heralds technological achievement in the service of art. Marinetti, the Futurist artist, poet-author, and force behind this project, consulted with workers in a can factory in Savona, Italy, which had printed a poem on a sheet of tin in 1931.

The making of this book, however, posed special difficulties in devising a spine that allowed the heavy pages to turn freely. The solution was the cylindrical mechanism seen at the left edge of the cover. The layout of the book was designed by Marinetti and d'Albisola, a sculptor and ceramist who executed the lithographs, combining typography with crisp geometric shapes. As seen on this cover, the artist created dynamic compositions, using sleek modern typefaces in boldly distorted sizes.

The Futurists promoted free verse and poetry based on sound rather than meaning, expanding their reach to the visual and performing arts. They exalted the machine, with its seemingly limitless possibilities for the future, as a symbol of the modern age. *Parole in libertà futuriste* represents a remarkable collaboration of artist, artisan, technician, and machine, which resulted in the first mechanical book.

Max Ernst | French, born Germany. 1891–1976

Two Children Are Threatened by a Nightingale. 1924

Oil on wood with wood construction, 27½ × 22½ × 4½" (69.8 × 57.1 × 11.4 cm)

Purchase

In *Two Children Are Threatened by a Nightingale*, a girl, frightened by the bird's flight (birds appear often in Ernst's work), brandishes a knife; another faints away. A man carrying a baby balances on the roof of a hut, which, like the work's gate (which makes sense in the picture) and knob (which does not), is a three-dimensional supplement to the canvas. This combination of unlike elements, flat and volumetric, extends the collage technique, which Ernst cherished for its "systematic displacement." "He who speaks of collage," the artist believed, "speaks of the irrational." But even if the scene were entirely a painted illusion, it would have a hallucinatory unreality, and indeed Ernst linked his work of this period to childhood memories and dreams.

Ernst was one of many artists who emerged from service in World War I deeply alienated from the conventional values of his European world. In truth, his alienation predated the war; he would later describe himself when young as avoiding "any studies which might degenerate into bread winning," preferring "those considered futile by his professors—predominantly painting. Other futile pursuits: reading seditious philosophers and unorthodox poetry." The war years, however, focused Ernst's revolt and put him in contact with kindred spirits in the Dada movement. He later became a leader in the emergence of Surrealism.

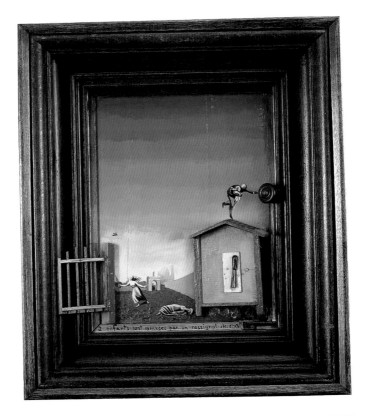

U.S.S.R. Russian Exhibition (USSR Russische Ausstellung).

1929
Poster: gravure, 49 × 35¼" (124.5 × 89.5 cm)
Jan Tschichold Collection. Gift of Philip Johnson

This propaganda poster, publicizing an exhibition in Switzerland about the Soviet Union, shows El Lissitzky's characteristic application of the photomontage technique, part of the new visual vocabulary employed in the graphic arts, replacing the objective art of illustration with collage. The two idealized portraits show young Soviets peering happily into Russia's bright future. Their androgyny and joined faces suggest the equal roles young men and women were to play in building the new Soviet society.

Visual artists in the Soviet Union rejected the fine arts in favor of the functional arts after the Bolshevik Revolution of 1917. It was believed that while painting and sculpture would have little utility in the burgeoning socialist regime, design could help advance the goals of the Revolution. Graphic design became the medium of choice for promoting specific political agendas.

El Lissitzky traveled more frequently than many of his Russian colleagues and thus was an important link between developments at the German Bauhaus, the Dutch de Stijl movement, and the Russian Constructivism of the 1920s and 1930s. His use of montage, straightforward typography, and dynamic compositions greatly influenced the evolution of modern graphic design.

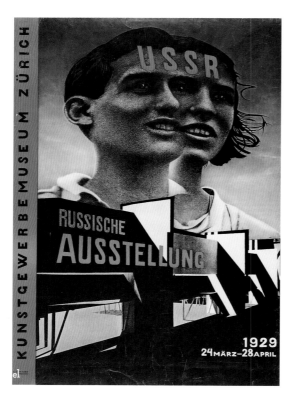

Oval Hanging Construction
Number 12. c. 1920

Plywood, open construction partially painted
with aluminum paint, and wire, 24 × 33 × 18½″
(61 × 83.7 × 47 cm)
Acquisition made possible through the extraor-
dinary efforts of George and Zinaida Costakis,
and through the Nate B. and Frances Spingold,
Matthew H. and Erna Futter, and Enid A.
Haupt Funds

A series of different-sized ovals that nest
and intersect, *Oval Hanging Construction*
hangs in space, moving slowly with any
current of air. The ovals were measured
out on a single flat sheet of plywood,
precisely cut, then rotated within each
other to make a three-dimensional object
resembling a gyroscope. The resulting
form suggests a chart of planetary
orbits, a cosmic structure. In companion
pieces, Rodchenko applied the same
principle and method to other basic geo-
metric forms, such as the square, but
those works no longer survive.

Rodchenko's interest in mathemati-
cal systems reflects the scientific bent of
the Russian Constructivists, artists who
aspired to create a radically new, radi-
cally rational art for the society that
came into being with the Russian Revo-
lution. *Hanging Construction* is a stage in
Rodchenko's progress away from con-
ventional painting and toward an art tak-
ing place in space—ultimately, an art of
social involvement. The work has no top,
no bottom, no base to rest on. It is virtu-
ally weightless, with suspension and
movement replacing mass. In short, it
was designed to be everything tradi-
tional sculpture was not—to reimagine
art from ground zero.

Maquette for Radio-Announcer. 1922

Construction of painted cardboard, paper, wood, thread, and metal brads, 45¾ × 14½ × 14½" (106.1 × 36.8 × 36.8 cm)
Sidney and Harriet Janis Collection Fund

Klucis made this maquette, or model, as a design for a "radio-announcer"—a street-based loudspeaker—to be placed at city intersections, where it was to broadcast a speech by Lenin on the fifth anniversary of the Russian Revolution. An architecture of struts and cables supports geometric panels and gaily painted loudspeakers. The work clearly announces its purpose: the name "Lenin" appears in large red letters on an arrangement of vanes; black letters running across the leader's name spell the Russian word for "speech"; and in smaller letters above appear the words for "radio-announcer." Like other Constructivist artists, Klucis chose simple forms, declarative colors, and bold typography—the aim was to be easily understood. Intricately calculated and visually involving, the structure of crossbars and wire rigging is also completely open to view, and every part is self-explanatory in function.

Klucis had studied abstract painting and had worked in the Suprematist style, but after the Revolution he joined the many Russian artists who threw their energies behind the developing Communist state. Artists throughout Europe were trying to find aesthetic languages that would have a place in a world shaped by new industries, new technologies, and new social forms, a world of mass publics and mass media of communication. *Radio-Announcer* puts this concern into a Russian context: the attempt to build a utopian society.

Potemkin (Bronenosets Potemkin). 1925

35mm film, black and white and hand-colored, silent, 75 minutes (approx.)
Acquired from Reichsfilmarchiv

Eisenstein used the events of the 1905 rebellion against czarist troops in the port of Odessa to give meaning to the Russian Revolution of 1917. *Potemkin* is made up of five major sequences: the rebellion of the ship's sailors over rotten food, the mutiny on the quarterdeck, the display of the martyr's body on the quay, the massacre of civilians on the Odessa steps, and the triumphant sailing of the battleship to meet the fleet. All of them exhibit Eisenstein's self-conscious manipulation of the medium of film. One of the most memorable shots, comprising the Odessa steps sequence, for example, captures the horror of the massacre in a close-up of a woman screaming after she has been wounded by the advancing soldiers. His brilliantly percussive editing, detailed shots, repetitions, contrasts, compressions and expansions of time, and collisions of images ran counter to the trend toward a seamless illusion of reality found in other national cinemas of the 1920s.

With this film, Soviet cinema took a central place on the world scene, in spite of the fact that the film was censored, even banned, in many countries for its powerful glorification of the Soviet ideal. After the Revolution, young film directors searched for a cinematic style that, by destroying tradition, would help to bring about a new society. In films on revolutionary subjects, they abandoned conventional structure, experimented with new techniques, and used montage. Eisenstein, in particular, believed that juxtapositions of images would shock viewers into becoming active cinematic agents.

The Man with the Movie Camera (Chelovek S. Kino-apparatom). 1929

35mm film, black and white, silent,
65 minutes (approx.)
Gosfilmofond (by exchange)

As *The Man with the Movie Camera* begins, the cameraman climbs out of the "head" of the camera. The film then takes its viewer on a kaleidoscopic, humorous ride through Soviet cities, while drawing parallels between the moviemaker and the factory laborer, and exposing the filmmaking process. At one moment, Vertov presents a man riding a motorcycle, and then, surprisingly, shows us shots of the cameraman filming the motorcycle, then shots of the editor editing these shots. By making use of all filming strategies then available—including superimposition, split screens, and varied speed—Vertov created a rev-olution in cinematic art with his defiant deconstruction of moviemaking and dramatic norms.

Vertov, whose name is a pseudonym meaning "spinning top," stated: "We proclaim the old films, based on romance, theatrical films and the like, to be...mortally dangerous! Contagious!" Under the influence of Futurist art theories and the movement's confidence in the machine, the medical student Denis Kaufman renamed himself and began experiments with sound recording and assemblage. After the Bolshevik Revolution, along with his wife/editor and brother/cameraman, he made films and developed polemics that called for the death of filmmaking and relied on artifice and drama. Like others of his generation, Vertov wanted to replace the human eye with the *kinoki*, an objective cinematic eye, in order to help build a new proletarian society.

Assembling for a Demonstration. 1928–30

Gelatin silver print, 19½ × 13⅞" (49.5 × 35.3 cm)
Mr. and Mrs. John Spencer Fund

Photographs made from above or below or at odd angles are all around us today—in magazine and television ads, for example—but for Rodchenko and his contemporaries they were a fresh discovery. To Rodchenko they represented freedom and modernity because they invited people to see and think about familiar things in new ways. This courtyard certainly was familiar to Rodchenko; he made the picture from the balcony of his own Moscow apartment.

The photograph strikes a perfect balance between plunging depth and a flat pattern—two darker forms enclosing a lighter one—and between this simple pattern and the many irregular details that enliven it. Rodchenko's control over the image is suggested by his particular point of view: to keep the balcony below him from intruding its dark form into the lighter courtyard, he was obliged to lean rather precariously over the railing of his own balcony.

Dancer Reflected in a Mirror. 1923

Woodcut, comp.: 19⁹⁄₁₆ × 15¾" (49.6 × 40 cm)
Publisher: Euphorian Verlag, Berlin. Edition: 51
Mrs. Bertram Smith Fund

The dramatic gestures of a seductively clad cabaret dancer, seen raising her skirt and pointing her toes, ironically clash with the bored expression on her face. The lines of her skirt and her bent right leg create strong diagonals that draw the viewer's attention to the row of men's faces, making them major protagonists in the scene. These men seem disconnected from their spatially compressed surroundings, and two of them appear overtly disinterested as they stare out with unfocused eyes. Pechstein, who himself had been a soldier at the Somme front in France, executed *Dancer Reflected in a Mirror* during the post–World War I years, a time of political unrest and financial insecurity in Germany. Reading this woodcut as social commentary, one senses the apathetic decadence that permeated the era.

Early in his career, Pechstein was a member of *Die Brücke*, the German Expressionist group. Although he disagreed with their policy of exhibiting exclusively together and was officially expelled in 1912, he continued to create Expressionist images.

The Widow I, The Mothers, and **The Volunteers** from the portfolio **Seven Woodcuts about War.**

1922–24
Woodcuts, sheet: each 18⅝ × 26" (46.7 × 66 cm) (approx.)
Publisher: Emil Richter, Dresden. Edition: 200
Gift of the Arnhold Family in memory of Sigrid Edwards

These prints express the raw agony that war inflicts on humanity. In *The Widow I* a woman hugs herself in anguish. Her rounded form and the tender contact of her massive hands over her chest and abdomen suggest that she may be pregnant, lending further poignancy to her situation. In *The Mothers*, a group of women locked in tight embrace console each other, while two frightened children peer out from beneath their protective huddle. In *The Volunteers*, four young men, whose distressed faces and clenched fists betray their sense of doom yet determination, volunteer to fight as they follow a drumming figure with a deathlike mask. Grief and torment pervade each of these images, so graphically conveyed by the crude slashes and gouges of the woodcut medium.

Kollwitz's *Seven Woodcuts about War* is one of several portfolios of prints by German artists focusing on the savagery of World War I. But rather than show the brutalities of warfare and bombing experienced by soldiers, the artist portrays the emotional responses of civilians. Although her sense of loss was very personal—her younger son Peter was killed in combat in Flanders—Kollwitz presents universal visions of the unending sorrow generated by war for those left behind.

Store, avenue des Gobelins.

1925
Albumen silver print, $8\frac{1}{8} \times 6\frac{5}{16}$" (20.6 × 16 cm)
Abbott-Levy Collection. Partial gift of Shirley
C. Burden

For more than three decades, Atget pho-
tographed Paris—its ancient streets and
monuments and finely wrought details,
its corners and hovels and modern com-
merce, and its outlying parks. He was
not an artist in the conventional sense
but a specialized craftsman, who sup-
plied pictorial records of French culture
to artists, antiquarians, and librarians.
That, at least, is how he earned his liv-
ing. Shortly before his death, however,
other photographers began to recognize
that Atget's work is art in everything but
name: full of wit, invention, beauty, wis-
dom, and the disciplined cultivation of
original perceptions.

This picture of the front of a men's
clothing store belongs to a series of pho-
tographs of store windows that Atget
made in the highly creative last years of
his life. He easily could have minimized
the reflection in the window, in which
we see part of the Gobelins complex,
where tapestries had been made for
nearly three centuries. Instead, he wel-
comed it. Indelibly melding two images
into one, the photograph simultaneously
evokes France's modern fashions and
one of her most noble artistic traditions.

Kurt Schwitters | British, born Germany. 1887–1948

Merz Picture 32A (The Cherry Picture). 1921
Cloth, wood, metal, fabric, cut-and-pasted papers, cork, gouache, oil, and ink on cardboard,
36⅛ × 27¾" (91.8 × 70.5 cm)
Mr. and Mrs. A. Atwater Kent, Jr. Fund

This highly animated picture is dominated by rectangular pieces of paper that cover the surface of the work. Schwitters created the illusion of depth by placing those papers with darker components behind those that are lighter in aspect. The brightest piece of paper, in the center of the composition, shows an eye-catching cluster of red cherries and the printed German and French words for the fruit.

In the winter of 1918–19 Schwitters had collected bits of newspaper, candy wrappers, and other debris, and began making the collages and assemblages for which he is best known today. *The Cherry Picture* belongs to a group of these works he called *Merz*, a nonsensical word that he made up by cutting a scrap from a newspaper: the second syllable of the German word *Kommerz*, or commerce.

By 1921 Schwitters had been painting seriously for ten years, largely in different naturalistic styles. In doing so, he learned how all art was based on measurement and adjustment and the manipulation of a variable but finite number of pictorial elements. He never forgot these lessons, which form a bridge between his earlier, representational work and the purely formal manipulation of found materials in the *Merz* pictures.

Cat and Bird. 1928

Oil and ink on gessoed canvas, mounted on wood, 15 × 21" (38.1 × 53.2 cm)
Sidney and Harriet Janis Collection Fund and gift of Suzy Prudden and Joan H. Meijer in memory of F. H. Hirschland

Klee was one of the many modernist artists who wanted to practice what he called "the pure cultivation of the means" of painting—in other words, to use line, shape, and color for their own sake rather than to describe something visible. That priority freed him to create images dealing less with perception than with thought, so that the bird in this picture seems to fly not in front of the cat's forehead but inside it—the bird is literally on the cat's mind. Stressing this point by making the cat all head, Klee concentrates on thought, fantasy, appetite, the hungers of the brain. One of his aims as an artist, he said, was to "make secret visions visible."

The cat is watchful, frighteningly so, but it is also calm, and Klee's palette too is calm, in a narrow range from tawny to rose with zones of bluish green. This and the suggestion of a child's drawing lighten the air. Believing that children were close to the sources of creativity, Klee was fascinated by their art, and evokes it here through simple lines and shapes: ovals for the cat's eyes and pupils (and, more loosely, for the bird's body), triangles for its ears and nose. And the tip of that nose is a red heart, a sign of the cat's desire.

Indian Dancer (From an Ethnographic Museum). 1930

Cut-and-pasted gravure, relief halftone, and silver-and-gold-embossed foil on buff paper, 10⅛ × 8⅞" (25.7 × 22.4 cm)
Frances Keech Fund

In this collage Höch obliquely makes reference to Joan of Arc, the androgynous heroine who went to battle dressed as a man, was later charged with heresy, burned at the stake, and subsequently regarded as a martyr. The mask covering the mouth and one eye may be read as an effort to restrain the figure, while the cutlery on the crown emphasizes the domestic role that women usually play. The paper framing the truncated head simulates the museological presentation of an object. In this compellingly strange image, it is the modern woman rather than a colonized artifact that is on display.

The woman in the photograph affixed to this work is the actress Renée (Maria) Falconetti portraying the title role in Carl Theodor Dreyer's 1928 film *The Passion of Joan of Arc.* Over the mournful face, Höch pasted a fragmented photograph of an African wood dance mask and, on top, a paper-and-foil headdress ornamented with cutouts of knives and spoons. This work belongs to a series of photomontages called *From an Ethnographic Museum* (1924–34), most of which juxtapose images of women and magazine reproductions of tribal art. Höch cited a visit to an ethnographic museum as an influence in the conception of this series; however, she used ethnographic material mostly as a point of departure in order to comment on the status of women in contemporary German society.

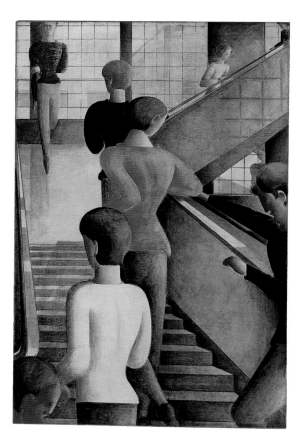

Bauhaus Stairway. 1932
Oil on canvas, 63⅞ × 45" (162.3 × 114.3 cm)
Gift of Philip Johnson

Visiting Stuttgart in the spring of 1933, Alfred H. Barr, Jr., the founding director of The Museum of Modern Art, discovered that an exhibition by Schlemmer had closed after a brutal and intimidating review in a Nazi paper. Barr responded by cabling Philip Johnson, already a frequent donor to The Museum of Modern Art, to ask him to acquire *Bauhaus Stairway* as an eventual gift. Barr acted, he later wrote, "partly to spite the Nazis just after they had closed [Schlemmer's] exhibition."

Schlemmer painted *Bauhaus Stairway* three years after leaving his teaching post at the Bauhaus, the famous school

of modern art, architecture, and design. The work's gridded structure celebrates Bauhaus design principles, and its upward movement, including the man *en pointe* at top left (Schlemmer had worked in dance), evokes the school's former optimism. Encouraging our involvement in this mood are the figures facing the same way we do, some of them partly cut off by the frame, as if they were in our space. Their simplified, almost modular shapes giving them an Everyman quality, they step up into the picture and then on up the stair.

Schlemmer's several staircase scenes of the early 1930s may reflect a desire to transcend a threatening period in German history. He exhibited this particular work soon after hearing that the Nazis had shut down the Bauhaus.

Wilhelm Wagenfeld | German, 1900–1990
Carl J. Jucker | Swiss, 1902–1997

Table Lamp. 1923–24
Glass and chrome-plated metal, 18 × 8"
(45.7 × 20.3 cm) diam. at base
Manufacturer: Metallwerkstätte, Staatliches
Bauhaus, Germany
Gift of Philip Johnson

This object, known as the "Bauhaus lamp," embodies an essential idea— form follows function—advanced by the influential Bauhaus school, founded in 1919 by the architect Walter Gropius, which taught a modern synthesis of both fine and applied arts. Through the employment of simple geometric shapes—circular base, cylindrical shaft, and spherical shade—Wagenfeld and Jucker achieved "both maximum simplicity and, in terms of time and materials, greatest economy." The lamp's working parts are visible; the opaque glass shade, a type formerly used only for industrial lighting, helps to diffuse the light.

The lamp was produced in the Bauhaus metal workshop after its reorganization under the direction of the artist László Moholy-Nagy in 1923. The workshop promoted the use of new materials and favored mass production under a collaborative, rather than individual, approach.

Initial attempts at marketing the lamp in 1924 were unsuccessful, primarily because most of its parts were still hand assembled at the Bauhaus. Today, the lamp is widely produced by Technolumen of Bremen, Germany, and is generally perceived as an icon of modern industrial design.

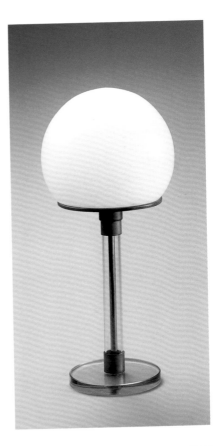

Barcelona Chair. 1929
Stainless steel bars and leather upholstery,
31 × 29⅜ × 30" (78.7 × 74.6 × 76.2 cm)
Manufacturer: Knoll International, USA
Gift of the manufacturer

The Barcelona Chair achieves the serenity of line and the refinement of proportions and materials characteristic of Mies van der Rohe's highly disciplined architecture. It is supported on each side by two chrome-plated, flat steel bars. Seen from the side, the single curve of the bar forming the chair's back and front legs crosses the S-curve of the bar forming the seat and back legs, making an intersection of the two. This simple shape derives from a long history of precedents, from ancient Egyptian folding stools to nineteenth-century neoclassical seating. The cantilevered seat and

the back of the original chairs were upholstered in white kid leather with welt and button details.

Mies van der Rohe designed this chair for his German Pavilion at the Barcelona Exposition of 1929. The Pavilion was the site of the inaugural ceremony for the German exhibits at the exposition, and the Spanish king was to preside. It had to be an "important chair, a very elegant chair," according to the architect. "The government was to receive a king.... The chair had to be... monumental. In those circumstances, you just couldn't use a kitchen chair."

Although only two Barcelona chairs were made for the German Pavilion, the design was put into production and became so popular that, with the exception of one sixteen-year period, it has been manufactured since 1929.

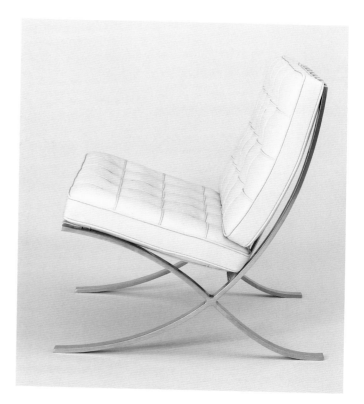

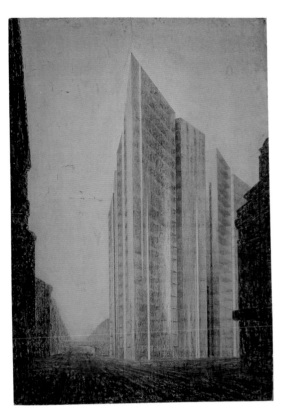

Honeycomb, Friedrichstrasse Skyscraper, Berlin. Competition project, 1921

Perspective, north and east sides: charcoal and pencil on brown paper, mounted on board, 68¼ × 48" (173.4 × 121.9 cm)

Mies van der Rohe Archive. Gift of the architect

This design for a crystal tower was unprecedented in 1921. It was based on the untried idea that a supporting steel skeleton would be able to free the exterior walls from their load-bearing function, allowing a building to have a surface that is more translucent than solid. Mies van der Rohe determined the faceted, prismatic shapes of its three connecting towers by experimenting with light reflections on a glass model. While the design anticipates his later preference for steel and glass, here a highly expressionistic character is more evident than any kind of rationalist intention.

A leader of the revolutionary modern movement in architecture, Mies van der Rohe designed a series of five startlingly innovative projects in the early 1920s, each of which had a profound influence on progressive architects all over the world. This competition entry was one of them. Code-named "Honeycomb," the Friedrichstrasse Skyscraper was distinguished by its daring use of glass, which symbolized the dawning of a new culture, and by an expressive shape that seems to owe nothing to history.

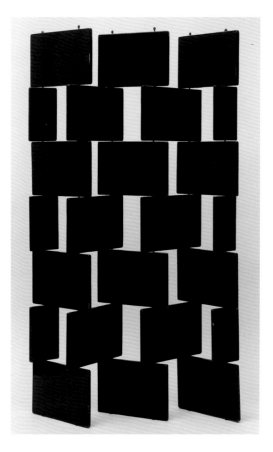

Screen. 1922

Lacquered wood and brass rods, 6' 2½" × 53½" × ¾" (189.2 × 135.9 × 2 cm)

Hector Guimard Fund

This black lacquered wood screen, composed of seven horizontal rows of panels joined by thin vertical brass rods, is not only a movable wall that serves to demarcate space but also a sculpture composed of solids and voids with an underlying Cubist influence. It is one of the most striking and elegant creations by Gray, who was one of the leading designers working in Paris after World War I. Gray popularized and perfected the art of lacquered furnishings, and her preference for its meticulous finish reveals a predilection for exotic materials, in particular those used in Japanese decorative arts.

Based on a larger version that Gray designed in 1922 for the Paris apartment of Madame Mathieu-Lévy, the owner of an exclusive millinery shop, the free-standing block screen can be seen as a bridge between furniture, architecture, and sculpture. Gray also became an accomplished textile designer and architect. Her first major architectural project, the E-1027 House in Roquebrune-Cap-Martin, France, was composed of multi-functional rooms and furniture, and was much admired by the Swiss-French architect Le Corbusier. The flexibility inherent in this project continued Gray's primary fascination in her earlier designs: pivoting parts and movable elements that transform both object and space.

Head. c. 1926
Gelatin silver print, 14⁹⁄₁₆ × 10⅝" (37 × 27 cm)
Given anonymously

The term *abstraction*, as it is generally applied to photography, is misleading. Completely indecipherable photographs are quite rare and usually quite boring. More common and more interesting are pictures such as this one, in which an unfamiliar configuration of form competes for our attention with what we are inclined to call the subject—in this case, the woman's face. That competition is the true subject of the picture.

Moholy-Nagy taught at the Bauhaus in Germany between 1920 and 1933. He began his career as a painter, but in the mid-1920s he came to regard photography as the universal visual language of the modern era because it was mechanical and impersonal and, therefore, objective—no matter how unexpected the results might be. Perhaps it was precisely the unpredictability of photography that he loved, because it unveiled fresh experiences.

In 1925 he published a picture book titled *Painting, Photography, Film*, which illustrated the many ways in which photography challenged old habits of seeing—by showing very distant or very small things, for example, or by looking up or down. The great majority of the illustrations were the work of scientists, journalists, amateurs, and illustrators—not of artists. The message was clear: photography had revolutionized modern vision without the aid of "art."

Theo van Doesburg | Dutch, 1883–1931
Cornelis van Eesteren | Dutch, 1897–1988

Contra-Construction Project.
1923
Project for a private house: axonometric drawing, gouache on paper, 22½ × 22½" (57.2 × 57.2 cm)
Edgar Kaufmann, Jr. Fund

Van Doesburg, a painter, writer, editor, and architect, was a founder and driving force behind the de Stijl movement, which was centered in the Netherlands in the late teens and early 1920s. Cornelis van Eesteren, an architect, joined the group in 1922. Artists and others contributing to van Doesburg's periodical, *De Stijl*, attempted to create a new harmonic order in the aftermath of World War I. They attempted to construct a utopian solidarity between art and life under the influence of Piet Mondrian's early theories of Neo-Plasticism, which proposed that the essence of the imagined and seen world could be conveyed only through a logical system of abstraction based on the line, square, and rectangle and the primary colors plus black and white.

According to van Doesburg, architecture had to be approached in an entirely new way, which would ultimately give rise to a universal aggregate of easel painting, sculpture, and architecture. As suggested by this axonometric drawing, one of a group rendered but never built, architecture, enlivened by flat colors, was to be economical and dynamic, with planar elements balanced asymmetrically around an open core. Such structures would allow the modern individual to achieve harmony with his or her surroundings.

Design for Smyrna Rug. 1925

Watercolor, gouache, and pencil on paper,
8⅛ × 6⁹⁄₁₆" (20.6 × 16.7 cm)
Gift of the designer

Albers was one of the most esteemed students of the weaving workshop at the Bauhaus, which she attended from 1920 to 1922 before teaching there herself until 1929. She often began her weaving projects with design sketches, such as this drawing for a rug. In this study, she explored the theme of horizontal-vertical construction using color, shape, proportion, and rhythm. The design reveals her admiration for the work of the painter Paul Klee, who also taught at the Bauhaus.

Of the weaving workshop she later observed: "Technique was acquired as it was needed and as a foundation for future attempts. Unburdened by any practical considerations, this play with materials produced amazing results, textiles striking in their novelty, their full-ness of color and texture, and possessing often a quite barbaric beauty."

Albers used textiles as her primary artistic medium for almost forty years, experimenting directly with innovative materials and creating prototypes for industrial production. She became as acclaimed for her activities as a teacher and writer on design and weaving as for her textile designs. Albers continued to explore relationships of color and line most markedly after 1963, when her interest shifted to printmaking.

Rayograph. 1922
Gelatin silver print, 9⅜ × 11¾" (23.9 × 30 cm)
Gift of James Thrall Soby

A photogram is a picture made on photographic paper without the aid of a camera. To make this one, Man Ray exposed the paper to light at least three times. Each time a different set of objects acted as a stencil: a pair of hands, a pair of heads kissing, and two darkroom trays, which seem almost to kiss each other with their corner spouts. With each exposure, the paper darkened where it was not masked.

"It is impossible to say which planes of the picture are to be interpreted as existing closer or deeper in space. The picture is a visual invention: an image without a real-life model to which we can compare it," notes curator John Szarkowski. A Surrealist might have said, instead, that it discloses a reality all the more precious because it is otherwise invisible.

Man Ray claimed to have invented the photogram not long after he emigrated from New York to Paris in 1921. Although, in fact, the practice had existed since the earliest days of photography, he was justified in the artistic sense, for in his hands the photogram was not a mechanical copy but an unpredictable pictorial adventure. He called his photograms "rayographs."

Paul Klee | German, born Switzerland. 1879–1940

Twittering Machine. 1922
Watercolor and pen and ink on oil transfer
drawing on paper, mounted on cardboard,
25¼ × 19" (63.8 × 48.1 cm)
Purchase

The "twittering" in the title doubtless
refers to the birds, while the "machine"
is suggested by the hand crank. The two
elements are, literally, a fusing of the
natural with the industrial world. Each
bird stands with beak open, poised as if
to announce the moment when the misty
cool blue of night gives way to the pink
glow of dawn. The scene evokes an
abbreviated pastoral—but the birds are
shackled to their perch, which is in turn
connected to the hand crank.

Upon closer inspection, however, an
uneasy sensation of looming menace
begins to manifest itself. Composed of a
wiry, nervous line, these creatures bear a
resemblance to birds only in their beaks
and feathered silhouettes; they appear
closer to deformations of nature. The
hand crank conjures up the idea that this
"machine" is a music box, where the
birds function as bait to lure victims to
the pit over which the machine hovers.
We can imagine the fiendish cacophony
made by the shrieking birds, their legs
drawn thin and taut as they strain against
the machine to which they are fused.

Klee's art, with its extraordinary
technical facility and expressive color,
draws comparisons to caricature,
children's art, and the automatic draw-
ing technique of the Surrealists. In
Twittering Machine, his affinity for the
contrasting sensibilities of humor and
monstrosity converges with formal
elements to create a work as intriguing
in its technical composition as it is in
its multiplicity of meanings.

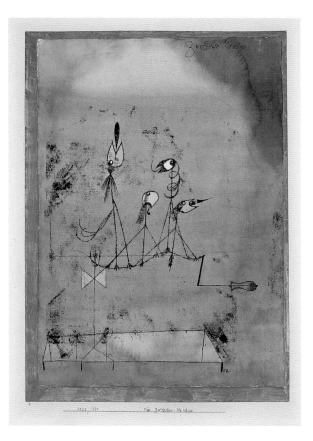

Wassily Chair. 1927–28
Chrome-plated tubular steel and canvas,
28⅛ × 30¼ × 27¾" (71.4 × 76.8 × 70.5 cm)
Manufacturer: attributed to Standard Möbel,
Germany
Gift of Herbert Bayer

While teaching at the Bauhaus, Breuer often rode a bicycle, a pastime that led him to what is perhaps the single most important innovation in furniture design in the twentieth century: the use of tubular steel. The tubular steel of his bicycle's handlebars was strong and lightweight, and lent itself to mass-production. Breuer reasoned that if it could be bent into handlebars, it could be bent into furniture forms.

The model for this chair is the traditional overstuffed club chair; yet all that remains is its mere outline, an elegant composition traced in gleaming steel. The canvas seat, back, and arms seem to float in space. The body of the sitter does not touch the steel framework. Breuer spoke of the chair as "my most extreme work . . . the least artistic, the most logical, the least 'cozy' and the most mechanical." What he might have added is that it was also his most influential work. An earlier version of this chair was designed by Breuer in 1925, and within a year, designers everywhere were experimenting with tubular steel, which would take furniture into a radically new direction. The chair became known as the "Wassily" after the painter Kandinsky, Breuer's friend and fellow Bauhaus instructor, who praised the design when it was first produced.

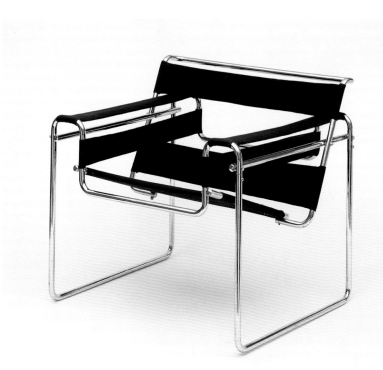

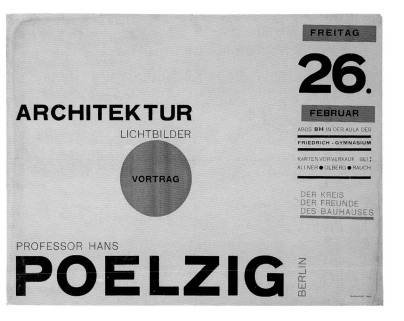

Architecture Slide Lecture, Professor Hans Poelzig (Architektur Lichtbilder Vortrag Professor Hans Poelzig).
1926
Poster: letterpress, 19⅛ × 25⅝" (48.6 × 65.1 cm)
Gift of Philip Johnson

This poster announcing a slide talk to be given by a guest lecturer, Hans Poelzig, an architect and professor, exemplifies what came to be known as the "new typography" of the 1920s: a strict use of sans-serif type, a single type treatment (here the exclusive use of uppercase letters), an underlying grid for the layout, and an asymmetrical composition. This revolutionary arrangement of type afforded a greater rationalism in the organization and communication of information.

As director of the new printing workshop established at the Bauhaus in 1925, Bayer had sought to overturn the typography styles prevailing in the early part of the twentieth century, in particular the overly decorative typefaces of the Art Nouveau and Gothic lettering commonly used in Germany. Building on what he had learned as a Bauhaus student under László Moholy-Nagy, Bayer promoted a new form of typography, a logical and universal means of graphic expression aimed, above all, at clarity. Bayer hoped to do what he called "a thorough alphabetical house-cleaning" in all publications issued by the Bauhaus. He and other devotees of the new style discarded the art of illustration, which they found subjective, in favor of unadorned typography, photography, and the modern technique of collage.

Dr. Mayer-Hermann. 1926
Oil and tempera on wood, 58¾ × 39"
(149.2 × 99.1 cm)
Gift of Philip Johnson

When Dix painted this picture of Wilhelm Mayer-Hermann, a prominent Berlin doctor, he was a favorite portraitist of Germany's cultural bohemia and its patrons. Yet his eye could be coolly unflattering. Dix had fought in World War I, a crucial formative experience: "It is necessary to see people in this unchained condition in order to know something about man," he said, and he came out of the war wanting "to depict things as they really are." Having experimented earlier with Expressionist and other modern styles, in 1920 he abandoned them for an approach and technique modeled on fifteenth- and sixteenth-century German art. In the process he was identified with what became known as the *Neue Sachlichkeit* (New Objectivity) movement, which advocated an unsentimental realism in the treatment of modern life.

Dix may portray the doctor exactingly, but the pose and the setting seem chosen to stress his rotundity. Everything is round: the face, the bags under the eyes, the double chin, the shoulders, the position of the arms, the tummy. A round lamp is affixed to the doctor's forehead, and the circular x-ray machine behind him reflects the room as rounded. Also behind him are a round clock-face and a round electrical socket. However precise the depiction, it verges on satire.

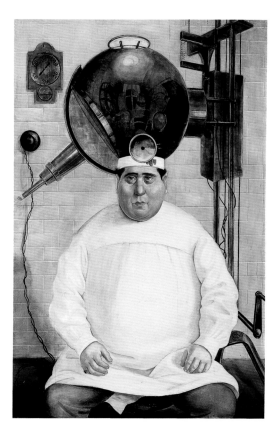

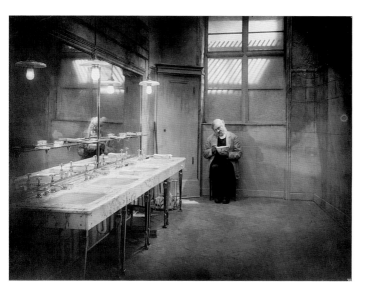

The Last Laugh (Der letzte Mann). 1924

35mm film, black and white, silent,
77 minutes (approx.)

Acquired from Universum-Film (UFA)

Emil Jannings

Murnau's silent film *The Last Laugh* tells the tragic story of a self-confident hotel porter, brilliantly portrayed by Jannings, who is demoted to lavatory attendant. The porter's entire identity is based upon his position and especially on his uniform, which symbolizes power and respectability to his lower-middle-class community of family and friends. The film's most shocking and brutal moment comes when the hotel manager unrelentingly strips the pleading porter of his uniform; it is as if the porter's skin were being ripped off. But this is only the beginning of his trials. The film's unexpected deus-ex-machina ending tries to whitewash the porter's suffering, but his tragic decline remains unforgettable.

Dispensing with the customary intertitles, and filming while moving the camera in extraordinarily inventive ways, Murnau and his cinematographer, Karl Freund, transformed the language of film. In shooting the opening sequence, the camera descended in the hotel's glass elevator and was then carried on a bicycle through the lobby. In addition, *The Last Laugh* succeeds in combining expressionist elements, such as extreme camera angles, distorted dream imagery, and disturbing light and shadow effects, with a complex psychological study of the main character in his fall from privilege.

Grand Illusion (La Grande Illusion). 1937

35mm film, black and white, sound, 93 minutes
Gift of Janus Films
Erich von Stroheim, Pierre Fresnay, Jean Gabin

Renoir's *Grand Illusion* is his best-known film and one of his most personal. It includes reminiscences of his World War I experience in the French Flying Corps and pays homage to an early mentor, Erich von Stroheim, who appears as the elegantly civilized commandant of a maximum-security German prison camp. The escape of two French officers is presented as an intellectual game that depends upon the cooperation of soldiers of different nations; the act of parting from the other prisoners, indicated by an emotional series of farewells, dominates the film.

While *Grand Illusion* may be considered the preeminent antiwar movie, it is far more inclusive and universal than that, posing questions about human existence that offer much food for thought. The film is a passionate statement of Renoir's belief in the commonality of all human beings, regardless of race, class, or nationality, which was to become a pervasive theme in his career. It is that passion, that emotional intensity, that makes Renoir's entire body of work so distinctive. Whether his films are directed at conjugal love, nature, the theater, the Paris that was, or prisoners of war, Renoir makes the viewer complicit in his obsessive devotion to his subjects.

Member of Parliament and First Deputy of the Democratic Party (Johannes Scheerer).
1928
Gelatin silver print, 11⅝ × 8¾" (29.6 × 22.3 cm)
Gift of the artist

Photographic works have often taken the form of an extended series of photographs presented in a book or album. Among the most ambitious projects in the history of photography was Sander's brilliant, unfinished *Citizens of the Twentieth Century*, a systematic survey of German society comprising portraits of representative types from all walks of life.

Here, the politician's cape sweeps upward in an unbroken line that extends to the tip of his umbrella—an appropriate attribute of a representative of the people—which he holds with proper German rectitude.

In 1929 Sander published a book of sixty photographs. Accompanying the book was an invitation to subscribe to the eventual publication of the entire body of portraits, which the photographer claimed to have made "without prejudice for or against any party, alignment, class, society." In 1934, the year after the Nazis came to power, they seized the book and destroyed its plates.

The General. 1926
35mm film, black and white, silent, 80 minutes (approx.)
Buster Keaton

Keaton, his ear to the cannon, always seems to be listening for the sound of silence. His "great stone face" is eloquent enough in repose, but even when his mouth opens it is often in mute amazement at the workings of a world beyond a sensible man's understanding. In many of Keaton's films, machinery has a will of its own, and humans tend to follow along without quite knowing why.

The General is considered Keaton's masterpiece, perhaps because its adventure, drawn from a Civil War incident, has a propulsive force that accommodates all the ingenious comic asides devised by Keaton and codirector Clyde Bruckman without losing its narrative momentum. While Keaton's character, a Confederate engineer, pursues a woman, this is above all the love story of a boy and his train, the ideal conveyance, companion, and mute friend.

Keaton's greatest collaborator was not an actor, director, or writer but the motion-picture camera, with which he perfected the physical beauty of silent comedy and expanded its emotive possibilities. His remarkable performances are rooted in his childhood experience as a comic acrobat, who was regularly tossed around the vaudeville stage by his performing parents. By the end of the 1920s, the infant tyrant—talking pictures—had silenced Keaton's genius.

The Blue Angel (Der blaue Engel). 1930

35mm film, black and white, sound, 109 minutes
Acquired from Twentieth Century-Fox
Marlene Dietrich

In *The Blue Angel,* which was shot in both English and German versions, Marlene Dietrich plays popular cabaret star Lola-Lola, who sings and performs at a dingy small-town cabaret, *Der blaue Engel.* Provocatively dressed, the siren lures a respected schoolmaster, Immanuel Rath (Emil Jannings), away from his orderly, secure, and predictable world into her bizarre demimonde of magicians, clowns, and other seedy performers. Fascinated and seduced by her charismatic aura, the aging teacher marries Lola-Lola and trades his teaching position for servitude to her. After years pass by, the humiliated Rath is ultimately broken by his wife's open affair with a young man.

Meticulously lit and embellished by extravagant costumes and props, Lola-Lola's stunning stage numbers leave the film's audience as attracted to her as is Rath, who can be seen as a stand-in for the viewer's own masochistic desire to fall victim to Dietrich's destructive charms, a relationship about which she sings: "Men flutter round me like moths around a flame/And if they get burned, well then I am not to blame."

Based upon Heinrich Mann's 1905 novel *Professor Unrat,* this was the first of seven films on which von Sternberg and Dietrich collaborated between 1930 and 1935. It catapulted the German actress to immediate stardom, turned her into one of cinema's most unforgettable femmes fatales, and paved her way to Hollywood.

Coronado Beach, California.

c. 1930
Gelatin silver print, $4\frac{3}{16} \times 2\frac{3}{8}$" (10.7 × 6 cm)
Lois and Bruce Zenkel Fund

Notice in this picture the way that the heel of the woman's right shoe meets the shadow of the toe of her left shoe, which itself barely touches the left edge of the image. It is a beautiful pictorial design, as satisfying to contemplate as it would have been difficult to predict. Recognizing and enjoying it does not keep us, the viewers, from sharing in the fun of the couple on Coronado Beach, or from wondering what became of them and their friend with the camera, who appears as a shadow in the foreground. Indeed, the special pleasure of the picture is that it gives us both things at once: the exuberant couple, who were there on the beach, and the design, which came into existence only when the photograph was made.

The picture is a snapshot, and it is unlikely that the untutored photographer who made it sought, or expected, the remarkable result or would have been able to repeat it. Nevertheless, exquisite accidents of this sort have played an important role in the evolution of the art of photography, by teaching ambitious photographers to appreciate and anticipate them.

Steamboat Willie. 1928
35mm film, black and white, sound, 8 minutes
Gift of the artist
Mickey Mouse

Disney's *Steamboat Willie* is a landmark in the history of animation. It was the first Mickey Mouse film released and the first cartoon with synchronized sound. It threw silent animation into obsolescence, and launched an empire. Previously, there had been little to distinguish Disney's cartoons from those of his competitors. He was facing bankruptcy when Alan Crosland's *The Jazz Singer*, with long sequences of song and dialogue, took America by storm in 1927. Sensing that sound movies meant big business, Disney decided to stake all on his talking mouse. The movie opened at the Colony Theater in New York on November 18, 1928, a date that would become known as Mickey's birthday.

Audiences were stunned by the vitality of the film's characters. Unhampered by the difficulties of using new equipment with live actors, Disney was able to fuse technology with handcrafts-manship, naturalism with abstraction, an ability that, over time, proved him to be a great artist. So strong was the audience demand for *Steamboat Willie* that two weeks after its premiere Disney re-released it at the largest theater in the world, the Roxy in New York City. Critics came to see in Mickey Mouse a blend of Charlie Chaplin in his championing of the underdog, Douglas Fairbanks in his rascally adventurous spirit, and Fred Astaire in his grace and freedom from gravity's laws.

Apples and Gable, Lake George. 1922

Gelatin silver print, 4⅝ × 3⁹⁄₁₆" (11.6 × 9.1 cm)
Given anonymously

This picture may be read as a symbol— of Eve's temptation in the Garden of Eden, perhaps, or of harmony between nature and mankind. Yet it presents itself as an immediate, sensual experience. You can almost feel yourself reaching up to the apples covered with dew and ripe for the picking.

Stieglitz was fifty-eight years old when he made this photograph at his family's estate on Lake George, New York, where he spent his summers from childhood to old age. At the turn of the century, it had seemed to him that photography, to become an art, must emulate the other arts and so restrain or disguise its earthbound realism. Later, in the 1920s, he helped to prove in his own photographs that engaging the stubborn specificity of his medium was itself a fine art.

Georgia O'Keeffe | American, 1887–1986

Lake George Window. 1929
Oil on canvas, 40 × 30" (101.6 × 76.2 cm)
Acquired through the Richard D. Brixey
Bequest

Lake George Window shows a detail of the farmhouse on Lake George, in northern New York State, where O'Keeffe and her husband, the photographer Alfred Stieglitz, spent many summers. The window's structure, flanking shutters, and ornamental pediment can all be recognized in many of Stieglitz's photographs of the house, but O'Keeffe concentrates them into an image that is simultaneously an essence of Americana and a near abstraction. Viewing the window straight on and close up, she evens and flattens its forms; framing it tightly to show only narrow bands of the wall around it, she almost erases its context. The composition becomes a geometric arrangement of rectangles, broken by the decorative curves and triangle of the pediment.

The clean straight lines and right angles of *Lake George Window* reflect a Precisionist side of O'Keeffe's work, which elsewhere entails a sensual response to organic shapes and a luxurious delicacy of color. But the austerity of the painting's flat planes and limited palette disguises a conceptual puzzle: the shutters announce a window but apparently hold a door as well, with rectangular panels below and a glass pane—the green rectangle—above. These features seem to offer a pun on transparency, while the green links the "interior" to the clapboard siding. O'Keeffe could see a universe of color in a petal; through this clear glass, though, she finds a dense opacity.

The Gold Rush. 1925
35mm film, black and white, silent,
66 minutes (approx.)
Charles Chaplin

The Gold Rush was the last movie
Chaplin made before the specter of the
"talkies" began to haunt him. Its bril-
liant set-pieces—Chaplin's character,
the Little Tramp, performing the dance
of the dinner rolls, Mack Swain hun-
grily mistaking the Tramp for a giant
chicken, Swain and the Tramp feasting
upon the latter's shoe, and the cabin
teetering on the edge of the abyss—are
among the highlights included in any
assemblage of the classic moments of
silent-film comedy. While all of Chap-
lin's silent features are somewhat
episodic, they are held together by his
sublime performances and inventive
imagination.

　　The Gold Rush is Chaplin's most
famous film, but it is atypical of his
work in several ways. Its snowy wastes
are far removed from his usual urban
and rural settings. Cannibalism and
murder seem peculiarly dark subjects for
a comedy made in the middle of the
twentieth century's most upbeat decade.
The film also ends strangely, with the
Tramp marrying and becoming a mil-
lionaire. *The Gold Rush* captured
Chaplin in a time of relative content-
ment—one of the century's great
geniuses at a moment of confidence in
his ability to control his destiny and his
art. Nevertheless, he returned in three
later films as unshackled and poverty-
stricken as ever.

Edward Hopper | American, 1882–1967

House by the Railroad. 1925
Oil on canvas, 24 × 29" (61 × 73.7 cm)
Given anonymously

Past and present meet in Hopper's picture: the railroad, symbol of modern industry, slices through a rural America embodied by a forlorn Victorian mansion. This once grand home stands tall but blank, isolated against the sky, and its verandah, designed for the leisurely contemplation of nature, now looks out on the steel tracks that cut across the foreground, obscuring both the horizon and the house's foundations in the earth. There is no human presence, but the window shades—some closed, others half open—suggest that the house may not be abandoned. Adding to the mystery and drama is the light flooding in from the left, reflecting an almost blinding white off part of the house but hiding the rest in deep shadow.

As a stubborn realist painter in a century of aesthetic innovation, Hopper had something in common with the building in *House by the Railroad*, old-fashioned in a changing world. But the color and the construction of Hopper's painting are precise and perduring, and his brand of realism has a haunting emotional quality. He finds the pathos in the slightly fussy grandiosity of this aging architecture, which, unlike the railroad tracks, isn't going anywhere.

Woman of the High Plains, Texas Panhandle. 1938

Gelatin silver print, 12 3/8 × 10" (31.5 × 25.4 cm)
Purchase

Seen from slightly below, the woman in this photograph has become a monumental figure, set against the open sky and the unforgiving earth. Her gesture is full of suffering but tells us nothing specific about her life or travails. Yet the sunlight falls on the palpable flesh of a person and on the worn cloth of her shift.

The picture exemplifies Lange's exceptional talent for making the leap from concrete fact to arching symbol without leaving reality behind. She made it for the Farm Security Administration, a government agency whose photographic unit was charged with documenting the plight of the rural poor in the 1930s. Her work created a lasting image of the Great Depression. It also deepened the link between the descriptive style of documentary photography and the ideal of social engagement, becoming a touchstone for photographers who felt that their work should not only record social conditions but try to persuade people to improve them.

Nanook of the North. 1922

35mm film, black and white and color tinted,
silent, 56 minutes (approx.)
Acquired from the artist; preserved with funding from the Celeste Bartos Film Preservation
Fund and the National Endowment for the Arts

In undertaking to shoot a narrative-based film that would demonstrate the character and majesty of the Inuit people of the Hudson Bay, Canada, Flaherty chose as his protagonist a revered hunter. He accompanied the man, named Nanook in the film, and his extended family for a year from igloo to igloo, from kill to kill. Technical ingenuity and the collaboration of the Inuit were key to the film's success. When an actual seal killing could not be filmed, for example, the Inuit dragged a carcass under the ice and re-created its fight for life.

An explorer who charted the Canadian tundra for mineral and railroad interests, Flaherty first brought a movie camera with him on an expedition of 1913 in order to make visual notes. Filmmaking soon became his primary focus. *Nanook of the North* was financed by a French furrier, Revillon Frères, and distributed by the French movie giant Pathé. America's top movie companies had turned it down, but the film became a huge critical and commercial success, and the progenitor of all documentaries to come. Unlike the typically detached travelogue, *Nanook of the North* blended realistic, stark, and beautifully composed images with a loose story line and a strong central character. Moreover, with its fictionalization of real-life events, and with Flaherty's romanticization of his subject, the film continues to raise issues about the objectivity of the documentary genre.

American Landscape. 1930

Oil on canvas, 24 × 31" (61 × 78.8 cm)
Gift of Abby Aldrich Rockefeller

A photographer as well as a painter, in 1927 Sheeler was hired by the Ford Motor Company's Philadelphia advertising firm to shoot at the Ford plant in River Rouge, Michigan, outside Detroit. *American Landscape* derives from one of his pictures there. Choosing a detail of the photograph, he copied it quite closely, but the different framing creates a clear pictorial structure of horizontal bands regularly divided by the verticals of the smokestack, the crane, and their reflections in the water.

The painting's clean, hard-edged look reflects Sheeler's belief in the need for a machine-age aesthetic. In the twentieth century, he argued, "Industry concerns the greatest numbers.... The Language of the Arts should be in keeping with the Spirit of the Age." Sheeler had studied Cubism and knew the machine-derived imagery of Marcel Duchamp and Francis Picabia, but wanted to "remove the method of painting ... from being a hindrance in seeing." He and other artists therefore devised a smooth, transparent, near-photographic style, called Precisionism, to address America's industrial scene.

Sheeler shows the Ford plant as literally impersonal—emptied of people. But for the tiny figure on the railroad tracks, there is no sign of the labor force, let alone of the complexities of labor relations in heavy industry. The plant also seems implausibly tidy—although its neatness did impress visitors of the period.

His Girl Friday. 1940
35mm film, black and white, sound, 92 minutes
Rosalind Russell, Cary Grant, Billy Gilbert, Clarence Kolb

Fast and furiously funny, *His Girl Friday* blends two formulas popular in Hollywood movies of the late 1930s: scathing satire on political corruption and romantic, screwball comedy. In the film, newspaper managing editor Walter Burns (Cary Grant) ruthlessly scoops the competition by hiding a fugitive with his top reporter and writer Hildy Johnson (Rosalind Russell), who is also his ex-wife. While Burns and Johnson clash romantically and professionally, it is a given that he and the newspaper cannot get along without her. Adding to the hilarity are Johnson's fiancé (Ralph Bellamy), whose courting is sweetly inept, and the governor's messenger (Billy Gilbert) whose rejection of bribery is the film's wickedest moment of truth.
 In *His Girl Friday* nothing is allowed to interfere with the dizzying pace set by the actors, who compete to interrupt each other. The talk crackles with wit; the overlapping dialogue of seasoned journalists and mayoral henchmen is smart, real, and mean. Like the stage play *The Front Page*, by Ben Hecht and Charles MacArthur, on which it is based, the film looks plain and feels tight, even claustrophobic, a feeling Hawks also achieved in his action movies, which test men's camaraderie and honor. The Hawksian comedy, here at its best, is a battle of the sexes, with roles reversed to allow for plenty of humiliation and triumph on both sides.

Duck Soup. 1933

35mm film, black and white, sound, 70 minutes
Acquired from Paramount Pictures
Groucho Marx

In its brilliant combination of silent-film pantomime and verbal fireworks, *Duck Soup* is the distillation of all the best elements to be found in the Marx brothers' comedies. In the film, under the leadership of Groucho's unforgettable prime minister Rufus T. Firefly, Freedonia goes to war with neighboring Sylvania for no reason whatsoever. Among the film's famous scenes are the moment when Groucho mistakes Harpo for his own mirror image, and the barrage of oranges and grapefruits that greet Margaret Dumont as she sings the national anthem in the film's riotous finale. *Duck Soup* is also filled with inimitable dialogue and the confusions of word play— double entendres, non sequiturs, and puns. In the film, the Marx brothers, with McCarey, present a world in which organized groups, political parties, nations, and social classes seem foolish, and court jesters sane.

Critics and moviegoers around the world regard *Duck Soup* as one of the Marx brothers' finest comedies. Yet the film was such a failure when it opened in 1933 that Paramount dropped its contract with the Marx brothers. With the American economy in collapse, Hitler on the rise in Germany, and democracy faltering at home and abroad, audiences were simply not in the mood for a political satire that held nothing sacred and left nothing unscathed. Though *Duck Soup* was provocative enough to have been banned in Italy by Mussolini, McCarey insisted that the only political message intended was "to kid dictators."

Swing Time. 1936

35mm film, black and white, sound, 103 minutes
Acquired from RKO
Fred Astaire, Ginger Rogers

There is no cinematic iconography more emblematic of the Hollywood musical than the dancing figures of Fred Astaire and Ginger Rogers. In Stevens's film, dance is used as an expression of romantic developments, a device typical of musicals of the 1930s. In the film, Lucky Garnett (Fred Astaire), a dancer and sometime gambler, arrives late for his marriage to Margaret Watson (Betty Furness) only to find that her furious father, the judge (Landers Stevens), has called off the wedding. The judge challenges Lucky to go to New York and earn $25,000 in order to win back Margaret's hand. In New York, Lucky meets Penny (Ginger Rogers), a dance instructor, who loses her job as a result of their chance encounter. The pair are, however, sent to audition at the Silver Sandal nightclub, where they eventually dazzle the patrons and are hired. When Margaret arrives in New York to tell Lucky she has met and fallen in love with another man, Lucky and Penny are free to pursue their relationship as lovers and dancers.

Swing Time marks the introduction of special effects into Astaire's dance routines. In the "Bojangles" number, Astaire dances with huge shadows of himself. To achieve this effect, the dance was filmed twice under different lighting conditions. The version with the strong shadow was then optically tripled in the lab and combined with the film made under standard lighting.

Odol. 1924
Oil on cardboard, 24 × 18" (60.9 × 45.6 cm)
Mary Sisler Bequest (by exchange) and purchase

Davis's pictures, he said, "have their originating impulse in the impact of the contemporary American environment." In the early decades of the twentieth century, that environment was boldly and innovatively modern—more so than its European counterparts, reined in by history, tradition, and an older physical infrastructure. Yet at the same time that French artists like Fernand Léger saw America as the model of modernity, they were themselves the innovators in art. So that Americans like Davis looked to the work of Europeans for ways to assimilate their experience of their own society.

Odol exemplifies this two-way traffic: Davis has applied Léger's monumentalizing simplicity and geometrized planes of color, as well as the Cubist interest in the logos and packaging of the new mass products, to a study of American commercial design. The bottle for a popular brand of mouthwash stands between a slanting transparent box and a display of green and white checkering. This anonymous space frames and accentuates the bottle's bold lettering and idiosyncratic shape, calculated both for convenience and for punchy distinctiveness in a marketplace fueled by modern advertising.

Davis's choice of product—an agent of personal hygiene—may slyly echo the modernist rhetoric of cleansing and washing away the debris of history. He had argued that the artwork "must be positive and direct"; positive and direct *Odol* is, and, "It Purifies."

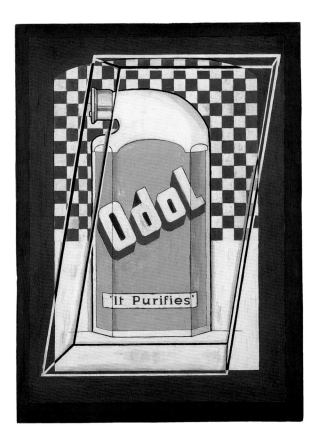

Sven Wingquist | Swedish, 1876–1959

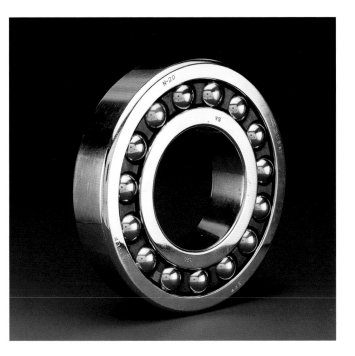

Self-Aligning Ball Bearing. 1907
Chrome-plated steel, 1¾ × 8½" (4.4 × 21.6 cm)
diam.
Manufacturer: SKF Industries, Inc., USA
Gift of the manufacturer

Both efficient and pleasing to the eye, the ball bearing can be seen as an emblem of the machine age—a name often used to define the 1920s and 1930s, when industrial designers as well as consumers took a new interest in the look and style of commercial products. Even parts of machines could be appreciated for their beauty, which came from the purity of abstract geometry. Good design was considered by modernists as essential to the elevation of society, and in 1934, this ball bearing was among the first works to enter The Museum of Modern Art's design collection.

Designed by Wingquist, this sturdy steel ball bearing is composed of a double layer of balls in a race. This type of bearing was structurally superior to the sliding bearing, which wastes energy in realigning machinery shafts thrown off during assembly-line manufacturing. The self-aligning quality of the ball bearing made it a superior product, since the bearing could absorb some shaft misalignment without lowering its endurance.

Mexico, D.F. 1925
Platinum print, 9⁹⁄₁₆ × 7³⁄₁₆" (24.3 × 18.3 cm)
Gift of the artist

It would be difficult to imagine a more austere nude. Framed in isolation against a dark, empty ground, the body has become a simple, symmetrical shape. This is as close as photography has come to achieving an image of ideal form, uncomplicated by earthly experience. And yet we see right away that it is a human body with volume and weight: an undeniably physical presence.

Weston's work of the 1920s, especially his nudes and photographs of vegetables and shells and other organic forms, set a new and demanding standard for modern photography. Nothing was left to chance in his pictures, no detail distracted from the power and clarity of the whole. At the same time, the photographs were unmistakably direct descriptions of particular things. The enormous influence of Weston's aesthetic rested on his ability to discover the abstract ideal within the perfectly real. The title refers to Mexico, Distrito Federal—Mexico City—where Weston was living when he made the picture.

Paimio Chair. 1931–32
Bent plywood, bent laminated birch, and solid birch, 26 × 24 × 34½" (66 × 61 × 87.6 cm)
Manufacturer: Oy Huonekalu-ja Rakennustyötehdas Ab, Finland
Gift of Edgar Kaufmann, Jr.

Admired as much for its sculptural presence as for its comfort, the Paimio Chair is a tour de force in bentwood that seems to test the limits of plywood manufacturing. The chair's framework consists of two closed loops of laminated wood, forming arms, legs, and floor runners, between which rides the seat—a thin sheet of plywood tightly bent at both top and bottom into sinuous scrolls, giving it greater resiliency. Inspired by Marcel Breuer's tubular-steel Wassily Chair of 1927–28, Aalto chose, instead, native birch for its natural feel and insulating properties, and developed a more organic form.

The Paimio Chair, the best-known piece of furniture designed by Aalto, is named for the town in southwestern Finland for which Aalto designed a tuberculosis sanatorium and all its furnishings. Used in the patients' lounge, the angle of the back of this armchair was intended to help sitters breathe more easily.

Aalto's bentwood furniture had a great influence on the American designers Charles and Ray Eames and the Finnish-born Eero Saarinen. In 1935 the Artek company was established in Finland to mass-produce and distribute wood furniture designed by Aalto and his wife, Aino. Most of their designs remain in production.

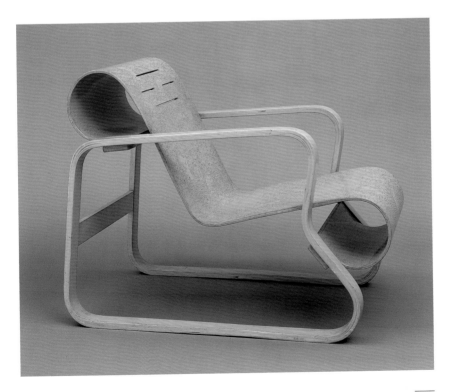

Le Corbusier (Charles-Édouard Jeanneret) | French, born Switzerland. 1887–1965
with Pierre Jeanneret | Swiss, 1896–1967

Villa Savoye, Poissy-sur-Seine, France. 1929–31

Model: wood, aluminum, and plastic,
14½ × 31½ × 34" (36.8 × 80 × 86.4 cm)
Modelmaker: Theodore Conrad (1932)
Purchase

The Villa Savoye, a weekend house outside Paris, is perhaps the finest example of Le Corbusier's early work. Le Corbusier, along with his cousin Pierre, planned the entire composition as a sequence of spatial effects. Arriving by automobile, the visitor drives underneath the house, circling around to the main entrance. From the entrance hall, he or she ascends the spiral stairs or the ramp to the main-level living area. The ramp continues from the central terrace to the upper-level sun deck. Sheltered by brightly colored wind screens, it is a perfect vantage point for savoring sunlight, fresh air, and nature.

In his famous book of 1923, *Vers une architecture (Towards a New Architecture)*, arguably the most influential architecture book of the twentieth century, Le Corbusier declared houses to be "machines for living in." Villa Savoye, a white rectilinear volume on a flat landscape, celebrates Le Corbusier's belief that ideal, universal forms, although rooted in the classical tradition, were appropriate to architecture for the machine age. The design incorporates Le Corbusier's "five points of architecture," which he believed to be indispensable elements: *pilotis* (reinforced-concrete columns), the free plan, the free facade, horizontal bands of windows, and the roof garden.

This model was included in The Museum of Modern Art's first architecture exhibition, in 1932, which documented the various trends that came to be known as the International Style.

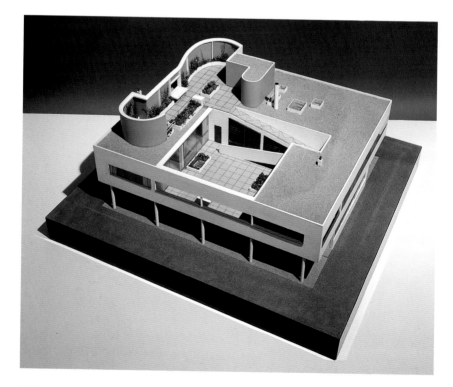

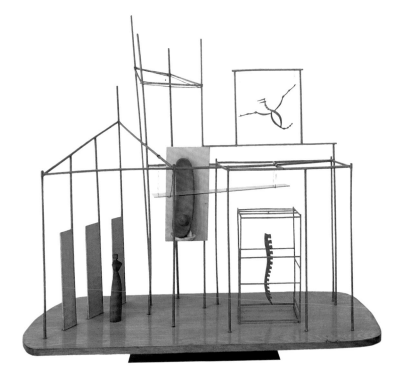

The Palace at 4 A.M. 1932–33
Construction in wood, glass, wire, and string,
25 × 28¼ × 15¾" (63.5 × 71.8 × 40 cm)
Purchase

An empty architecture of wood scaffolding, *The Palace at 4 A.M.* undoes conventional ideas of sculptural mass. Even early on, Giacometti once wrote, he had struggled to describe a "sharpness" that he saw in reality, "a kind of skeleton in space"; human bodies, he added, "were never for me a compact mass but like a transparent construction." Here he extends that vision to render a building as a haunting stage set.

Haunting and haunted, for the palace is lived in: isolated forms and figures inhabit its spaces. The enigma of their connection charges the air that is the sculpture's principal medium. Giacometti was a Surrealist when he made the *Palace*, and it has the requisite eerie mood. It was his practice, he said, to execute "sculptures that presented themselves to my mind entirely accomplished. I limited myself to reproducing them...without asking myself what they could mean."

Yet Giacometti did relate *The Palace at 4 A.M.* to a period he had spent with a woman who enchanted him, and with whom he had built "a fantastic palace at night,...a very fragile palace of matchsticks." He did not know why he had included the spinal column or the skeletal bird, though he associated both with her. As for "the red object in front of the board; I identify it with myself."

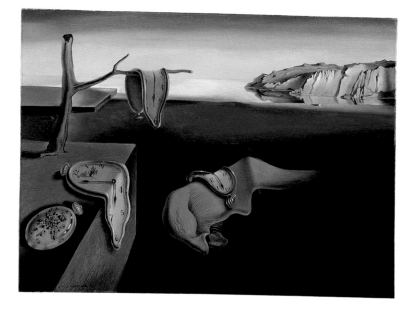

The Persistence of Memory.

1931
Oil on canvas, 9½ × 13" (24.1 × 33 cm)
Given anonymously

The Persistence of Memory is aptly named, for the scene is indelibly memorable. Hard objects become inexplicably limp in this bleak and infinite dreamscape, while metal attracts ants like rotting flesh. Mastering what he called "the usual paralyzing tricks of eye-fooling," Dalí painted with what he called "the most imperialist fury of precision," but only, he said, "to systematize confusion and thus to help discredit completely the world of reality." It is the classical Surrealist ambition, yet some literal reality is included too: the distant golden cliffs are the coast of Catalonia, Dalí's home.

Those limp watches are as soft as overripe cheese—indeed "the camembert of time," in Dalí's phrase. Here time must lose all meaning. Permanence goes with it: ants, a common theme in Dalí's work, represent decay, particularly when they attack a gold watch, and become grotesquely organic. The monstrous fleshy creature draped across the painting's center is at once alien and familiar: an approximation of Dalí's own face in profile, its long eyelashes seem disturbingly insectlike or even sexual, as does what may or may not be a tongue oozing from its nose like a fat snail.

The year before this picture was painted, Dalí formulated his "paranoiac-critical method," cultivating self-induced psychotic hallucinations in order to create art. "The difference between a madman and me," he said, "is that I am not mad."

Meret Oppenheim | Swiss, born Germany. 1913–1985

Object (Le Déjeuner en fourrure). 1936
Fur-covered cup, saucer, and spoon; cup 4⅜" (10.9 cm) diam.; saucer, 9⅜" (23.7 cm) diam.; spoon 8" (20.2 cm) long; overall height 2⅞" (7.3 cm)
Purchase

Oppenheim's fur-lined teacup is perhaps the single most notorious Surrealist object. Its subtle perversity was inspired by a conversation between Oppenheim, Pablo Picasso, and the photographer Dora Maar at a Paris café: admiring Oppenheim's fur-trimmed bracelets, Picasso remarked that one could cover just about anything with fur. "Even this cup and saucer," Oppenheim replied.

In the 1930s, many Surrealist artists were arranging found objects in bizarre combinations that challenged reason and summoned unconscious and poetic associations. *Object*—titled *Le Déjeuner en fourrure* (The lunch in fur) by the Surrealist leader André Breton—is a cup and saucer that was purchased at a Paris department store and lined with the pelt of a Chinese gazelle. The work takes advantage of differences in the varieties of sensual pleasure: fur may delight the touch but it repels the tongue. And a cup and spoon, of course, are made to be put in the mouth.

A small concave object covered with fur, *Object* may also have a sexual connotation and politics: working in a male-dominated art world, perhaps Oppenheim was mocking the prevailing "masculinity" of sculpture, which conventionally adopts a hard substance and vertical orientation that can be seen as almost absurdly self-referential. Chic, wry, and simultaneously attractive and disturbing, *Object* is shrewdly and quietly aggressive.

Seville. 1933
Gelatin silver print, 9 3/16 × 13 9/16" (23.4 × 34.5 cm)
Gift of the artist

This picture describes a group of children both as living individuals and as shapes deployed against the jagged forms of the crumbling walls, and its vitality arises from the reciprocal relationship between these two ways of looking at the world. In fact, only two of the boys are in motion, but the vitality of graphic pattern infuses the whole picture with the antic energy of youth. Cartier-Bresson coined a term for the instant at which the interplay of human meaning and photographic form can yield such a surprise. He called it "the decisive moment."

Later, as a photojournalist after World War II, Cartier-Bresson earned the envy of his peers for his ability to seem invisible—to capture an event without disturbing it by his presence. In many of his early photographs, however, his subjects were aware of and even performed for him, as the boy at the upper right does here. It is as if the unpredictable theater of the street had been choreographed for the photographer alone.

This photograph has sometimes been misinterpreted as a document of the Spanish Civil War, but it was made three years before that war began. However, its social dimension—the photographer's identification with the poor and disenfranchised—is quite real.

Penny Picture Display, Savannah, Georgia. 1936

Gelatin silver print, 8⅝ × 6¹⁵⁄₁₆" (21.9 × 17.6 cm)
Gift of Willard Van Dyke

In the Savannah photographer's window there are fifteen blocks of fifteen pictures each, for a total of 225 portraits, less the ones hidden by the letters. Most of the sitters appear at least twice, but altogether there are more than one hundred different men, women, and children: a community.

Evans explored the United States of the 1930s—its people, its architecture, its cultural symbols (including photographs)—with the disinterested eye of an archaeologist studying an ancient civilization. *Penny Picture Display* might be interpreted as a celebration of democracy or as a condemnation of conformity. Evans takes no side.

The photograph is very much a modern picture—crisp, planar, and resolutely self-contained. But instead of reconfirming a timeless ideal, as artistically ambitious American photographers before Evans generally had aimed to do, it engages a contemporary particular, rooted in history. And it announces Evans's allegiance to the plainspoken vernacular of ordinary photographers, such as the Savannah portraitist who made the pictures in the window.

Arched Drinker. c. 1939–42
Watercolor and pencil on cardboard, 14 × 13¾"
(35.6 × 35 cm) (irreg.)
Gift of Mr. and Mrs. Henry R. Kravis

The articulated silhouette and fluid monochrome wash of *Arched Drinker* embody the idiosyncratic poetic vision and unselfconscious technique of this self-taught artist. Traylor's single figures, or more complex scenes in which he weaves figures, architecture, and other motifs into intricate patterns, show an acute observation, a visionary imagination, and a deftness of execution that are altogether astounding. Whereas some of Traylor's motifs may appear somewhat folkloric, others translate into an exuberant expression and sophisticated invention comparable to the more studied naïveté found in the works of Paul Klee or Jean Dubuffet, for example. These mainstream artists and others have long been inspired by the freshness and authenticity of expression of artists such as Traylor.

Born into slavery in Benton, Alabama, Traylor practiced his art only during a three-year period, after the age of eighty-five. His initial mediums were watercolor and pencil, later expanded to include charcoal and poster paint; his supports were pieces of discarded cardboard. Traylor's subject matter was the street life of downtown Montgomery, observed from his makeshift sidewalk studio (a crate and a table), where he produced between 1,200 and 1,500 whimsical drawings.

Gibraltar. 1936
Construction of lignum vitae, walnut, steel
rods, and painted wood, 51⅞ × 24¼ × 11⅜"
(131.7 × 61.3 × 28.7 cm)
Gift of the artist

Although *Gibraltar* is abstract, the con-
nection is easily made between its
base—a weighty lump of lignum vitae
(a tropical hardwood)—and the Mediter-
ranean rock that gives the work its name.
This mass of wood is rough and solid,
and seemingly unshaped. More delicate,
and more clearly marked by human arti-
fice, are the work's sloping plane of wal-
nut, its painted wood ball, and its two
steel rods balancing a crescent and a
sphere, respectively. *Gibraltar* recalls the
biomorphic forms in Surrealist art, par-
ticularly that of Joan Miró, a strong

influence on Calder. But there is also a
poetic whimsy that is Calder's alone.

The sculpture is contradictory in its
qualities. The rods are thin and linear,
and express an upward, airborne drive
and eccentric balance; the lignum vitae
is heavy, earth-hugging, solid. The sur-
faces, too, show various materials being
variously treated, implying methods
from machine-making to hand-polishing
to leaving well enough alone. These dis-
junctions have a good-humored wit,
which does not disguise the work's
grace. Calder once said that "the under-
lying sense of form" in his work was
"the system of the Universe," and
Gibraltar, with its sun, moon, and heavy
earth, is a solar system in miniature—a
system revealed as a fine-tuned balance
of opposites.

Pierre Bonnard | French, 1867–1947

Nude in Bathroom. 1932
Oil on canvas, 47⅝ × 46½" (121 × 118.1 cm)
Florene May Schoenborn Bequest

The scene is the bathroom of Bonnard's own home—Le Bosquet, his house near Cannes—and the woman naked at her *toilette* is the artist's wife, Marthe. The choice of both space and figure, then, is intensely personal, and the work maintains a sense of privacy and even of confinement. Although Marthe appears in many of Bonnard's paintings, seldom is her face fully visible: here she bows her head low. The window is shuttered, sealing off the outside world. A painting in which the whites of bath and stool are brighter and more vibrant than the barred panel of daylight suggests claustrophobia as well as intimacy, even though Bonnard's extraordinary painted color implies the richness of the domestic and interior life.

Bonnard's composition is asymmetrical, darker on the right than on the left, and its human subject is off-center and out of focus. His technique and use of color emerge from Impressionism, but advance the independence of paint quality and surface from form. Indeed the work's intensity as a field of color may outweigh its descriptiveness: overlapping planes, indistinct patterns, balanced areas of coolness and warmth, and close-valued hues create a blurring of edges and textures, a shimmer. Behind the curving foreground forms, systematic grids of rectangles and lozenges create a structure of eminent logic.

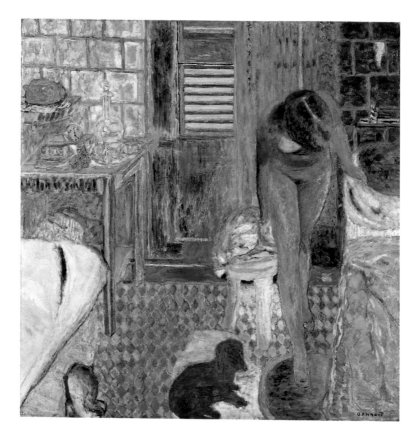

Pablo Picasso | Spanish, 1881–1973

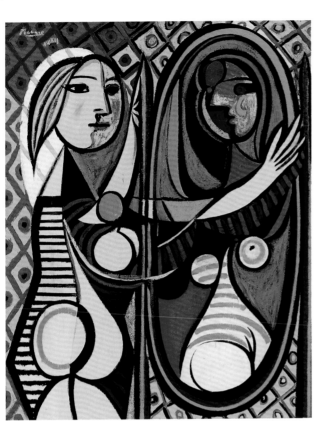

Girl Before a Mirror. 1932
Oil on canvas, 64 × 51 ¼" (162.3 × 130.2 cm)
Gift of Mrs. Simon Guggenheim

Girl Before a Mirror shows Picasso's young mistress Marie-Thérèse Walter, one of his favorite subjects in the early 1930s. Her white-haloed profile, rendered in a smooth lavender pink, appears serene. But it merges with a more roughly painted, frontal view of her face—a crescent, like the moon, yet intensely yellow, like the sun, and "made up" with a gilding of rouge, lipstick, and green eye-shadow. Perhaps the painting suggests both Walter's day-self and her night-self, both her tranquillity and her vitality, but also the transition from an innocent girl to a worldly woman aware of her own sexuality.

It is also a complex variant on the traditional Vanity—the image of a woman confronting her mortality in a mirror, which reflects her as a death's head. On the right, the mirror reflection suggests a supernatural x-ray of the girl's soul, her future, her fate. Her face is darkened, her eyes are round and hollow, and her intensely feminine body is twisted and contorted. She seems older and more anxious. The girl reaches out to the reflection, as if trying to unite her different "selves." The diamond-patterned wallpaper recalls the costume of the Harlequin, the comic character from the commedia dell'arte with whom Picasso often identified himself—here a silent witness to the girl's psychic and physical transformations.

Departure. 1932–33
Oil on canvas; triptych, center panel, 7' 3/4" × 45 3/8"
(215.3 × 115.2 cm), side panels, each 7' 3/4" × 39 1/4"
(215.3 × 99.7 cm)
Given anonymously (by exchange)

In the right panel of *Departure*, Beck-mann once said, "You can see yourself trying to find your way in the darkness, lighting the hall and staircase with a miserable lamp, dragging along tied to you, as part of yourself, the corpse of your memories." The triptych is full of personal meaning, and also of mysteries. The often-appearing fish, for example, are ancient symbols of redemption, but may also connote sexuality. Perhaps the woman under torture gazes prophetically into a crystal ball—but what she seems to see is the daily paper. Men's faces are hidden: averted in the side panels, masked in the center. Is it the same couple whose fate each image tracks?

Beckmann's accounts of *Departure* are fragmentary, and, in any case, he believed that "if people cannot understand it of their own accord, ... there is no sense in showing it." But the work, however elusive in its details, is clear overall: painted at a dark time in Germany (that of Hitler's rise to power), it tells of harsh burdens and sadistic brutalities through which the human spirit, regally crowned, may somehow sail in serenity. Beckmann called the center panel "The Homecoming," and said of it, "The Queen carries the greatest treasure—Freedom—as her child in her lap. Freedom is the one thing that matters—it is the departure, the new start."

Pablo Picasso | Spanish, 1881–1973

Minotauromachy. 1935
Etching and engraving, plate: 19½ × 27⅜"
(49.6 × 69.6 cm)
Publisher: the artist. Edition: approx. 55
Abby Aldrich Rockefeller Fund

This provocative scene, full of symbolic content, is difficult but not impossible to interpret. Several actions take place in a narrow, confined space. The main protagonists—a young girl with a candle and a bouquet of flowers, and a huge Minotaur, a mythological creature with a human body and a bull's head—appear frozen in their confrontation. Between them a wounded female bullfighter is flung across a lacerated horse that snarls with teeth bared. Above, two girls with doves, symbols of peace, peer out from a window, while a bearded man appears on a ladder at the left. A tiny sailboat can be glimpsed on the far horizon.

Executed when Picasso's personal life was in turmoil and he had ceased to paint, *Minotauromachy* presents a deeply private mythology. Not only was his marriage to Olga Khokhlova troubled at the time, but he was also ambivalent about the pregnancy of his young mistress, Marie-Thérèse Walter, whose facial features are similar to those of the female figures. The paradoxical Minotaur, the bull-man, was a frequent theme for the artist during this time.

This disturbing and violent representation is also prophetic of the Spanish Civil War, which began in 1936, a year after this print was executed. *Minotauromachy* served as a visual source for *Guernica*, Picasso's famous mural of 1937 about that conflict, which contains some of the same imagery that is seen here.

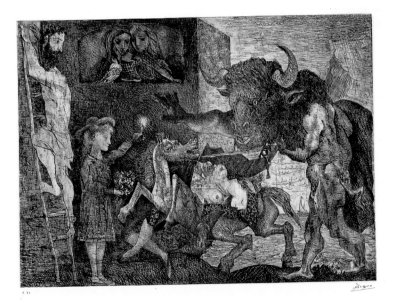

Kiki Singing in a Montparnasse Cabaret. 1933

Gelatin silver print, 15⅝ × 11¾" (39.7 × 29.8 cm)
David H. McAlpin Fund

Kiki was celebrated among avant-garde artists, who haunted the bars and cabarets of Montparnasse, her Paris neighborhood, in the 1920s. She is pictured here in the full glow of her own professional persona, as an authentic descendant of the ribald heroines of the fifteenth-century poet François Villon. The accordionist, who gazes at her with awe and affection, is unidentified.

Brassaï's photographs are the last great expression of a tradition of picturing Parisian popular culture that included such masters as Edgar Degas and Henri de Toulouse-Lautrec. By the time this picture was made, that tradition had become tinged with nostalgia for the past, and was soon to be obliterated by the engines of modernity and the business of tourism.

Brassaï's blunt, no-nonsense pictures, such as this one, in which the subject is often fixed by the unapologetic scrutiny of a flash, soon became, and remain, a model of photography's fierce curiosity and proof of the mystery of unvarnished photographic fact—a foundation of what came to be called the documentary tradition.

The Street. 1933
Oil on canvas, 6' 4¾" × 7' 10½" (195 × 240 cm)
James Thrall Soby Bequest

Though set in a real place—the rue Bourbon-le-Château, Paris—*The Street* has the intensity of a dream. The figures in this strange frozen dance are precisely placed in a shallow, friezelike line, yet except for the struggling couple on the left, they don't interact at all. The toque-wearing chef isn't even human— he is a pavement sign for a restaurant— but he stands no more stiffly than the other characters, who, stylized and solid, seem less to walk than to pose.

Part of the work's tension comes from the diversity in the traditions it fuses. Its receding architectural perspective emulates Renaissance geometry, for Balthus much admired Quattrocento artists, particularly Piero della Francesca. But another, quite different influence links him to his Surrealist peers: long after painting *The Street*, he would still say that he had never stopped seeing things as he saw them in childhood. He well knew children's books such as Lewis Carroll's "Alice" stories, with their illustrations by John Tenniel, and, indeed, the girl caught in the tussle has been said to be Alice herself; the youth in the center resembles Tweedledum or Tweedledee; and the man with the plank could be Carroll's carpenter, without his walrus companion—though his simultaneous resemblance to a figure in Piero's *Discovery and Proving of the True Cross*, at Arezzo (c. 1455), suggests a different symbolic register.

Fish. 1930
Gray marble, 21 × 71 × 5½" (53.3 × 180.3 ×
14 cm), on three-part pedestal of marble 5⅛"
(13 cm) high, and two limestone cylinders 13"
(33 cm) high and 11" (27.9 cm) high × 32⅛"
(81.5 cm) diam. at widest point
Acquired through the Lillie P. Bliss Bequest

Less an image of a fish than an embodi-
ment of the idea of one, *Fish* conjures
the animal's liquid course by simplifying
details like fin and scale, tail and head,
into smooth streamline. ("Simplicity,"
Brancusi believed, "is not an end in art,
but we usually arrive at simplicity as we
approach the true sense of things.") The
material too contributes: a blue-gray
marble veined with flecks of flowing white,
its surface intimates both movement
through water and moving water itself.
Brancusi was fascinated by animals,
and believed in the primacy of animal
consciousness. In reducing animals
to elemental shapes, he felt he was
approaching the essence of nature. Also,

like a number of European artists of his
period, he was excited by art from out-
side the classical tradition so influential
in Western aesthetics. The art of Africa,
Native America, and the Pacific, and
also the art of prehistory (including
Cycladic sculpture, a particular influ-
ence on Brancusi), took imaginative lib-
erties with human and animal bodies,
alternately exaggerating, attenuating,
and eliminating their features. These
examples liberated Brancusi and others
in their treatment of form. By the time
he made *Fish*, in fact, Brancusi seems
almost to have left form behind alto-
gether, for something more incorporeal:
what he described as the fish's "speed,
its floating, flashing body seen through
the water ... the flash of its spirit."

Gaston Lachaise | American, born France. 1882–1935

Standing Woman. 1932
Bronze, 7' 4" × 41⅛" × 19⅛" (223.6 ×
104.3 × 48.4 cm)
Mrs. Simon Guggenheim Fund

"At twenty, in Paris," Lachaise wrote in
1928, "I met a young American person
who immediately became the primary
inspiration which awakened my vision
and the leading influence that has
directed my forces." The young Ameri-
can in question, Isabel Nagle, would
eventually become Lachaise's wife, and
Standing Woman and other works are
certainly inspired by her. In Isabel,
Lachaise seems to have seen greater
forces and principles of human life: "You
are," he once told her, "the Goddess I
am searching to express in all things."

Like many twentieth-century
sculptors, Lachaise wanted to escape the
classical tradition, and some of his
smaller, more private works distend and
exaggerate parts of the female body in
ways that recall the swollen forms of
Paleolithic fertility figures. The unshak-
able calm and dignity of *Standing
Woman* are closer to classical art, but
Lachaise stretches classical proportion
with muscular rounding and augmented
mass and height. For all their weight,
the figure's breasts and hips, arms and
thighs balance evenly around her slender
waist. Her easy pose, commanding
uprightness, and direct gaze give her a
regal force. *Standing Woman* embodies
Lachaise's stated ambition for his art: to
express "the glorification of the human
being, of the human body, of the human
spirit, with all that there is of daring, of
magnificence, of significance."

Julio González | Spanish, 1876–1942

Woman Combing Her Hair. 1936
Wrought iron, 52 × 23½ × 24⅝" (132.1 × 59.7 × 62.4 cm)
Mrs. Simon Guggenheim Fund

"To draw in space": that, for González, was the exciting possibility in the art of his time. A painter and draftsman as well as a sculptor, González realized that by cutting, rolling, and bending metal, or fusing found metal pieces into an assemblage, he could draw images not on paper but in air, his instrument not a pencil but a welding torch. He often worked in iron, a tough, unyielding material utterly lacking in the fine sinuosity of the precious metals. The stiff spine, shallow curves, and spiky, spearlike lines and points of *Woman Combing Her Hair* seem integral to the medium itself, but the work tempers its austerity with a subtle eroticism.

González himself associated iron with weaponry and with engineering, but wanted to direct it elsewhere. "It is high time," he wrote, "that this metal cease to be a murderer and the simple instrument of an overly mechanical science. Today, the door is opened wide to this material to be . . . forged and hammered by the peaceful hands of artists." Decorative ironwork is a Spanish tradition, and González learned it as a young man, but considered it only a craft until, in 1928, he began to advise Pablo Picasso on making iron sculpture—an experience that inspired him to become a sculptor himself.

Aristide Maillol | French, 1861–1944

The River. 1938–43
Lead (cast 1948), 53¾" × 7' 6" × 66" (136.5 × 228.6 × 167.7 cm), on lead base designed by the artist, 9¾ × 67 × 27¾" (24.8 × 170.1 × 70.4 cm)
Mrs. Simon Guggenheim Fund

The daring instability and torsion of *The River* are rare in Maillol's sculpture. Instead of trying to emulate the dynamism of twentieth-century life, as did so many artists of his time, Maillol usually sought an art of serenity and stillness, of classical nobility and simplicity. As late as 1937, in fact, he remarked, "For my taste, there should be as little movement as possible in sculpture." Yet within a year or so afterward he had conceived *The River*, a work in which the movement is almost reckless.

Commissioned to create a monument to a notable pacifist, the French writer Henri Barbusse, Maillol conceived the sculpture as a work on the theme of war: a woman stabbed in the back, and falling. When the commission fell through, he transformed the idea into *The River*. In a departure from the usual conventions of monumental sculpture, the figure lies low to the ground and rests apparently precariously on the pedestal, even hanging below its edge. Twisting and turning, her raised arms suggesting the pressure of some powerful current, this woman is the personification of moving water.

La Miniatura, Mrs. George Madison Millard House, Pasadena, California. 1923

Perspective: colored pencil and pencil on gampi paper, 20⁹⁄₁₆ × 19¹¹⁄₁₆" (52.2 × 50 cm)
Gift of Mr. and Mrs. Walter Hochschild

La Miniatura, the Millard House in Pasadena, is the earliest in a series known as the Textile Block houses, designed by Wright in the 1920s; all are located in southern California. This color rendering depicts the Millard House in its lush surroundings. The house is constructed of a combination of plain-faced and ornamental concrete blocks, which were cast on the site from molds designed by Wright. The square blocks, with perforated, glass-filled apertures, form a continuous interior and exterior fabric. The relatively small scale of the blocks allows for a design that closely follows the contours of the landscape.

In his autobiography, Wright wrote: "The concrete block? The cheapest (and ugliest) thing in the building world. . . . Why not see what could be done with that gutter-rat?" In his Textile Block houses, Wright attempted to introduce a flexible building system, marrying the merits of standardized machine production to the innovative, creative vision of the artist. While the block system was intended to be an efficient, low-cost method of building that incorporated ornament, it proved to be time consuming and more expensive than traditional construction.

Frank Lloyd Wright | American, 1867–1959

Fallingwater, Edgar J. Kaufmann House, Mill Run, Pennsylvania. 1934–37

Model: acrylic, wood, metal, expanded polystyrene, and paint, 40½ × 71½ × 47⅝" (102.8 × 181.6 × 121 cm)

Modelmakers: Paul Bonfilio with Joseph Zelvin, Larry List, and Edith Randel (1984)

Best Products Company Architecture Fund

From the moment Fallingwater was built, critics recognized this private retreat for Edgar J. Kaufmann, a Pittsburgh department store magnate, as a masterpiece of modern architecture. It is one of Wright's boldest creations, integrating architecture and nature. Situated atop a waterfall in a wooded ravine in western Pennsylvania, the house is anchored to a large boulder, which serves in the interior as the central hearth and the symbolic core of domestic life. From here the house extends vertically and horizontally in rhythmic patterns out into the landscape. Made of rough-cut stone from a nearby quarry, the walls and chimney complement the natural strata of the site.

As shown in The Museum of Modern Art's model, sleek cantilevered balconies of reinforced concrete, made possible by modern engineering, seem to float effortlessly, if precariously, over the water. Their shape echoes the stepped rock ledges in the stream. An outdoor staircase suspended from below the living room leads to the plunge pool below.

Fallingwater embodies Wright's deeply held values about the underlying unity of humans and nature, which is reflected in his selection of building materials. As a great work of art, Fallingwater transcends its function as a house to meet a client's needs and symbolizes an American democratic ideal: to be able to live a free life in nature.

Collective Suicide. 1936

Enamel on wood with applied sections, 49" × 6'
(124.5 × 182.9 cm)
Gift of Dr. Gregory Zilboorg

Collective Suicide is an apocalyptic vision of the Spanish conquest of Mexico, when many of the indigenous inhabitants killed themselves rather than submit to slavery. Siqueiros shows armored Spanish troops advancing on horseback, a bowed captive staggering before them in chains. The broken statue of a god demonstrates the ruin of the indigenous culture. Chichimec indians, separated from their tormentors by a churning pit, slaughter their own children, hang themselves, stab themselves with spears, or hurl themselves from cliffs. Mountainous forms create a backdrop crowned with swirling peaks, like fire or blood.

Siqueiros, one of the Mexican mural painters of the 1920s and 1930s, advocated what he called "a monumental, heroic, and public art." An activist and propagandist for social reform, he was politically minded even in his choices of materials and formats: rejecting what he called "bourgeois easel art," he used commercial and industrial paints and methods. *Collective Suicide* is one of his relatively few easel paintings, but here, too, he used spray guns and stencils for the figures, and strategically let the paints—commercial enamels—flow together on the canvas. *Collective Suicide* is both a memorial to the doomed pre-Hispanic cultures of the Americas and a rallying cry against contemporary totalitarian regimes.

Diego Rivera | Mexican, 1886–1957

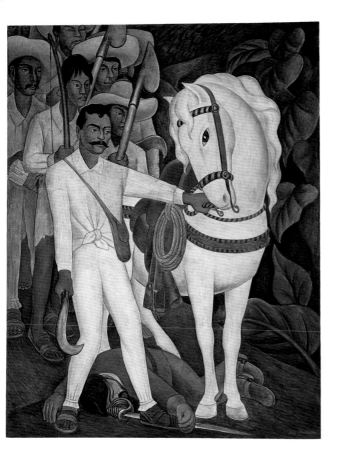

Agrarian Leader Zapata. 1931
Fresco, 7' 9¾" × 6' 2" (238.1 × 188 cm)
Abby Aldrich Rockefeller Fund

In the 1920s, after the end of the Mexican Revolution, Rivera was among the painters who developed an art of public murals to celebrate Mexico's indigenous culture, and to teach the nation's people about both their own history and the new government's dreams for their future. Rivera had lived in Paris, and knew modernist painting well. He had also visited Italy to study Renaissance frescoes, since Mexican artists and politicians recognized the value of this mural form as a medium of education and inspiration. Returning to Mexico in 1921, Rivera began a remarkable series of frescoes—paintings made on moist plaster, so that the pigments fuse with the plaster as it dries.

Agrarian Leader Zapata, which Rivera created for his exhibition at The Museum of Modern Art in 1931, replicates part of a fresco he had painted in 1930 in the Palace of Cortés, Cuernavaca. Emiliano Zapata had been a hero of the Mexican Revolution. (He was killed in 1919, a victim of the Revolution's internal struggles.) Rivera shows him wearing the local costume of the Cuernavaca region, and carrying a sugarcane-cutter's machete. His followers, too, bear the rough tools of peasant soldiers. Yet the rider sent to oppose this ragged army lies in the dirt, and Zapata has seized his horse—whose shape Rivera borrowed from a work by the fifteenth-century Florentine painter Paolo Uccello.

The Wind. 1928
35mm film, black and white, silent,
73 minutes (approx.)
Acquired from MGM
Lillian Gish

The Wind is the last surviving silent picture by Seastrom, the great Swedish director who worked in Hollywood in the 1920s. It is also the last silent film of Lillian Gish, the mute art's greatest actress. In *The Wind*, natural forces destroy a delicate young woman, played by Gish, who is isolated in a desert cabin struck by sand storms. Through both cinematography and Gish's performance, wind represents all the cosmic forces that have ever borne down on a vulnerable humanity. When faced with a brutal male attacker, Gish's seemingly fragile and innocent character summons a ferocious strength and resilience.

What makes *The Wind* such an eloquent coda to its dying medium is Seastrom's and Gish's distillation of their art forms to the simplest, most elemental form: there are no frills. Seastrom was always at his best as a visual poet of natural forces impinging on human drama; in his films, natural forces convey drama and control human destiny. Gish, superficially fragile and innocent, could plumb the depths of her steely soul and find the will to prevail. The genius of both Seastrom and Gish comes to a climactic confluence in *The Wind*. Gish is Everywoman, subject to the most basic male brutality and yet freshly open to the possibility of romance. As a result, the film offers a quintessential cinematic moment of the rarest and most transcendentally pure art. Seastrom made nine films in the United States after accepting a 1923 offer from Hollywood, and although the silent film was on its way out, he left, in *The Wind*, one last enduring monument of the genre.

New York. 1938
Gelatin silver print, 5⅞ × 7⅜" (14.9 × 18.7 cm)
Grace M. Mayer Collection

Levitt has devoted a lifetime of creative energy to photographing the poetry and drama of life on the streets of New York. This picture is from a series made in the late 1930s and early 1940s, when Levitt was in her twenties. It conveys the unrestrained emotions in the spontaneous gestures of children, who were often her subjects. The world-weary boy in the suit jacket in this picture was described by Levitt's friend, the writer James Agee: "He epitomizes for all human creatures in all times the moment when masks are laid aside." Indeed, he and his skeptical companion seem to form a backstage duo, resting between demanding performances.

Photographers had begun to explore the poetics of street life in the mid-1920s, with the advent of small handheld cameras, some of which used roll film, permitting the photographer to make a series of shots in rapid succession. The portability and ease of the small camera changed the way photographs could be made and, consequently, what could be photographed. The commonplace events of daily life could be transformed into art, as Levitt so gracefully demonstrated.

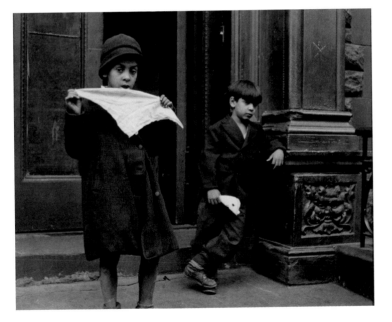

The Daughter of the Dancers (La Hija de los Danzantes). 1933

Gelatin silver print, 9¼ × 6¹¹⁄₁₆" (23.5 × 17 cm)
Purchase

In this picture, as in many of Álvarez Bravo's photographs, our experience begins with the theme of looking: we must wonder what it is that the girl sees, or what she seeks. It has been suggested that her awkwardly placed feet, with one foot atop the other as she stands on her toes, evokes the figures in Mexican reliefs and carvings made before the Spanish conquest, and that the girl, dressed in traditional Mexican costume, may be interpreted as representing a Mexico searching for its past through the window in the well-worn wall. Clearly, the picture was staged, and we know that the photographer has intentionally provoked our curiosity.

Photography has an inherent power to create mystery because it only describes aspects of things and never tells the whole story. In the hands of a skillful photographer, this capacity to intrigue can become the foundation of an aesthetic, a way of working. Throughout his seventy-five-year career, the Mexican photographer Álvarez Bravo consistently made deeply human photographs rife with enigma.

Joseph Cornell | American, 1903–1972

Taglioni's Jewel Casket. 1940
Wood box containing glass ice cubes, jewelry, etc., $4\frac{3}{4} \times 11\frac{7}{8} \times 8\frac{1}{4}$" ($12 \times 30.2 \times 21$ cm)
Gift of James Thrall Soby

The art form that Cornell made his own was the box, its contents carefully arranged to evoke a mood or narrative. These works may recall toys the artist had played with as a child, but they must also trace back to devices in Surrealist art (which Cornell knew well) and, earlier, in paintings by Giorgio de Chirico. In *Taglioni's Jewel Casket*, small glass cubes lie in a wood box. Beneath them, and under blue glass, necklaces, sand, crystal, and rhinestones rest on a mirrored surface. This romantic scene of ice and jewels relates to an event in the life of the legendary nineteenth-century ballerina Marie Taglioni.

A label in the box's lid tells the story: "On a moonlight night in the winter of 1835 the carriage of Marie TAGLIONI was halted by a Russian highwayman, and that enchanting creature commanded to dance for this audience of one upon a panther's skin spread over the snow beneath the stars. From this actuality arose the legend that to keep alive the memory of this adventure so precious to her, TAGLIONI formed the habit of placing a piece of artificial ice in her jewel casket or dressing table where, melting among the sparkling stones, there was evoked a hint of the atmosphere of the starlit heavens over the ice-covered landscape."

Autumn, Yosemite Valley. 1939
Gelatin silver print, 7¼ × 9½" (18.4 × 24.1 cm)
Gift of Albert M. Bender

From the late 1920s through the 1960s, Adams made hundreds of photographs of Yosemite Valley, and he often aimed to evoke its vastness and sublime grandeur. Many of his pictures, however, are quite intimate. In this view, for example, the cliffs do not seem to loom above us. Instead, along with the trees and the reflections in the water, the face of the cliff belongs to a gossamer tissue of glittering detail, animated by light.

Adams's devotion to wild nature made him a figurehead for conservationists, and his mastery of technique made him a hero to many who were unable to distinguish between the art and craft of photography. But all that came much later. When he made this picture, Adams was still practically unknown. His love of nature was a matter of private feeling, not political conviction; and his attention to craft was not a matter of slavish adherence to formulas and rules. It was made necessary by his art, in which the most ephemeral fluctuation of weather or light could be a major event.

Meshes of the Afternoon. 1943
16mm film, black and white, silent, 14 minutes
Acquired from the artist
Maya Deren

Meshes of the Afternoon is one of the most influential works in American experimental cinema. A non-narrative work, it has been identified as a key example of the "trance film," in which a protagonist appears in a dreamlike state, and where the camera conveys his or her subjective focus. The central figure in *Meshes of the Afternoon*, played by Deren, is attuned to her unconscious mind and caught in a web of dream events that spill over into reality. Symbolic objects, such as a key and a knife, recur throughout the film; events are open-ended and interrupted. Deren explained that she wanted "to put on film the feeling which a human being experiences about an incident, rather than to record the incident accurately."

Made by Deren with her husband, cinematographer Alexander Hammid, *Meshes of the Afternoon* established the independent avant-garde movement in film in the United States, which is known as the New American Cinema. It directly inspired early works by Kenneth Anger, Stan Brakhage, and other major experimental filmmakers. Beautifully shot by Hammid, a leading documentary filmmaker and cameraman in Europe (where he used the surname Hacken-schmied) before he moved to New York, the film makes new and startling use of such standard cinematic devices as montage editing and matte shots. Through her extensive writings, lectures, and films, Deren became the preeminent voice of avant-garde cinema in the 1940s and the early 1950s.

Frida Kahlo | Mexican, 1907–1954

Self-Portrait with Cropped Hair. 1940
Oil on canvas, 15¾ × 11" (40 × 27.9 cm)
Gift of Edgar Kaufmann, Jr.

Kahlo painted *Self-Portrait with Cropped Hair* shortly after she divorced her unfaithful husband, the artist Diego Rivera. As a painter of many self-portraits, she had often shown herself wearing a Mexican woman's traditional dresses and flowing hair; now, in renunciation of Rivera, she painted herself short haired and in a man's shirt, shoes, and oversized suit (presumably her former husband's).

Kahlo knew adventurous European and American art, and her own work was embraced by the Surrealists, whose leader, André Breton, described it as "a ribbon around a bomb." But her stylistic inspirations were chiefly Mexican, especially nineteenth-century religious painting, and she would say, "I do not know if my paintings are Surrealist or not, but I do know that they are the most frank expression of myself." The queasily animate locks of fresh-cut hair in this painting must also be linked to her feelings of estrangement from Rivera (whom she remarried the following year), and they also have the dreamlike quality of Surrealism. For, into the work she has written the lyric of a Mexican song: "Look, if I loved you it was because of your hair. Now that you are without hair, I don't love you anymore."

Citizen Kane. 1941

35mm film, black and white, sound, 119 minutes
Acquired from RKO
Joseph Cotten, Orson Welles, Everett Sloane

Welles's first feature is probably the most respected, analyzed, and parodied of all films. Although its archival and historical value are unchallenged, *Citizen Kane*, nevertheless, seems fresh on each new viewing. The film touches on so many aspects of American life—politics and sex, friendship and betrayal, youth and old age—that it has become a film for all moods and generations. In its expansive way, it creates a kaleidoscopic panorama of a man's life. Loosely based on the life of the newspaper publisher William Randolph Hearst, *Citizen Kane* is the saga of the rise to power of a "poor little rich boy" starved for affection, as Welles himself was after his parents' early deaths. It is also a meditation on emotional greed, the ease of amassing wealth, and the difficulty of sustaining love.

Welles completed it at the age of twenty-five. Here is a young director's movie, full of boyish bravado, impatient with the genteel traditions of seamless cinematic storytelling, and eager to plunder other media (incorporating the staccato rhythm of newsreel clips, the briskness of radio narrative, and the moodiness of stage lighting). Through its cunning flashback format, the film shows that the future is both inevitable and unknowable. *Citizen Kane* is a classic tour de force, for which Welles not only wrote, directed, and edited but played the title role as well.

Harry Maxwell Shot in a Car.

1941
Gelatin silver print, 13 15/₁₆ × 10 ½" (35.4 × 26.6 cm)
Gift of the artist

Weegee, a news photographer, borrowed his professional name from the ouija board as a way of advertising his uncanny ability to show up in the right place at the right time. On this occasion, however, it appears that he was not the first to arrive at the scene. Instead of a grisly close-up of the corpse, he gives us a generous view of the aftermath of the crime: the cops have seen it all before and pass the time in bored distraction while the photographers work.

Photographs began to appear in newspapers around the turn of the century, and the heyday of newspaper photography did not get under way until the 1920s. But it did not take long thereafter to establish the staples of the trade: winners and losers, heroes and villains, catastrophes and celebrations—timeless dramas reinvigorated on a daily basis by the specificity of photographic fact. The genre was at its most pure in the tabloid papers, which dispensed with the facade of journalistic reserve in their headlong pursuit of sensation. Nevertheless, as the writer Luc Sante notes: "In Weegee's hands, this cynicism is so extreme it almost becomes a kind of innocence."

Untitled, from **"Country Doctor."** 1948
Gelatin silver print, 13⅜ × 10³⁄₁₆" (33.9 × 25.9 cm)
Purchase

In the photograph Dr. Ernest Ceriani attends Lea Marie Wheatley, two and a half years old, who has been kicked in the head by a horse. The photographer had been sent to remote Kremmling, Colorado, to shoot a photo-essay on Ceriani, whom the editors of *Life* magazine had selected as a typical country doctor. Smith's "Country Doctor," comprising twenty-eight pictures plus text, appeared in *Life* on September 20, 1948.

Picture magazines such as *Life*, founded in 1936, gave photographers the opportunity to address millions of readers. However, this opportunity obliged the photographer to work with editors and writers as part of a team, and it imposed the formula of the photo-essay, in which weaker pictures might be chosen over stronger ones because they did a better job of moving the story along.

No one struggled harder or with more success than Smith to make this system of journalism responsive to his personal convictions and artistic standards, and "Country Doctor" is among his most persuasive essays. His best individual pictures, such as this one, are more persuasive still.

The Migration Series. 1940–41

Number 58, from a series of 60 works (30 in the Museum): tempera on gesso on composition board, 12 × 18" (30.5 × 45.7 cm)
Gift of Mrs. David M. Levy

During the first half of the twentieth century, as the expanding modern industries in America's northern cities demanded ever more workers, great numbers of African Americans saw in these jobs a chance to escape the poverty and discrimination of the rural South. Between 1916 and 1930 alone, over a million people moved north. Lawrence's own parents made this journey, and he grew up hearing stories about it; as a young artist living in Harlem, the heart of New York City's African American community, he recognized it as an epic theme. Originally known as *The Migration of the Negro*, but renamed by the artist in 1993, this distinguished cycle of images chronicles a great exodus and arrival.

Visually, the cycle moves between panels of great incident and panels of near abstraction and emptiness. Using exaggerated perspectives, rhythmic constructions, astringent colors, and angular figures, Lawrence bent decorative forms to the task of history, and made social realism consonant with modern art. Yet he never lost touch with the task of telling a complex story clearly and accessibly. Leaving hardships behind in the South, African Americans received a mixed reception in the North; along with the possibility of jobs, the vote, and education, the new life also brought unhealthy living conditions, race riots, and other trials all documented in Lawrence's cycle, along with his community's heroic perseverance in facing them. Each part of the story carries a legend by the artist; for the image shown here, the legend reads: "In the North the Negro had better educational facilities."

The Beautiful Bird Revealing the Unknown to a Pair of Lovers. 1941
Gouache, pencil, and oil wash on paper, 18 × 15"
(46 × 38 cm)
Acquired through the Lillie P. Bliss Bequest

This is one of a celebrated group of twenty-four drawings, collectively referred to as the Constellation series, which was executed during a period of personal crisis for Miró triggered by the Spanish Civil War and World War II. Trapped in France from 1936 to 1940, the artist embarked on these obsessively meticulous works on paper in an attempt to commune with nature and escape the tragedies of current events. Despite their modest formats, they represented the most important works of his career up to that time, a fact he quickly realized.

The first eleven works in the series were executed in Normandy between December 1939 and May 1940. Although the motifs throughout correspond to Miró's classic repertory, in the earlier works the washed grounds are more saturated, the motifs larger, and the compositions looser than in those that would follow. In the later thirteen works, executed in Palma de Mallorca in 1940–41, of which *The Beautiful Bird Revealing the Unknown to a Pair of Lovers* is exemplary, the grounds are almost opalescent, and the familiar motifs are smaller and tightly woven into a continuous linear web. In its elusive poetry yet rigorous control, this work not only embodies Miró's artistic personality, but it also mirrors the luminous tracks of constellations in a clear night sky.

Broadway Boogie Woogie.

1942–43
Oil on canvas, 50 × 50" (127 × 127 cm)
Given anonymously

Mondrian arrived in New York in 1940, one of the many European artists who moved to the United States to escape World War II. He fell in love with the city immediately. He also fell in love with boogie-woogie music, to which he was introduced on his first evening in New York, and he soon began, as he said, to put a little boogie-woogie into his paintings.

Mondrian's aesthetic doctrine of Neo-Plasticism restricted the painter's means to the most basic kinds of line—that is, to straight horizontals and verticals—and to a similarly limited color range, the primary triad of red, yellow, and blue plus white, black, and the grays between. But *Broadway Boogie Woogie* omits black and breaks Mondrian's once uniform bars of color into multicolored segments. Bouncing against each other, these tiny, blinking blocks of color create a vital and pulsing rhythm, an optical vibration that jumps from intersection to intersection like the streets of New York. At the same time, the picture is carefully calibrated, its colors interspersed with gray and white blocks in an extraordinary balancing act.

Mondrian's love of boogie-woogie must have come partly because he saw its goals as analogous to his own: "destruction of melody which is the destruction of natural appearance; and construction through the continuous opposition of pure means—dynamic rhythm."

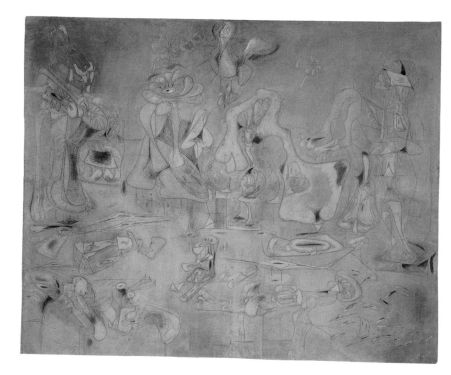

Summation. 1947
Pencil, pastel, and charcoal on buff paper mounted on composition board, 6' 7⅝" × 8' 5¾" (202.1 × 258.2 cm)
Nina and Gordon Bunshaft Fund

The sheer grandness of *Summation*, its alloy of precision and imposing scale, associates it with the classical masters of the past. Quite unclassical, though, is the drawing's nervous, extraordinarily sensuous bonding of sexual or visceral images and references to animals and plants. "This is a world," Gorky said of *Summation*, but it is a world ambiguously placed—a nature felt in the flesh. Some of its creatures have orifices, joints, and limbs, while others seem to *be* such body parts, or else internal organs. They blossom or flop, poke or rub or tickle each other, pile up or scurry off in a flock, defying identification even while their forms are definite and clear.

Surrealist automatism had freed Gorky's line, reinforcing its mobility. It is this mobility that allows the line to form what the Surrealist leader André Breton called "hybrids"—units with multiple metaphoric meanings. Separate yet related, clusters of incident form a structure both episodic and unified: the work is conceived not as a whole made up of parts but of parts that together make up a whole. We easily read (if not quite decipher) the various motifs, and by recognizing the formal and familial analogies among them, and the soft continuity of the shading around them, we also read them as one single, richly detailed image.

The Vertigo of Eros. 1944
Oil on canvas, 6' 5" × 8' 3" (195.6 × 251.5 cm)
Given anonymously

Matta's paintings do not describe the world we see when we open our eyes. Nor are these the dream or fantasy scenes of his fellow Surrealists Salvador Dalí and René Magritte, which include commonplace objects from waking life; the forms in Matta's works suggest many things but can be firmly identified with none. In the late 1930s and early 1940s Matta had produced works he called "inscapes," imaginary landscapes that he imagined as projections of psychological states. *The Vertigo of Eros* evokes an infinite space that suggests both the depths of the psyche and the vastness of the universe.

A galaxy of shapes suggesting liquid, fire, roots, and sexual parts floats in a dusky continuum of light. It is as if Matta's forms reached back beyond the level of the dream to the central source of life, proposing an iconography of consciousness before it has hatched into the recognizable coordinates of everyday experience. There is a sense of suspension in space, and indeed the work's title relates to Freud's location of human consciousness as caught between Eros, the life force, and Thanatos, the death wish. Constantly challenged by Thanatos, Eros produces vertigo. The human problem, then, is to achieve physical and spiritual equilibrium.

In French, the work's title is a pun, *Le Vertige d'Eros* doubling as *Le Vert Tige des roses* (the green stem of the roses).

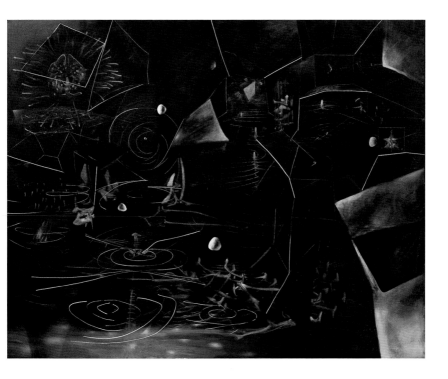

Wifredo Lam | Cuban, 1902–1982

The Jungle. 1943

Gouache on paper, mounted on canvas,
7' 10¼" x 7' 6½" (239.4 x 229.9 cm)
Inter-American Fund

In this monumental and thematically complex gouache, masked figures simultaneously appear and disappear amid the thick foliage of sugarcane and bamboo. The multiperspectival rendering of these figures mirrors Cubist vocabulary, while the fantastical moonlit scene around these monstrous beings—half man, half animal—emerging out of a primeval jungle evokes the realm of the Surrealists. In his desire to express the spirit of Afro-Cuban culture, in particular that of the uprooted Africans "who brought their primitive culture, their magical religion, with its mystical side in close correspondence with nature," Lam reinforces the Surrealist aspect of this work.

Born in Cuba, Lam spent eighteen years in Europe (1923–41), which deeply affected his artistic vision. While there, he befriended Pablo Picasso and also established himself as an integral member of the Surrealist movement. The artistic and cultural traditions of Lam's homeland and Europe converged when he returned to Cuba and renewed his familiarity with its light, vegetation, and culture. In *The Jungle* the presence of the woman-horse, who in Afro-Cuban mysticism refers to a spirit in communication with the natural world, mirrors Lam's own confrontational dialogue with the so-called primitive interests expressed in advanced European painting. His work is an example of this confluence of two cultures.

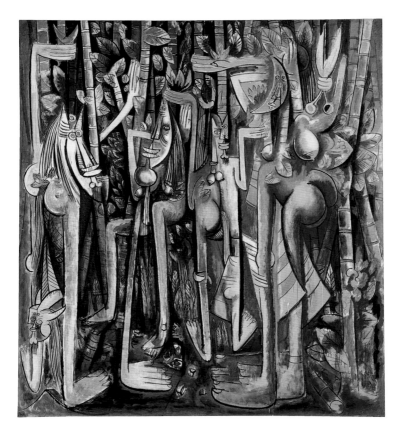

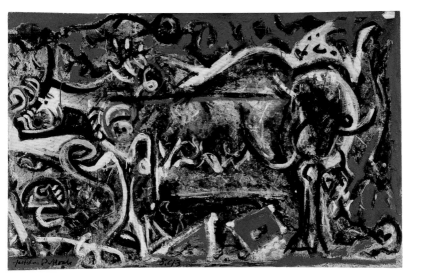

The She-Wolf. 1943
Oil, gouache, and plaster on canvas, 41 ⅞ × 67"
(106.4 × 170.2 cm)
Purchase

When Pollock painted *The She-Wolf* he had not yet arrived at his so-called "drip" style, one of the great inventions of Abstract Expressionism. The canvas's traces of multicolored washes and spatters show that a free-form abstraction and an unfettered play of materials were already parts of his process; but in this work and others his focus is a compound of mythology and an iconography of the unconscious. (He was influenced here both by Surrealism and his own Jungian analysis.) Perhaps Pollock's she-wolf is the legendary foster-mother to Romulus and Remus, the founders of ancient Rome. But he himself refused to identify her, saying, "*She-Wolf* came into

existence because I had to paint it. Any attempt on my part to say something about it, to attempt explanation of the inexplicable, could only destroy it."

Drawn in heavy black and white lines, the wolf advances leftward. Her body is overlaid with abstract lines and patches, a thick, unreadable calligraphy that spreads throughout the canvas. These hieroglyphic intimations, along with the somber palette and the conjuring of myth, reflect the climate of a period shadowed by war. Intended to approach ultimate human mysteries, they were to be simultaneously meaningful and unknowable.

Painting. 1948
Enamel and oil on canvas, 42 ⅝ × 56 ⅛"
(108.3 × 142.5 cm)
Purchase

Painting is a scene of tensile energy.
Black forms fluidly outlined in white
interlock and overlap, slip under or into
each other. Their springing curves evoke
the human body, and also perhaps letters
of the alphabet, supplying familiarity
without legibility. The palette is simpli-
fied but the handling is various: paint
may drip or bleed, black may be solid or
run to gray, white may be pulled thin
across black or may suggest a width
between black shapes. Figure and
ground confuse in this shallow space, yet
the painting conveys less ambiguity than
enormous certainty.

Painting is one of a group of black-
and-white abstractions that de Kooning
produced in the late 1940s. He had
painted abstractly before, but had also
addressed the human figure, and, in fact,
continued to do so in other pictures

from the same period as this one;
abstraction and figuration are not mutu-
ally exclusive in de Kooning's art, but
feed into each other, not only in similari-
ties among forms in outwardly abstract
and outwardly figurative paintings, but
often within the same image. "Even
abstract shapes must have a likeness,"
the artist believed, and many viewers
have seen the forms of breasts, limbs,
and buttocks in the black-and-white
works. The critic Thomas Hess, dis-
cussing these and other abstractions of
de Kooning's, remarked, "He also
includes orgies."

Painting 1944-N. 1944

Oil on unprimed canvas, 8' 8¼" × 7' 3¼"
(264.5 × 221.4 cm)

The Sidney and Harriet Janis Collection

Painting 1944-N is a powerful early example of Still's mature style. The surface is a black impasto, enlivened with knife marks. A jagged red line cuts high on the canvas, and is intersected by two vertical, irregular, pointed shapes before plunging downward to the bottom edge. The size of paintings like this one, its largely empty expanse, and the lightning-bolt quality of Still's line have led some to see in his work a vision of the broad spaces of the Western prairies, where he grew up. But he himself believed that such associations only diminished his work.

Still commanded a new kind of abstraction, free from decipherable symbols. The tarry surface of *Painting 1944-N* concentrates attention on itself, denying the illusion of depth, and the intensely saturated hue carries emotional force without relying on associative imagery. More programmatically than any of the other Abstract Expressionists, Still consciously tried to erase any traces of modern European art from his painting, and to develop a new art appropriate to the New World. "Pigment on canvas," he believed, "has a way of initiating conventional reactions. . . . Behind these reactions is a body of history matured into dogma, authority, tradition. The totalitarian hegemony of this tradition I despise, its presumptions I reject."

One (Number 31, 1950). 1950
Oil and enamel on unprimed canvas, 8' 10" ×
17' 5 ⅝" (269.5 × 530.8 cm)
Sidney and Harriet Janis Collection Fund
(by exchange)

One is a masterpiece of the "drip," or
pouring, technique, the radical method
that Pollock contributed to Abstract
Expressionism. Moving around an
expanse of canvas laid on the floor, Pol-
lock would fling and pour ropes of paint
across the surface. *One* is among the
largest of his works that bear evidence
of these dynamic gestures. The canvas
pulses with energy: strings and skeins of
enamel, some matte, some glossy, weave
and run, an intricate web of tans, blues,
and grays lashed through with black and
white. The way the paint lies on the can-
vas can suggest speed and force, and the
image as a whole is dense and lush—yet

its details have a lacelike filigree, a deli-
cacy, a lyricism.

The Surrealists' embrace of acci-
dent as a way to bypass the conscious
mind sparked Pollock's experiments
with the chance effects of gravity and
momentum on falling paint. Yet
although works like *One* have neither a
single point of focus nor any obvious
repetition or pattern, they sustain a
sense of underlying order. This and the
physicality of Pollock's method have
led to comparisons of his process with
choreography, as if the works were the
traces of a dance. Some see in paintings
like *One* the nervous intensity of the
modern city, others the primal rhythms
of nature.

Vir Heroicus Sublimis. 1950–51
Oil on canvas, 7' 11⅜" × 17' 9¼" (242.2 × 541.7 cm)
Gift of Mr. and Mrs. Ben Heller

Newman may appear to concentrate on shape and color, but he insisted that his canvases were charged with symbolic meaning. Like Piet Mondrian and Kazimir Malevich before him, he believed in the spiritual content of abstract art. The very title of this painting—in English, "Man, heroic and sublime"—points to aspirations of transcendence.

Abstract Expressionism is often called "action painting," but Newman was one of the several Abstract Expressionists who eliminated signs of the action of the painter's hand, preferring to work with broad, even expanses of deep color. *Vir Heroicus Sublimis* is large enough so that when the viewer stands close to it, as Newman intended, it creates an engulfing environment—a vast red field, broken by five thin vertical stripes. Newman admired Alberto Giacometti's bone-thin sculptures of the human figure, and his stripes, or "zips," as he called them, may be seen as symbolizing figures against a void. Here they vary in width, color, and firmness of edge: the white zip at center left, for example, looks almost like the gap between separate planes, while the maroon zip to its right seems to recede slightly into the red. These subtly differentiated verticals create a division of the canvas that is surprisingly complex, and asymmetrical; right in the middle of the picture, however, they set off a perfect square.

Magenta, Black, Green on Orange. 1949

Oil on canvas, 7' 1 ⅜" × 65" (216.5 × 164.8 cm)
Bequest of Mrs. Mark Rothko through
The Mark Rothko Foundation, Inc.

Magenta, Black, Green on Orange follows a compositional structure that Rothko explored for twenty-three years beginning in 1947. Narrowly separated, rectangular blocks of color hover in a column against a colored ground. Their edges are soft and irregular, so that when Rothko uses closely related tones, the rectangles sometimes seem barely to coalesce out of the ground, concentrations of its substance. The green bar in *Magenta, Black, Green on Orange*, on the other hand, appears to vibrate against the orange around it, creating an optical flicker. In fact the canvas is full of gentle movement, as blocks emerge and recede, and surfaces breathe. Just as edges tend to fade and blur, colors are never completely flat, and the faint unevenness in their intensity, besides hinting at the artist's process in layering wash on wash, mobilizes an ambiguity, a shifting between solidity and impalpable depth.

The sense of boundlessness in Rothko's paintings has been related to the aesthetics of the sublime, an implicit or explicit concern of a number of his fellow painters in the New York School. In fact, the remarkable color in his paintings was for him only a means to a larger end: "I'm interested only in expressing basic human emotions—tragedy, ecstasy, doom," he said. "If you...are moved only by...color relationships, then you miss the point."

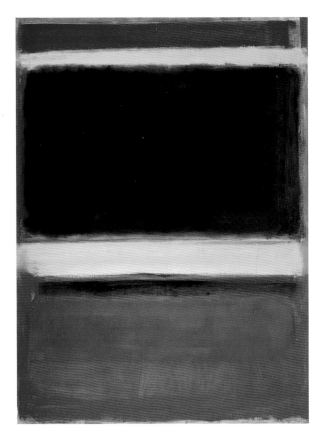

Tokyo Story (Tokyo Monogatari). 1953

35mm film, black and white, sound, 135 minutes
Acquired from Dan Talbot
Chiyeko Higashiyama, Setsuko Hara

Tokyo Story is one of the greatest masterpieces of Japanese cinema. Its director, Ozu, is more firmly rooted in the twentieth century than any other Japanese director. His films do not rely on exotic historical spectacle, elaborate costumes, and tales of honor and conquest. He is also the filmmaker most committed to the traditional values of institutions such as the family. There is no exoticism in Ozu's *Tokyo Story*, and no sweeping action, no horses, no historical reenactments, only people. But the viewer is compensated by the intensity of feeling his domestic dramas engender and by the sincerity of his message. People sit around drinking green tea; they sit at noodle bars; they sit in offices. Ozu's contemplative camera hardly ever moves, and his actors seldom emote.

The understated performances of this film's well-matched actors complement the serenity of Ozu's atmosphere and the sparseness of his naturalistic dialogue. The film explores family dynamics and the conflict of the traditional versus the contemporary through an aging couple's visit to their adult children in the city. Although *Tokyo Story* is about tangible loss, its radiant spirituality transcends death.

Australia. 1951
Painted steel, 6' 7½" × 8' 11⅞" × 16⅛" (202 ×
274 × 41 cm); at base, 14 × 14" (35.6 × 35.6 cm)
Gift of William Rubin

In *Australia* Smith uses thin rods and
plates of steel, simultaneously delicate
and strong, to draw in space. Sculpture
has traditionally gained power from
solidity and mass, but *Australia* is linear,
a skeleton. The Constructivists were the
first to explore this kind of penetration
of sculpture by empty space. Smith
learned about it from photographs of
the welded sculpture of Pablo Picasso:
he had begun his career as a painter, but
he knew how to weld (he had worked as
a riveter in the automobile industry) and
Picasso's works liberated him to start
working in steel.

Like a painting or drawing, *Aus-
tralia* must be seen frontally if its form
is to be grasped. It has been identified as
an abstraction of a kangaroo, and its
lines have that animal's leaping vitality;
but it is an essay in tension, balance, and
shape more than it is any kind of repre-
sentation. In calling the work *Australia*,
Smith may have had in mind the passages
on that country in James Joyce's novel
Finnegans Wake. He may also have been
thinking of the magazine illustration of
aboriginal Australian cave drawings that
the critic Clement Greenberg sent him
in September of 1950, with the note,
"The one of the warrior reminds me
particularly of some of your sculpture."

John Ford | American, 1895–1973

My Darling Clementine. 1946
35mm film, black and white, sound, 97 minutes
Acquired from Twentieth Century-Fox;
restored with funding from the National
Endowment for the Arts
Henry Fonda

Among Ford's finest Westerns and one
of the greatest of films for its sense of
poetic tragedy, *My Darling Clementine* is
pervaded by a feeling of loss—of family,
place, honor, and self-worth. The reluc-
tant hero, Wyatt Earp (Henry Fonda),
can never find the peace the church-
going pioneer families pay him to estab-
lish. Equally, he is a reluctant romantic,
deeply chivalrous like other Fordian
leading men. Among the more elusive
protagonists of the Western genre, Earp
seems laid-back, reserved, or repressed.
His friend and ally, Doc Holliday (Victor
Mature), is a dentist turned gambler
who carries a tragic weight. Earp's sorrow
is quieter, more introspective. His gentle
attempts to achieve balance on a sunny

Sunday morning yield one of cinema's
most sublime moments.

Ford gave a lonely landscape a par-
ticular resonance. No other filmmaker is
as identified with a specific location;
none has imbued a site with greater
meaning. His Westerns are an evocation
of his strong feeling for the American
past; the frontier is his landscape of mem-
ory. *My Darling Clementine* is a triumph of
his unique Western mise-en-scène, rich
characterization, and breathtaking black-
and-white cinematography. The town of
Tombstone, a settlement emerging in
the middle of nowhere, is a universe
unto itself. The town represents the
civilization of the white man, with the
Indian nation of no importance. Prob-
lems are caused by greed and drunken-
ness, clannish loyalties, and a thirst for
revenge. The film plays freely with myth
and legend, often departing from what is
known about the historical figures who
inspire the tale: the Earps, the Clantons,
and Holliday.

Apparition. 1945

Soft ground etching, plate: 20⅛ × 15¼"
(51.1 × 38.7 cm)
Publisher: the artist. Edition: 15
The Associates Fund

The mysterious *Apparition* is composed of a dense patchwork of tone and texture. Compartmentalized figures and cryptic signs, icons, and symbols occupy flat, rectilinear areas stacked above one another, with the narrow four-tiered shaft to the right of center suggesting totems. Eyes appear on almost every form; a pair dominates center stage and other, more enigmatic, single eyes occur frequently. Not one apparition but multiple manifestations magically reveal themselves at the same moment as we enter a new realm, peopled with fantastical inventions of the artist's subconscious.

This work belongs to a unique type of picture, divided into grids, that Gottlieb called the "pictograph." Taking myth as a subject appropriate to the violence of the time in which they were conceived—the turbulent years of World War II—and finding a sense of primeval spirituality in the arts of Native Americans and other tribal cultures, Gottlieb created these highly evocative compositions spontaneously, letting a visual "stream of consciousness" direct his artistic imagination. In *Apparition*, the velvety qualities of the soft ground etching technique produce a blurred, dreamlike atmosphere, creating one of Gottlieb's most haunting pictographs.

Number 20. 1949
Oil on canvas, 7' 2" × 6' 8¼" (218.5 × 203.9 cm)
Gift of Philip Johnson

Some of the ribbons and bars so rhythmically meshed in *Number 20* are recognizable as letters of the alphabet (E, X, or Z), but these and their more abstract neighbors evoke calligraphy without constituting it. Like the circles and crosses in the painting, they can be traced to the Surrealist interest in universal images—immediately legible images that nevertheless escape facile interpretation by the conscious mind. Tomlin had made repeated visits to the exhibition *Fantastic Art Dada Surrealism* at The Museum of Modern Art in 1936–37, and he shared the wide interest in Surrealism among the artists of the New York School. (This interest was encouraged when World War II drove a number of European Surrealist artists to emigrate to New York.)

His work of the 1930s, however, had been Cubist in inspiration, and the background of shifting rectangles in *Number 20* ultimately derives from the structural grid of Cubism; the work's limited color range also recalls the reduced palette of Cubist paintings of 1911–12. The result is a painting that combines decorative elegance with an austere sobriety of spirit.

Charles Eames | American, 1907–1978
Ray Eames | American, 1912–1988

Low Side Chair (model LCM).

1946
Molded walnut veneered plywood, chrome-
plated steel rods, and rubber shock mounts,
27⅜ × 22¼ × 25⅜" (69.5 × 56.3 × 64.5 cm)
Manufacturer: Herman Miller Inc., USA
Gift of the manufacturer

The LCM (Lounge Chair Metal) was
conceived by Eames, who, with his wife
and professional partner, Ray, formed
one of the most influential design teams
of the twentieth century. First produced
in 1946, the LCM and its companion,
the DCM (Dining Chair Metal), met
with great commercial success and have
become icons of modern design. The
LCM's molded-plywood seat and back
sit on a chrome-plated steel frame, with
rubber shock mounts in between. That
the back and seat are separate pieces

simplified production, while also provid-
ing visual interest.

Together with Eero Saarinen,
Eames had first experimented with bent
plywood for a group of prize-winning
designs they submitted to the 1940 com-
petition "Organic Design in Home Fur-
nishings," organized by The Museum of
Modern Art. These, however, proved
difficult to manufacture, and most were
upholstered for comfort. Intent on pro-
ducing high-quality objects at economi-
cal manufacturing costs, the Eameses
devoted the better part of the next five
years to refining the technique of mold-
ing plywood to create thin shells with
compound curves. The chair was ini-
tially manufactured by the Evans Prod-
ucts Company; in 1949 Herman Miller
Inc. bought the rights to produce it.

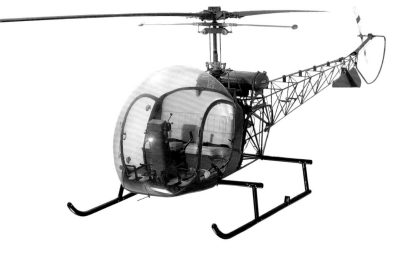

Bell-47D1 Helicopter. 1945
Aluminum, steel, and acrylic, 9' 2¾" × 9' 11" ×
41' 8¾" (281.3 × 302 × 1271.9 cm)
Manufacturer: Bell Helicopter Inc., USA
Marshall Cogan Purchase Fund

More than three thousand Bell-47D1
helicopters were made in the United
States and sold in forty countries
between 1946 and 1973, when produc-
tion ceased. While the Bell-47D1 is a
straightforward utilitarian craft, its
designer, Young, who was also a poet
and a painter, consciously juxtaposed
its transparent plastic bubble with the
open structure of its tail boom to create
an object whose delicate beauty is in-
separable from its efficiency. That the
plastic bubble is made in one piece rather
than in sections joined by metal seams
sets the Bell-47D1 apart from other
helicopters. The result is a cleaner,
more unified appearance.

The bubble also lends an insectlike
appearance to the hovering craft, which
generated its nickname, the "bug-eyed
helicopter." It seems fitting, then, that
one of the principal uses of the Bell-
47D1 has been for pest control in crop
dusting and spraying. It has also been
used for traffic surveillance and for the
delivery of mail and cargo to remote
areas. During the Korean War, it served
as an aerial ambulance.

Awarded the world's first commer-
cial helicopter license by the Civil Aero-
nautics Administration (now the FAA),
the Bell-47D1 weighs 1,380 pounds. Its
maximum speed is 92 miles per hour
and its maximum range 194 miles. It can
hover like a dragonfly at altitudes up to
10,000 feet.

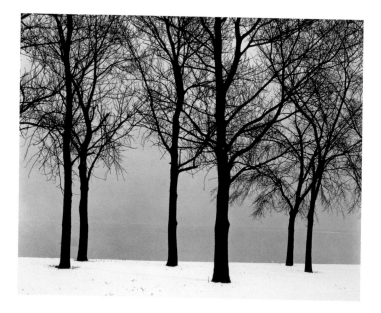

Chicago. c. 1950
Gelatin silver print, 7⅝ × 9⁹⁄₁₆" (19.4 × 24.3 cm)
Purchase

Alfred Stieglitz, Edward Weston, and others defined the dominant aesthetic of modern American photography of the 1920s. The formal rigor and precision of their pictures set forth an ideal of purity and contemplation, unsullied by the complexities of the modern world. It was their acute alertness to subtle particulars that saved their work from lifeless perfection.

Beginning in the early 1940s and for nearly half a century thereafter, Callahan extended the tradition by intensifying both of its poles. His pictures mark an extreme of austerity, but they are full of variety and playful experiment. Like snowflakes, they adhere to a rigid set of rules, but no two are the same.

Callahan's view of the shore of Lake Michigan reduces photography's unbroken scale of tones to the extreme white of the snow, the pure black of the trees, and a middle gray. Yet the distinction between water and sky is there—just barely. And, while the tree trunks make strong vertical accents, they vary in thickness and shape; and they group themselves into pairs, like three figures poised for action. As the trunks branch and branch again, they make a tapestry: flattened, whole, unbroken, but delicate and inexhaustibly intricate.

Franz Kline | American, 1910–1962

Chief. 1950
Oil on canvas, 58⅜" × 6' 1½" (148.3 × 186.7 cm)
Gift of Mr. and Mrs. David M. Solinger

True to an alternate name for Abstract Expressionism, "action painting," Kline's pictures often suggest broad, confident, quickly executed gestures reflecting the artist's spontaneous impulses. Yet Kline seldom worked that way. In the late 1940s, chancing to project some of his many drawings on the wall, he found that their lines, when magnified, gained abstraction and sweeping force. This discovery inspired all of his subsequent painting; in fact many canvases reproduce a drawing on a much larger scale, fusing the improvised and the deliberate, the miniature and the monumental.

"Chief" was the name of a locomotive Kline remembered from his childhood, when he had loved the railway. Many viewers see machinery in Kline's images, and there are lines in *Chief* that imply speed and power as they rush off the edge of the canvas, swelling tautly as they go. But Kline claimed to paint "not what I see but the feelings aroused in me by that looking," and *Chief* is abstract, an uneven framework of horizontals and verticals broken by loops and curves. The cipherlike quality of Kline's configurations, and his use of black and white, have provoked comparisons with Japanese calligraphy, but Kline did not see himself as painting black signs on a white ground; "I paint the white as well as the black," he said, "and the white is just as important."

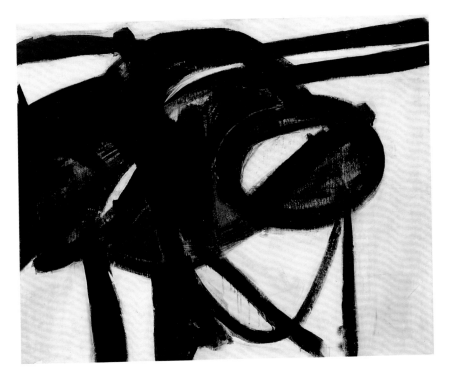

Woman, I. 1950–52
Oil on canvas, 6' 3⅞" × 58" (192.7 × 147.3 cm)
Purchase

Woman, I is the first in a series of de Kooning works on the theme of Woman. The group is influenced by images ranging from Paleolithic fertility fetishes to American billboards, and the attributes of this particular figure seem to range from the vengeful power of the goddess to the hollow seductiveness of the calendar pinup. Reversing traditional female representations, which he summarized as "the idol, the Venus, the nude," de Kooning paints a woman with gigantic eyes, massive breasts, and a toothy grin. Her body is outlined in thick and thin black lines, which continue in loops and streaks and drips, taking on an

independent life of their own. Abrupt, angular strokes of orange, blue, yellow, and green pile up in multiple directions as layers of color are applied, scraped away, and restored.

When de Kooning painted *Woman, I*, artists and critics championing abstraction had declared the human figure obsolete in painting. Instead of abandoning the figure, however, de Kooning readdressed this age-old subject through the sweeping brushwork of Abstract Expressionism, the prevailing contemporary style. Does the woman partake of the brushwork's energy to confront us aggressively? Or is she herself under attack, nearly obliterated by the welter of violent marks? Perhaps something of both; and, in either case, she remains powerful and intimidating.

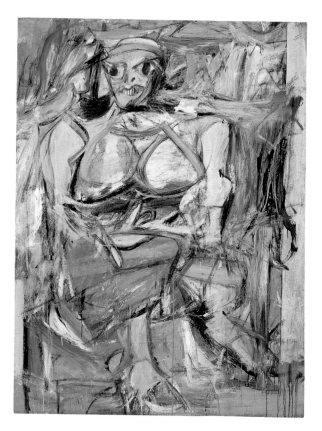

Bed. 1955
Combine painting: oil and pencil on pillow,
quilt, and sheet on wood supports, 6' 3¼" ×
31½" × 8" (191.1 × 80 × 20.3 cm)
Gift of Leo Castelli in honor of
Alfred H. Barr, Jr.

Bed is one of Rauschenberg's first
Combines, his own term for his tech-
nique of attaching cast-off items, such
as rubber tires or old furniture, to a tra-
ditional support. In this case he framed
a well-worn pillow, sheet, and quilt,
scribbled them with pencil, and
splashed them with paint, in a style
derived from Abstract Expressionism.
In mocking the seriousness of that
ambitious art, Rauschenberg predicted
an attitude more widespread among
later generations of artists—the Pop
artists, for example, who also appre-
ciated Rauschenberg's relish for everyday
objects.

Legend has it that the bedclothes in
Bed are Rauschenberg's own, pressed
into use when he lacked the money to
buy a canvas. Since the artist himself
probably slept under this very sheet and

quilt, *Bed* is as personal as a self-portrait,
or more so—a quality consistent with
Rauschenberg's statement, "Painting
relates to both art and life. . . . (I try
to act in that gap between the two)."
Although the materials here come
from a bed, and are arranged like one,
Rauschenberg has hung them on the
wall, like a work of art. So the bed loses
its function, but not its associations with
sleep, dreams, illness, sex—the most
intimate moments in life. Critics have
also projected onto the fluid-drenched
fabric connotations of violence and
morbidity.

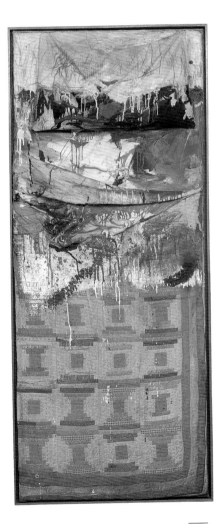

Bicycle Thief (Ladri di biciclette). 1948
35mm film, black and white, sound, 91 minutes
Ceskoslovensky Filmovy Archiv (by exchange)
Lamberto Maggiorani, Enzo Staiola

In *Bicycle Thief*, a worker whose liveli-hood depends on his bicycle finds that it has been stolen, and spends a heart-breaking day with his young adoring son searching for it in the streets of Rome. The film represents a genre of Italian cinema known as neo-realism, an enor-mously influential style in which films were shot on location, outdoors, and with available light. Filmmakers such as De Sica, Roberto Rossellini, Giuseppe De Santis, and Luchino Visconti often used nonprofessional actors in their sto-ries about common people adjusting to the brutal conditions of a society hum-bled and impoverished by war.

De Sica, an actor, directed his first film in 1939, but it was not until he made his postwar neo-realist master-works, *Shoeshine, Bicycle Thief*, and *Umberto D*, in particular, that he became internationally celebrated. In spite of its having initially been censored in the United States, *Bicycle Thief* was so well received in America that the Academy of Motion Picture Arts and Sciences honored it with a special award two years before the Oscar for the best foreign-language film was inaugurated.

Meet Me in St. Louis. 1944

35mm film, color, sound, 113 minutes
Restored in cooperation with Turner Entertainment Co., with funding from AT&T
Tom Drake, Judy Garland

Meet Me in St. Louis grew out of a series of decidedly undramatic stories by Sally Benson about her midwestern childhood that were first published in *The New Yorker* magazine. MGM screenwriters labored to create a plot until Arthur Freed, the head of MGM's famed musical production unit, decided the film should be a vehicle for former child star Judy Garland. In the film, Garland plays Esther, a daughter in the Smith family of St. Louis, who sings her way through the seasons from summer 1903 to spring 1904, as the city prepares for the 1904 Louisiana Purchase Exposition. Among her many tunes, Esther sings "The Trolley Song," discovering the clang, clang, clang of her heartbeat because she is in love. Minnelli highlighted the simplicity and naturalness of her acting and singing, which captivated audiences.

Following his success in the 1930s as a director and designer for the Broadway theater, Minnelli moved on to Hollywood as a member of Freed's unit at MGM, bringing to this popular genre a fresh approach. Whereas others were reluctant to use Technicolor, Minnelli understood and embraced the new process, showing off the dazzling brightness of its colors. He became one of Hollywood's most accomplished colorists and a master of cinematic musical comedy. Minnelli set a new standard for the genre, smoothly inserting dance numbers into the narrative in a blend of naturalism and fantasy, as realistic characters discover and declare their hopes, fears, or loves. He simultaneously hid and revealed the darker side of domestic America, the fragility of its structure and the terror of possible change.

The Knife Thrower from Jazz

by Henri Matisse. 1943–47
Illustrated book with 20 pochoirs, page: 16½ ×
12¹¹/₁₆″ (42 × 32.2 cm)
Publisher: Tériade Éditeur, Paris. Edition: 270
The Louis E. Stern Collection

The energetic, vivid fuchsia form shown
here at the left represents a knife
thrower, while the static, pale blue form
with upraised arms at the right suggests
his female partner in the popular circus
act. Shapes resembling leaves float across
the composition, providing a dreamlike
atmosphere for this aesthetic vision.
"These images, with their lively and vio-
lent tones, derive from crystallizations of
memories of circuses, folktales, and voy-
ages." So wrote Matisse in the poetic
text accompanying his compositions for
Jazz, his extraordinary artist's book. *The
Knife Thrower* is one of twenty images in
this volume, which are interleaved with
pages on which his own handwritten
words are printed.

Late in his career, after being
bedridden following surgery in 1941,
Matisse turned to making collages from
painted papers. Using scissors, he cut
curved shapes, which he then arranged
in animated compositions. The adven-
turous publisher Tériade encouraged
Matisse to create a book from these daz-
zling creations. The artist chose the
printing technique of pochoir, which is
notable for its ability to achieve satu-
rated areas of flat brilliant colors by a
process of applying gouache inks
through stencils.

Ellsworth Kelly | American, born 1923

Colors for a Large Wall. 1951
Oil on canvas, mounted on sixty-four wood panels; overall, 7' 10¼" × 7' 10½" (239.3 × 239.9 cm)
Gift of the artist

"I have never been interested in painterliness," Kelly has said, using painterliness to mean "a very personal handwriting, putting marks on a canvas." There is no personal handwriting, nor even any marks as such, in *Colors for a Large Wall*, which comprises sixty-four abutting canvases, each the same size (a fraction under a foot square) and each painted a single color. Not even the colors themselves, or their position in relation to each other, could be called personal; Kelly derived them from commercial colored papers, and their sequence is arbitrary. Believing that "the work of an ordinary bricklayer is more valid than the artwork of all but a very few artists," he fused methodical procedure and a kind of apollonian detachment into a compositional principle.

As a serial, modular accumulation of objects simultaneously separate and alike, *Colors for a Large Wall* anticipated the Minimalism of the 1960s, but it is unlike Minimalism in the systematic randomness of its arrangement, which is founded on chance. Produced at the height of Abstract Expressionism (but quite independently of it, since Kelly had left New York for Paris), the work also has that art's mural scale, and Kelly thought deeply about the relationship of painting to architecture; but few Abstract Expressionists could have said, as he has, "I want to eliminate the '*I* made this' from my work."

Joë Bousquet in Bed from More Beautiful Than They Think: Portraits. 1947

Oil emulsion in water on canvas, 57⅝ × 44⅞"
(146.3 × 114 cm)
Mrs. Simon Guggenheim Fund

Joë Bousquet was a poet who had been paralyzed in World War I, and lived, bedridden, for over thirty years in Narbonne, in the south of France. Dubuffet shows him lying in bed. Beside him on the covers lie two of his books (*La Connaissance du soir* and *Traduit du silence*), a newspaper, two letters addressed to him, and a package of Gauloises cigarettes.

The newspaperlike brochure for Dubuffet's October 1947 show in Paris included the announcement, "People are more beautiful than they think they are.

Long live their true faces. . . . Portraits with a resemblance extracted, with resemblance cooked and conserved in the memory, with a resemblance exploded in the memory of Mr. Jean Dubuffet, painter." At a time when few modern artists were producing portraits, the perpetually rebellious Dubuffet depicted the intellectuals who were his friends, but he made no effort at descriptive or psychological exactness. Inspired by the art of children, the insane, and the unschooled (all of which he collected under the name *l'art brut*), he made crude, caricatural images, roughly scratched into a thick impasto. Repelled by the conformity of modern life, he hoped that this crudeness would make his work more authentic.

Study of a Baboon. 1953
Oil on canvas, 6' 6⅛" x 54⅛"
(198.3 x 137.3 cm)
James Thrall Soby Bequest

By his own account, Bacon completed his first mature painting in 1944, during World War II. Appropriately to the time, he addressed themes not just of suffering but of torment, and drew from a combination of mythological and Christian sources to articulate themes of violent revenge. The mood endured throughout his work, and certainly informed the somber *Study of a Baboon.*

Bacon often derived his images from photographs—from newsprint and film stills and, notably, a reproduction of a Diego Velázquez painting—and he copied this baboon from one of his favorite books, Marius Maxwell's *Stalking Big Game with a Camera in Equatorial Africa*, published in 1925. The photographs are chiefly of large wild animals such as the elephant and the rhinoceros, but among the plates is a startling reproduction of baboons in acacia trees. The baboon at the right is perched on a forked tree trunk much like that in Bacon's work. Bacon had traveled often in Africa and was reportedly fascinated to see monkeys and apes of various kinds caged in the parks, while outside others roamed in freedom. *Study of a Baboon* pointedly incarnates this ambivalence. The baboon is half imprisoned, half free. The vigorously painted bars of the cage force the baboon uncomfortably close to the viewer. Its body is partly transparent and ghostly, but its sinister open maw and glinting white fangs mark a very real presence. Bacon pens the viewer into the enclosure with the ferocious creature, suggesting a close correlation between the two beings.

Man Pointing. 1947

Bronze, 70½ × 40¾ × 16⅜" (179 × 103.4 × 41.5 cm), at base 12 × 13¼" (30.5 × 33.7 cm)
Edition: 1/6
Gift of Mrs. John D. Rockefeller, 3rd

Frail yet erect, a man gestures with his left arm and points with his right. We have no idea what he points to, or why. Anonymous and alone, he is also almost a skeleton. For the Existentialist philosopher Jean-Paul Sartre, in fact, Giacometti's sculpture was "always halfway between nothingness and being."

Such sculptures were full of meaning to Sartre, who said of them, "At first glance we seem to be up against the fleshless martyrs of Buchenwald. But a moment later we have a quite different conception: these fine and slender natures rise up to heaven. We seem to have come across a group of Ascensions."

In the years leading up to World War II, Giacometti abandoned his earlier Surrealism. Dissatisfied with the resource of imagination, he returned to the resource of vision, focusing on the human figure and working from live models. Under his eyes, however, these models seem virtually to have dissolved. Working in clay (the preparation to casting in bronze), Giacometti scraped away the body's musculature, so that the flesh seems eaten off by a terrible surrounding emptiness, or to register the air around it as a hostile pressure. Recording the touch of the artist's fingers, the surface of *Man Pointing* is as rough as if charred or corroded. At the same time, the figure dominates its space, even from a distance.

Spatial Concept. 1957
Pen and ink on paper, mounted on canvas, with punctures and scrapes, 55" × 6' 6⅞" (139.3 × 200.3 cm)
Gift of Morton G. Neumann

The strongest visual device in *Spatial Concept* is a wide, irregular oval of rough holes, their broken rims poking outward as if some force in the hidden dark behind the picture plane were struggling to break through. Scratches of black ink, most of them short and bristlelike, scatter in flurries across the surface; the lighter lines and whorls are abrasions scored in the thick paper, ridged scars that compensate for their relative faintness with their violence. Fontana's Spatial Concepts—the first of which dates from 1949—have a physical concreteness in tune with the anti-idealist mood of postwar Europe.

Fontana felt that scientific advances demanded parallel innovations in art, which, he declared, should reach out into its surroundings—should exist not in two dimensions but in space. Sculpture, being three-dimensional, did this necessarily, as did the kind of environmental installation that Fontana explored early on (the form has since become a whole genre of art). Painting, though, would demand radical surgery: the rupturing of the picture's flatness.

The canvas or paper support is a literal foundation of painting, the stage on which all of the picture's events must play themselves out. To puncture this plane, or to slash it with a knife, is a daring, even shocking act for a painter. *Spatial Concept* clearly conveys the considerable psychological nerve Fontana's gesture took.

The Swimming Pool. 1952

Nine-panel mural in two parts: gouache on paper, cut-and-pasted, on white painted paper, mounted on burlap, a–e: 7'6⅝" × 27'9½" (230.1 × 847.8 cm); f–i: 7'6⅝" × 26'1½" (230.1 × 796.1 cm)

Mrs. Bernard F. Gimbel Fund

Commenting on *The Swimming Pool,* his largest cutout, Matisse said, "I have always adored the sea, and now that I can no longer go for a swim, I have surrounded myself with it." Indeed, this nearly fifty-four-foot-long frieze of blue bathers silhouetted against a white rectangular band was designed to adorn the walls of Matisse's dining room at the Hôtel Régina in Nice. At the time of its creation, the artist was restricted to his bed or to a wheelchair, and he conjured this lyrical depiction of the natural world for his personal enjoyment.

Read from right to left, beginning and ending with a representation of a starfish, the contours of the diving or swimming forms eventually dissolve until the blue shapes define the splashing water and the negative white space represents the abstract figures. In a dynamic interplay with the background support, each bather flows rhythmically into the next, sometimes breaking free of the horizontal band in a graceful arabesque. Matisse combines contrasting viewing angles—from above looking down into the water or sideways as if from in the water—so that the different postures of the figures themselves determine the composition as a whole. With this spirited yet serene aquatic imagery, the artist brings to brilliant culmination his career-long desire to create an idealized environment.

Farnsworth House, Plano, Illinois. 1946–51

Preliminary version, north elevation, 1946:
pencil and watercolor on tracing paper, 13 × 25"
(33 × 63.5 cm)
Mies van der Rohe Archive. Gift of the architect

The weekend house for Dr. Edith Farnsworth represented by this rendering is one of Mies van der Rohe's clearest expressions of his ideas about the relationship between architecture and landscape. The transcendent quality he achieved in his architecture is epitomized by the reductive purity and structural clarity of this steel and glass structure. The space of the house is defined by its roof and floor planes, the whole supported by eight steel columns. All the steel elements are painted white. The architect claimed: "We should strive to bring Nature, houses, and people together into a higher unity. When one looks at Nature through the glass walls of the Farnsworth House it takes on a deeper significance than when one stands outside. More of Nature is thus expressed— it becomes part of a greater whole."

Set in a meadow overlooking the Fox River, which is prone to flooding, the house is elevated above the ground. Aesthetically, this contributes to the effect of weightlessness, reinforced by the cantilevered roof and floor planes and by the asymmetrical placement of the two travertine terraces that imply an infinite extension into space. Mies van der Rohe's transformation of a classical pavilion into a completely modern, abstract idiom—based on a carefully studied sense of proportion and structural logic—is a sublime testament to his apocryphal statement: "less is more."

Shirley Embracing Sam. 1952
Gelatin silver print, 13⅜ × 10⅛" (34 × 25.7 cm)
Gift of the artist

This picture appeared in DeCarava's book *The Sweet Flypaper of Life*, in 1955, with a text by the American poet Langston Hughes. The book has been praised as a sympathetic view of everyday life in Harlem, New York, drawn by two members of the community rather than by visiting sociologists or reformers. The praise is reasonable as far as it goes, but it fails to note the originality of the photographs DeCarava made behind closed doors, which describe his friends with the same gentleness and warmth they accord to each other. No photographer before him had pictured domestic life—black or white—with such unsentimental tenderness.

To make a picture, a photographer must be in the presence of the subject. This simple fact, often overlooked, except where inaccessible mountain peaks or bloody battlefields plainly have demanded the photographer's resourcefulness or heroism, is a fundamental condition of photography. It helps to explain the relative rarity (apart from snapshots) of intimate pictures of domestic life: to photograph in another person's home, the photographer must be invited inside.

Jacob's Ladder. 1957

Oil on unprimed canvas, 9' 5 ⅜" × 69 ⅞"
(287.9 × 177.5 cm)
Gift of Hyman N. Glickstein

The delicately colored *Jacob's Ladder* shows compositional echoes ranging back to Cubism and the early abstractions of Vasily Kandinsky, but as a young New York artist in the 1950s, Frankenthaler was most influenced by the Abstract Expressionists. Like Jackson Pollock, she explored working on canvases laid on the floor (rather than mounted on an easel or wall), a technique opening new possibilities in the handling of paint, and therefore in visual appearances. Letting paint fall onto canvas emphasized its physicality, and the physicality of the support too.

Frankenthaler also admired the scale of Pollock's work, and she took from him, she said, her "concern with line, fluid line, calligraphy, and...experiments with line not as line but as shape."

Frankenthaler departed from Pollock's practice in the way she used areas of color and in her distinctive thinning of paint so that it soaked into her unprimed canvases. Because the image is so plainly embedded in the cloth, its presence as flat pigmented canvas tends to overrule any illusionistic reading of it—a priority in the painting of the time. Nor should the work's title suggest any preplanned illustrational intention. "The picture developed (bit by bit while I was working on it) into shapes symbolic of an exuberant figure and ladder," Frankenthaler said, "therefore *Jacob's Ladder*."

Tulip Armchair. 1955–56

Fiberglass-reinforced polyester shell, cast
aluminum base with fused plastic finish, and
upholstered cushion, 31½ × 25¾ × 23"
(80 × 65.4 × 58.4 cm)
Manufacturer: Knoll International, USA
Gift of the manufacturer

The Tulip Armchair, which resembles
the flower but also a stemmed wineglass,
is part of Saarinen's last furniture series.
This one-legged chair was meant to alle-
viate one of Saarinen's great concerns:
clutter. Describing his intentions to sim-
plify and clarify structure, he said: "The
undercarriage of chairs and tables in a
typical interior makes an ugly, confusing,
unrestful world. I wanted to clear up the
slum of legs. I wanted to make the chair
all one thing again." Saarinen designed
each piece in the Tulip series of furni-
ture with a single pedestal leg, creating a
unified environment of chairs, tables,
and stools.

The Tulip chair also marks the cul-
mination of Saarinen's efforts to create a
chair molded from a single material,
which furthered his design concept of
"one piece, one material." But, while the
elegant Tulip chair looks as if it is made
of all one material, the sculptural fiber-
glass shell seat is actually supported on an
aluminum stem with a fused plastic finish.

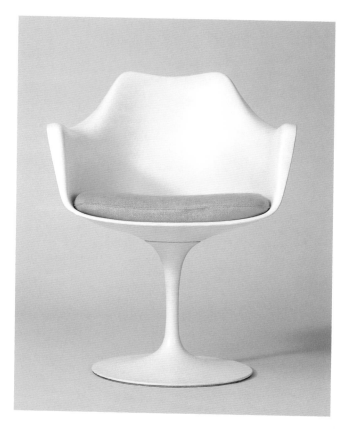

Study for **White Plaque: Bridge Arch and Reflection.** 1951
Cut-and-pasted black papers, 20¼ × 14¼"
(51.4 × 36.1 cm) (irreg.)
Gift of the artist in honor of Mr. and
Mrs. Joseph Pulitzer, Jr.

Like most of Kelly's collages from the late 1940s to the early 1950s, Study for *White Plaque: Bridge Arch and Reflection* was inspired by a real-life experience: the view of the Pont de La Tournelle in Paris arching over the Seine. The darker strip of glossy black paper stretched horizontally across the center indicates the area in deepest shadow; it also separates the bridge's shaded tunnel, or negative space, from its murky reflection.

Executed in France, where Kelly lived from 1948 to 1954, works such as this study provided the genesis for the ensuing development of his art. With their uniquely stylized motifs, these works established the basis for the singular abstract vocabulary that defines his later work.

In 1954–55, after his return to New York, Kelly executed a larger wood relief identical to this image. He painted this work a luminous white, thus distancing the motif from its original source and creating an autonomous pictorial statement. The wood relief is considered a major breakthrough toward his mature emblematic style and was an early forerunner of what came to be known as the shaped canvas.

Sky Cathedral. 1958

Assemblage: wood construction painted black,
11' 3½" × 10' ¼" × 18" (343.9 × 305.4 × 45.7 cm)
Gift of Mr. and Mrs. Ben Mildwoff

As a rectangular plane to be viewed from the front, *Sky Cathedral* has the pictorial quality of a painting—perhaps one of the preceding decade's Abstract Expressionist canvases, which share its mural scale. But this sculpture in relief commands a layered depth. Its intricacy lies in both the method of its construction—it is made of shallow open boxes fitted together in a jigsawlike stack—and those boxes' contents, the salvaged wood bits and pieces with which Nevelson filled many of her works. These include moldings, dowels, spindles, chair parts, architectural ornaments, and scroll-sawed fragments. Nevelson makes this material into a high wall variegated by a play of flatness and recession, straight lines and curves, overlaps and vacancies, that has been likened to the faceting of Cubism and has an absorbing visual complexity.

A Surrealist artist might have shared Nevelson's relish for curious bric-à-brac, but might also have arranged such a collection in jarring and disorienting juxtapositions. Nevelson, by contrast, paints every object and box the same dully glowing black, unifying them visually while also obscuring their original identities. The social archaeology suggested by the objects' individual histories and functions, then, is muted but not erased; it is as if we were looking at the wall of a library, in which all of the books had been translated into another language.

Oskar Fischinger | German, 1900–1967

Motion Painting I. 1947
35mm film, animated, color, sound, 11 minutes
Gift of the Walt Disney Company

A film of extraordinary beauty and rhythmic power, this eleven-minute masterpiece is an abstract work created by painting with oils on Plexiglas. Set to an excerpt from J. S. Bach's *Brandenburg Concerto No. 3*, it comprises a joyfully exuberant series of intricate transformations, one every twenty-fourth of a second, that explore the dynamic relationship between sound and image. A film whose unique combination of visual and aural tonalities never ceases to amaze and charm, *Motion Painting I* is a testament to one remarkable artist's passion for experimentation and invention.

In 1936 Fischinger had accepted an invitation from Paramount to come to America and work for its studio in Hollywood. In Germany he had been a distinguished inventor, theorist, and maker of abstract and industrial short films. Once in the United States, however, he soon found himself at odds with the factorylike methods of the major studios, and sought expression in the creation of independently financed, experimental films. His greatest achievement in this field, and his last completed project, is *Motion Painting I*. However, the film was misunderstood by its financial backers, and Fischinger was unable to make copies of it for distribution. During the next twenty years, Fischinger continued to work on various film projects, but none were brought to completion.

Towards Disappearance, II. 1958

Oil on canvas. 9' ½" × 10' 5⅞" (275.6 × 319.7 cm)
Blanchette Rockefeller Fund. Purchased from
Robert Elkon Gallery, New York

Towards Disappearance, II is a cloud of
blues, yellows, and reds, and of red's
variants in oranges and pinks. In earlier
works, Francis had used a structure of
interlocking cells or globules, close in
size and shape; traces of this structure
remain, but more-ragged formations
and drips suggest a less orderly energy.
Restraining clusters of black collect in
the upper part of the canvas, but their
weight only heightens the force of the
exuberant primaries, which seem to loft
them by bubbling up from below. After
the mid-1950s, Francis increasingly
enjoyed creating contrast through areas
of white. Pressing in from the sides, and
glimmering in the crevices among the
patches of pigment, the white in
Towards Disappearance, II only makes
the colors brighter.

Studying painting in California in
the late 1940s, Francis had seen exhibi-
tions of Abstract Expressionism, and
had absorbed the ideas of the New York
School. His next stop, though, was not
New York but Paris, where he lived
through much of the 1950s; he admired
Pierre Bonnard and Henri Matisse, and
was particularly influenced by the irides-
cent atmospheres of Claude Monet's
Water Lilies series. In consequence,
Francis is often seen as inheriting the
potent love of color in French art. As he
himself said, "Color is the real substance
for me, the real underlying thing which
drawing and line are not."

Ladybug. 1957
Oil on canvas, 6' 5⅞" × 9' (197.9 × 274 cm)
Purchase

The formal structure of Mitchell's paintings, and their physical quality and sense of process, are extensions of Abstract Expressionism, but in some respects Mitchell challenged the conventional wisdom of the New York School. (She also left New York, joining Sam Francis and others of her generation in Paris.) Abstract though her paintings are, she saw them as dealing with nature—with the outside world, that is, rather than the inner one. In fact she shunned self-expression as such; her work, she said, was "about landscape, not about me." Nor did she consider herself an "action painter," since she worked more from thought than from instinct. "The freedom in my work is quite controlled," Mitchell said, "I don't close my eyes and hope for the best."

Ladybug abuts pure colors with colors that mix on the canvas, dense paint with liquid drips, flatness with relief. Empty areas at the work's edges suggest a basic ground, which seems to continue under the tracery of color; but the white patches here are actually more pigment, and shift in intensity and texture. Struggling out between short, firm, jaggedly arranged strokes of blue, mauve, green, brown, and red, the whites aerate this energized structure, appearing ambiguously both under and over it. No landscape is evident; Mitchell set out not to describe nature but "to paint what it leaves me with."

Á toute épreuve by Paul Éluard.
1947–58
Illustrated book with 79 woodcuts including collagraph and collage, page: 12⁹⁄₁₆ × 9¹³⁄₁₆"
(32 × 25 cm)
Publisher: Gérald Cramer, Geneva. Edition: 130
The Louis E. Stern Collection

On facing pages, two fantastical beings of Miró's imagination engage the viewer with dramatic gestures and bright colors. The whimsical abstract form on the right appears to reach out to the female figure at the left with the assertion, "Je n'ai jamais changé" ("I have never changed"). These words repeat the last line from a poem on the previous page.

Á toute épreuve, a monumental project executed over more than a decade, consists of a series of lyrical poems that Éluard had written in the late 1920s, at the time that his wife, Gala, abandoned him for Salvador Dalí. This book about love and the Catalan region of Spain was a collaborative effort involving the artist Miró, the poet Éluard, and the Swiss publisher Cramer. All three had a hand in the imaginative layouts—which interlock text and images—and the choice of paper and typeface.

Miró's woodcuts and collagraphs demonstrate the inventiveness of his printmaking. Instead of cutting into a block of wood to create the compositions, Miró arranged his designs—composed of "found" scraps of wood—on pieces of plywood. He also bent metal wires into linear elements and then glued these components to a plywood backing before printing. The results are some of the most exuberant graphic images ever created.

Sea Grasses and Blue Sea. 1958

Oil on canvas, 60⅛" × 6' ⅜" (152.7 × 183.7 cm)

Gift of friends of the artist

Avery painted scenes of nature throughout his career, but he preferred simple forms to realistic details, and his palette is distinctively personal. The results come close to abstraction. In *Sea Grasses and Blue Sea* (based on Avery's memories of Provincetown, Massachusetts), the sky is a straight and narrow blue band at the painting's upper rim. The rest of the canvas is divided into two trapezoids of almost equal size and shape. The lower of these, the sea grass, is pale and lightly streaked, and echoes the tonality of the sky; above it is a wedge of a predominantly darker, saturated blue, with patches both of a lighter blue and, more sharply, of deep black. Magically, the overall effect is of waves flecked with white foam.

That black is paradoxical: as Matisse remarked of the black in one of his own paintings, it is used as "a color of light and not as a color of darkness." In various ways, in fact, Avery is closer to Henri Matisse than to the styles that prevailed in America during his lifetime—in his love of clarified form and flat color, for example, and in the sense of rich serenity that permeates his art.

Large Sleeve (Sunny Harnett), New York. 1951

Gelatin silver print, 13⁹⁄₁₆ × 13⁹⁄₁₆" (34.5 × 34.5 cm)
Gift of the artist

A fashion photograph aims to describe an ideal, one that we, as consumers, might aspire to. It is the creation of an illusion. In this picture, the curved forms—the woman's mouth, her neck, the shape of her hat, her left sleeve and, of course, her beautifully deployed right sleeve—are so exquisitely balanced that we accept as inevitable the photographer's daring cropping of the model's head.

Penn came into prominence as a photographer of fashion in 1950. His signature style, at once austere and elegant, swept away the elaborate theatrical trappings of the past. His pictures seemed to embody a new American confidence and taste for clarity in the aftermath of World War II. As times and fashions changed, however, the pictorial economy and rigorous craft of Penn's work—the poise and grace of his pictures—did not. Over the course of half a century, his stubborn pursuit of perfection has indeed given us something to aspire to.

Vertigo. 1958
35mm film, color, sound, 128 minutes
James Stewart, Kim Novak

A suspense drama as well as a complex psychological study, *Vertigo* tells the story of a former police detective, Scottie Ferguson (James Stewart), who is hired to shadow the suicidal Madeleine Elster (Kim Novak) as she sleepwalks through San Francisco. The enigmatic blond soon becomes the object of Ferguson's repressed desire, and he becomes so obsessed with curing her that he endangers his rational belief system. As he compulsively tries to help (and control) Elster, his own fear of heights makes him, ultimately, unable to prevent her suicide. Later, he meets another woman, who looks just like Elster, and tries to regain control by remaking her into a fetishized image of the dead woman. Eventually, however, the detective is revealed to have been a pawn in somebody else's deceptive scheme all along.

Employing surreal imagery and using fog filters to create dreamlike colors—all supported by Bernard Herrmann's haunting score—Hitchcock brilliantly explores his protagonist's spiraling psychological disintegration and pathological obsession with the perfect image of an unattainable woman. The filmmaker's masterful manipulation of the audience parallels the story line, particularly the detective's compulsion to manipulate the fate of the woman. Hitchcock visualizes Ferguson's acrophobia by repeating a vertiginous zoom-forward/track-backward shot. In addition, many familiar themes that recur in other Hitchcock films—fetishism, scopophilia, necrophilia, and the Doppelgänger motif—are present in this chilling, probing film.

Parade, Hoboken, New Jersey. 1955

Gelatin silver print, 8⅛ × 12¹⁵/₁₆" (20.6 × 31.2 cm)
Purchase

In this picture two citizens observe a parade, and a flag is on display to celebrate the patriotic occasion. The mood is dark, however, and the faces of the people are obscured, one of them by the flag itself.

The photograph is from Frank's book *The Americans*, first published in France in 1958 and in the United States the following year. In the years before museums and galleries took widespread notice of photography—that is, before the 1970s—books conceived and edited by the photographer played a leading role in bringing advanced photography to public notice. *The Americans*, one of the touchstones of this genre, helped to establish the artistic significance of what photographers call "a body of work"—a series of pictures unified by the author's sensibility and outlook rather than by a particular theme or by an assignment from a magazine editor.

In fact, the nominal subject of *The Americans* is so broad that it scarcely serves as an organizing principle. The book's coherence rests instead on Frank's talent for transforming fragments of observation into articulate symbols, all of them tinged by his caustic and forlorn vision of his adoptive country. The pictures are knit together, as well, by recurring icons of national identity, notably the flag, which appears and reappears on the scene like the sinister protagonist of a tragedy.

Canto XXXI: The Central Pit of Malebolge, The Giants: Illustration for Dante's Inferno. 1959–60

Solvent transfer, pencil, gouache, and color pencil on paper, 14⅜ × 11⅜" (36.6 × 29 cm)
Given anonymously

In eighteen months, Rauschenberg created thirty-four illustrations for Dante's *Inferno*, using the technique of transfer drawing. Each illustration, one for each canto, is intended to be read vertically from upper left to lower right as an episodic narrative with sequential events flowing into one another. Characters in the allegory are represented by photographs—culled from the mass media—of athletes, politicians, and astronauts, among others. In this image, Dante and his guide, Virgil, approach the eighth circle of Hell. Dante appears in the upper left-hand corner as a man wrapped in a towel. The guardians of Hell, described in the poem as formidable giants, are shown at the lower right as Olympic athletes standing on a podium. The oversized chain link indicates the giants' power; it also refers to their being chained for their sins. Below, the tiny figures of the two poets are lowered into the pit. By using recognizable imagery to relate the classic text of a quest for divine truth, Rauschenberg integrates the high and the low, the real and the illusory, the past and the present.

In creating his illustrations, the artist clipped reproductions from magazines, coated them with chemical solvent, and placed them face down on the drawing surface. The reverse sides of the clippings were rubbed over with a pen, transferring the images onto the paper. Finally, an overlay of transparent washes of gouache and pencil marks was added to allude to different moods or emotional states.

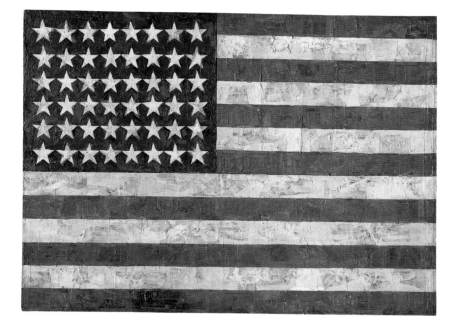

Flag. 1954–55 (dated on reverse 1954)
Encaustic, oil, and collage on fabric, mounted
on plywood, 42¼ × 60⅝" (107.3 × 153.8 cm)
Gift of Philip Johnson in honor of Alfred H.
Barr, Jr.

When Johns made *Flag*, the dominant
American art was Abstract Expression-
ism, which enthroned the bold, sponta-
neous use of gesture and color to evoke
emotional response. Johns, though, had
begun to paint common, instantly recog-
nizable symbols—flags, targets, num-
bers, letters. Breaking with the idea of
the canvas as a field for abstract personal
expression, he painted "things the mind
already knows." Using the flag, Johns
said, "took care of a great deal for me
because I didn't have to design it." That
gave him "room to work on other levels"
—to focus his attention on the making
of the painting.

The color, for example, is applied
not to canvas but to strips of newspa-
per—a material almost too ordinary to
notice. Come close to the painting,
though, and those scraps of newsprint
are as hard to ignore as they are to read.
Also, instead of working with oil paint,
Johns chose encaustic, a mixture of pig-
ment and molten wax that has left a sur-
face of lumps and smears; so that even
though you recognize the image in a sec-
ond, close up it becomes textured and
elaborate. It is at once impersonal, or
public, and personal; abstract and repre-
sentational; easily grasped and demand-
ing of close attention.

The Marriage of Reason and Squalor, II. 1959

Enamel on canvas, 7' 6¾" × 11' ¾" (230.5 × 337.2 cm)

Larry Aldrich Foundation Fund

In each half of *The Marriage of Reason and Squalor, II*, stripes outline stripes in an inverted U-shape, a regular, self-generating pattern. Filling the canvas according to a methodical program, Stella suggests an idea of the artist as laborer or worker. (He also uses commercial paint—black enamel—and a house-painter's brush.) The systematic quality of Stella's Black Paintings decisively departed from the ideas of inspired action associated with Abstract Expressionism, the art of the preceding generation, and anticipated the machine-made Minimal art of the 1960s. But many of them, like this one, are subtly personal:

Stella worked freehand, and irregularities in the lines of the stripes reveal the slight waverings of his brush. His enamel, too, suggests a bow to the Abstract Expressionist Jackson Pollock, who had also used that paint.

Stella's use of stripes was motivated by the work of Jasper Johns, particularly Johns's paintings of flags. "The thing that struck me most," Stella has said, "was the way he stuck to the motif...the idea of stripes—rhythm and interval— the idea of repetition." But Stella went farther than Johns in "sticking to the motif," removing the flag and leaving only the stripes. "My painting," he said, "is based on the fact that only what can be seen there *is* there.... What you see is what you see."

Pather Panchali. 1955
35mm film, black and white, sound, 112 minutes
Acquired from Edward Harrison
Subir Banerjee

In *Pather Panchali*, the tale of a poor family living in its ancestral Bengali village, Ray employed unknown actors and shot the film on location. His use of neo-realist techniques challenged the song-and-dance melodramatic form then characteristic of Indian cinema. Over the course of this film and its two sequels, *Aparajito* and *The World of Apu*, viewers witness the world through the eyes of the young boy, Apu, whose developing consciousness parallels the changing face of a newly independent India.

A filmmaker who could capture the essential themes of his culture while also evoking universal truths and values, Ray is recognized worldwide as a great poetic realist. In the early 1950s he was working as a graphic artist when he decided to make a film from a book he was illus-trating, the popular serial novel *Pather Panchali*. Ray had great difficulty financing his film throughout its production, and much of the work was done by amateurs. Although Ray was dissatisfied with its technical deficiencies, *Pather Panchali* is admired for its casual and direct style. The prolific body of cinematic work produced in India, which today ranks in ambition and popularity with that of the United States and Japan, owes much of its international stature to Ray's distinguished career, which was launched by this film.

F-111. 1964–65
Oil on canvas with aluminum, overall 10 × 86'
(304.8 × 2621.3 cm)
Gift of Mr. and Mrs. Alex L. Hillman
(by exchange) and Lillie P. Bliss Bequest
(by exchange)

"Painting is probably much more exciting than advertising," Rosenquist has said, "so why shouldn't it be done with that power and gusto, with that impact." Like other Pop artists, Rosenquist is fascinated by commercial and everyday images. He also understands the power of advertising's use of "things larger than life"—he once painted billboards for a living—and even in early abstractions he borrowed the exaggeratedly cheerful palette of the giant signs. His next step was to explore the artistic potential of the billboard's scale and photographic style.

Rosenquist generally spikes that style with disorienting fractures and recombinations of images. *F-111* becomes still more overwhelming through its particularly enormous size and panoramic shape: it is designed to fill the four walls of a room, engulfing and surrounding the viewer—unlike a billboard, which, despite its magnitude, can be viewed all at once. Also unlike a billboard, *F-111* fuses pictures of American prosperity with a darker visual current. A diver's air bubbles are rhymed by a mushroom cloud; a smiling little girl sits under a missilelike hairdryer; a sea of spaghetti looks uncomfortably visceral; and weaving through and around all these images is the F-111 itself, a U.S. Air Force fighter-bomber. Painted during the Vietnam War, *F-111* draws disturbing connections between militarism and the consumerist structure of the American economy.

2001: A Space Odyssey. 1968
35mm film, color, sound, 137 minutes
Acquired from Turner Entertainment Co.
Keir Dullea

This landmark science-fiction odyssey uses the idea of futuristic space travel to fashion an allegory on the nature of God, the evolution of life on earth, and the role of technology in human existence. Attempting to ask, not answer, the metaphysical questions that plague human existence, this film begins with "the dawn of man," when tools are first used, and ends as the human cycle is renewed in the year 2001.

In the film, astronauts are sent deep into the solar system to investigate the sound waves emanating from a black monolith discovered beneath the moon's surface. (This same structure is found on earth by the early hominids appearing at the beginning of the film.) During the journey, the HAL 9000, the computer that maintains the ship, becomes an independent thinker, not a tool, and attempts to kill the humans. One survives, disables the computer, and continues forward through time and space to an undefined interior, where he is confronted by his aged self and ultimately his death and rebirth.

Initially, many critics were hostile toward the film, which forced viewers to speculate and seemed confusing. Yet most, and certainly the large audiences that attended, found the film—with its innovative techniques, realistic effects, and graceful score—to be spellbinding and intelligent. *2001: A Space Odyssey* remains equally fresh and thought-provoking, at the high-water mark in the science-fiction genre.

Girl with Ball. 1961
Oil and synthetic polymer paint on canvas,
60¼ × 36¼" (153 × 91.9 cm)
Gift of Philip Johnson

Lichtenstein took the image for *Girl with Ball* straight from an advertisement, for a hotel in the Pocono Mountains. In pirating the image, however, he transformed it, submitting the ad's photograph to the techniques of the comic-strip artist and printer—and transforming those techniques, too, into a painter's versions of them. The resulting simplifications intensify the artifice of the picture, curdling its careful dream of fun in the sun. The girl's rounded mouth is more doll-like than female; any sex appeal she had has become as plastic as her beach ball.

In choosing the banal subject matter of paintings like *Girl with Ball*, Lichtenstein challenged the aesthetic orthodoxy of the time, still permeated by the spiritual and conceptual ambitions of Abstract Expressionism. The moral seriousness of art, and art's longevity, seemed foreign to this cheap, transient ad from the consumer marketplace, a sector of roiling turnover. Startling though the image was as an artwork, in fact, as advertising it was already old-fashioned—so that Lichtenstein's painting admits of a certain nostalgia. His simulation of printing similarly robs the technology of the polish it had already achieved: overstating the dots of the Benday process, and limiting his palette to primary colors, he exaggerates the limitations of mechanical reproduction, which becomes as much the subject of the painting as the girl herself.

Richard Hamilton | British, born 1922

Pin-up. 1961
Oil, cellulose, and collage on panel, 48 × 32 × 3"
(121.9 × 81.3 × 7.6 cm)
Enid A. Haupt Fund and an anonymous fund

"Popular (designed for a mass audience), transient (short-term solution), expendable (easily forgotten), low cost, mass-produced, young (aimed at youth), witty, sexy, gimmicky, glamorous, big business." So Hamilton once described modern consumer culture—the culture that he and the other Pop artists (whether British, like Hamilton, or American) felt art had to confront. No surprise, then, that the sources of *Pin-up* include what Hamilton calls "girlie pictures," both "the sophisticated and often exquisite photographs in *Playboy*" and the more "vulgar" images found in that magazine's "pulp equivalents." Less obvious, perhaps, are the references to art history—

the passages, for example, that Hamilton asserts "bear the marks of a close look at Renoir."

The nude, or the more provocative odalisque, is of course an enduring theme in art, and *Pin-up* advances an argument over what an appropriate contemporary treatment of a classic art-historical theme might be. Such a treatment, Hamilton believes, would demand a "diversifying" of the languages of art, so that he approaches the odalisque tradition through a variety of pictorial modes: the hair, for example, is a stylized cartoon, the breasts appear both in drawing and in three-dimensional relief, and the bra is a photograph applied as collage. "Mixing idioms," Hamilton has said, "is virtually a doctrine in *Pin-up*"—an image both tawdry and extraordinarily sophisticated.

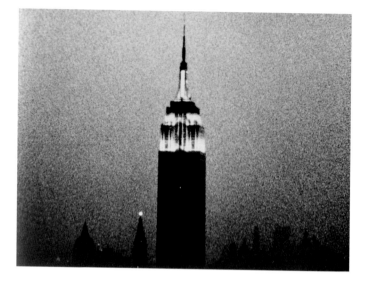

Empire. 1964

16mm film, black and white, silent, 8 hours, 6 minutes (approx.)

The Andy Warhol Foundation for the Visual Arts Film Preservation Program

Empire consists of one stationary shot of the Empire State Building taken from the forty-fourth floor of the Time-Life Building. Jonas Mekas served as cameraman. The shot was filmed from 8:06 p.m. to 2:42 a.m. on July 25–26, 1964. *Empire* consists of a number of one-hundred-foot rolls of film, each separated from the next by a flash of light. Each segment of film constitutes a piece of time. Warhol's clear delineation of the individual segments of film can be likened to the serial repetition of images in his silkscreen paintings, which also acknowledge their process and materials.

Warhol conceived a new relationship of the viewer to film in *Empire* and other early works, which are silent, explore perception, and establish a new sense of cinematic time. With their disengagement, lack of editing, and lengthy nonevents, these films were intended to be part of a larger environment. They also parody the goals of his avant-garde contemporaries who sought to convey the human psyche through film or used the medium as metaphor.

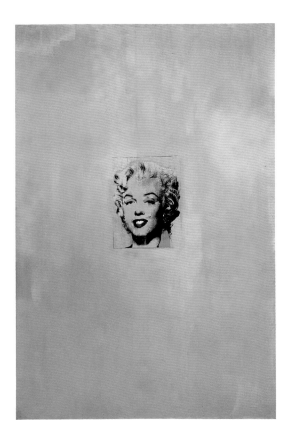

Gold Marilyn Monroe. 1962

Synthetic polymer paint, silkscreened, and oil
on canvas, 6' 11¼" × 57" (211.4 × 144.7 cm)
Gift of Philip Johnson

Marilyn Monroe was a legend when she
committed suicide in August of 1962,
but in retrospect her life seems a gradual
martyrdom to the media and to her pub-
lic. After her death, Warhol based many
works on the same photograph of her, a
publicity still for the 1953 movie *Nia-
gara*. He would paint the canvas with a
single color—turquoise, green, blue,
lemon yellow—then silkscreen Monroe's
face on top, sometimes alone, sometimes
doubled, sometimes multiplied in a grid.
As the surround for a face, the golden
field in *Gold Marilyn Monroe* (the only
one of Warhol's Marilyns to use this
color) recalls the religious icons of
Christian art history—a resonance,
however, that the work suffuses with a
morbid allure.

In reduplicating this photograph of
a heroine shared by millions, Warhol
denied the sense of the uniqueness of
the artist's personality that had been
implicit in the gestural painting of the
1950s. He also used a commercial tech-
nique— silkscreening—that gives the
picture a crisp, artificial look; even as
Warhol canonizes Monroe, he reveals
her public image as a carefully structured
illusion. Redolent of 1950s glamour, the
face in *Gold Marilyn Monroe* is much like
the star herself—high gloss, yet tran-
sient; bold, yet vulnerable; compelling,
yet elusive. Surrounded by a void, it is
like the fadeout at the end of a movie.

Blue Monochrome. 1961
Dry pigment in synthetic polymer medium on
cotton over plywood, 6' 4⅞" × 55⅛"
(195.1 × 140 cm)
The Sidney and Harriet Janis Collection

"*Yves le monochrome*," as Klein called
himself, saw the monochrome painting
as an "open window to freedom, as the
possibility of being immersed in the
immeasurable existence of color."
Although he used a range of colors
before concentrating on three—blue,
gold, and a red he called Monopink—he
is most associated with a blue he named
International Klein Blue, which he
arrived at by working with a chemist to
develop a binding medium that could
absorb pure color pigment without dim-
ming its brilliant intensity. A student of
Rosicrucianism and of Eastern religions,
Klein entertained esoteric and spiritual

ideas in which blue played a vital role as
the color of infinity. Keenly aware that
pigment is a substance of the earth, Klein
also devised methods to make paintings
using the other three elements—air (in
the form of wind), water (in the form of
rain), and fire.

Kazimir Malevich's *Suprematist
Composition: White on White* (1918) is
the major historical precedent for recent
monochrome, but Klein argued that the
Russian artist's primary concern had
been with form—the square—rather
than with color. As a result, Klein felt
that "Malevich was actually standing
before the infinite—I am in it."

Ad Reinhardt | American, 1913–1967

Abstract Painting. 1963
Oil on canvas, 60 × 60" (152.4 × 152.4 cm)
Gift of Mrs. Morton J. Hornick

To the hasty viewer, *Abstract Painting* must present a flat blackness. But the work holds more than one shade of black, and longer viewing reveals an abstract geometrical image. Reinhardt has divided the canvas into a three-by-three grid of squares. The black in each corner square has a reddish tone; the shape between them—a cross, filling the center square of the canvas and the square in the middle of each side—is a bluish black in its vertical bar and a greenish black in its horizontal one.

Works like this were strongly influential for the Minimalist and Conceptual artists of the 1960s, who admired their reductive and systematic rigor. But the poetry of their finely handled surfaces, and their deeply contemplative character, tie them to the Abstract Expressionist generation of which Reinhardt was a member, if a dissident one. Insisting on the separation of art from life, Reinhardt tried to erase from his work any content other than art itself. In the late black canvases that include *Abstract Painting* (he called them his "ultimate" paintings) he was trying to produce what he described as "a pure, abstract, non-objective, timeless, space-less, changeless, relationless, disinterested painting—an object that is self-conscious (no unconsciousness), ideal, transcendent, aware of no thing but art."

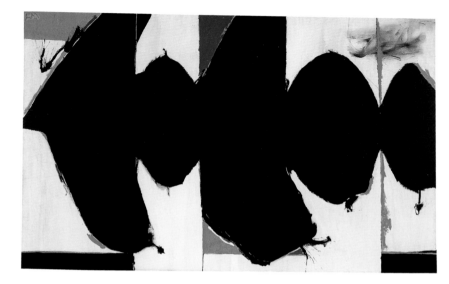

Elegy to the Spanish Republic, 108. 1965–67

Oil on canvas, 6'10" × 11'6¼" (208.2 × 351.1 cm)
Charles Mergentime Fund

Elegy to the Spanish Republic, 108
describes a stately passage of the organic
and the geometric, the accidental and
the deliberate. Like other Abstract
Expressionists, Motherwell was
attracted to the Surrealist principle of
automatism—of methods that escaped
the artist's conscious intention—and his
brushwork has an emotional charge, but
within an overall structure of a certain
severity. In fact Motherwell saw careful
arrangements of color and form as the
heart of abstract art, which, he said, "is
stripped bare of other things in order to
intensify it, its rhythms, spatial intervals,
and color structure."

Motherwell intended his Elegies to
the Spanish Republic (over 100 paint-
ings, completed between 1948 and 1967)
as a "lamentation or funeral song" after
the Spanish Civil War. His recurring
motif here is a rough black oval, repeated
in varying sizes and degrees of compres-
sion and distortion. Instead of appearing
as holes leading into a deeper space,
these light-absorbent blots stand out
against a ground of relatively even, pre-
dominantly white upright rectangles.
They have various associations, but
Motherwell himself related them to the
display of the dead bull's testicles in the
Spanish bullfighting ring.

Motherwell described the Elegies as
his "private insistence that a terrible death
happened that should not be forgot. But,"
he added, "the pictures are also general
metaphors of the contrast between life
and death, and their interrelation."

Man with Keloidal Scars. 1962
Gelatin silver print, 13 × 8¹³/₁₆" (33 × 22.4 cm)
Gift of the artist

This picture appeared in Tomatsu's first book, *Nagasaki 11:02*, whose title marks the minute that the American atomic bomb devastated Nagasaki on August 9, 1945, precipitating the end of World War II. The subject is a man who survived, but was permanently scarred by, the explosion. Tomatsu has cast the man's face in shadow and has sharply illuminated his scars to register a frightening, irregular form—a striking metaphor for violence and suffering. The picture was made in the 1960s, during Japan's extraordinary economic recovery from the war, and it may be interpreted not only as a cry of protest against the bomb but as a call to memory to the Japanese people.

The war deeply affected Japanese photographers of Tomatsu's generation in two key respects: it compelled them to confront the unprecedented catastrophe that had been unleashed on their people, and it opened a path for them to do so, for the American occupation dismantled the Shinto state, dissolving the emperor's autocratic rule. Liberated from the weight of ancient cultural strictures, Tomatsu and his contemporaries created a highly expressive style of photography, full of dramatic forms and abrupt contrasts of light and dark, through which they were able to address the profound events that had shaped their lives.

Beta Lambda. 1960
Synthetic polymer paint on canvas, 8' 7⅜" ×
13' 4¼" (262.6 × 407 cm)
Gift of Mrs. Abner Brenner

Beta Lambda belongs to Louis's
Unfurled series, in which diagonal
bands of paint at each picture's sides are
widely separated by the expanse of bare
canvas between them, a powerful empti-
ness. Each band contains multiple
rivulets of color, which now progress
evenly through the spectrum, now pop
with contrast, like the blue at the right
of *Beta Lambda*. The pared-down sim-
plicity of Louis's work focused a concern
in the painting of the time: a concentra-
tion on the art's essential elements—line,
color, ground.

Chronologically, Louis came from
the Abstract Expressionist generation,
but he mostly worked at a geographical
and psychological remove from the New
York School, and although he was cru-
cially influenced by a member of that
circle—Helen Frankenthaler—she was
rather younger than its pioneers. As a
result, his work both reflects and departs
from Abstract Expressionist ideas. Like
Frankenthaler, Louis used unprimed
canvas, which absorbs paint into its fab-
ric, so that it retains a presence in the
finished work. (Primed canvas, con-
versely, takes paint as a discrete layer
resting on and hiding its surface.) Louis
also invented brushless techniques of
applying paint, leaning the canvas
against the wall and pouring the liquid
down the tilted plane. The method
deflates the Abstract Expressionist stress
on the artist's hand and psyche, making
Beta Lambda a visual field to be appreci-
ated for its own sake.

Stan Brakhage | American, 1933–2003

The Text of Light. 1974
16mm film, color, silent, 68 minutes
Jerome Foundation Purchase Fund

Beginning in the 1950s, Brakhage, probably America's most prolific and preeminent independent filmmaker, pursued what he called the "art of vision," using processes of layering, repetition of elements, accumulations of details, juxtapositions of unrelated images, and non-narrative sequences in his experimental films. While many of his works draw from autobiographical experiences, with images of family members and events from his daily life, others are limited in scope and draw from the properties of filmmaking itself.

In the 1970s Brakhage and other filmmakers, such as James Herbert and Andrew Noren, intensified their explorations of cinema's formal properties.

The richest areas of investigation were two of film's basic means of expression: the apparent motility of light and the resultant texture of the transient image. Brakhage's *Text of Light* is the purest of the astonishing works made by these filmmakers. The spare but vital subject of the film is light, and nothing but light. To compose this "text of light," Brakhage examined light refracted through a glass ashtray. Moving and changing color, light offers the viewer a motion picture that percolates vigorously.

Highrise Building: Sparkplug.

Project, 1964
Perspective: collage with photograph and
halftone reproduction, 4¾ × 7¼" (12.1 × 18.4 cm)
Philip Johnson Fund

The surreal juxtaposition of a giant
sparkplug and a rural landscape is a
deliberately provocative gesture. This
fantastic collage registers Hollein's dis-
satisfaction with the architectural status
quo of the early 1960s and invites spec-
ulations about the future of architecture.
Declaring all forms of architecture, even
the vocabulary of modernism, to be
inadequate, Hollein drew upon the con-
sumer products of science and technol-
ogy to create images he believed appro-
priate to the times.

While Hollein's transformations of
commonplace objects and the landscape
in a number of photomontages have
certain parallels with Pop art, he shared
the larger concerns of polemical archi-
tects, such as his countryman Walter
Pichler and members of the British
group Archigram. The imaginary pro-
posals for buildings, cities, and services
made in the early 1960s by Hollein and
other visionary architects anticipated the
radical, often utopian, statements of the
Italian groups Archizoom Associati and
Superstudio toward the end of the 1960s,
a decade that culminated in cultural
upheavals throughout much of the world.
By this time, however, Hollein was redi-
recting his focus. In interiors and build-
ings of the late 1960s and the 1970s, he
included references to historical Viennese
architecture while continuing to juxta-
pose the built and the natural landscape.

Giant Soft Fan. 1966–67
Construction of vinyl filled with foam rubber, wood, metal, and plastic tubing; fan, 10' × 58⅞" × 61⅞" (305 × 149.5 × 157.1 cm), variable; cord and plug, 24' 3¼" (739.6 cm) long
The Sidney and Harriet Janis Collection

Pop art's gaze on the universe of commercial products is often deadpan and cool. With Oldenburg, though, it becomes more comically disorienting: sculptures like *Giant Soft Fan* challenge our acceptance of the everyday world both by rendering hard objects in soft materials, so that they sag and droop, and by greatly inflating their size. (There are also Oldenburg works that make soft objects hard.) The smooth, impersonal vinyl surfaces of *Giant Soft Fan* are Oldenburg's knowing inversion of the hard-edge aesthetic of the 1960s.

There is humor in this transformation of a hard machine into a collapsible object, which, like Salvador Dalí's limp watches, has a not too elliptical bodily and sexual connotation. There is also a subtle nostalgia: in its focus on the culture of its time, Pop art seemed jarringly up-to-date in the 1960s, but this fan's design was old-fashioned even then.

Oldenburg often makes monumental public sculpture, enlarging his everyday objects to a scale far more enormous than even the *Giant Soft Fan*. Notes he wrote in 1967 show him playing with that idea: "The Fan's first placement was on Staten Island, blowing up the bay. Later, I sited it as a replacement for the Statue of Liberty... [guaranteeing] workers on Lower Manhattan a steady breeze."

OOF. 1962–63
Oil on canvas, 71 ½ × 67″ (181.5 × 170.2 cm)
Gift of Agnes Gund, the Louis and Bessie
Adler Foundation, Inc., Robert and Meryl
Meltzer, Jerry I. Speyer, Anna Marie and
Robert F. Shapiro, Emily and Jerry Spiegel, an
anonymous donor, and purchase

"The single word, its guttural monosyl-
labic pronunciation, that's what I was
passionate about," Ruscha has said of
his early work. "Loud words, like *slam,
smash, honk.*" The comic-book quality of
these words reflects the Pop artists' fas-
cination with popular culture. (This
interest is even more explicit in Ruscha's
images of vernacular Los Angeles archi-
tecture.) Lettered in typography rather
than handwriting, the words are definite
and impersonal in shape; unlike the
Abstract Expressionists of the 1940s and
1950s, Ruscha had no interest in letting

a painting emerge through an introspec-
tive process: "I began to see that the
only thing to do would be a precon-
ceived image. It was an enormous free-
dom to be premeditated about my art."
 Words like *oof, smash,* and *honk* all
evoke sounds, and loud and sharp ones.
They also, as Ruscha says, have "a cer-
tain comedic value," and their comedy
is underlined by the paradox of their
appearance in the silent medium of
paint, and with neither an image nor a
sentence to help them evoke the sounds
they denote. *Oof* is particularly paradox-
ical, as a word describing a wordless
grunt. In Ruscha's hands, its double O's
also pun on recent paintings—the Tar-
gets and Circles of Jasper Johns and
Kenneth Noland. Works like this one
wryly point up the arbitrariness of our
agreements on the meanings of our
visual and verbal languages.

Robert Venturi | American, born 1925

Vanna Venturi House, Chestnut Hill, Pennsylvania.

1959–64

Model, Scheme VI (final): cardboard and paper, 7¾ × 20½ × 6¾" (19.7 × 52 × 17.1 cm)

Gift of Venturi, Rauch and Scott Brown, Inc.

The design represented by this modest, cardboard study model of a house for the architect's mother is deceptively simple. The front facade of Venturi's design, for example, has the elements of a conventional house: large gable, chimney, front door, and windows. Yet throughout the building, the adept juxtaposition of big and little elements and the intentional distortion of symmetry establish a richness of meaning and perceptual ambiguity that make the Vanna Venturi residence one of the most important houses of the second half of the twentieth century.

The design for the house coincided in 1961–62 with Venturi's writing of *Complexity and Contradiction in Architecture* (published by The Museum of Modern Art in 1966). This brilliant architectural critique, supported by numerous illustrations of historical buildings, sought to overturn the limitations and reductive simplicity of orthodox modern architecture. Describing his own mannerist inclusive sensibility as "both-and," as opposed to "either-or," he wrote: "If the source of the both-and phenomenon is contradiction, its basis is hierarchy, which yields several levels of meanings among elements with varying values. It can include elements that are both good and awkward, big and little, closed and open, continuous and articulated, round and square, structural and spatial. An architecture which includes varying levels of meaning breeds ambiguity and tension." The Vanna Venturi House is one of the earliest demonstrations of the architect's highly influential ideas.

Ale Cans. 1964
Lithograph, sheet: 22⅞ × 17¾" (58.1 × 45.1 cm)
Publisher: Universal Limited Art Editions, West
Islip, New York. Edition: 31
Gift of the Celeste and Armand Bartos
Foundation

At first glance, *Ale Cans* appears to be a
representation of immediately recogniz-
able mundane objects portrayed in a
realistic manner. A second look, how-
ever, reveals small details that challenge
this initial assumption. The pair of cans,
placed frontally with exacting care, sits
on a base that seems to float in the sur-
rounding black void. Black scribbled
lines, some extending into the empty
margin around the composition and oth-
ers creating shadows on the cans and
base, affirm the artist's touch. And while
the cans have a three-dimensional pres-
ence, the black background is clearly

flat. These conflicting sensations create
an unsettling tension between reality
and illusion.

For this print, Johns used as his
subject his own 1960 sculpture *Painted
Bronze,* his first work showing two Bal-
lantine Ale cans. Since the publication
of this print, the artist has periodically
reinterpreted these cans in various
mediums, while subjecting the image to
continuing metamorphosis. The trans-
formation of everyday "found" objects
into fine art was first introduced by the
Dada and Surrealist artists early in the
twentieth century. Here Johns has taken
this transformation one step further,
manipulating the object until it becomes
something other than what it is.

**Boy in a Straw Hat Waiting
to March in Pro-War Parade,
New York City.** 1967
Gelatin silver print, 14¾ × 14½" (37.5 × 36.8 cm)
The Ben Schultz Memorial Collection. Gift of
the artist

Arbus approached photographic portraiture as a two-way street, through which a relationship is established between the viewer (who has taken the place of the photographer) and the subject. To experience the picture is to enter into that relationship, whose candor and depth may be assessed in just the same way that we gauge the sincerity of others every day—and as they judge ours.

Many of Arbus's subjects are outcasts of one sort or another, and many viewers are at first repelled or merely fascinated by her pictures. Only after these defenses are set aside are we able to see that the vulnerability of her people invites us to recognize our own.

Apart from a handful of pictures, including this one, Arbus did not address political issues directly. But her unsparing frankness in confronting human frailty is one of the signal achievements of American art in the dark days of the Vietnam War.

Untitled. 1961

Relief construction of welded steel, wire, and
canvas, 6' 8¼" × 7' 5" × 34¾" (203.6 × 266 × 88 cm)
Kay Sage Tanguy Fund

Painting or sculpture? Organic or indus-
trial? Invitation or threat? A rectangle
of canvas, like a painting, but one that
pushes its faceted, equivocally machine-
like mouth out from the wall, this un-
titled work lives on ambiguity. What
many have seen in Bontecou's works of
this kind, with their built-up rims and
hollow voids, are the nacelles or casings
of jet engines, and she, too, acknowledged
their influences: "Airplanes at one time,
jets mainly." Interest in the streamlined
products of modernity may link Bonte-
cou to Pop art, a movement developing
at the time, but her work's dark and

restricted palette gives it a sobriety
distant from much of Pop, and she
describes the world more obliquely.
Also, instead of replicating an engine's
metallic surfaces, she stitches panels of
canvas over a steel skeleton. If this is a
machine, it is a soft one—which, again,
leads many to think of the body, and its
charged interiors and openings.

Mystery is one quality Bontecou is
interested in, and also "fear, hope, ugli-
ness, beauty." As for those inky cavities,
a consistent theme, she remarks, "I like
space that never stops. Black is like that.
Holes and boxes mean secrets and shelter."

George Segal | American, 1924–2000

The Bus Driver. 1962

Figure of plaster over cheesecloth; bus parts including coin box, steering wheel, driver's seat, railing, dashboard, etc.; figure, 53½ × 26⅞ × 45" (136 × 68.2 × 114 cm), overall 7' 5" × 51⅝" × 6' 4¾" (226 × 131 × 195 cm)

Philip Johnson Fund

The idea for *The Bus Driver* came to Segal on a late-evening bus from New York to New Jersey. The driver was grim, sullen, and arrogant, and Segal caught himself thinking, "My God, dare I trust my life to this prig?" Soon afterward he found a derelict bus in a junkyard and hacked out the driver's platform. Incorporated in *The Bus Driver*, this metal armature pens in a plaster figure—a life cast. (The model was Segal's brother-in-law.)

When they first appeared, in the early 1960s, Segal's plaster molds of people in fragments of real environments were considered Pop art, since they described the everyday life of public places. But where Pop often focused on mass-media images and mass-produced objects, Segal was interested in individuals, their gestures, statures, stances, and also their inner, psychological or spiritual condition. He often left his plaster molds unpainted, valuing their whiteness for "its special connotations of disembodied spirit, inseparable from the fleshy corporeal details of the figure." In the bus driver (who has been likened to Charon, the ferryman of Greek myth who guides dead souls to the underworld), Segal saw "the dignity of helplessness— a massive, strong man, surrounded by machinery, and yet basically a very unheroic man trapped by forces larger than himself that he couldn't control and least of all understand."

Line 1000 Meters Long. 1961
Chrome-plated metal drum containing a roll of
paper with an ink line drawn along its 1000-
meter length, 20¼" × 15⅜"
(51.2 × 38.8 cm) diam.
Gift of Fratelli Fabbri Editori and Purchase

Manzoni began his career as a painter,
but his later work anticipated the Con-
ceptual art of the 1960s. *Line 1000
Meters Long* reflects both sides of his
thought. Regarding a painting not as
"a surface to be filled with colors and
forms" but as "a surface of unlimited
possibilities," he imagined in that "total
space" a line going "beyond all problems
of composition and size." This was what
he produced in his many works on the
pattern of *Line 1000 Meters Long*—each
a tube or drum containing a roll of
paper marked with a single continuous
line. The length of the roll varies from
work to work, but in theory, Manzoni
believed, the line could stretch to
infinity.

Despite its relationship to painting,
Line 1000 Meters Long is more concep-
tual than visual. Indeed the line that is
its heart eludes the eye, for these canis-
ter works are usually shown closed. Art
that is invisible raises the act of thinking
above the act of seeing, as Manzoni also
did when, for example, he signed eggs
with his thumbprint and asked a show's
visitors to eat them. A line in a can is
itself a conceptual conundrum. Playful
but acute, *Line 1000 Meters Long* invites
us to question our expectations of the
artwork, and our responses to it.

One and Three Chairs. 1965

Wood folding chair, photographic copy of chair, and photographic enlargement of dictionary definition of a chair; chair, 32⅜ × 14⅞ × 20⅞" (82 × 37.8 × 53 cm); photo panel, 36 × 24⅛" (91.5 × 61.1 cm), text panel, 24 × 24⅛" (61 × 61.3 cm)

Larry Aldrich Foundation Fund

A chair sits alongside a photograph of a chair and a dictionary definition of the word *chair*. Perhaps all three are chairs, or codes for one: a visual code, a verbal code, and a code in the language of objects, that is, a chair of wood. But isn't this last chair simply ... a chair? Or, as Marcel Duchamp asked in his *Bicycle Wheel* of 1913, does the inclusion of an object in an artwork somehow change it? If both photograph and words *describe* a chair, how is their functioning different from that of the real chair, and what is Kosuth's artwork doing by adding these functions together? Prodded to ask such questions, the viewer embarks on the basic processes demanded by Conceptual art.

"The art I call conceptual is such because it is based on an inquiry into the nature of art," Kosuth has written. "Thus, it is . . . a working out, a thinking out, of all the implications of all aspects of the concept 'art,' . . . Fundamental to this idea of art is the understanding of the linguistic nature of all art propositions, be they past or present, and regardless of the elements used in their construction." Chasing a chair through three different registers, Kosuth asks us to try to decipher the subliminal sentences in which we phrase our experience of art.

Centennial Ball, Metropolitan Museum, New York. 1969
Gelatin silver print, 10 ⅝ × 15 ⅞" (27 × 40.3 cm)
Purchase

This photograph invites any number of scenarios to explain the intimate drama at this fancy party, but declines to endorse any single one. Who, for example, might be romantically involved with whom? What has provoked the anxious stare of the woman in the background? We shall never know the answers to these questions.

Winogrand loved to observe the behavior of humans and other animals, and he loved photography's voracious capacity for description, but he did not confuse the two. In his pictures he created a parallel theater of experience, the force of which resides not in the reliability of its facts but in the liveliness of its fictions.

This picture belongs to a long series, begun in the late 1960s, made at demonstrations, press conferences, and other gatherings whose participants expected to be noticed and, often, photographed. For the photographer Tod Papageorge, Winogrand's series vividly evokes the 1960s by offering "a unilateral report of how we behaved under pressure during a time of costumes and causes, and of how extravagantly, outrageously, and continuously we displayed what we wanted."

Federico Fellini | Italian, 1920–1993

8½ (Otto e mezzo). 1963
35mm film, black and white, sound, 135 minutes
Gift of Joseph E. Levine
Marcello Mastroianni

Fellini created a remarkably personal cinematic confession in this film about a director who is mentally unable to commence work on his latest production. Suffering from a psychosomatic liver ailment, Guido Anselmi (Marcello Mastroianni) takes to a spa for physical and spiritual rejuvenation, only to be haunted by the specter of his professional and personal life. In the black-and-white-tiled world of the spa, Anselmi confronts his problems, his boyhood memories, and his lusty fantasy world. Yet interruptions keep coming at him—from his producer, who wants to get the production of an outer-space adventure underway, and from his wife Luisa, upset about his mistress. His imagination serves as his escape: in imaginary sequences, he brandishes a whip instead of a megaphone to orchestrate his actors, and he also fantasizes that he is the master of a harem of women demurely under his control.

The containment of *8½* within the artificial world of the spa manifests a subjective, self-created reality, one that Fellini populates with priests, journalists, and Saraghina, the mythical prostitute who initiated Anselmi into the self-created mysteries of sex in his youthful days. Like Anselmi's incomplete film script in the story, *8½* relied a great deal on Fellini's gift for improvisation. The film's title represents the total number of films made by Fellini before this production: seven plus three collaborations (each counting as one-half). This uniquely autobiographical work is enhanced by a musical score written by Nino Rota.

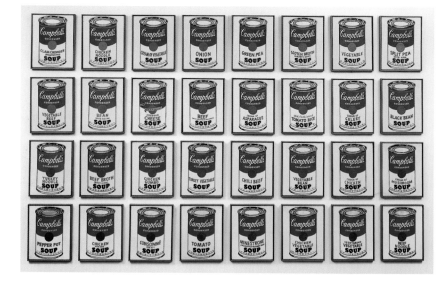

Campbell's Soup Cans. 1962
Synthetic polymer paint on thirty-two canvases,
each 20 × 16" (50.8 × 40.6 cm)
Gift of Irving Blum; Nelson A. Rockefeller
Bequest, gift of Mr. and Mrs. William A.M.
Burden, Abby Aldrich Rockefeller Fund, gift of
Nina and Gordon Bunshaft in honor of Henry
Moore, Lillie P. Bliss Bequest, Philip Johnson
Fund, Frances Keech Bequest, gift of Mrs.
Bliss Parkinson, and Florence B. Wesley
Bequest (all by exchange)

"I don't think art should be only for the
select few," Warhol believed, "I think it
should be for the mass of the American
people." Like other Pop artists, Warhol
used images of already proven appeal to
huge audiences: comic strips, ads, pho-
tographs of rock-music and movie stars,
tabloid news shots. In *Campbell's Soup
Cans* he reproduced an object of mass
consumption in the most literal sense.
When he first exhibited these can-

vases—there are thirty-two of them, the
number of soup varieties Campbell's
then sold—each one simultaneously
hung from the wall, like a painting, and
stood on a shelf, like groceries in a store.

Repeating the same image at the
same scale, the canvases stress the uni-
formity and ubiquity of the Campbell's
can. At the same time, they subvert the
idea of painting as a medium of inven-
tion and originality. Visual repetition of
this kind had long been used by adver-
tisers to drum product names into the
public consciousness; here, though, it
implies not energetic competition but a
complacent abundance. Outside an art
gallery, the Campbell's label, which had
not changed in over fifty years, was not
an attention-grabber but a banality. As
Warhol said of Campbell's soup, "I used
to drink it. I used to have the same lunch
every day, for twenty years, I guess, the
same thing over and over again."

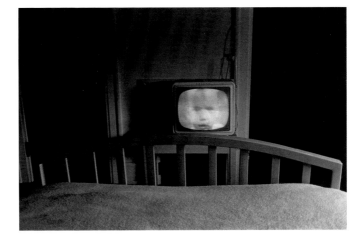

Galax, Virginia. 1962
Gelatin silver print, 5⅞ × 8⅞" (14.9 × 22.5 cm)
Gift of Mrs. Armand P. Bartos

The bare facts of the picture are bare indeed: an undecorated room, a plain blanket, a sturdy bed with rails like prison bars or like the slats of a crib. All that animates the room is the electronic image on the television screen. That image is human, nonetheless, and it serves as a companion of sorts for the occupant of the room.

Televisions became common in living rooms (and motel rooms) in the early 1950s, so it is fair to say that this picture confronts a significant aspect of the then contemporary American "social landscape," a term coined by Friedlander. But unlike the photographs that *Life* and other magazines had made familiar to millions, this picture declines to state a case—to judge or explain. Alertly engaged with the material of contemporary life, it fiercely resists the ready conclusions of journalism or sociology. In this respect, it is exemplary of the most adventurous American photography of the 1960s, whose leaders opened new artistic territory by transforming the pictorial vocabulary of photojournalism into a means of asserting and exploring their distinctly individual sensibilities.

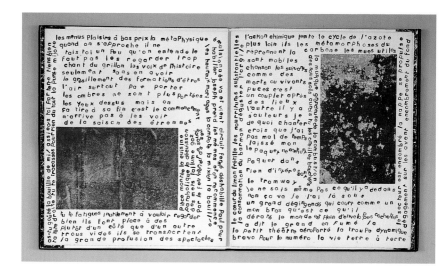

La Lunette farcie by Jean Dubuffet.
1962–63
Illustrated book with 11 lithographs, page:
17¹⁄₁₆ × 14¹⁵⁄₁₆" (43.4 × 38 cm)
Publisher: PAB (Pierre André Benoit), Alès and
Paris. Edition: 55
Gift of Mr. and Mrs. Ralph F. Colin

This double-page spread from the book *La Lunette farcie (The Stuffed Lunette)* offers immediate immersion into the fanciful, haphazard world of Dubuffet. He created the atmospheric abstractions by chance, experimenting with a variety of "accidental" happenings to produce textures on the lithographic plates, which might include indiscriminate scratching and the random exposure of the plates to fire, liquid, dirt, or other elements. Otherworldly images are surrounded by the artist's nonsensical ramblings that consist of French words arranged more by sound or look than by meaning. The unpunctuated writing,

reproducing the artist's own stenciled words, is placed in different orientations around the pages, making the text even more problematic. The inane title is virtually untranslatable. Dubuffet's relaxed, playful attitude reflects his admiration for children's art, the art of the insane, and that of the untrained. He was among the first artists to appreciate "visionary" or "outsider" art, which he called *l'art brut* (rough art).

La Lunette farcie was one of several books Dubuffet made with the poet-publisher Benoit. This man, whimsical by nature, would send blank etching or lithographic plates to artists such as Pablo Picasso and Max Ernst to tempt them to make images for his innovative publications.

White Cabinet and White Table. 1965

Wood, oil, and eggshells; cabinet 33⅞ × 32¼ × 24½" (86 × 82 × 62 cm), table 41 × 39⅜ × 15¾" (104 × 100 × 40 cm)

Fractional and promised gift of Jo Carole and Ronald S. Lauder

Explaining his beginnings in art, Broodthaers once wrote, "The idea of inventing something insincere . . . crossed my mind and I set to work at once." Anyone upset to find a cabinet of eggshells presented as art might take this to mean that the work is a joke. But there is another possibility: Broodthaers is warning us not to take him at face value, but to look for hidden meanings.

White Cabinet and White Table actually does have aesthetic ancestors, in Marcel Duchamp's Readymade objects and in the surprises of Surrealism. It also reflects the concern with everyday reality in the Pop and neo-realism of Broodthaers's own time. But Broodthaers wanted to avoid glamorizing modern products, and eggshells have nothing uniquely contemporary about them. They interested Broodthaers, rather, as empty containers—containers "without content other than the air."

There are other containers in *White Cabinet and White Table*: the cabinet and table themselves, both stuffed with content, but an apparently empty or meaningless one. If the table stands on the floor like a sculpture's pedestal while the closet hangs on the wall like a painting's frame (Broodthaers described himself as "painting with eggs"), then the work subtly analyzes art itself: how does art contain meaning for its viewers? Or has it been drained of meaning, like an eggshell minus its egg?

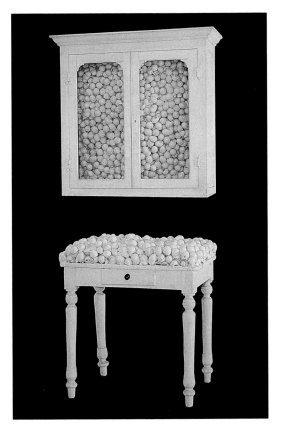

P. D. Zeichnung. 1963
Ink and pastel on two sheets of paper, overall:
33½ × 24¼" (85 × 61.5 cm)
Purchased with funds given by Jo Carole and
Ronald S. Lauder and Leon D. Black

Baselitz described this drawing as "the depiction of a table with knots of figural motifs. Above and below landscape formation." The bulbous, knotted forms, spread over two sheets of paper in disjointed and contorted spaces, signal the artist's desire to formulate his own pictorial language. They also point to his fascination with the Mannerist painters, such as the Italians Jacopo da Pontormo and Parmigianino, as well as with what he considered "outsider" art, namely, the work of Antonin Artaud, Vincent van Gogh, and August Strindberg, for example, and the expressive visual language of the art of the insane. These nightmarish, amorphous, distorted, almost putrefying shapes express a sense of anger, alienation, disease, and decay that informed the artist's vision in the early 1960s.

Several of Baselitz's paintings of 1962–63 include similar knotted forms, which continued to populate his work throughout most of the decade, culminating in the famous Heroes series. These works mark his search for symbols and vocabulary that assert his own identity and iconography, which, at the time, expressed themselves through the introduction of disjointed fragments of the body, placed in irrational spaces. This drawing is also related to the artist's early iconoclastic texts, the *Pandemonium* manifestos, published in 1961 and 1962.

Philip Guston | American, born Canada. 1913–1980

City Limits. 1969
Oil on canvas, 6'5" × 8'7¼" (195.6 × 262.2 cm)
Gift of Musa Guston

A three-man crew of slapstick thugs cruises a vacant metropolis in a beat-up jalopy. Wearing Ku Klux Klan hoods, they are plainly up to no good; but rather than invoking a specific evil, these men are symbolic embodiments of a general know-nothing violence. The principal story told here is that of an America run afoul of its democratic promise. Guston refused to exempt himself from responsibility: in other paintings he depicted an artist in Klan robes at his easel.

Guston began his career as a figurative painter, then, around mid-century, developed a lyrical Abstract Expressionism, a typical path for a member of the New York School. In the late 1960s, however, Guston made a surprising return to narrative painting—but not in the vein of the classic studio tradition in which he had trained. The art of Guston's last decade is antically cartoonlike. It has precedents in his earlier figurative period (and in his occasional satiric drawings of artists and writers), but rephrases them in a type of caricature dating to his childhood imitations of comic strips such as Krazy Kat. At the same time, paintings like *City Limits* have a strange baroque grandeur, and a bitter undertow—an insistence on the fascination of cruelty.

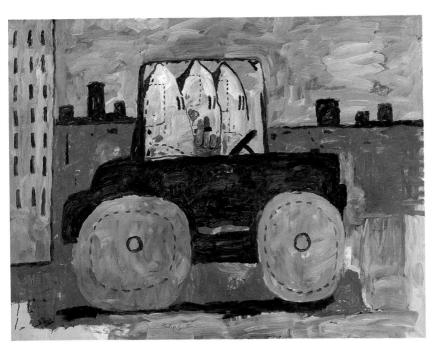

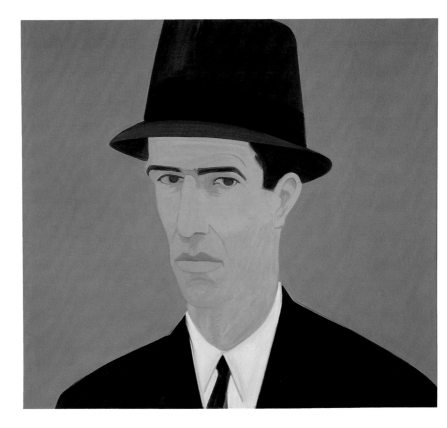

Passing. 1962–63
Oil on canvas, 71 ¾" × 6' 7⅝" (182.2 × 202.2 cm)
Gift of the Louis and Bessie Adler Foundation,
Inc., Seymour M. Klein, President

Ambitious, elegant, impersonal, large in
scale, and simultaneously timeless and
reflective of its time—these, according
to Katz, are the qualities of "high style"
in painting, and they are also the quali-
ties of many of his own works. Believing
that "you have no power unless you have
traditional elements in your pictures,"
Katz achieves high style by integrating
familiar traditions with avant-garde
practice. *Passing* belongs to a venerable
genre—it is a self-portrait—but has
the scale of Abstract Expressionism.
Another inspiration is the advertising
billboard; like the Pop artists, Katz pays
attention to the cultural scene. Mean-
while, his reductive approach and his

conception of pictorial space match those
in the formalist painting of the 1960s.

The ground in *Passing* is a flat
monochrome, and Katz's face and
shoulders are so simplified that it is
mainly their clarity as parts of a figure
that insinuates their volume. Neither
smiling nor frowning, Katz meets our
gaze frankly, but his character is muted
by the artifice of the painting's design:
the perfect ellipse of the hat brim; the
asymmetry in the height of the shoul-
ders; the limited palette, all near-flat
blacks, whites, and grays except for the
face. Far from the bohemian artist, Katz
looks coolly imperturbable in his busi-
nessman's suit and hat—stylish not only
in his painting but in his person.

Memphis. 1969–70
Dye transfer print, 11¾ × 18" (29.9 × 45.8 cm)
Purchase

The tricycle may be a little worse for wear, but it is pictured here as the most important thing in the world. To make the photograph, Eggleston adopted a viewpoint even lower than the eye-level of the tricycle's owner, so as to give us a clear view between its wheels to the grown-up sedan parked in the carport across the street.

Eggleston's photographs began as Kodachrome slides, a popular medium of amateur photography, and they resemble snapshots in the way they forthrightly describe ordinary people and objects, framed squarely in the center of the picture. Critics who found this resemblance grounds for dismissing the work overlooked the paradoxical power of snapshots. To the insider, snapshots are keys that open reservoirs of memory and feeling; to the outsider, who does not recognize the faces or know the stories, they are forever opaque. But because we all have snapshots of our own, we know the habit of understanding them and of projecting ourselves into the dramas and passions they conceal.

Color became available to the ordinary photographer in the 1950s and 1960s, but before then photography had been a black-and-white medium for more than a century. Not only did color photographers have to master a new medium, they also had to forget the distinguished precedents that had drawn them to photography in the first place. The conviction that serious photographs are made in black and white has not entirely disappeared, even today.

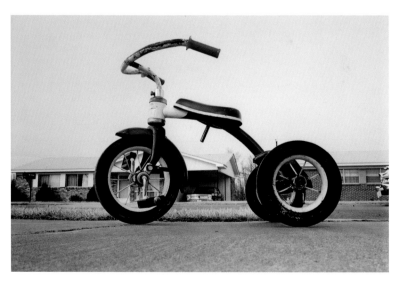

Friendship. 1963
Incised gold leaf and gesso on canvas, 6' 3" × 6' 3"
(190.5 × 190.5 cm)
Fractional gift of Celeste and Armand P. Bartos

A grid connotes regulation and regularity, and therefore the human hand: natural forms as uniform as these patterns of evenly spaced horizontal and vertical straight lines are seldom visible to the unaided eye. In *Friendship* and other works, however, Martin draws a grid that somehow both softens the firm lines of geometry and seems to open onto a space far wider than the human sphere. Her art, she said, "is about what is known forever in the mind"—perfection, the transcendent reality spoken of in Eastern religions. For her, the grid evoked not a human measure but a supernal one, a boundless order.

Like many Abstract Expressionist artists (her chronological contemporaries), Martin honored the spiritual potential of art, but none of those painters approached the spiritual through symmetry. The organization of *Friendship* shares more with the Minimal art of a later generation, but the lines Martin hand-scored into that shimmering plane of gold have a unique delicacy. From a distance, too, they fade, structuring the field almost subliminally. The result is a sense of an infinite space with a mysterious vitality. Indeed the experience Martin said she wanted from a painting was "the simple, direct going into a field of vision as you would cross an empty beach to look at the ocean."

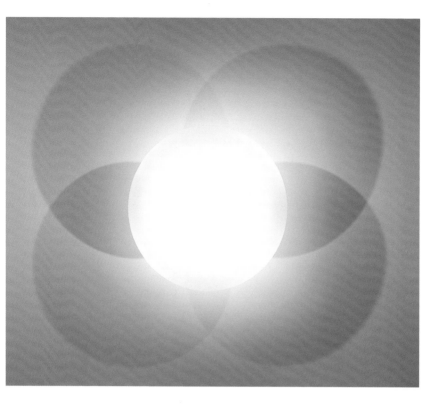

Untitled. 1968
Synthetic polymer paint on metal, 60⅜"
(153.2 cm) diam.
Mrs. Sam A. Lewisohn Fund

This untitled work is a convex, spray-painted disk held a foot or so out from the wall by a central post. Its subtle, tactile surface modulates delicately from center to edge, and it is softly lit from four angles, creating a cloverleaf pattern of shadow. The white center of the disk can seem to lie level with the white wall, so that the eye spends time trying to understand what it sees—what is nearer and what is farther, what is solid and what is immaterial light, or even light's absence. For Irwin, the result is "this indeterminate physicality with different levels of weight and density, each on a different physical plane. It [is] very beautiful and quite confusing, everything starting and reversing."

Evading confinement by the rectangle of the conventional painting, Irwin's disks literally extend past their own boundaries—spread out into their environment, which is as much a part of them as their own substance. The idea, in part, extends the Abstract Expressionist notion of an infinite, all-encompassing, allover field, but with the qualification that for Irwin, "To be an artist is not a matter of making paintings or objects at all. What we are really dealing with is our state of consciousness and the shape of our perceptions."

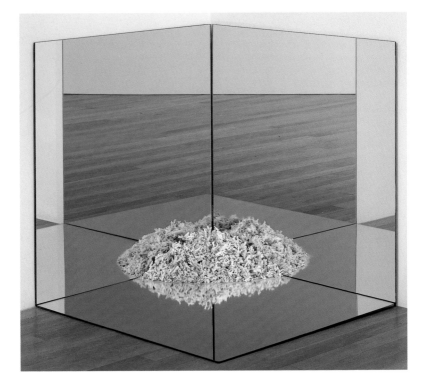

Corner Mirror with Coral. 1969
Mirrors and coral, 36 × 36 × 36" (91.5 × 91.5 × 91.5 cm)
Fractional gift of Agnes Gund

Smithson's three mirrors in a corner create a structure both lucid and elusive: as each mirror reflects the space around it, it multiplies the reflections in the other mirrors, creating an image with the symmetry of a crystal. Mirrors appear often in Smithson's art, as do fragments of the natural world—here, there are pieces of coral piled in the angle where the mirrors meet. Smithson also combined mirrors with heaps of sand, gravel, and other rocks, matching nature's brute rubble with its precise visual twin. (The delicacy of the lacy pink coral is unusual in his work.) The pairing of matter and reflection corresponds to another duality: on the one hand, unshaped shards of stone or reef;

on the other, art, sculpture, and the indoor space of the gallery.

One of the earthworks artists of the 1960s and 1970s, in other pieces Smithson manipulated the natural landscape, sometimes simply and temporarily, through mirrors, sometimes drastically, with a bulldozer. *Corner Mirror with Coral* relates to his "Non-Sites," indoor works containing substances from an outdoor site elsewhere. Both cerebral and powerfully material, his art shows a fascination with entropy, the tendency of all structures and energies to lose their integrity. In this work a perfect form—the mirrors make three sides of a cube—is made illogical and illusory, for the coral seems to float in midair.

Repetition 19, III. 1968

Nineteen tubular fiberglass units, 19 to 20¼" × 11 to 12¾" (48 to 51 cm × 27.8 to 32.3 cm) diam.

Gift of Charles and Anita Blatt

Repetition 19, III comprises nineteen bucketlike forms, all the same shape but none exactly alike. Nor do they have a set order, since Hesse allowed latitude in placing them: "I don't ask that the piece be moved or changed, only that it could be moved and changed. There is not one preferred format." The Minimalist artists, who emerged a little before Hesse did, had explored serial repetitions of identical units. Hesse loosened that principle: *Repetition 19* is simultaneously repetitive and irregular. She also tended to work on a humbler scale than the Minimalists often had, and her forms and materials are less techno-cratic; she herself called the forms in *Repetition 19* "anthropomorphic," and recognized sexual connotations in these "empty containers."

This fiberglass version of *Repetition 19*, is the third Hesse planned. (The first is in papier-mâché; the second, which she imagined first in metal, then in latex, was never completed.) Besides beautifully modulating the light, the fiberglass seems both soft and hard, contributing to the richly paradoxical character of these subtle objects: nonconformist individuals somehow make a group; the arrangement, whatever it is, is both random and coherent, unified by the similarity preserved through difference. And paradox is fitting here: Hesse wanted, she said, to make an art object that "accedes to its nonlogical self. It is something, it is nothing."

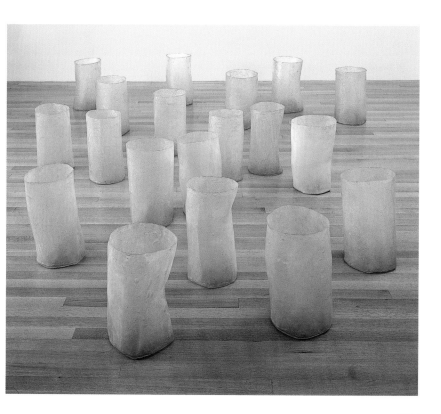

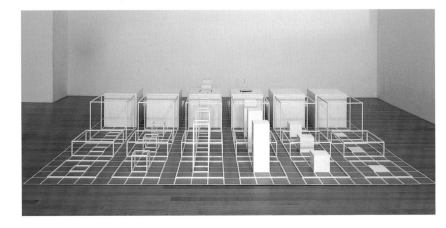

Serial Project, I (ABCD). 1966
Baked enamel on aluminum, 20" × 13'7" × 13'7"
(50.8 × 398.9 × 398.9 cm)
Gift of Agnes Gund and purchase (by exchange)

LeWitt's work emerged alongside the Minimalist and Conceptual art movements of the 1960s, and combines qualities of both. Like the Minimalists, he often uses simple basic forms, in the belief that "using complex basic forms only disrupts the unity of the whole"; like the Conceptualists, he starts with an idea rather than a form, initiating a process that obeys certain rules, and that determines the form by playing itself out. The premise of *Serial Project* demands the combination and recombination of both open and closed enameled aluminum squares, cubes, and extensions of these shapes, all laid in a grid. Both intricate and methodical, the system produces a visual field that gives its viewers all the evidence they need to unravel its logic.

In a text accompanying *Serial Project*, LeWitt wrote, "The aim of the artist would not be to instruct the viewer but to give him information. Whether the viewer understands this information is incidental to the artist; he cannot foresee the understanding of all his viewers. He would follow his predetermined premise to its conclusion avoiding subjectivity. Chance, taste, or unconsciously remembered forms would play no part in the outcome. The serial artist does not attempt to produce a beautiful or mysterious object but functions merely as a clerk cataloging the results of his premise."

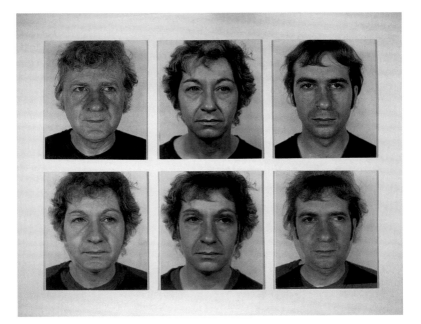

Family Combinations. 1972

Six gelatin silver prints, each 12⅞ × 10³⁄₁₆"
(31.6 × 25.9 cm)
Gift of Robert and Gayle Greenhill

The top row of this tableau of six pictures represents, from right to left, Wegman, his mother, and his father. The bottom row consists of superimpositions of all possible combinations of any two of the three images above. The combinations resemble the sorts of pictures that once circulated as scientific illustrations of racial and social types. The humor of Wegman's tableau derives from the deadpan sincerity with which he has reenacted this absurd operation.

Photographs perform many banal functions in our everyday lives, so banal that we rarely stop to think about them. The head shots that appear on identity cards and drivers' licenses are good examples. In the early 1970s Wegman helped to lead an artistic movement that emulated the look of such photographs but short-circuited their functions. The idea was to invite us to consider the meanings we attach to these pictures, and so to explore our habits of thought and our social arrangements. Wegman's talent for comedy has been evident from the beginning, but it took a while to see that his playful wit is colored by kindness and warmth.

Robert/104,072. 1973–74

Synthetic polymer paint and ink with graphite
on gessoed canvas, 9 × 7' (274.4 × 213.4 cm)
Gift of J. Frederic Byers III and promised gift
of an anonymous donor

"No work of art was ever made without a process," Close has said, and *Robert/104,072* was made by a painstaking process indeed: it is composed of tiny black dots, each set inside a single square of a 104,072-square grid. The sense of shape and texture—of the distinction between metal and skin, between knitted sweater and bushy mustache—depends on the density of the paint, which Close applied with a spray gun, revisiting each square an average of ten times. Not surprisingly, the work took fourteen months to make.

When Close began to paint portraits, in 1967–68, figurative painting was widely considered exhausted. The figures in Pop art were coolly ironic; and other artists were painting abstractions, or were abandoning painting altogether for more conceptual systems of art-making. Close preferred to apply a conceptual system to a traditional mode of painting. The aggressive scale makes the system clear—close up, the gridded dots in *Robert/104,072* are quite apparent—and the black-and-white palette reflects the image's source in a photograph.

Robert/104,072 announces itself as less illusion than code. For Close, a picture like this one is not "a painting of a person as much as it is the distribution of paint on a flat surface.... You really have to understand the artificiality of what you are doing to make the reality."

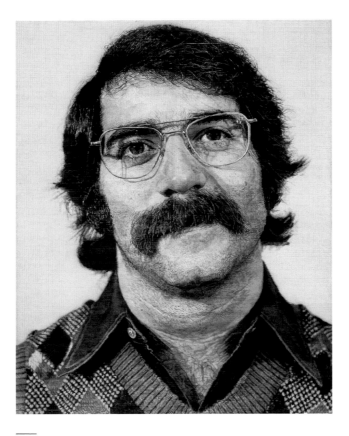

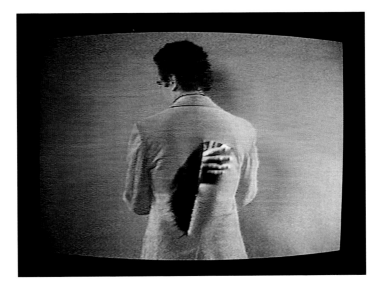

Three Transitions. 1973
¾" video, color, sound, 6 minutes
Gift of Barbara Pine

In *Three Transitions*, Campus presents three introspective self-portraits that incorporate his dry humor. He begins with an image created by two cameras facing opposite sides of a paper wall and filming simultaneously. His back to one camera, Campus cuts through the paper. In the double image, it appears as if he is cutting through his back, which is both disconcerting and tongue-in-cheek. Campus then uses the "chroma-key effect" of superimposing one video image onto a similarly colored area of another image. He applies blue paint to his face, and during this process another image of himself is revealed; he then superimposes his image on a piece of blue paper, which he sets afire. As *Three Transitions* moves between deadpan humor and seeming self-destruction, Campus explores the limits of visual perception as a measure of reality.

Faces and masks have long been subjects in art, but, with the advent of television, these analytical discursive figures intimately entered our daily lives. Campus's video art is concerned with exploring the subtle balance between remote but penetrating and formal, but unsettling, elements.

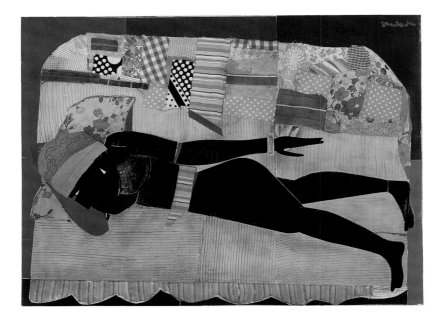

Patchwork Quilt. 1970

Cut-and-pasted cloth and paper with synthetic
paint on composition board, 35¾ × 47⅞"
(90.9 × 121.6 cm)
Blanchette Rockefeller Fund

"I try to show," Bearden once said, "that
when some things are taken out of the
usual context and put in the new, they are
given an entirely new character." And a
patchwork quilt, no matter how rich its
pattern, is always made out of remnants
cut from their context—out of scraps of
outworn cloth, now put to a new use, and
acquiring a nobler quality. Whether faded
or frayed, their role in a new design
refreshes their meaning and beauty.

Bearden's *Patchwork Quilt*, made
up, in part, of exactly such fragments of
cloth, has a share in this kind of enno-

blement. A student of many cultures,
Bearden took Egyptian tomb reliefs as
his inspiration for the figure, with its
graceful lines, its distinctive left arm and
hand, its sideways posture, and its legs
parted as if in midstride. Another
influence was the centuries-old sculp-
ture of Benin. These bases in high,
specifically African aesthetics claim a
regal ancestry for Bearden's lounging
African American woman. In fact, his
work lives in its cosmopolitan and demo-
cratic fusions—of the distinguished
heritage of painting and the domestic
practice of quilting (in which there is a
distinct African American tradition), of
analytic art (in the echoes of Cubism)
and household decoration, and of
everyday leisure and utter elegance.

Scalar. 1971
Chipboard, crude oil, paper, and nails, overall
6' 8" × 9' 6½" × 3½" (203.2 × 289.5 × 8.9 cm)
Gift of Jo Carole and Ronald S. Lauder and Estée
Lauder, Inc. in honor of J. Frederic Byers III

Scalar inherits the geometry and literal-
ness of Minimal art, but softens these
qualities through variations in its tones
and in the disposition of its forms.
Tacked-up rectangles (and one cylinder)
of paper and chipboard suggest a modular
order, but differ in size and proportion.
Sometimes they overlap, sometimes leave
the wall bare; their placement seems both
careful and irregular, as in Incan masonry.
Unpigmented oil applied to their sur-
faces has left gentle mottlings and stains,
which have spread through an interac-
tion between oil and support that must
have lain largely outside the artist's
control. These planes against the wall
invoke paintings, but at the bottom they
rest on the floor, so that they also cite
sculpture and weight.

In reaction against Abstract
Expressionism, many American artists
of the 1960s, such as Rockburne, tried
to minimize or erase signs of their own
individuality in their art. Instead, their
work drew attention to the process by
which it was made and to impersonal
agents in its making: its physical con-
text, the qualities of its materials, the
force of gravity, a system or procedure
that might generate a form independ-
ently of the artist's aesthetic judgment.
Scalar is party to these ideas, but with its
blotched surfaces, its echoes of painting,
and its rhythmic arrangement of uprights
and horizontals, it remains subtly pic-
torial, in a powerful combination of
rigor and delicacy.

122 rue du Temple. 1968

Torn-and-pasted printed papers on linen,
62⅝ × 82½" (159.2 × 209.6 cm)
Gift of Joachim Aberbach (by exchange)

The title of this work derives from the street in Paris from which these torn posters were taken. The layers of fragmentary color, words, and images of faces were pasted onto linen in a technique called *décollage* (literally, un-collage). In this technique, posters or other promotional materials are torn up to create new compositions, with one image often superimposed over another. Villeglé stated that *122 rue du Temple*, a combination of movie posters and political advertisements for a legislative election instigated by the events of May 1968 in Paris, is a reflection of reality. Thus, not only is he interested in the visual impact and pictorial construction of his works, but he also confers upon them a sociological status.

Villeglé has devoted his entire career to *décollage*. He was affiliated with *Nouveau Réalisme,* a French art movement of the late 1950s and early 1960s devoted to transforming everyday objects and detritus into art in the belief that painting was incapable of conveying the actuality of postwar society. Villeglé sees the street as a repository of ready-made art. He invented the persona of the anonymous passerby, or common man, whose random tears are "discovered" by the artist and thereby poeticized. Through this incorporation of chance and choice, Villeglé assumes the role of a conservator of works of art unconsciously created by others.

Truisms. 1978–87
Photostat, 8' × 40" (243.8 × 101.6 cm)
Publisher: the artist. Edition: unlimited
Gift of the artist

Holzer's *Truisms* have become part of the public domain, displayed in storefronts, on outdoor walls and billboards, and in digital displays in museums, galleries, and other public places, such as Times Square in New York. Multitudes of people have seen them, read them, laughed at them, and been provoked by them. That is precisely the artist's goal.

The Photostat, *Truisms*, seen here presents eighty-six of Holzer's ongoing series of maxims. Variously insightful, aggressive, or comic, they express multiple viewpoints that the artist hopes will arouse a wide range of responses. A small selection of *Truisms* includes: "A lot of professionals are crackpots"; "Abuse of power comes as no surprise"; "Bad intentions can yield good results"; and "Categorizing fear is calming."

Holzer began creating these works in 1977, when she was a student in an independent study program. She hand-typed numerous "one liners," or Truisms, which she has likened, partly in jest, to a "Jenny Holzer's *Reader's Digest* version of Western and Eastern thought." She typeset the sentences in alphabetical order and printed them inexpensively, using commercial printing processes. She then distributed the sheets at random and pasted them up as posters around the city. Her *Truisms* eventually adorned a variety of formats, including tee-shirts and baseball caps.

A LITTLE KNOWLEDGE CAN GO A LONG WAY
A LOT OF PROFESSIONALS ARE CRACKPOTS
A MAN CAN'T KNOW WHAT IT'S LIKE TO BE A MOTHER
A NAME MEANS A LOT JUST BY ITSELF
A POSITIVE ATTITUDE MAKES ALL THE DIFFERENCE IN THE WORLD
A RELAXED MAN IS NOT NECESSARILY A BETTER MAN
A SENSE OF TIMING IS THE MARK OF GENIUS
A SINCERE EFFORT IS ALL YOU CAN ASK
A SINGLE EVENT CAN HAVE INFINITELY MANY INTERPRETATIONS
A SOLID HOME BASE BUILDS A SENSE OF SELF
A STRONG SENSE OF DUTY IMPRISONS YOU
ABSOLUTE SUBMISSION CAN BE A FORM OF FREEDOM
ABSTRACTION IS A TYPE OF DECADENCE
ABUSE OF POWER SHOULD COME AS NO SURPRISE
ACTION CAUSES MORE TROUBLE THAN THOUGHT
ALIENATION PRODUCES ECCENTRICS OR REVOLUTIONARIES
ALL THINGS ARE DELICATELY INTERCONNECTED
AMBITION IS JUST AS DANGEROUS AS COMPLACENCY
AMBIVALENCE CAN RUIN YOUR LIFE
AN ELITE IS INEVITABLE
ANGER OR HATE CAN BE A USEFUL MOTIVATING FORCE
ANIMALISM IS PERFECTLY HEALTHY
ANY SURPLUS IS IMMORAL
ANYTHING IS A LEGITIMATE AREA OF INVESTIGATION
ARTIFICIAL DESIRES ARE DESPOILING THE EARTH
AT TIMES INACTIVITY IS PREFERABLE TO MINDLESS FUNCTIONING
AT TIMES YOUR UNCONSCIOUS IS TRUER THAN YOUR CONSCIOUS MIND
AUTOMATION IS DEADLY
AWFUL PUNISHMENT AWAITS REALLY BAD PEOPLE
BAD INTENTIONS CAN YIELD GOOD RESULTS
BEING ALONE WITH YOURSELF IS INCREASINGLY UNPOPULAR
BEING HAPPY IS MORE IMPORTANT THAN ANYTHING ELSE
BEING HONEST IS NOT ALWAYS THE KINDEST WAY
BEING JUDGMENTAL IS A SIGN OF LIFE
BEING SURE OF YOURSELF MEANS YOU'RE A FOOL
BELIEVING IN REBIRTH IS THE SAME AS ADMITTING DEFEAT
BOREDOM MAKES YOU DO CRAZY THINGS
CALM IS MORE CONDUCIVE TO CREATIVITY THAN IS ANXIETY
CATEGORIZING FEAR IS CALMING
CHANGE IS VALUABLE BECAUSE IT LETS THE OPPRESSED BE TYRANTS
CHASING THE NEW IS DANGEROUS TO SOCIETY
CHILDREN ARE THE CRUELEST OF ALL
CHILDREN ARE THE HOPE OF THE FUTURE
CLASS ACTION IS A NICE IDEA WITH NO SUBSTANCE
CLASS STRUCTURE IS AS ARTIFICIAL AS PLASTIC
CONFUSING YOURSELF IS A WAY TO STAY HONEST
CRIME AGAINST PROPERTY IS RELATIVELY UNIMPORTANT
DECADENCE CAN BE AN END IN ITSELF
DECENCY IS A RELATIVE THING
DEPENDENCE CAN BE A MEAL TICKET
DESCRIPTION IS MORE VALUABLE THAN METAPHOR
DEVIANTS ARE SACRIFICED TO INCREASE GROUP SOLIDARITY
DISGUST IS THE APPROPRIATE RESPONSE TO MOST SITUATIONS
DISORGANIZATION IS A KIND OF ANESTHESIA
DON'T PLACE TOO MUCH TRUST IN EXPERTS
DON'T RUN PEOPLE'S LIVES FOR THEM
DRAMA OFTEN OBSCURES THE REAL ISSUES
DREAMING WHILE AWAKE IS A FRIGHTENING CONTRADICTION
DYING AND COMING BACK GIVES YOU CONSIDERABLE PERSPECTIVE
DYING SHOULD BE AS EASY AS FALLING OFF A LOG
EATING TOO MUCH IS CRIMINAL
ELABORATION IS A FORM OF POLLUTION
EMOTIONAL RESPONSES ARE AS VALUABLE AS INTELLECTUAL RESPONSES
ENJOY YOURSELF BECAUSE YOU CAN'T CHANGE ANYTHING ANYWAY
EVEN YOUR FAMILY CAN BETRAY YOU
EVERY ACHIEVEMENT REQUIRES A SACRIFICE
EVERYONE'S WORK IS EQUALLY IMPORTANT
EVERYTHING THAT'S INTERESTING IS NEW
EXCEPTIONAL PEOPLE DESERVE SPECIAL CONCESSIONS
EXPIRING FOR LOVE IS BEAUTIFUL BUT STUPID
EXPRESSING ANGER IS NECESSARY
EXTREME BEHAVIOR HAS ITS BASIS IN PATHOLOGICAL PSYCHOLOGY
EXTREME SELF-CONSCIOUSNESS LEADS TO PERVERSION
FAITHFULNESS IS A SOCIAL NOT A BIOLOGICAL LAW
FAKE OR REAL INDIFFERENCE IS A POWERFUL PERSONAL WEAPON
FATHERS OFTEN USE TOO MUCH FORCE
FEAR IS THE GREATEST INCAPACITATOR
FREEDOM IS A LUXURY NOT A NECESSITY
GIVING FREE REIN TO YOUR EMOTIONS IS AN HONEST WAY TO LIVE
GOING WITH THE FLOW IS SOOTHING BUT RISKY
GOOD DEEDS EVENTUALLY ARE REWARDED
GOVERNMENT IS A BURDEN ON THE PEOPLE
GRASS ROOTS AGITATION IS THE ONLY HOPE
GUILT AND SELF-LACERATION ARE INDULGENCES
HABITUAL CONTEMPT DOESN'T REFLECT A FINER SENSIBILITY
HIDING YOUR MOTIVES IS DESPICABLE

Leda and the Swan. 1962

Oil, pencil, and crayon on canvas, 6' 3" × 6' 6¾"
(190.5 × 200 cm)
Acquired through the Lillie P. Bliss Bequest
(by exchange)

Interest in the mural form was wide-
spread among the Abstract Expression-
ists, who often worked on a scale far
larger than that of most easel paintings.
Twombly, a member of a younger gener-
ation, transposed that interest in the
wall into a different register: no painter
of his time more consistently invites
association with the language of graffiti.
His scrawled calligraphic markings may
recall the automatic writing of Surreal-
ism, another inheritance passed on to
him through Abstract Expressionism,
but they also evoke the scratches and
scribbles on the ancient walls of Rome
(his home since 1957).

Rome supplies another touchstone
for Twombly through his fascination
with classical antiquity. Here he refers to
the myth in which Jupiter, lord of the
gods, took the shape of a swan in order
to ravish the beautiful Leda. (This vio-
lation ultimately led to the Trojan War,
fought over Leda's daughter Helen.)
Twombly's version of this old art-
historical theme supplies no contrasts of
feathers and flesh but an orgiastic fusion
and confusion of energies within furi-
ously thrashing overlays of crayon, pen-
cil, and ruddy paint. A few recognizable
signs—hearts, a phallus—fly out from
this explosion. A drier comment is the
quartered, windowlike rectangle near
the top of the painting, an indication of
the stabilizing direction that Twombly's
art was starting to take.

Untitled. 1977
Synthetic polymer paint, tallow, and adhesive
tape on brown paper, 39¼ × 58⅛"
(99.6 × 147.6 cm)
Gift of Barbara G. Pine

In this drawing, a thin roll of tallow with a wick, symbolizing an extinguished candle, is attached with two strips of white tape to a sheet of brown paper. The background is splattered with irregular dark blue smudges of paint that recall smudges of smoke. These irregular spots evoke marks made by the burning wick of the tallow cord. The work invites the viewer to question its very structure and the meaning of its unusual combination of composite elements.

Always confrontational and forceful, yet beautiful and often poetic, Kounellis's work engages the viewer on several levels: visual, emotional, and physical. It represents the artist's commentary on the surrounding reality and reflects his political attitudes. For example, his Fire installations of the late 1960s related his optimistic belief in revolutionary fervor, whereas the Smoke works of the early 1970s are symbolic of extinguished revolutionary zeal. According to Kounellis, "Smoke creates ghosts" and is a metaphor for history and the passage of time.

Kounellis's art is closely identified with the Italian Arte Povera movement of the mid-1960s. Encompassing both an aesthetic and a political dimension, the movement emphasized the use of everyday, poor *(povera)* non-art materials raised to the level of art through the artist's intervention, thus attempting a merger of art and life.

Alfred Newton Richards Medical Research Building, University of Pennsylvania, Philadelphia. 1957–61

Model: basswood, 13½ × 14¾ × 22¾" (34.2 × 37.5 × 57.8 cm)
Gift of the architect

The design of the Richards Medical Research Building, as shown in this model, was a reaction against the prevalent idea in modern architecture that a single envelope of space should encompass all parts of a building. The distinction between what Kahn called "served" and "servant" spaces underlies the highly articulated massing and overall structure of the Richards Medical Research Building. Kahn explained that he conceived its design "in recognition of the realizations that science laboratories are studios and that the air to breathe should be away from the air to throw away." By placing the "servant" spaces—stairs, elevators, and air-handling towers—on the periphery, Kahn was also able to provide the "served" spaces—the laboratories—maximum flexibility by means of their uninterrupted floor areas. While Kahn developed a practical response to programmatic needs, he made aesthetic choices as well: the towers echo the lively silhouette of the neighboring turn-of-the-century dormitories.

The model shows the innovative structural system of precast, post-tensioned concrete that Kahn designed with structural engineer August Komendant. The clear division between the concrete structural members (the trusses and cantilevered beams) and the brick-and-glass infill is a further indication of the hierarchical order underlying Kahn's work.

144 Lead Square. 1969
144 lead plates, each approx. ³⁄₈ × 12 × 12"
(.9 × 30.5 × 30.5 cm), overall ³⁄₈" × 12'7⁄₈" × 12'1½"
(.9 × 367.8 × 369.2 cm)
Advisory Committee Fund

144 Lead Square is one of several works
in which Andre abuts twelve-by-twelve-
inch metal squares to form a larger
square, also based on the number twelve
(twelve feet to a side). In this case the
metal is lead; elsewhere Andre uses alu-
minum, steel, zinc, copper, magnesium,
and tin. What is fascinating is the com-
plexity of the aesthetic ideas enforced in
this simple plan.

Simplicity, after all, is itself an idea.
144 Lead Square implicitly argues with
the sculptural conventions that it refuses:
an elevating base or pedestal, the craft
and talent of shaping, high finish, even
three-dimensionality. (Only marginally

volumetric, *144 Lead Square* rises a
mere ³⁄₈ of an inch off the floor.)
Instead, Andre uses a straightforward
system to organize flat modules of basic
materials. It is the system, and the shape
and size of the materials themselves,
that determine the work's form. Each
part of this Minimalist work is the same
proportion of the whole, and no part
commands more attention than any other.

"My works are not the embodi-
ments of ideas or conceptions," Andre
has said. "My works are, in the words of
William Blake, 'The lineaments of
Gratified Desire.'" There is indeed a
sensuousness in Andre's approach to
materials, and to the artwork's relation-
ship with the surrounding space. Like
Minimalism generally, however, his
sculpture is fundamentally impersonal,
and evinces a solemn austerity.

Large Torso: Arch. 1962–63
Bronze, 6' 6⅛" × 59⅛" × 51¼" (198.4 × 150.2 ×
130.2 cm)
Edition: 3/7
Mrs. Simon Guggenheim Fund

Invited by the title of this sculpture to
expect a description of a human torso,
the viewer may notice a striking absence
of the solid body that lies below the
shoulders, at least in a living being.
Basing the piece on the shoulder-bone
structure of a male torso, Moore actually
made a simplified skeleton. The shapes
of bones fascinated Moore. He was also
one of the many artists of his generation
who wanted to escape the classical tradi-
tion—in his words, to remove "the
Greek spectacles from the eyes of the
modern sculptor"—and who therefore
studied objects of many eras and areas,
from Cycladic art to pre-Columbian art
to the African and Oceanic art of rela-
tively recent times. "Keep ever promi-
nent the world tradition—the big view
of Sculpture," Moore once wrote, and
the near-abstract forms of his art show
how far he left classical naturalism
behind.

In its scale and weight, *Large Torso*
evokes a natural form—perhaps an arch
of wind-smoothed rock. The word *Arch*
in the work's title also asks viewers to
look at that central vacancy, as important
formally as the solid bronze. Stripping
the skeleton of flesh, and melding it
with landscape, Moore gives his work
the sense of having been shaped by the
long passage of time.

Tony Smith | American, 1912–1980

Moondog. 1964

Painted aluminum (fabricated 1998), 17' 1¼" × 15' 8½" × 13' 7¼" (521.3 × 478.8 × 414.7 cm)
Gift of Agnes Gund, Helen Acheson Bequest (by exchange), and Thomas W. Weisel Fund

Moondog is formed out of geometric modules—a combination of tetrahedrons and elongated octahedrons, joined through their facing planes. Rare in the natural environment, regular geometries are commonly taken as signs of human reason, but they do exist in nature, as Smith well knew; he studied the growth of crystals, and once based an architectural design on the hexagons of the honeycomb. Rational as his structures are, they follow organic principles. Like the Minimalist artists who emerged alongside him in the early 1960s, Smith favored geometric shapes and impersonal surfaces, and was alert to the artwork's exchange with the space around it; but he was actually a contemporary of the Abstract Expressionists, and unlike the Minimalists he worked intuitively. "All my sculpture," he said, "is on the edge of dreams."

Despite its self-evident logic, *Moondog* tricks the eye. Symmetrical and upright from some angles, from others it leans to one side, and its interlocking planar patterns seem to twist and shift as the viewer moves. The form was inspired by a photograph of a little jade house, and Smith interpreted it variously as a human pelvis and a Korean garden lantern. The title came from Joan Miró's painting *Dog Barking at the Moon* (1926) and from the New York street poet "Moondog," who wore a Viking-like helmet that reminded Smith of the sculpture.

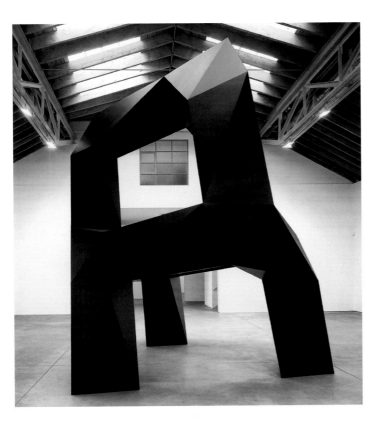

Cage II. 1965
Stainless steel, 7' 1¼" × 14¼" × 14¼" (216.5 × 36.2 × 36.2 cm)
Edition: 2/2
Gift of Agnes Gund and Lily Auchincloss

Cage II may seem easy to grasp: a space sealed by bars—a cage. But it would be a thin person indeed who could fit in this narrow room, and in any case, how would anyone get in? There are no doors, no hinges. The metal, too, a pris-

tine stainless steel, is richer than brute prison iron. *Cage II* is surely a paradox: a cage made elegant and abstract.

The paradox only multiplies, for *Cage II* is also a kind of portrait. It remakes a piece from 1961, in wood, but otherwise the same except for the title: *Statue of John Cage*. The John Cage whose name gave de Maria a pun was, of course, the well-known composer and theorizer of modern music. But an aesthetic tradition is also cited here, for Cage had close links to an art-making approach associated with Marcel Duchamp (a long-standing friend of Cage's)—an approach favoring conceptual thought, and, also, a love of puns and wordplay.

The foursquare geometry of *Cage II*, meanwhile, and the purity of the work's medium, point in another direction—toward the Minimal art of the 1960s, an art of system and order. Yet in the work's enigmatic combination of openness and rigor there remains a tribute to the paradoxical artist and musician who inspired it.

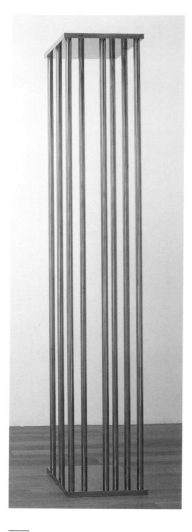

Robert Morris | American, born 1931

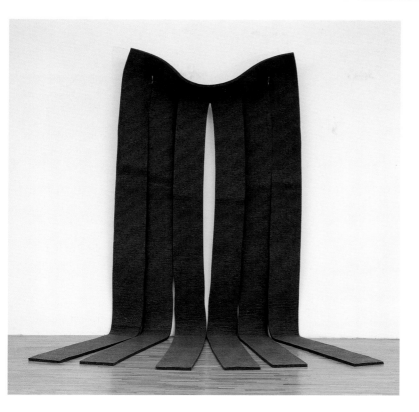

Untitled. 1969
Gray-green felt, draped, 15' ¾" × 6' ½" × 1"
(459.2 × 184.1 × 2.5 cm)
The Gilman Foundation Fund

Although Morris helped to define the principles of Minimal art, writing important articles on the subject, he was also an innovator in tempering the often severe appearance of Minimalism with a new plasticity—a literal softness. In works like this one, he subjected sheets of thick industrial felt to basic formal procedures (a series of parallel cuts, say, followed by hanging, piling, or even dropping in a tangle), then accepted whatever shape they took as the work of art. In this way he left the overall configuration of the work (a configuration he imagined as temporary) to the medium itself. "Random piling, loose stacking, hanging, give passing form to material," Morris wrote. "Chance is accepted and indeterminacy is implied.... Disengagement with preconceived enduring forms and orders for things is a positive assertion."

This work emphasizes the process of its making and the qualities of its material. But even if Morris was trying to avoid making form a "prescribed end," as a compositional scheme, the work has both formal elegance and psychological suggestiveness: the order and symmetry of the cut cloth is belied by the graceful sag at the top. In fact, a work produced by rigorous aesthetic theory ends up evoking the human figure. "Felt has anatomical associations," Morris has said, "it relates to the body—it's skinlike."

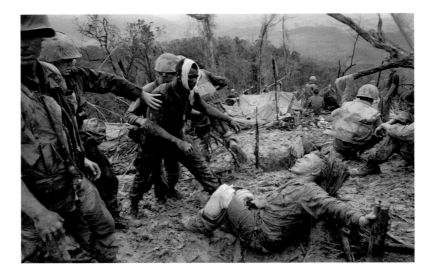

At a First-Aid Center during Operation Prairie. 1966

Dye transfer print, 19¼ × 29¾" (48.9 × 75.5 cm)
Gift of Time, Inc.

An expert at photographic technique, Burrows was the first photographer to cover a war comprehensively in color. In this scene, the white and bloodied bandages and the vulnerable pale flesh of the wounded man on the ground are all the more striking because they stand out against the muted grays and browns of the devastated landscape. The composed drama of the photograph recalls the stylized choreography of history painting from earlier centuries. Yet the picture's power lies no less in its vivid description of utter ruin and existential exhaustion than in our knowledge, through photography, that these are real men in a real place.

Burrows covered the Vietnam War for *Life* magazine from 1962 until his death at the age of forty-four, in 1971, when the helicopter carrying him to the invasion of Laos crashed. In his work, Burrows sought the center of violent action and attempted to describe its effects on people. He hoped that his photographs would "penetrate the hearts of those at home who are simply too indifferent" and that they would "show people what others go through."

Donald Judd | American, 1928–1994

Untitled (Stack). 1967
Lacquer on galvanized iron, twelve units, each
9 × 40 × 31" (22.8 × 101.6 × 78.7 cm), installed
vertically at 9" (22.8 cm) intervals
Helen Acheson Bequest (by exchange) and gift
of Joseph Helman

Sculpture must always face gravity, and
the stack—one thing on top of another—
is one of its basic ways of coping. The
principle traditionally enforces a certain
hierarchy, an upper object being not
only usually different from a lower one
but conceptually nobler, as when a statue
stands on a pedestal. Yet in Judd's stack
of galvanized-iron boxes, all of the units
are identical; they are set on the wall and
separated, so that none is subordinated
to another's weight (and also so that the
space around them plays a role in the
work equivalent to theirs); and their reg-
ular climb—each of the twelve boxes is
nine inches high, and they rest nine
inches apart—suggests an infinitely
extensible series, denying the possibility
of a crowning summit. Judd's form of
Minimalism reflected his belief in the
equality of all things. "In terms of exist-
ing," he wrote, "everything is equal."

The field of Minimalist objects,
however, is not an undifferentiated
one—Judd also believed that sculpture
needed what he called "polarization,"
some fundamental tension. Here, for
example, the uniform boxes, their tops
and undersides bare metal, suggest the
industrial production line. Meanwhile
their fronts and sides have a coat of
green lacquer, which, although it is auto
paint, is a little unevenly applied, and
has a luscious glamour.

Axes. 1976
Synthetic polymer paint, gesso, charcoal, and
pencil on canvas, 64⅝" × 8' 8⅞" (164.2 × 266.4 cm)
Purchased with the aid of funds from the
National Endowment for the Arts

"By the middle of the '70s," Rothenberg
has said, "I sensed that people were tired
of Minimal and Conceptual art. It made
sense to paint an image of something
you could recognize and feel something
about." Having found herself doodling a
horse on a bit of canvas in 1973, Rothen-
berg shortly began a series of full-scale
paintings of horses. These works antici-
pated the powerful return of figurative
and subjective content in American and
European art of the late 1970s and 1980s.

Rothenberg, however, runs the
emotional immediacy of figurative art
through the filter of abstraction. In
Axes, her working of the paint favors its
material presence over its illusionistic or
expressive possibilities. The body of the
horse is a largely flat white—there is lit-
tle modeling to give it volume or detail
to give it character. It shares that white
with the ground around it, which it trav-
erses improbably slantwise, and straight
lines cross both body and ground, insist-
ing that they are constituents of the
same flat surface. The result is neither
wholly representational nor wholly
abstract, and reflects the ideas of its time
even while it breaks from them: "I was
able to stick to the philosophy of the
day—keeping the painting flat and anti-
illusionist—but I also got to use this big,
soft, heavy, strong, powerful form."

Ocean Park 115. 1979
Oil on canvas, 8' 4" × 6' 9" (254 × 205.6 cm)
Mrs. Charles G. Stachelberg Fund

Diebenkorn's Ocean Park series, begun in 1967, makes general reference to the beachside land- and cityscape of the neighborhood in Santa Monica, California, around the artist's studio. The series is the work of an artist who synthesized the principal currents of the twentieth century's most rigorous abstract art (after painting representationally), joined it to a painterly 1950s sensibility, and created a new style with both the seriousness and the decorativeness of his exemplars, and with a gentle but firm sensuousness that is entirely his own. The work uses the components of Piet Mondrian's mature art, but escapes from the form of geometry that Mondrian had adapted from Cubism to learn more from the less confining structures, and the breathing surfaces, of Barnett Newman and Mark Rothko. But Diebenkorn recomplicates the spareness of those artists' fields, reintroducing a searching, durational record of the work's creation.

The influence of another touchstone for Diebenkorn, Henri Matisse, is apparent in *Ocean Park 115*, as in the rest of the series, in the way the space is divided into flat planes and bands of color. Built up of successive layers of pigment, the painting's blues and greens shift in their density, invoking a translucent luminosity.

Tizio Table Lamp. 1971

ABS plastic and aluminum, max. 46¾ × 42½"
(118.7 × 108 cm)
Manufacturer: Artemide S.p.A., Italy
Gift of the manufacturer

Sapper claimed that he designed the Tizio lamp because he could not find a work lamp that suited him: "I wanted a small head and long arms; I didn't want to have to clamp the lamp to the desk because it's awkward. And I wanted to be able to move it easily." The designer's dream lamp, the Tizio is an adjustable table fixture that can be moved in four directions. It swivels smoothly and can be set in any position, its balance ensured by a system of counterweights. The halogen bulb, adjustable to two dif-ferent light intensities, is fed through the arm from a transformer concealed in the base. In 1972, when the Tizio lamp was first produced, the use of the arms to conduct electricity was an innovation seen in few other lamp designs.

From a formal point of view, the Tizio lamp was revolutionary. Black, angled, minimalist, and mysterious, the lamp achieved its real commercial success in the early 1980s, when its sleek look met the Wall Street boom. Found in the residences of the young and successful and in the offices of executives, the lamp has become an icon of high-tech design.

Mario Bellini | Italian, born 1935

Divisumma 18 Electronic
Printing Calculator. 1972
Cast-injected ABS plastic body, flexible
synthetic rubber, and melamine, $1^7/_8 \times 9^3/_4 \times 5''$
($4.8 \times 24.8 \times 12.7$ cm)
Manufacturer: Ing. C. Olivetti & C., S.p.A., Italy.
Design collaborators: Dario De Diana, Alessandro
De Gregori, Derk Jan De Vries, Antonio Macchi
Cassia, Giani Pasini, and Sandro Pasqui
Gift of the manufacturer

It was hard to resist touching the
Divisumma 18 calculator when it first
appeared on the market. Produced by
Olivetti, for whom Bellini began work-
ing as a chief industrial design consult-
ant in 1963, it proved to be enormously
popular. The Divisumma 18 was small
and portable, in contrast to earlier com-
puting machinery, much of which
looked like heavy cabinetry. The key-
board, with its nipplelike buttons, is

encased in Bellini's typical rubber skin,
which in this design is a playful yellow.

In the 1960s, Bellini began his
career at a turning point in the history of
twentieth-century design: the transition
from mechanical to microelectronic
technology. To accommodate rapidly
changing technology and increasing
miniaturization, new products had to be
designed. Bellini was able to link the
necessities of the developing electronics
industry to contemporary visual culture
by emphasizing tactile qualities and
taking advantage of the expressive possi-
bilities of such new materials as plastic.
Bellini made industrial products desirable
by injecting into his designs subtle
anthropomorphic references, which
stimulate emotional responses. Plastic,
leather, or rubber, for example, may have
the sensual properties of human skin.

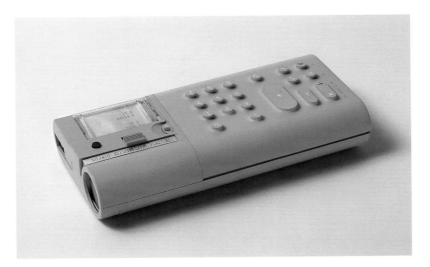

Rem Koolhaas | Dutch, born 1944
Elia Zenghelis | British, born 1937

The Voluntary Prisoners from **Exodus, or the Voluntary Prisoners of Architecture.** 1972
Collage, watercolor, and ink on paper,
19¾ × 25⅞" (50 × 65.7 cm)
Associates: Madelon Vriesendorp (Dutch, born 1945), Zoe Zenghelis (Greek, born 1937)
Patricia Phelps de Cisneros Purchase Fund, Takeo Obayashi Purchase Fund, and Susan de Menil Purchase Fund

Koolhaas completed a series of eighteen drawings, watercolors, and collages in his last year of study at the Architectural Association in London, a virtual incubator for radical architectural theory in the 1970s. Presented at his final thesis review, Exodus was a collaborative effort that was also submitted jointly to an Italian urban design competition and, ultimately, served as a catalyst for the formation of the Office for Metropolitan Architecture, in 1975.

The immediate inspiration for this series, to which The Voluntary Prisoners belongs, was the Berlin Wall. Images of the Wall are juxtaposed with those of the American suburbs and of Manhattan; and superimposed over a collage of rock-and-roll, Cold War, and pornographic imagery is text from Charles Baudelaire's *Les Fleurs du mal.* Multiple symbolic references to historical and contemporary architectural movements intensify the portrayal of urban "delirium" and reflect contemporaneous urban theory, pop culture, and post-1968 politics.

In the text accompanying the project, referring to The Voluntary Prisoners, the architects explained: "Suddenly, a strip of intense metropolitan desirability runs through the center of London.... From the outside this architecture is a sequence of serene monuments; the life inside produces a continuous state of ornamental frenzy and decorative delirium, an overdose of symbols."

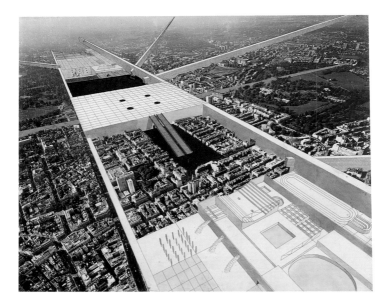

Cindy Sherman | American, born 1954

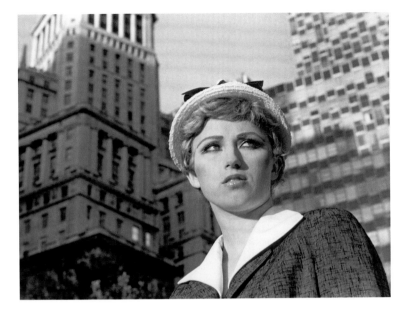

Untitled Film Still #21. 1978
Gelatin silver print, 7 ½ × 9 ½" (19.1 × 24.1 cm)
Purchase

Each of Sherman's sixty-nine Untitled Film Stills (1977–80), presents a female heroine from a movie we feel we must have seen. Here, she is the pert young career girl in a trim new suit on her first day in the big city. Among the others are the luscious librarian (#13), the chic starlet at her seaside hideaway (#7), the ingenue setting out on life's journey (#48), and the tough but vulnerable film noir idol (#54). To make the pictures, Sherman herself played all of the roles or, more precisely, played all of the actresses playing all of the roles. In other words, the series is a fiction about a fiction, a deft encapsulation of the image of femininity that, through the movies, took hold of the collective imagination in postwar America—the period of

Sherman's youth, and the crucible of our contemporary culture.

In fact, only a handful of the Untitled Film Stills are modeled directly on particular roles in actual movies, let alone on individual stills of the sort that the studios distribute to publicize their films. All the others are inventive allusions to generic types, and so our sure sense of recognition is all the more telling. It tells us that, knowingly or not, we have absorbed the movie culture that Sherman invites us to examine as a powerful force in our lives.

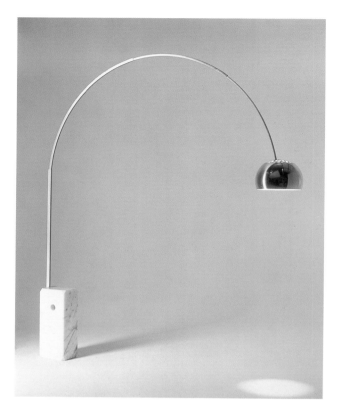

Arco Floor Lamp. 1962

Marble and stainless steel, 8' 2½" × 6' 7" × 12½"
(2.5 × 2 × .32 m)
Manufacturer: Flos S.p.A., Italy
Gift of the manufacturer

Castiglioni designed more than sixty lamps and a host of other objects, working from 1945 until 1968 with his brother Pier Giacomo and then on his own. One of their best-known lamp designs, Arco, came about through the challenge of a practical problem: how to provide a ceiling lamp that would not require drilling a hole in the ceiling. Castiglioni's motto, "design demands observation," proved accurate, for it was a street lamp that gave the brothers the inspiration for this fixture. Street lamps, affixed to the ground, have a shape that enables them to project their light beams several feet away from their bases.

In this domestic adaptation, the Castiglionis were able to illuminate objects eight feet away from the lamp's base—far enough to light the middle of a dining table—by inserting a steel arch into a heavy Carrara marble pedestal. They studied the span of the arch to be sure that its form would provide enough space for one person carrying a tray to pass behind someone sitting at the table. In addition, they made sure the heavy lamp could be moved by two people by inserting a broomstick through the hole in the marble base. Arco is a prime example of the Castiglionis' rigorous approach to design solutions.

Beogram 6000 Turntable. 1974
Steel, aluminum, and rosewood, $3\frac{3}{4} \times 19 \times 14\frac{1}{2}"$
$(9.5 \times 48.3 \times 36.8$ cm)
Manufacturer: Bang & Olufsen, Denmark
Gift of the manufacturer

The appearance of most audio equipment is seldom given thoughtful attention, and its impact on the domestic interior is frequently ignored. For this turntable, Jensen applied strict aesthetic criteria, emphasizing a horizontal profile and the clarity of basic geometric forms. Jensen, who has designed products for Bang & Olufsen since the late 1960s, dislikes conventional dials and knobs, and frequently reinvents the way in which controls appear and are used. His turntables are distinguished by an innovative use of a tone arm that moves tangentially, rather than diagonally, over the plane of the record.

The Danish manufacturer Bang & Olufsen, established in the late 1920s, has produced radios, phonographs, televisions, VCRs, and acoustic components—all sleek, well-detailed appliances intended to reform the way electronic equipment looks and even functions, as well as how the user interacts with it. Interestingly, Bang & Olufsen designers often mask the function of an object in favor of a handsome appearance that highlights the quality of its materials.

Pikes Peak Park, Colorado Springs. 1970
Gelatin silver print, 5⅞ × 6" (14.8 × 15.2 cm)
David H. McAlpin Fund

Vacationers often turn their cameras away from the crowded highway toward a pristine mountain range, taking care to exclude power lines and other tourists from the beautiful view. They are performing a ritual of homage to the ideal of the American West, and to its grand tradition in photography. In the late 1960s, Adams, an inhabitant of the West, pioneered an alternative landscape tradition, which included man and his creations in the picture. "We have built these things and live among them," his photographs seem to say, "and we need to take a good, hard look at them."

Photography had never before been so plain and brittle, so lacking in embellishment and seduction. Yet the very aridness of Adams's early style introduced to the medium a new kind of beauty, rooted in the frankness of his acknowledgment that what we see in his photographs are our own creations, our own places.

The Conversation. 1974

35mm film, color, sound, 113 minutes
Gift of the artist
Gene Hackman

Hidden within the confines of an electronically outfitted van, Harry Caul (Gene Hackman) is capable of wiretapping even the most remote whisper of a conversation. While he is often at the epicenter of moral corruption, Caul remains fastidious with respect to his own conduct and usually takes no interest in the content of what he overhears transpire between lovers and thieves. When he believes he hears plans for a murder, however, he desperately tries to prevent the event. But his talent lies in his technical abilities, not in his skill in interpreting nuances.

Coppola's most claustrophobic and meticulous film, *The Conversation* was released at the height of the Watergate investigation. It is a slow yet harrowing film conveying the repulsiveness of surveillance, the loss of personal liberty, and our inability to reverse the catastrophic end results of technology once it has been set into motion. Keenly aware of the fact that invasion is possible by even the most amateur eavesdropper, Caul is enormously protective of his private life. His San Francisco apartment, although nearly empty, is secured with multiple door locks and a burglar alarm, and he wears a plastic raincoat as a metaphoric protectant against the unwelcome intrusion of society.

Burnt Piece. 1977–78
Cement, burnt wood, and wire mesh, 33⅞ ×
34 × 34" (86.1 × 86.4 × 86.4 cm)
Gift of Agnes Gund

A member of the post-Minimalist gen-
eration, Winsor inherits the Minimal-
ists' preference for simple geometric
shapes. But her works are handmade,
and their surfaces are more various and
tactile than Minimalism's impersonal,
machine-honed planes. They also show
slotlike openings that invite us to peer
into their dark interiors: "You go up to
the windowed cubes and touch them,"
says Winsor, "you peek, you use your
eyes, your nose." In this way "the cubes
parallel and are metaphors for the body."
 For *Burnt Piece* Winsor built a cube
out of wood and wire-reinforced con-
crete. Then she set this cube over a
bonfire, burning away the wood and

turning the concrete brown, black, and
ash gray. This volatile process has cre-
ated a dramatic narrative. Winsor
burned the cube for about five hours,
until, she says, it "began to expand and
round slightly. As it cooled later, it con-
tracted and the cube became slightly
concave. During the firing, fragments of
concrete popped off the main body to a
distance of twenty feet. I had researched
the material's properties because I
wanted to push to its structural limit, to
where the concrete was actively, danger-
ously, responding to the heat but was not
overwhelmed or destroyed. . . . That is
what physically happened to the form
and material. That is its history."

Richard Long | British, born 1945

Cornish Stone Circle. 1978

Fifty-two stone slabs (Delabole slate),
overall 19' 8⅜" (600 cm) diam.
Gift of Barbara Jakobson and John R. Jakobson,
Junior Council, and Anonymous Funds

Ancient stone circles survive at scattered
sites in many parts of Long's native
England, relics of the country's distant
past. In evoking these local and age-old
forms, *Cornish Stone Circle* bypasses the
classical tradition of sculpture in favor
of "primitive" art, an influence on
artists since the early twentieth century.
Long's art, however, also inflects more
recent ideas.

Like certain Minimalist sculptures,
Cornish Stone Circle has no base or
pedestal, no height to speak of, nor is it
even an intact mass. More, its mass is
mutable: the circle must be three meters
in radius, and its fifty-two rough stones
must be stably situated, evenly distrib-
uted and separated, and randomly
arranged, but otherwise their placement
is open to change. Long's most search-
ing revision of the character of the
art object, however, has to do with his

relationship with the natural environ-
ment. Like other earthworks artists, he
is attracted to outdoor, often remote, ter-
rain, where he may pile stones, mark a
path, or simply take a long walk; later he
may exhibit photographs, maps, or writ-
ten descriptions of these actions, for his
work shares Conceptual art's concern
with the different experiences conveyed
by different visual and verbal systems.
In this context, *Cornish Stone Circle*
becomes not only a sculptural configura-
tion but a way of representing a far-off
place, through the presence of materials
gathered there.

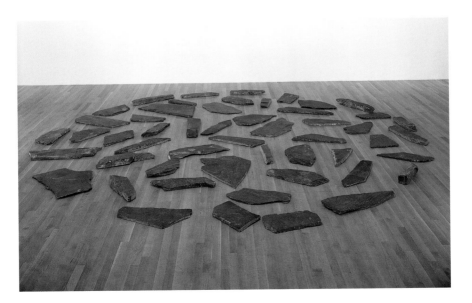

Untitled (Sun State). 1974
Chalk on painted board with wood frame,
47½" × 6' (120.7 × 183 cm)
Gift of Abby Aldrich Rockefeller and acquired
through the Lillie P. Bliss Bequest (by exchange)

This drawing unites the cosmic and terrestrial, as it maps an ideal state in which the social order is conceived as a living organism, intimately linked to a balanced natural order. Each motif is a metaphor: the sun creates energy, which circulates by means of a looping line; through alchemy it takes form in a threefold system of culture—art, science, and religion—and travels toward the ideal state; this life principle is balanced by the death principle, and the earth by the primary actor, Man, an androgynous figure accompanied by an emblem of his animalistic and spiritual nature—the stag.

Untitled (Sun State) is one of

Beuys's Blackboard drawings, which were created during his lectures at educational institutions and museums. This drawing evolved during his participation in the public dialogue, "Art into Society, Society into Art" at The Art Institute of Chicago in 1974. Here Beuys demonstrates, with a thin looping line and verbal descriptions, the connections among myth, alchemy, astrology, anthropology, and the social and political sciences. The result is a work described by the artist as a kind of astrological chart embodying his ideas of the ideal state, in which democratic principles inform cultural life (freedom), law (equality), and economics (fraternity). It is a constellation delineating a structure for a harmonious social body, or, alternatively, a social sculpture—an evolutionary process whose goal is to "sculpt new models for the entirety of life."

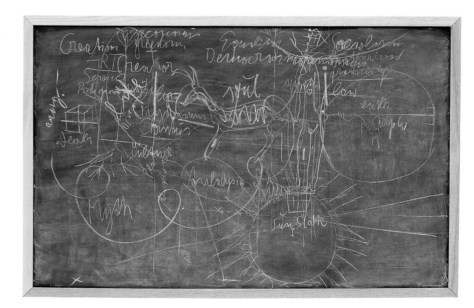

Brice Marden | American, born 1938

Grove Group, I. 1973
Oil and wax on canvas, 6' × 9' ⅛" (182.8 × 274.5 cm)
Treadwell Corporation Fund

The beautiful blue-gray-green of *Grove Group, I* was inspired by the colors Marden saw in a stand of olive trees in Greece, and he has described works like this one as referring to nature. Yet this monochromatic painting is far from the "window on the world" of the conventional landscape, and even from the sense that many abstract pictures allow of opening onto another space. Working in a sensuous mix of oil paint and wax, Marden creates a surface of substance and mass, opaque and dense. At the same time, that mass seems weightless, that density luminescent: it is as if, in carefully building up the surface, Marden had been able to trap within its layers the light that saw its making.

The painting comes from a series of five, dating from 1973–76. In each of the other four works, monochrome panels, in different but related colors, abut to produce an overall format of the same size and shape as the single-panel *Grove Group, I*. This modular and methodical design recalls the strategies of Minimal art, but few Minimalists would call their work "highly emotional," as Marden has. "The paintings are made in highly subjective states," the artist says, though he adds, "within Spartan limitations."

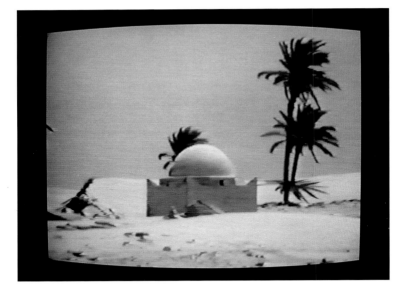

Chott el-Djerid (A Portrait in Light and Heat). 1979
¾" video, color, sound, 28 minutes
Gift of Catherine V. Meacham

Chott el-Djerid (A Portrait in Light and Heat) almost magically captures the optical and acoustic distortions of nature. Focused on landscape, the video work dwells briefly on the snowy plains of midwestern America and Saskatchewan, then abruptly switches to the arid Tunisian desert. Viola investigates the world of illusion and how it is made. He works by slowly discovering the distinctive character of a place, probing its power and energy, drawing upon the associations it evokes, and searching instinctively for its archetypal symbols. In Tunisia, he was fascinated by the pastel-colored desert mirages floating mysteriously near the horizon.

To shoot *Chott el-Djerid*, the artist used one video camera set on a tripod and meticulously framed his subject from a fixed vantage point. He would only begin filming when he considered ideal atmospheric conditions to have occurred; at times he waited up to several days. He moved his camera only a few inches forward or backward between many shots so that he could fabricate a zoom during editing. In his studio, Viola carefully developed the rhythm of this nonverbal narrative of ordinary events happening in real time. Its pace compels viewers to assume a mindset of dream-like suspended animation. It is filled with ambient natural sounds that temper its sense of otherworldliness: for example, the viewer first identifies an oncoming pair of motorcycles through aural, rather than visual, cues.

Watchtower (Hochsitz). 1984

Synthetic polymer paints, dry pigment, and oil-stick on various fabrics, 9' 10" × 7' 4½" (300 × 224.8 cm)

Fractional and promised gift of Jo Carole and Ronald S. Lauder

The high scaffold in *Watchtower* could be a hunters' blind but also whispers of the guards' post—perhaps on the East-West border within a still-divided Germany, perhaps on a concentration-camp fence. Polke stenciled this skeletal frame in a series of paintings begun in 1984, varying the imagery around it. Here, he clothes the watchtower in a baleful phosphorescent glow, which sends up a hollow arm to catch the tower's top.

In the 1960s Polke had produced what he called "Capitalist Realism," a German variant of Pop art. An element of Pop survives in *Watchtower*'s support, made of commercial yard goods printed, respectively, with a cheerful floral and with a weave or mesh. Refusing consistency, however, Polke combines these with both the sinister tower image and an abstraction (which, with its alternately smooth and spidery lines, suggests more than one painting process). Images and styles from different eras, and associated with different moods and intentions, jostle and layer in the same work—a "postmodern" approach that Polke pioneered, and that a variety of artists explored in the 1980s.

Visual layering brings a layering of sense. In *Watchtower*, painted and printed images compete for visibility; if the watchtower is haunted and haunting, the prints connote a banal dailiness. It is as though different registers of consciousness and of memory were struggling for resolution.

Bruce Nauman | American, born 1941

White Anger, Red Danger, Yellow Peril, Black Death. 1984

Two steel beams, four painted metal chairs, and cable, overall 62¾" × 17' 11⅛" × 16' (159.4 × 546.4 × 487.7 cm)

Gift of Werner and Elaine Dannheisser

Two steel girders hang in an X-shape. Slid over them are three chairs (variously seatless, backless, and legless) in different metals, one red, one yellow, one black, while a fourth metal chair, in white, hangs adjoining—the girders may hit it if they swing or spin. Usually designed for rest and comfort, chairs here grow precarious, both menaced and menacing.

Escaping convenient labeling by school or style, Nauman has explored many materials and art forms—fiberglass, video, neon, installation, drawing, and more. He emerged alongside the Conceptual artists of the 1960s, and although his work is often more concretely physical than theirs, he shares their interest in the functioning of language. Nauman sees artmaking not primarily as the creation of aesthetic form but as a question of picking apart the habits of perception and structures of language that dictate the meaning of the work of art.

The title *White Anger, Red Danger, Yellow Peril, Black Death* invokes perennial fears and prejudices: racism, xenophobia, plague. Nauman's art, he says, "comes out of being frustrated about the human condition. And about how people refuse to understand other people." Given the animosities and anxieties cited in the work's title, the chairs' tensely dangling balance can be seen as conjuring the instability of the global equilibrium, but with a stringency surpassing verbal metaphor.

Grane. 1980–93
Woodcut with paint additions, comp.: 9' 1¹/₁₆" ×
8' 2½" (277.1 × 250.3 cm) (irreg.)
Edition: unique

Purchased with funds given in honor of Riva
Castleman by The Committee on Painting and
Sculpture, The Associates of the Department of
Prints and Illustrated Books, Molly and Walter
Bareiss, Nelson Blitz, Jr. with Catherine
Woodard and Perri and Allie Blitz, Agnes
Gund, The Philip and Lynn Straus Foundation
Fund, Howard B. Johnson, Mr. and Mrs. Her-
bert D. Schimmel, and the Riva Castleman
Endowment Fund

The title of this work refers to Brun-
hilde's horse in the renowned operatic
cycle, *The Ring*, by Richard Wagner.
Near the opera's end, Brunhilde, in grief
over the murder of the hero Siegfried,
makes a funeral pyre for him and rides
her horse, Grane, into the flames to join
her beloved in death. The rigid skeletal
horse positioned over flames, the
primeval scorched landscape, and the
tombstonelike format of the composi-
tion directly allude to death.

Much of the power of this image
derives from Kiefer's forceful use of the
woodcut medium; in the jagged edges of
the white areas we sense the artist's bold
cutting of the woodblock. For climactic
drama, he applied white paint to heighten
the flames and orange-brown staining for
the smoldering glow surrounding the
scene. The monumental size of this work
required thirteen sheets of paper to be
joined together and mounted on linen.

Kiefer has created a large body of
work exploring his nation's identity and
the moral and philosophical issues fac-
ing post–World War II Germany. His
imagery contains references to his coun-
try's historical and cultural past but also
serves as a metaphor for universal suf-
fering, sacrifice, and destruction.

October 18, 1977. 1988

Fifteen paintings, oil on canvas, installation variable, from 13¾ × 15½" (35 × 40 cm) to 6' 6¾" × 10' 6" (200 × 320 cm); shown: *Man Shot Down*, 39½ × 55¼" (100.5 × 140.5 cm)
Purchase

On October 18, 1977, Andreas Baader, Jan-Carl Raspe, and Gudrun Ensslin were found dead in their cells in a Stuttgart prison. The three were members of the Red Army Faction, a coalition of young political radicals led by Baader and Ulrike Meinhof, who had earlier hung herself in police custody. Turning to violence in the late 1960s, the Baader-Meinhof group had become Germany's most feared terrorists. Although the prisoners' deaths were pronounced suicides, the authorities were suspected of murder.

The fifteen works in *October 18, 1977* evoke fragments from the lives and deaths of the Baader-Meinhof group. Richter has worked in a range of styles over the years, including painterly and geometric abstraction as well as varieties of realism based on photography; the slurred and murky motifs of this work derive from newspaper and police photographs or television images. Shades of gray dominate, the absence of color conveying the way these second-hand images from the mass media sublimate their own emotional content. An almost cinematic repetition gives an impression, as if in slow motion, of the tragedy's inexorable unfolding. Produced during a prosperous, politically conservative era eleven years after the events, and insisting that this painful and controversial subject be remembered, these paintings are widely regarded as among the most challenging works of Richter's career.

Greed's Trophy. 1984

Steel rods and wire, wood, rattan, and leather,
12' 9" × 20" × 55" (388.6 × 50.8 × 139.7 cm)
David Rockefeller Fund and purchase

The wire and the cagelike form of
Puryear's sculpture may suggest a
hunter's trap or a fisherman's basket;
another allusion could be to sport, and
the lacrosse stick. These different echoes
resonate with the title *Greed's Trophy*,
but the work has no single model among

human artifacts, and its traces of them
fuse with hints of the human body: the
dark eye, and the lolling tongue at the
bottom, evoke a head, while the shape—
dwindling at the foot, expanding at the
"chest," and swelling slightly into a cir-
cle at the top of the armature on the
wall—is subtly figural. Meanwhile, as
Greed's Trophy is taking us in these vari-
ous interpretive directions, it remains
conspicuously empty and open, its tense
curves a sculptural essay in shape with-
out physical substance.

"I was never interested in making
cool, distilled, pure objects," Puryear
has said, and his work is deliberately
associative. Minimalism has informed
his involvement with materials, but
whereas the classic Minimalist object is
industrially fabricated and impersonal in
shape and surface, Puryear's art is
steeped in cultural and historical refer-
ence, and he is enormously adept at car-
pentry and other manual skills. In fact
Greed's Trophy, in evoking the tools of
the American outdoorsman, claims a
place for the history of craft in our
understanding of the country's art.

Dis Pair. 1989–90
Oil and synthetic polymer paint on two canvases and wood, overall 10' 2½" × 10' 9¼" × 13" (331.3 × 328.3 × 33 cm)
Gift of Marcia Riklis, Arthur Fleischer, and Anna Marie and Robert F. Shapiro; Blanchette Rockefeller Fund; and purchase

Great blue ovals collide against stiff trapezoids, twining yellow tendrils tie them all together: as abstract form, *Dis Pair* has a springy rhythmic dynamism. Yet it also applies the stylistic vocabulary of the comic strip to depicting a pair of shoes. Besides being wittily distorted and distended, these shoes are over ten feet high, using a strategy of enlargement prefigured in Claes Oldenburg's Pop sculpture; and Pop art also anticipated Murray's interest in the commonplaces of domestic life, which she paints on an undomestic, even heroic, scale.

Murray dramatizes the beautiful ordinariness of familiar objects. "I paint about the things that surround me," she says, "things that I pick up and handle every day. That's what art is. Art is an epiphany in a coffee cup."

Standing out from the wall in relief, the surface of *Dis Pair* suggests a stretched and rounded skin—perhaps these curving forms humorously evoke heads and faces, and their visual relationship the relationship of a human couple. The title of the work certainly puns on the slang word "dis," or "disrespect," and also, more gravely, on "despair." The household bond described here must be strained, but the tension seems more everyday than tragic: the suspense in the airborne lift of these grand swelling forms, and in their taut interaction, is subverted by their humor and their clunky domesticity.

Adjustable Wall Bra. 1990–91
Plaster, steel, canvas, electrical light bulbs, and
audio equipment; each cup 7'3" × 7'10½" × 37"
(221 × 240 × 94 cm), installation variable
Sid R. Bass Fund and purchase

"I want to put the viewer on shaky
ground," Acconci has said, "so he has
to reconsider himself and his circum-
stances." *Adjustable Wall Bra* prompts
just this doubt. One possible reflexive
response to it, sexual desire, is mocked
by the work's size; another reduces us to
infants dwarfed by their mother. Yet
nothing says that the giantess implicit
here is unfriendly. In fact the work is
wittily accommodating.

Hinged in the center, the bra can be
variously installed: both cups against the
wall; one against the wall, one hanging

outward, or on the wall adjoining; one
cup on the wall, the other on the floor,
or bridging wall and floor, or bulging
from the ceiling. The cups are lined with
canvas, and you can sit in them; and on
the floor they suggest a tent or igloo. Its
form invokes clothing, its scale evokes
both furniture and architecture, and the
work itself speaks of physical shelter.
Even as its size disconcerts, its humor
reassures: the cups light up, and built-in
speakers broadcast steady breathing.

A former performance artist,
Acconci is acutely attuned to the politics
of the human body. Here he applies out-
size scale (a strategy used by Pop artist
Claes Oldenburg in his soft sculptures of
the 1960s) to induce awkwardness—he
may invite you to sit, but you will feel
self-conscious if you do.

Nam June Paik | American, born Korea. 1932–2006

Untitled. 1993
Player piano, fifteen televisions, two cameras,
two laser disk players, one electric light and
lightbulb, and wires, overall size approximately
8' 4" × 8' 9" × 48" (254 × 266.7 × 121.9 cm)
Bernhill Fund, Gerald S. Elliott Fund, gift of
Margot Paul Ernst, and purchase

A pioneer in video art since the 1960s,
Paik believed he was particularly suited to
this medium by his training in music. "I
think I understand time better than the
video artists who came from painting-
sculpture," said Paik, because "music is
the manipulation of time. . . . As painters
understand abstract *space*, I understand
abstract *time*"—and time is integral to
video art, which must unfold in a tempo-
ral duration. Paik's art often uses or refers
to music and musical instruments. Mean-
while he also built structures out of or
incorporating television sets, so that his
video images become elements in an over-
all sculptural configuration.

Paik was a veteran of the Dada-
inspired Fluxus group, and his work can
be cheerfully anarchic. This untitled
piece, though, is elegiac in tone. An
upright player piano is piled with fifteen
televisions. Wired to these sets are small
closed-circuit cameras trained on the
instrument's mechanism, so that as the
piano, unmanned, plays ragtime, its work-
ings appear on the screens. We also see, on
one monitor at the sculpture's top and on
another at its foot, the image of the late
John Cage. A composer and aesthetic
thinker who embraced chance, accident,
and a certain playfulness of approach,
Cage was influential for many postwar
artists, including Paik.

Anular by José-Miguel Ullán. 1981
Illustrated book with 23 etchings,
page: 12⅞ × 9⁷⁄₁₆" (32.7 × 24 cm) (irreg.)
Publisher: R.L.D., Paris. Edition: 150
Abby Aldrich Rockefeller Fund (by exchange)

Anular—the word means to nullify or invalidate—presents a copy of an early Spanish constitution displayed as a single-spaced typewritten manuscript overlaid with Ullán's short poetic phrases and Tàpies's cryptic alphabet letters and symbol-like forms. Tàpies's super-imposed letters, looking like graffiti strewn across the pages, derive from the first character of the poet's adjacent words. Frequently portions of the text are torn, turned upside-down, or even obscured by Tàpies's "graffiti," possibly suggesting a disregard for the constitutional rights of individuals. The overall visual effect produces a sense of contra-diction and dissent, while also implying an act of nullification. Tàpies had lived through the many years of Franco's rule in Spain, and, at the time of the book's

execution, Ullán was living in exile due to his refusal to serve in the military.

As seen in the four-page spread dis-played here, each sheet is attached at its left and right edges to the next sheet. The pages are assembled in an accordion fold, making possible various panoramas. Pages can be turned one by one in the conventional manner, revealing a double-page spread; the continuous ensemble can be completely unfolded to show the entirety of text and images; or selected segments can be opened and spread out, as here. The resulting effect of this unusual book format is the creation of a world of words, an ongoing dialogue between painter and poet.

Michael Schmidt | German, born 1945

Untitled from **Waffenruhe (Cease-fire).** 1985–87
Gelatin silver print, 35⅛ × 27⅜" (89.2 × 69.5 cm)
Acquired through the generosity of Jo Carole and Ronald S. Lauder

It is only a dirty plate-glass window, but it is a barrier all the same. The nondescript scene beyond is out of focus because the photographer, instead, has focused, literally, on the window and its ugly mark, perhaps the remains of a poster that has been ripped from the glass.

Schmidt was born in Berlin five months after the German surrender ended World War II in Europe. In 1961, when he was sixteen, the city was decisively split into East and West by the feuding victors of the war, and so it remained until 1989. Although he had lived for a time in East Berlin, Schmidt came of age in the West, where he photographed the city's neighborhoods in a sober style ultimately derived from the American documentary tradition.

This picture belongs to a series of the mid-1980s in which Schmidt abandoned the reserve of his earlier style and radically narrowed the scope of his views so as to deepen their symbolic and emotional force. The Berlin Wall appears in some of the pictures; its presence is felt in all of them. When the Wall came down a few years later, Germans on both sides discovered that the rift Schmidt had evoked still divided them.

Scott Burton | American, 1939–1989

Pair of Rock Chairs. 1980–81
Gneiss, a: 49¼ × 43½ × 40" (125.1 × 110.5 × 101.6 cm); b: 44 × 66 × 42½" (111.6 × 167.7 × 108 cm)
Acquired through the Philip Johnson, Mr. and Mrs. Joseph Pulitzer, Jr., and Robert Rosenblum Funds

From behind, these sculptures resemble nothing so much as half-buried boulders, or the tips of submerged outcrops of living rock. It is only from the front that they show the results of human artifice: two simple cuts, one horizontal, one vertical. In each stone the result is a flat and ample ledge with an upright back—an invitation to sit.

The opportunity extended by *Pair of Rock Chairs* is actually not only physical but social, for two seats will tempt two people to rest and talk. Burton had a deep interest in social exchange—in fact, his first artworks were performances in front of an audience. His sculpture developed out of the furniture he used as props in these performances, and always remains part furniture, undermining the common notion that art is somehow separate from everyday life. Burton admired the Russian Constructivist artists who, earlier in the century, had linked innovative forms to a concern with their practical social applications. The natural shapes of these chairs, and their beautiful surface—variously rough and smooth, and veined in gray and white—inject aesthetic pleasure into their obvious usefulness.

Raging Bull. 1980
35mm film, black and white and color, sound,
119 minutes
Acquired from United Artists
Robert De Niro

This is a film about the escalation of domestic violence that begins with a family sitting around the kitchen table, bantering, bickering, goading, and then exploding into rage. Boxer Jake La Motta (Robert De Niro) was no artist but, rather, a club brawler whose singular gift was a tolerance for absorbing his opponent's punishment. Outside the ring, he was more likely to be the one providing the punishment, to his brother (Joe Pesci) and his platinum-blonde wife (Cathy Moriarty). In life, there are no referees, no mandatory eight counts, no limits. For La Motta, whose real-life story inspired the film, brutality was a career as well as a compulsion; for those who watched his progress toward the middleweight crown, it was blood sport masquerading as entertainment.

Scorsese has studied urban man's connection to violence for thirty years in film after powerfully charged film. *Raging Bull* is his simplest, most direct demonstration of what turns tough guys into mayhem machines. It was shot in grainy black and white; its potent chiaroscuro is reminiscent of old tabloid photos of "the big fight." The image that lingers longest from this painful, poignant film is the face of the middle-aged Jake, broken and bloated. He has suffered much and inflicted much more, yet, over a lifetime of pain, he has learned nothing.

Bubbles Chaise Longue. 1987
Corrugated cardboard with fire-retardant coating,
27¾" × 29" × 6' 4⅜" (70.5 × 73.7 × 194 cm)
Manufacturer: New City Editions, USA
Kenneth Walker Fund

Gehry worked with an unexpected, throwaway material—corrugated cardboard—in two series of surprisingly sturdy and humorous home furnishings. The instant success of the first series, Easy Edges, introduced in 1972, earned him national recognition. Gehry conceived its cardboard tables, chairs, bed frames, rocking chairs, and other items to suit the homes of young as well as old, of urban sophisticates as well as country dwellers. The Bubbles Chaise Longue belongs to Experimental Edges, the second series, which was introduced in 1979. These objects were intended to be artworks; yet they are sturdy enough for regular use. As the cardboard wears, it begins to appear suedelike and soft. Gehry's material lends itself to the curving form of this chair; its rollicking folds are, perhaps, a play on the corrugations themselves.

Heavily marketed and intentionally inexpensive, this furniture epitomized Gehry's interest in promoting affordable good design. The choice of "lowbrow" cardboard for Bubbles reflects Gehry's broad interest in using industrial, commercial, and utilitarian materials. An award-winning architect, he has worked with exposed chainlink fencing, corrugated metal, and plywood in concurrent architectural projects. In both the furniture series and the buildings, Gehry has given value to seemingly worthless materials by using them to create lasting designs.

Formula 1 Racing Car 641/2.
1990
Body materials: composite with monocoque chassis in honeycomb with carbon fibers and Kevlar, 40½" × 7' × 14' 8½" (102.9 × 213.4 × 448.3 cm)
Manufacturer: Ferrari S.p.A., Italy
Gift of the manufacturer

This Formula 1 Racing Car—with an exterior body designed by Barnard and interior chassis engineered and designed by the Ferrari company—clearly illustrates the modernist dictum "form follows function." The shape of its exterior has been determined by the laws of physics and aerodynamics, and falls within the rules and guidelines set up by the governing body of the sport of automobile racing. The sleek and sculptural silhouette of this Ferrari allows air to pass over the body with minimal drag and maximal down-force, which ensures precision handling even at speeds in excess of two hundred miles per hour.

High-performance racing cars represent the ultimate achievement of one of the world's largest industries. Painstakingly engineered to go faster, handle better, and stop more quickly than any other kind of automobile, they are the most technologically rational and complex type of motorcar produced. Experimentation and innovation in design, stimulated by the desire to win, are constants in the ongoing quest for the optimal racing machine.

Articulated Lair. 1986
Painted steel, rubber, and metal, overall 9' 3" ×
21' 6" × 16' 1" (281.7 × 655.7 × 555.6 cm)
Gift of Lily Auchincloss, and of the artist in
honor of Deborah Wye (by exchange)

Articulated Lair, Bourgeois has said, is
"a protected place you can enter to take
refuge," but at the same time she allows
that "the security of the lair can also be
a trap." She separates this charged space
from the world with a simple screen—a
row of thin metal panels, hinged, or
articulated, at their edges. There is an
entrance at either end; no matter where
Bourgeois's "invading, frightening visi-
tor" enters, you have "a back door
through which you can escape." Inside,
for furniture, is a single small stool, as
though the lair's resident were child-sized
and sought no company. Yet there are
other presences here, hanging against
the walls: pendulous forms in black rub-
ber, suggesting body parts. Perhaps a
hunter is storing prey; or we could be
inside some creature's stomach, among
its internal organs.

These rubber shapes have ante-
cedents in Surrealist biomorphism, and
in the paintings of Arshile Gorky. At the
same time, the anxiety over the integrity
of the human body that runs through so
much of Bourgeois's work anticipates
the concerns of many younger artists of
the 1980s and 1990s. *Articulated Lair* is
simultaneously safe and ensnaring—a
cryptic refuge for human frailty.

Puissance de la parole. 1988
¾" video, color, sound, 25 minutes
Acquired from France Telecom

Godard, one of cinema's most influential artists, has also made significant contributions to the field of video. He began making films in the mid-1950s, and since 1974 has been working with video technologies, employing techniques such as deconstruction, reassemblage, and collage to create a fresh aesthetic that is both resonant and intriguing. Godard overlaps music, sounds, and dialogue and establishes visual rhythms through juxtaposing slow takes and rapid cuts to create what he calls *son image*, that is, sound and image. In *Puissance de la parole* explosive sequences from nature abut those consisting of passionate discussions by two couples. One pair argues in dialogue spoken by the lovers in the novel *The Postman Always Rings Twice*

by James Cain; the other couple quotes a tale by Edgar Allan Poe.

Whether making a feature film, an experimental video, or a work for television, Godard expresses a wide range of thematic interests. His passions in life are brought to his videos and films, which focus on art, politics, history, television, communication, anxiety, sex, desire, music, and the history of the movies. As a critic and artist, Godard believes that his mission—to provoke new thinking—depends equally on language and image. He thus creates, in *Puissance de la parole* and other works, a new kind of essay in moving imagery.

The Peak, Kowloon, Hong Kong. Project, 1983

Exterior perspective, 1991: acrylic on paper, mounted on canvas, 51" × 6' (129.5 × 183 cm)
David Rockefeller, Jr. Fund

This project by Hadid, whose work has been called "deconstructivist," was the winning design in a competition for a private club to be located in the hills of Kowloon, overlooking Hong Kong. Hadid proposed a transformation of the site itself by excavating the hills and using the excavated rock to build artificial cliffs. Into this new topography, she interjected cantilevered beams, shardlike fragments, and other elements that seemed to splinter the structure into its myriad constituent parts, as if it had been subjected to some powerful destabilizing force.

Seemingly defiant of gravity, the forms of Hadid's project hover and float, animated by the same visionary power that marked the ground-breaking Constructivist structures that Vladimir Tatlin, El Lissitzky, and Moisei Ginzburg imagined would arise in a new, postrevolutionary Soviet society. That seeming instability, which can also be found in the works of a number of other architects active in the 1980s, has been related to the literary movement of deconstruction, whose principal interpreter, the French philosopher Jacques Derrida, has become a familiar figure within contemporary debates on architectural theory.

Japanese Society for the Rights of Authors, Composers, and Publishers. 1988

Poster: silkscreen, 40½ × 28⅝" (102.9 × 72.7 cm)
Gift of the designer

Yokoo's designs characteristically possess a level of personal expression that is remarkable within the graphic arts; the subjects being publicized frequently seem only incidental to the overall design. Craftsmanship is also of paramount importance to Yokoo, who utilizes an elaborate silkscreen process that is unusual in the production of posters, which are ephemeral. His challenges to the commercial nature of the poster are in many respects an homage to traditional Japanese *ukiyo-e* prints, woodblocks produced for the popular market.

In contemporary culture, the individual is increasingly inundated and bombarded with vast amounts of visual information relayed by a variety of means, including television, film, digital media, and print. Combining visual motifs from a multiplicity of cultures and periods, Yokoo's eclectic graphic art reflects this complexity. Included in this poster are references to Édouard Manet's painting *The Fifer*, Michelangelo's Medici tombs, and traditional and contemporary Japanese images. The complicated appropriation in Yokoo's work echoes Japan's evolution in the 1960s and 1970s from an insular culture to an economic world power.

85 Lamps Lighting Fixture. 1992
Standard lightbulbs, cords, and sockets,
39⅜ × 39⅜" (100 × 100 cm) diam.
Manufacturer: Droog Design, the Netherlands
Patricia Phelps de Cisneros Purchase Fund

Contemporary Dutch designers have
been markedly innovative in experi-
menting with materials, a trend that
crosses international boundaries.
Readily available at any hardware store,
Graumans's simple materials—eighty-
five black cords, sockets, and lightbulbs—
yield a grand chandelier through the
strength of his design. Gathered in a
unified bundle at the ceiling, the cords
flare out to accommodate the mass of
lightbulbs below.

Graumans's 85 Lamps was selected
for inclusion in the first design collec-
tion offered by Droog Design, estab-
lished in 1994 by designers and theorists
Gijs Bakker and Renny Ramakers. It is a
firm that has captured much attention
for its stance against consumerism and its
use of industrial and recycled materials.
The diverse works of the talented young
designers chosen for The Museum of
Modern Art design collection celebrate
ingenuity, economy of form, and a mini-
malist aesthetic, as does this lamp by
Graumans.

Kazuo Kawasaki | Japanese, born 1949

Carna Folding Wheel Chair. 1989
Titanium, rubber, and aluminum honeycomb
core, 33 × 22 × 35¼" (83.8 × 55.9 × 89.5 cm)
Manufacturer: SIG Workshop Co., Ltd., Japan
Gift of the designer

Kawasaki's goal was to create a wheel-chair that felt as good, and looked as cool, as the newest pair of sneakers. The Carna is colorful and has high-tech style. Since it had to be light and easy to carry, an improvement over most collapsible wheelchairs, Kawasaki used a titanium frame, with aluminum honeycomb-core wheels and rubber seat and tires. Moreover, to offer personalized comfort, he designed optional parts that users can add to the standard frame, according to the needs of the moment. Appropriately, Carna was named for the ancient Roman goddess who had power over entrances and exits.

Kawasaki is interested in bringing technology and fine craft closer together. Known for his works for Toshiba, Kawasaki pursued personal projects after a disabling accident in 1977. He has written: "Older people, handicapped and normal people are separated in today's Japan, so designers need to make designs that are kind and caring and need to treat more handicapped people equally in society.... To be a visionary designer I want to design products for myself first."

Large Head. 1993
Etching, plate: 27⁵⁄₁₆ × 21¼" (69.4 × 54 cm)
Publisher: Matthew Marks Gallery, New York.
Edition: 40
Mrs. Akio Morita Fund

The large man depicted here with great intensity and keen observation is Leigh Bowery, a favorite model of the German-born British artist and grandson of Sigmund Freud. Bowery's brief career as a brilliant but abrasive performance artist was cut short by his early death in 1995. He performed mainly in London, where Freud first saw him, but he also appeared in New York and elsewhere. His distinctive physiognomy and massive physicality attracted Freud, who depicted Bowery in a series of paintings and prints over a period of four years. The calm repose of the figure seen here contrasts sharply with more provocative and disturbing representations of this brash eccentric artist, as shown in several large paintings.

Freud is not a traditional printmaker. Instead, he treats the etching plate like a canvas, standing the copper upright on an easel. He delineates his meticulously rendered composition across the plate, working day after day until the tightly woven representation is complete. The image is created with lines alone, which intersect, swell, and recede.

Nicholas Nixon | American, born 1947

Covington, Kentucky. 1982
Gelatin silver print, 7 $^{11}/_{16}$ × 9 $^{11}/_{16}$" (19.5 × 24.6 cm)
The Family of Man Fund

The taut clapboards zip across the open middle of the picture as if to measure the outward stretch of the boy's arms, while he blissfully tilts his head skyward. A photograph can only describe what the camera sees, but this one also shows how a body can feel. There is something else, which the reproduction cannot fully capture. The print was made from a negative as large as itself—eight by ten inches. To make the negative, Nixon used a big camera on a tripod and put his head under a black cloth to focus the image. All of that old-fashioned effort was worthwhile because the richness of detail in the negative yielded a print that is at once sharp as a pin and smooth as a child's skin and the light that falls upon it.

By the 1970s the artistic traditions of photography were old enough for abandoned styles and techniques to serve as fresh points of departure. After photographers had been in love with the ease and quickness of hand-held cameras for two generations, the cumbersome cameras of the past presented a new challenge. For Nixon, the challenge was to make the old box responsive to unfolding experience: to marry the ancient precision of photography with its modern agility.

Double Lunar Dogs. 1984
¾" video, color, sound, 24 minutes
Acquired from Electronic Arts Intermix

Double Lunar Dogs, based on Robert Heinlein's science-fiction story "Universe," is about passengers who have been aboard a spaceship for so long that they no longer remember their mission. The small team of astronauts moves through the starry sky in a cabin that resembles a mad-scientist's lab. The fragmented story is told by means of special effects and inserted vignettes created by a stellar group of avant-garde actors, video artists, and musicians, including Spalding Gray, the Residents, and Steina Vasulka.

Jonas was among the first artists in the 1970s to combine performance and video. Her work, at times, has expanded to encompass dance and sculpture. She has often adapted her intricate and personal performances into narrative videotapes to give them added dimension. In both mediums, she incorporates her signature gestural actions and symbolic props, such as mirrors, masks, and hearts, as a means of exploring subjectivity and identity.

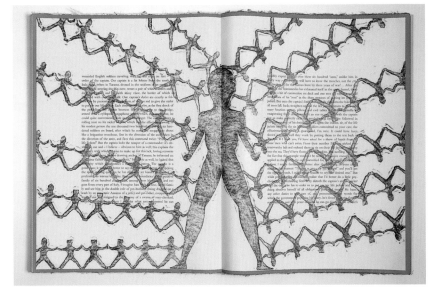

The Departure of the Argonaut by Alberto Savinio. 1983–86

Illustrated book with 49 photolithographs,
page: 25 9/16 × 19 11/16" (65 × 50 cm)
Publisher: Petersburg Press, New York and
London. Edition: 288
Gift of Petersburg Press Inc.

Clemente's composition flows across
this double-page spread, overlapping
and almost obscuring the text beneath.
The large figure in the center is echoed
in the smaller figures—resembling
paper dolls joined at the hands and
feet—that radiate from it. The careful
placement of turquoise ink allows the
text to be decipherable.

This text, a poetic diary titled
The Departure of the Argonaut, was
written in 1917–18 by the Italian artist
Savinio (an alias of Andrea de Chirico,
the younger brother of the celebrated
painter Giorgio de Chirico). It recounts
Savinio's travels as a soldier from
northern Italy to the Macedonian
front near Salonika. The title alludes to
another voyage in the same part of the
world, the mythological journey of
Jason and the Argonauts in search of the
Golden Fleece. Clemente's enormous
admiration for Savinio's book, which he
referred to as his Bible, led to his deci-
sion to illustrate it.

Clemente has been associated with
a 1980s avant-garde movement known
as Neo-Expressionism, in which the
figure played a significant role. In this
work the human form assumes center
stage, offering a visual complement to
the written text.

Untitled. 1987–90
Twelve silvered glass water bottles arranged
in a row, each bottle 20½ × 11½" (52.1 × 29.2 cm)
diam. at widest point
Gift of the Louis and Bessie Adler
Foundation, Inc.

In this work, twelve water-cooler bottles,
silvered to a mirror surface, are each
engraved with the name of a different
bodily fluid: blood, tears, urine, milk,
and more. The piece was inspired,
Smith has said, by the medieval book of
hours, the volumes of Christian obser-
vance that provided "some kind of med-
itation, something you could think about
or believe in," for every hour of the day.
Choosing "fluids everyone knows about
that come out of the body," Smith found
physical substitutes for the intangibles
of religious belief. She also created a
provocative friction between the scale

and uniform shape of the bottles and the
intimate and internal processes evoked
by the words they bear.

For Smith, the human body, even
more than human consciousness, is "our
primary vehicle for experiencing our
lives." A more consistent presence in
Smith's art than any format or medium
(her materials range from concrete to
glass, and she has also produced many
prints), the body is a widespread con-
cern in the art of the 1980s and 1990s.
This focus is partly aesthetic, reflecting a
need to break from immediate prece-
dents—the dematerialized linguistic
propositions of Conceptual art, or the
hard, machine-made, geometric surfaces
of Minimalism. But the period also saw
intense public debate on issues of sexu-
ality and health, and on their conver-
gence in the AIDS crisis.

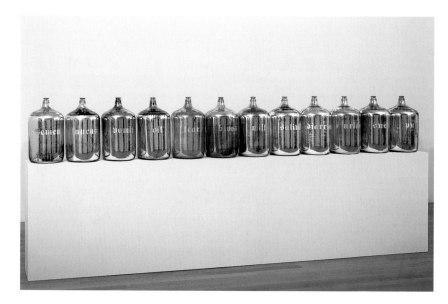

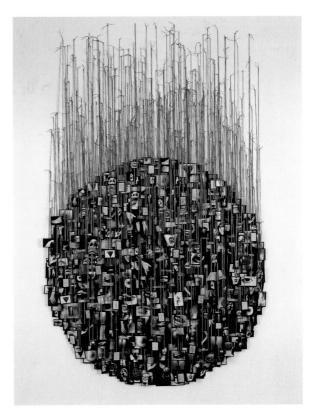

My Vows (Mes Voeux). 1988–91
Gelatin silver prints under glass, and string,
overall 11' 8¼" × 6' 6¾" (356.2 × 200 cm)
Gift of the Peter Norton Family Foundation

This work brings together hundreds of photographs, each of which presents a small part of a human body: mouths, ears, feet, noses, genitals, hands, breasts, and so on. Each hangs from a string, joining and partly obscuring others. Together they make a dense circle whose diameter is barely greater than the height of a person or the span of his or her arms. The individual elements— male and female, old and young, seductive and repellent—form a whole that is greater than the sum of its parts. Their physical, psychological, and sexual identities co-mingle in an inexhaustible variety of unpredictable relationships,

which, together, overwhelm the stable patterns of our familiar arrangements.

Messager's *Vows* might be the passionate devotions of sexual love, or they might be the votive offerings of an old religion, hung in a chapel to ask for the healing of an ailing eye or limb. These divergent allusions are fused in this hybrid work—part photography and part sculpture.

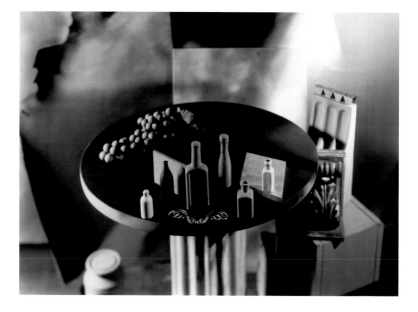

Untitled. 1988
Chromogenic color print (Ektacolor), 16⁷/₁₆ × 23"
(41.7 × 58.5 cm)
John Parkinson III Fund

Everything in this photograph is utterly artificial, beginning with the painted backdrop. Its mottled forms create an impression of light, which complicates the shaft of genuine light that Groover has introduced from above on the right side of the composition. These effects enliven the somber beauty of the picture and participate in a visual balancing act that also includes the table and all the objects on and around it, which the artist has painted before arranging them. The imprudent red at the lower left adds to the impression of a voluptuous whole.

Since 1978, the still-life genre has been the focus of Groover's photography, the arena in which she has tested her conviction that "formalism is everything." That declaration may be under-stood to mean that the artist's pictorial decisions—what color meets with what color, how shapes are seen in relationship to each other and to the space they occupy, the scale of forms within the picture—are enough to create a world of meaning. Pursuing this conviction in the closed environment of the studio, Groover has, in fact, created a seemingly infinite variety of visual experience, as rich and surprising as life outside.

High Falutin'. 1990

Metal (some parts painted with oil), oil on wood, glass, rubber, velvet, plastic, and electric lightbulbs; installation 13' 2" × 48" × 30½" (396 × 122 × 77.5 cm)
Robert and Meryl Meltzer Fund and purchase

Hammons's art is a reclamation project of sorts; he revalues bits of street flotsam and other unwanted debris by assembling them in new combinations.

High Falutin', one of his several works based on the basketball hoop, is a battered wood window frame atop a pole, crowned and fringed by ruffles of rubber tire, a subtly figural ensemble incongruously glamorized by fussy glass candelabra, which are wired to light up. The theme of light and energy reappears in the crinkled loop of wire around the frame, a cartoon electric current.

The practice of working with found objects has an ancestry in Surrealism, and Hammons acknowledges the influence of Marcel Duchamp, among others, but he also remarks, "I feel it is my moral obligation to try to graphically document what I feel socially." The urban society to which he is so attuned is crucially inflected by the presence of African Americans, and if Hammons admires basketball, it is as a game of which African Americans have made an "art of improvisation," "a whole other thing—ballet, theater." *High Falutin'*, which was originally named *Spirit Catcher*, also relates to African traditions of masks and other spiritually protective sculpture. "Art," Hammons has said, "is a way to keep from getting damaged by the outside world, to keep the negative energy away. Otherwise you absorb it."

Wigs (Portfolio). 1994
Portfolio of 21 lithographs, sheet (each): 23 × 18"
(58.5 × 45.8 cm) or 32 × 16" (81.3 × 40.7 cm)
Publisher: Rhona Hoffman Gallery, Chicago.
Edition: 15
Purchased with funds given by Agnes Gund,
Howard B. Johnson, and Emily Fisher Landau

Among the subjects of Simpson's art
is the experience of African American
women in contemporary American
society, a topic that encompasses issues
of race and gender. Since 1990 African
American hairstyles, which, over the
centuries, have taken on social and polit-
ical implications, have been some of her
motifs. Depicted here is a diverse group
of wigs in an orderly presentation that
suggests a lineup of scientific specimens.

Many types of styles are represented,
from the short, fuzzy-textured Afro at
the upper left to a wig of long, silky blond
hair near the upper right. Text panels
interspersed among the wigs record
Simpson's wide-ranging commentary on
their use by women, entertainers, and
transvestites. The wig's potential as
an instrument for conformity, metamor-
phosis, and concealment is thereby
underscored.

Simpson has used the traditional
format of the print portfolio in which
a sequence of images produces a cumu-
lative, narrative effect. The images have
a tactile, suggestive quality as they
isolate hair as an important aspect of
self-image that affects a deeper sense of
overall reality.

Inasmuch as It Is Always Already Taking Place. 1990
16-channel video/sound installation, with 16 modified monitors recessed into a wall
Gift of Agnes Gund, Barbara Wise, and Margot Ernst

The components of the body displayed on sixteen monitors in this video installation are without any apparent distinction. They belong, however, to the artist. The arrangement of images on the monitors, which are of various sizes and stripped of their casings, does not follow the organization of the human body. Representations of Hill's ear and foot lie side by side; tucked modestly behind them is an image of his groin. Within this unassuming configuration, each raster invites meditation. For example, on one screen a thumb plays with the corner of a book page. By concentrating the viewer's attention on such a rudimentary activity, Hill causes the movement to take on the significance of a much larger event. The ceaselessness of the activity is an illusion in that each component exists only as a seamless loop lasting five to thirty seconds.

Long, nervelike black wires attached to each monitor are bundled together like spinal cords. They snake along a shelf and disappear from view at the back of a recess. This electrical network emphasizes the presentation of body parts as extremities without a unifying torso. The hidden core to which the components of the body *are* attached serves as a metaphor for a human being's invisible, existential center: the soul. Reinforcing the living quality of the installation is its textured composition of ambient sound.

Untitled. 1989–90
Wax, cotton, leather, human hair, and wood,
11 ³⁄₈ × 7 ³⁄₄ × 20" (28.9 × 19.7 × 50.8 cm)
Gift of the Dannheisser Foundation

As a copy of a man's leg and foot, this work is strikingly real: its fleshy waxen skin, clad in leather shoe and in cotton pant and sock, sprouts actual human hair. Exactness like this slides over into the unsettling, a macabre tone amplified by the leg's placement, its owner having presumably collapsed to the floor—and then, too, he has only one leg, which issues from the wall, as if the architecture had eaten him. For some, it may also have a subtle fetishistic eroticism, inasmuch as it focuses on a narrow band of the body where men routinely and unselfconsciously show their nakedness.

Many of the artists who emerged alongside Gober in the 1980s were interested in the modern communications media, or in quoting from art history. Gober, by contrast, insists on the handmade quality of his sculpture, and although his works can remind us of earlier art (this one, for example, may recall the body fragments in the sculpture of Auguste Rodin, or the living disembodied arms bearing candelabra in Jean Cocteau's film *La Belle et la bête*, of 1946), their mood of displaced normalcy transforms any such references. These works often evoke the paradoxical phenomenon that Sigmund Freud called "the uncanny"—something ordinary that, through even a slight disorientation, reveals a hidden strangeness, bringing out long-forgotten fears and collapsing long-established certainties.

**Bauhaus Foundation
Dessau, Jul–Aug.** 1995
Poster: offset lithograph, 33 × 23 ⅜"
(83.8 × 59.4 cm)
Members: Sophie Alex (German, born 1967),
Wilhelm Ebentreich (German, born 1952),
Detlef Fiedler (German, born 1955), Daniela
Haufe (German, born 1966), Siegfried Jablonsky
(German, born 1950)
Gift of the designers

Cyan's images frequently evoke the past
through the use of a complex layering of
disparate historical images. Its posters
and other graphic designs suggest the
hazelike state of memory from which
only bits and pieces can be retrieved.
The innovative use of collage, made
possible by the use of computer software,
is an extension of the photomontage and
photogram experiments performed by
many modernist designers in the 1920s

and 1930s. In addition, cyan frequently
uses simple sans-serif type organized
in a grid that appears to follow many of
the rules of the "new typography"
practiced at the Bauhaus in the 1920s.

Computer technology was not
available to this five-person design col-
lective from the former East Berlin until
after the fall of the Berlin Wall in
November 1989. Since then, they have
skillfully mixed new visual forms—
produced with the aid of sophisticated
technologies—and more traditional
modernist typography, creating posters
that are extremely inventive and yet true
in spirit to the modernist concern for
clarity. Much of their work has been for
German cultural institutions; among
them, appropriately, is the Bauhaus
Foundation Dessau.

Chlorosis. 1994

Ink, gouache, and synthetic polymer paint on twenty-four sheets of paper, each 26 × 19½" (66.2 × 49.5 cm)

The Herbert and Nannette Rothschild Memorial Fund in memory of Judith Rothschild

In this multipaneled drawing, the twenty-four portraits, arranged in a nonhierarchical grid, resemble casual snapshots or Polaroid-like close-ups. The faces are both beautiful and disturbing; they avert their eyes and express longing, lethargy, and pleading. Their status as apparitions or psychic projections of internal states is emphasized by thin, exquisite washes of color. Certain elements of theatricality are recalled in Dumas's rendering of these phantomlike portraits as bloodless, pale

shadows. They invite multiple layers of interpretation: the images are simultaneously distressing, fascinating, haunting, and equivocal. Their expressiveness results from the tension between the depicted, the concealed, and the implied.

Chlorosis has been referred to as an "image of collective desolation." Its title comes from the Greek word for light green and describes greensickness, an anemic disease mostly affecting pubescent females and marked by a characteristic green skin tone. Sometimes referred to as the virgin's disease, chlorosis was considered a sickness of sorrowful love, caused by the intense suffering provoked by unrequited love, and appears in several of Shakespeare's plays, including *Romeo and Juliet*.

Pace. 1984
Synthetic polymer paint on fiberglass on
wood with aluminum, 59½ × 26 × 28" (151.2 ×
66 × 71.1 cm)
Gift of an anonymous donor and gift of
Jo Carole and Ronald S. Lauder

Like his Minimalist contemporaries,
Ryman is a carefully systematic artist,
but he has a painter's respect for the
qualities of surface and touch. To exam-
ine the medium methodically, he
imposes two limitations: his paintings
are white, and square. Yet white, Ryman
shows, changes dramatically depending
on what paint is used and how it is
applied. Paint lies differently on differ-
ent supports, and Ryman has used a
gamut of materials besides canvas,
including cardboard, wood, and alu-
minum. The scale of his works varies
widely. Exploring the way the painting
stands against the wall, Ryman has used
all the stages between near flush and
deep relief. He has also made the paint-

ing's hanging devices integral to the
composition.
 In *Pace* the painting is horizontal.
The narrow edge of the work is
unpainted redwood. The upward plane
is fiberglass, and is painted in a reflective
white enamel, while the underside, also
white, has a soft, light-absorbent surface.
The painting is supported by wall fas-
teners and aluminum legs.
 Paintings are always hung vertically
against the wall, Ryman realized,
because pictures "need to be seen that
way. I thought . . . since I'm not really
making pictures, a work could possibly
not be vertical. It could be just the oppo-
site. . . . I thought I was a little crazy, but
I thought, 'I'll try it; it'll be interesting,
a challenge.'"

Unforgiven. 1992
35mm film, color, sound, 130 minutes
Gift of the artist and Warner Bros.
Clint Eastwood

A Western that is at once moody and ambivalent, comical and cruel, *Unforgiven* follows its unlikely, unheroic avengers across a broad, pristine landscape under bright skies to a frontier town where legend and death by violence are equally ridiculed. In the film, the aging Will Munny (Clint Eastwood) pleads with his former partner Ned Logan (Morgan Freeman), to come back just one more time to kill a man who slashed a prostitute. Although their task is dishonorable, their success will ensure them a peaceful old age. Bluffing his way as the third partner is a rookie outlaw (Jaimz Woolvett), who survives the unfolding events and learns a painful moral truth.

Also appearing in the film is a bogus legend, English Bob (Richard Harris), who is no verbal match for the acid-tongued sheriff (Gene Hackman). The mocking tone of the dialogue provides a counterpoint to the Western genre's rhythms of hit, run, and destroy. The idea that men who live by violence can also be brilliantly funny sharpens director Eastwood's steady gaze. With this film, which instills a new morality into the tradition of the Western, Eastwood single-handedly revived the genre.

An actor turned director, Eastwood depicts the ambivalence of his own screen characters in understated, spare terms, set against the stunning beauty of the deep landscape and culminating in fluid action scenes that end in loss and death. In this film violence is itself critiqued; there is no joyful ending for the traditional code of the West.

Intersection II. 1992

Cor-Ten steel, four plates, each 13' 1½" × 55' 9⅜" × 2" (400 × 1700 × 5 cm). Gift of Jo Carole and Ronald S. Lauder

Slightly younger than the Minimalist artists, Serra has intensified a quality of their work—a heightening of the viewer's physical self-awareness in relation to the art object. In early works of Serra's, heavy metal slabs stood in precarious balance; any close look at them was a charged affair. *Intersection II*, similarly, sensitizes its visitors, inviting them under and between its massive walls—which, they will find, exert an enormous psychic pressure.

That pressure arises from the weight, height, and leaning angles of the walls, and from their variously dark and rusted surfaces. It is tempered by the elegant precision of their lines and the satisfying logic of their arrangement. The slopes and placements of the great steel curves produce two outer spaces that invert each other at floor and ceiling, one being wide where the other is narrow. Meanwhile the central space is a regular yet biased ellipse. Whether these spaces are experienced as intimate or threateningly claustrophobic, what Serra has said of his earlier work applies: "The viewer in part became the subject matter of the work, not the object. His perception of the piece resided in his movement through the piece, [which] became more involved with anticipation, memory, and time, and walking and looking, rather than just looking at a sculpture the way one looks at a painting."

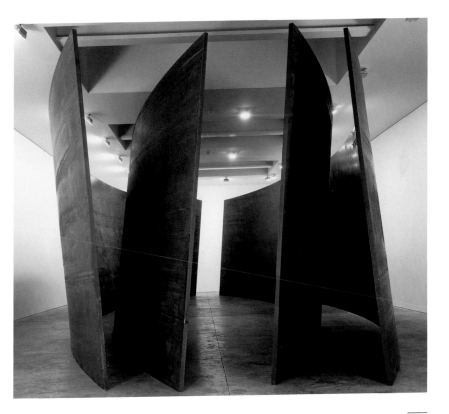

Eddie Anderson; 21 Years Old; Houston, Texas; $20.

1990–92
Chromogenic color print (Ektacolor), 23⅝ × 35⅞"
(60 × 91.1 cm)
Gift of the artist

It is no accident that this picture has the slick feel of a Hollywood production or a magazine ad. DiCorcia casts, poses, lights, and frames his photographs with the same attention to detail that is lavished on a scene in a movie. The key difference is that his still dramas have no beginnings or endings, only middles, for which we are invited to write the scripts.

In diCorcia's earlier work the protagonists were mainly friends, deployed in familiar domestic settings; this picture belongs to a later series made in a Hollywood neighborhood frequented by male prostitutes, drug addicts, and drifters, whom the photographer hired to pose. The photographer asked each man for his name, age, and place of birth, and titled the picture with the answer, followed by the amount he paid the subject to pose.

The high artifice of diCorcia's photographs keeps us from reading the series as a straightforward record of a Hollywood street culture. In this sense, his work is representative of a widespread contemporary sensibility that has become weary or suspicious of the earnest realism of documentary photography. Nevertheless, the series gives us a picture of a world as persuasive as any we know from a traditional documentary project—and as moving.

A Frontal Passage. 1994
Fluorescent light installation, dimensions variable: approx. 12' 10" × 22' 6" × 34' (391.2 × 685.8 × 1036.3 cm)
Douglas S. Cramer, David Geffen, Robert and Meryl Meltzer, Michael and Judy Ovitz, and Mr. and Mrs. Gifford Phillips Funds

Throughout history, the artist has been a shaper of matter, whether the pigment of an image or the solid substance of sculpture. *A Frontal Passage*, like other works by Turrell, breaks from those ancient traditions in that it has no mass. Instead, Turrell shapes light.

An interest in a dematerialized art object appears in a range of work from the 1960s and 1970s—in Conceptual art, for example, which posits art more as language and idea than as visual form. But Turrell differs from the Conceptualists in the absorbing sensual power his work commands. He is closer to the Minimalist sculptor Dan Flavin, who also worked with light; but where Flavin would incorporate not only the light of fluorescent tubes but the tubes themselves into his art's appearance, the fluorescents in *A Frontal Passage* are obscured. The spectacle is light itself, given the illusion of palpable shape.

To view *A Frontal Passage*, the visitor passes through a darkened entryway into a chamber, also dark—but divided diagonally by a radiant yet crisply defined wall of red light. Instead of diffusing freely from one side of this wall to the other, the light ends abruptly in space, as if it had density. The power of the work lies in this paradox, in which nothingness gains physical presence.

"Untitled" (Death by Gun).
Begun 1990
Nine-inch stack of photolithographs, sheet:
44$^{15}/_{16}$ × 32$^{15}/_{16}$" (114.1 × 83.6 cm)
Purchased in part with funds from Arthur
Fleischer, Jr. and Linda Barth Goldstein

The viewer's first reaction to *"Untitled"*
(Death by Gun) is one of uncertainty. Is
this stack of papers on the floor meant to
be walked around and viewed from dif-
ferent angles, like sculpture? Or did the
artist intend these papers to be picked up
and examined? Listed on the sheets are
the names of 460 individuals killed by
gunshot during the week of May 1-7,
1989, cited by name, age, city, and state,
with a brief description of the circum-
stances of their deaths, and, in most
cases, a photographic image of the
deceased. These images and words,
appropriated from *Time* magazine, where
they first appeared, reflect Gonzalez-
Torres's interest in gun control.

Conceptually, *Death by Gun* is an
ongoing work of art. Viewer participa-
tion is an important element, and the
public is encouraged to read the sheets
and take them away to keep, display, or
give to others. While Gonzalez-Torres
determined that the stack is "ideally"
nine inches high, he arranged for the
depleted sheets to be continually
reprinted and replaced, thus insuring
that *Death by Gun* can be distributed
indefinitely. From its beginnings,
printed art has been made in multiple
copies for dissemination to a wide audi-
ence. Here that idea is expanded with an
edition that is "endless."

Family Romance. 1993
Mixed mediums, 53" × 7' 1" × 11" (134.6 × 215.9 × 27.9 cm)
Gift of The Norton Family Foundation

Two parents, two young children: "It's a nuclear family," as Ray says, the model of American normalcy. Yet a simple action has put everything wrong: Ray has made all of them the same height. They are also naked, and unlike the store-window mannequins they resemble, they are anatomically complete. This and the work's title, the Freudian phrase for the suppressed erotic currents within the family unit, introduce an explicit sexuality as disturbing in this context as the protagonists' literally equal stature.

Early works of Ray's submitted the forms and ideas of Minimalism to the same kind of perceptual double-take that *Family Romance* works on the social life of middle-class Anglo-Saxon America. He has worked in photography and installation as well as sculpture, and his art has no predictable style or medium; but it often involves the surprise of the object that seems familiar yet is not. Like other works of Ray's involving mannequins, *Family Romance* suggests forces of anonymity and standardization in American culture. Its manipulations of scale also imply a disruption of society's balance of power: not only have the children grown, but the adults have shrunk.

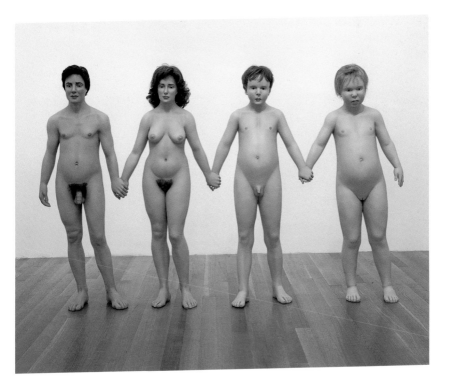

Rachel Whiteread | British, born 1963

Untitled (Paperbacks). 1997
Plaster and steel, room installation, dimensions variable
Gift of Agnes Gund; Thomas W. Weisel, Patricia Phelps de Cisneros, Frances R. Dittmer, John Kaldor, Emily Rauh Pulitzer, and Leon Black Funds; and an anonymous fund

Untitled (Paperbacks) is a room-sized installation that feels empty but isn't quite: on all four walls hang rows of long white objects that look like shelves but are not, for they are plaster, not wood, and their surfaces are uneven, and vacant. These regularly spaced tiers suggest a library without books, yet books were here, and their traces remain. Whiteread made these objects by casting shelves of paperbacks, whose slightly differing sizes account for the plaster's uneven surfaces. Look closely, too, and you may see a residue of paper embedded in the casts, the edges of the pages caught as the plaster dried.

Whiteread specializes in the sculptural reversal that makes a solid object speak less of its own material presence than of objects that are no longer present, yet maintain a ghostly presence in their absence. The early work of this British artist comprised castings of everyday furniture—mattress, table, bathtub—in mediums from resin to concrete. She next addressed architecture, as in *Untitled (Room)* (1993), a plaster work also in the Museum's collection: here empty space becomes an opaque cube marked on its outside by the lines of a room's windows and door. Her more recent outdoor Holocaust memorial in Vienna is another room, once lined with books, which left their marks on the outside of a sealed block, symbolizing the lives and the culture lost to Nazi persecution. *Untitled (Paperbacks)*, by contrast, is a library you can enter. Although there is nothing to read in it, it is filled with the knowledge, ideas, and memories contained in books, even if you must bring those associations with you into this serene, but haunted, place.

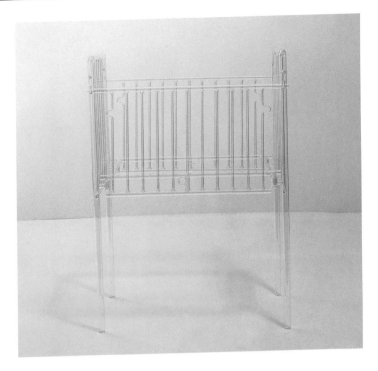

Silence. 1994
Glass, 49⅞ × 36⅞ × 23⅛" (126.6 × 93.7 × 58.7 cm)
Robert B. and Emilie W. Betts Foundation Fund

Mona Hatoum first became known for performance and video works that involved a quality of ordeal or actual danger, and that sometimes more or less plainly examined the quality of lives permeated by war, as in the Middle East. (Hatoum was born and grew up in Lebanon, her parents Palestinian exiles.) When she began making sculpture, often adapting the Minimalism that she had absorbed as a London art student, Hatoum retained her feeling for the physical vulnerability of the human body. And so it is with *Silence*, a crib that would threaten the child it protected: any slight shock and the baby would lie in broken glass.

Ethereally translucent and delicate, an empty cage, *Silence* is a whole that implies its own destruction into fragments, and an ear-shattering crash—the antithesis of the work's title. There is also a resonance of the hospital (subject of other art by Hatoum), in that the glass comes in the form of tubing, evoking medical paraphernalia, and also the body's circulatory system; but once again, the idea that this rigid, frighteningly brittle structure—ungainly on its tall and narrow legs, and made of the most fragile material—should be associated with the tender human shell creates a sense of dread. Whatever the associations of *Silence*, they seem to share this threatening unease.

Domestic I.D., IV. 1992

Steam-iron scorches and pencil on paper,
mounted in dilapidated and recycled painted
wood window frame, comp. (incl. frame):
35 × 32 × 1⅜" (88.9 × 81.3 × 3.5 cm)
Edition: unique
Purchased with funds given by Agnes Gund

At first glance, these images are easily
recognizable as made by steam irons. Yet
Domestic I.D., IV, a seemingly straight-
forward arrangement of everyday
objects, also hints at a deeper signifi-
cance implied by the aged, chipped-
paint window-frame casement and the
soft yellow glow emanating from within.
The scorch marks themselves call atten-
tion to how they were made—a hot iron
was left on the paper too long, which
caused it to burn—and suggest brand-
ing. In turn, we are reminded of the
monotonous task of ironing, a common
household activity, and the particular
domain of domestic servants. The mask-
like images patterned with slashes,
arrowhead-like markings, and beadlike
dots recall African tribal art and ritual.
This latter allusion was made intention-
ally by Cole, an African American artist,
who has studied African art and tradi-
tions extensively.

During the 1980s, Cole amassed an
assortment of broken irons. Some were
given to him for repair by his grand-
mother, herself a domestic worker; others
were discarded objects that he collected
near his studio. Initially, he made sculp-
tures assembled from these irons and
from additional materials. Later, he used
the appliance itself as a tool to create
other artworks, such as this paper
imprinted with scorch marks.

A–Z Escape Vehicle: Customized by Andrea Zittel. 1996

Exterior: steel, insulation, wood, and glass. Interior: colored lights, water, fiberglass, wood, papier-mâché, pebbles, and paint, 62" × 7' × 40" (157.5 × 213.3 × 101.6 cm)
The Norman and Rosita Winston Foundation, Inc. Fund and an anonymous fund

A–Z Escape Vehicle: Customized by Andrea Zittel is one in a line of works inspired by the mobile home. All have the same stainless steel outer shell, but the interiors differ, each being customized to specifications designed by its owner. Like trailers, these capsules can be hooked to a car and driven away, but they are actually designed to be installed in a garden or driveway, or even indoors. The "escape" of their title, then, lies not so much in their mobility as in their provision of a retreat tailor-made for one individual's comfort.

Simultaneously aesthetic and useful, the escape vehicles challenge the idea of the artwork as an object of contemplation. They implicitly argue that artists can participate in their societies rather as designers and architects do— by producing works with practical and benign applications in daily life. In this way Zittel belongs to a tradition of social involvement running back to the Bauhaus and the Russian Constructivists. A more recent precedent of a different kind is Pop art, with its attraction to vernacular and commercial visual forms and production methods.

The name "A–Z" is a pun, fusing the idea of embracing inclusiveness with the artist's initials. Zittel customized this particular escape vehicle herself, creating a papier-mâché grotto in striking contrast to the sleek metal outer skin.

Andreas Gursky | German, born 1955

Times Square, New York. 1997
Chromogenic color print, 6' 1" × 8' 2" (185.4 × 248.9 cm)
The Family of Man Fund

This picture is large for a photograph—six by eight feet. It measures itself not against its mammoth subject but against the human viewer, and against other works of art. Gursky emerged from art school in Düsseldorf, Germany, in the mid-1980s, just as photographers were beginning to compete successfully with painters for attention and space on the walls of galleries and museums. In the process they discovered new opportunities in scale. Here the viewer is assaulted from afar by the eye-popping bands of color but, upon approaching, is invited to study in detail the vast atrium of the Marriott Marquis Hotel, built in New York's Times Square in 1985.

In fact, the picture is, to a considerable degree, an invention—a seamless image derived from photographs but recomposed and otherwise manipulated in Gursky's computer. It is at once hyper-real and unreal, an indelible image of our artificial world, made with the aid of the tool of our time.

My New Theater 1. 1997

Video/sound installation with color DVD
(approx. 32 min.), DVD player, projector, rear
projection screen, balsa wood props, black-
and-white and color photographs, and free-
standing wood structure, 65.5" × 20" × 6' 1"
(166.4 × 50.8 × 185.4 cm)
The Richard Florsheim Art Fund, The Junior
Associates, Barbara Pine, and Joanne Stern

Jonas has worked in video and perform-
ance for more than thirty years, inte-
grating the two art forms in unexpected
ways. With this recent work she contin-
ues her exploration of the dual art form
but on a radically altered scale, under-
taking what she has described as "a
new effort to create performances in
miniature."

My New Theater 1 is a tabletop
installation in the form of a box that
slopes upward from front to back. Open
on one end, this "theater" allows several
viewers to observe a video projected
onto a screen filling the far wall. The
sparse props of the maquette—minia-
ture fishing pole, owl, rabbit, chaise
longue—are reminiscent of the stage
design of a typical Jonas performance.
The video presents a Cape Breton step
dancer performing to the accompani-
ment of a fiddler and a piano player,
intercut with a young girl dancing in a
more elaborate style. The Scottish
music radiates over the lush green of
summertime, contrasting sharply with
the murky theater setting. The scale
evokes the miniature cityscapes and
elongated figures by Alberto Giacometti,
whose work has influenced Jonas, and
the spirit recalls the New York avant-
garde theater companies The Wooster
Group, with whom the artist has fre-
quently collaborated, and Mabou
Mines.

Commingled Containers. 1996

16mm, color, silent, 3 minutes
Gift of the artist

If *The Text of Light* (1974) is Brakhage's grand exploration of light and its dynamics, then *Commingled Containers* is a poetic meditation on the same subject. Made when the artist was facing a life-threatening illness, the work focuses on light as it plays on and below the surface of water (the source of all life on earth, according to many creation myths). The "commingled" containers of the title refer not only to the recyclable refuse bins in which water is often found but also to the bubbles in the water and—most importantly—to life itself.

In three short minutes, Brakhage intensifies and deepens our experience of light, and in so doing creates a contemplative summation of his own life and work.

Brakhage survived to make dozens more films, increasingly turning his attention to the manipulation of film stock itself by painting, scratching, and other methods. This was a process that had been used in cinema's earliest days as a means of altering and enhancing the look of black-and-white films. In Brakhage's hands it became a way to maintain a direct experiential relationship with his chosen medium while refining his art to its essential elements.

Smart Car ("Smart & Pulse" Coupé). 1998

Steel frame and thermoplastic body panels,
61" × 59⅜" × 8' 2⅜" (154.9 × 150.8 × 254.9 cm)
Manufacturer: Micro Compact Car Smart
GmbH, Renningen, Germany, and Hambach,
France, 2002
Gift of the manufacturer, a company of the
DaimlerChrysler Group

Size matters. As its clever marketing slogan "reduced to the max" suggests, the Smart Car has been developed to maximize the convenience, comfort, and safety of driver and passenger, while minimizing the impact on the environment. Low fuel consumption (averaging 49 miles per gallon) and eco-friendly methods of production distinguish this two-passenger car from the others on the market.

The Smart Car was developed in the early 1990s at the Mercedes-Benz design studio in Irvine, California, where a team of engineers and designers, led by Gerhard Steinle, created the prototype. The design and marketing strategy was further developed with input from the Swatch watch company.

Cars are sold at "Smart Centers" throughout Europe, where the brightly colored vehicles are stacked in towers like objects in a display case, clearly aimed at youthful, style-conscious consumers seeking an affordable car.

The Smart Car's body reveals a clear, functional, modular design. The black frame of reinforced steel—the so-called Tridion safety cell—gives the vehicle its inherent strength. The safety cell defines the car as an integral unit, enabling the Smart Car to be conveniently short for a city car, without the front and back ends that project beyond the passenger compartment in a conventional vehicle. The steel frame is coated with powder paint, considerably less harmful to the environment than conventional painting processes. Colorful, lightweight body panels made of recycled plastic are virtually dent-resistant and rust-free. They are easily exchanged for a new set whenever the owner wants to change color. The interior is unexpectedly spacious. The engine is located below the passengers, allowing space to be conserved and seats to be given additional height.

Untitled (Cubism and Abstract Art). 1997

Oil, lithography ink, and modeling paste on
paper mounted on wood and canvasboard,
10¼ × 8 × ⅞" (26 × 20.3 × 2.2 cm)
Given anonymously

In a matter-of-fact description of the
labor-intensive process and range of
techniques that went into this work,
Wolfe has said, "What you're looking at
is an object that has a paper jacket, as a
real book would have, which is lami-
nated onto canvasboard and wood and
that has been jointed with modeling
paste. The brown background is hand
painted. The red band at the bottom was
originally printed lithographically and
then overpainted with oil paint. The
diagram itself was done completely lith-
ographically. The pages were created by
painting the edges with oil paint and
then dragging a very stiff brush across
the wet paint, and then stained later to
give them an aged and discolored feel."
Wolfe is one of a number of contempo-
rary artists who have directed their prac-
tice toward exacting, literal works that
replicate an existing object. With vary-
ing degrees of similitude, these works
pose as duplicates of the real.

Carefully placed in the perceptual
gap between the illusory and the real,
Untitled (Cubism and Abstract Art) is a
precise lookalike of a worn and dog-
eared copy of the exhibition catalogue
by Alfred H. Barr, Jr., published in
1936, that became a cornerstone in the
early history of modernism. Painstak-
ingly handcrafted, it plays with absolute
notions of true and false, reality and
illusion. Installed frontally and upright
on the wall, it presents itself simultane-
ously as a work of art and a book whose
subject matter is art, reversing expecta-
tions of both. Despite its affinity with
Marcel Duchamp's readymades, *Untitled
(Cubism and Abstract Art)* is far from a
found object. Like readymades, it raises
questions about where life ends and
art begins, yet its handcrafted quality
and use of artistic materials generate
the paradox of appropriating something
from the world while engaging the
traditional language of art.

Mass. 1997
Two silver dye bleach prints (Cibachrome),
each 60 × 48" (152.4 × 122 cm)
The Fellows of Photography Fund and
Anonymous Purchase Fund

Seeing and believing are two sides of
the same coin, which is why the eye can
so easily fool the mind and vice versa.
Muniz has made a large body of art,
at once intelligent and funny, exploring
this interdependence.

Here, for example, he began by
copying a black-and-white photograph
of a crowd, drawing it carefully in
chocolate syrup on a small piece of
paper. He then photographed the draw-
ing in color and greatly enlarged it in the
final print. The enlargement invites us
to enjoy the delicious viscosity and
gleaming highlights of the sticky-sweet
stuff (and the skill with which Muniz
has handled it). But the surprise and sat-
isfaction of the picture lie in the stub-
bornness with which the photographic
image reasserts its legibility despite the
artist's playful depredations.

Untitled (Man with Megaphone Cluster). 1998

Etching and aquatint, with pastel additions, plate: 9 ¹³⁄₁₆ × 14 ¹⁵⁄₁₆" (25 × 37.9 cm)
Publisher: the artist, Johannesburg, and Kunstverein München, Munich. Printer: Caversham Press, Kwazulu-Natal, South Africa. Edition: 70
Mary Ellen Meehan Fund

A South African artist of Eastern European descent, Kentridge evokes the tragic and complex history of his homeland with works in film animation, theater, sculpture, drawing, and printmaking. *Untitled (Man with Megaphone Cluster)* depicts a paunchy nude man lifting one hand to his hat and covering his face with the other, in an awkward pose suggesting shame and submission. To the left of the composition, a menacing totemic object—megaphones clustered on a pole blaring sound from an unknown source—implies authority and control. The forlorn nude male with megaphone is a recurring motif in Kentridge's work, appearing, for instance, in his film animations as "Felix Teitlebaum" (an artist) and "Soho Eckstein" (a businessman), antiheroic characters who physically resemble the artist and can be seen as alter egos.

Printmaking plays a central role in Kentridge's oeuvre. He began making political resistance posters and prints in the 1970s, and since then has created more than 250 prints in various techniques. He often favors working in a series or portfolio format, which allows for the development of a narrative structure such as in his film animations and theater productions. In this print, Kentridge used etching and aquatint to create effects ranging from delicate to crude. The electric blue pastel line that bisects the composition is a detail that Kentridge often adds to his otherwise black and gray color schemes. Formally, it separates the work into two halves; metaphorically, it helps suggest the divide between the oppressive mechanisms of society and the naked helplessness of the individual.

Boris Mikhailov | Ukrainian, born 1938

Untitled. 1997–98
Chromogenic color print, 58⁷⁄₁₆ × 39³⁄₁₆"
(148.5 × 99.5 cm)
Gift of Howard Stein

The demise of the Soviet Union in 1991
spelled disaster for many citizens of
Mikhailov's native Kharkov, in Ukraine.
As the state apparatus collapsed, bleak
predictability rapidly gave way to chaos
and want. The photographer, whose ear-
lier work includes sympathetic records
of communal pastimes, responded
with a bitter series that starkly evokes
the squalor of desperation, drink,
and despair. In the same years, but in
another photographic mode altogether,
he experimented with flagrantly staged
political and sexual satires.

A decade later, as a few made mil-
lions, the least fortunate Ukrainians
were more desperate still. This untitled
work belongs to Mikhailov's bold and
risky series Case History, for which he
paid Kharkov's outcasts to pose and
perform. The best of his new photo-
graphs improbably blend the opposing
poles of his art. No-nonsense realism
and impromptu playacting seamlessly
conspire in a persuasive theater of
wrenching misery.

Torus House, Old Chatham, New York. Project, 1999
Interior perspective: Digital Duraflex print,
24 × 32" (61 × 81.3 cm)
Barbara Pine Purchase Fund

Torus House represents a contemporary revision of the artist's house, a type of residence rooted in the nineteenth-century Arts and Crafts movement. The two largest spaces in the house will be painting studios. The space pictured in this computer-generated print will be used for easel painting and will also serve as a gallery and a living space. The glass walls provide generous views of the partially wooded field in this remote, contemplative setting. Spatially and visually, the vertical circulation in the center of the studio links all the principal elements of the house.

The formal character of the Torus House design is remarkable for its melding of seemingly incompatible geometric languages. The architect hopes to reinvigorate the historical tension between the orthodox and the radical: "The dialectic between norm and exception in architecture relies on the persistence or memory of social and building conventions on the one hand and formal transgression on the other." In this instance, the norm is a courtyard house, which is transformed by the use of nonarchitectural, seamless, curvilinear forms derived from the torus. That topological form is generated by rotating one circle along the path of a second, larger circle, usually producing a doughnutlike shape.

Amplifying the ambiguity between the house's interior and exterior, a stair, which occupies what would be the hollow core of the torus, bypasses the interior of the house by running directly from the parking area at ground level to the roof above. The architect explains that "the curvilinear lines and undulations blend the individual components into an unbroken surface that resembles features of the landscape beyond."

Untitled. 2001
Etching and drypoint with chine collé,
plate: 23⅝ × 17¹¹⁄₁₆" (60 × 45 cm)
Publisher and printer: Paulson Press, Berkeley.
Edition: 40
Anna Marie and Robert F. Shapiro Fund

In this spare, understated composition, Puryear's fine webbed lines have been rendered with a slightly wavering hand, a tangible record of the artist's sensitive employment of the etching needle. One of approximately twenty-five prints Puryear has made to date, the work demonstrates his predilection for direct, physical mediums such as etching and woodcut, which involve the process of scratching or digging into metal or wood. Its abstracted form recalls the artist's better-known sculptural works in wire or latticed wood strips, and the evocative shape echoes their frequent bird- or molelike references. A related detail etched delicately in red at the upper left transforms this otherwise iconic presentation of the main figure into something like a freehand sketch, reinforcing a sense of spontaneity.

With its clean lines and organic shape suggesting both a natural form and a useful object, such as a vessel or musical instrument, this print reflects the wide range of influences that inform Puryear's overall oeuvre. These include a lifelong aptitude for carpentry, an affinity for various craft traditions, and an early fascination with subjects as diverse as ornithology, archery, and Native American history. As a young man Puryear spent two years working for the Peace Corps in Sierra Leone, where he developed a profound respect for the wood-carvers of that region. He later enrolled in the printmaking program at Sweden's Royal Academy of Art, and while there found himself drawn to Scandinavian wood carving. Upon his return to the United States, in the late 1960s, he studied fine art at Yale University, absorbing the current developments in Minimalism, earthworks, and site-specific sculpture. Blending modernist abstraction with a commitment to hand-craftsmanship, Puryear's work is remarkable for the sheer beauty that comes from its exacting manipulation of materials and techniques.

4.6.1999 (99/45). 1999
Graphite on paper, sheet: 8¼ × 11¾"
(21 × 29.8 cm)
Purchased with funds provided by
The Edward John Noble Foundation

At first glance, this modest pencil draw-
ing appears to be a simple image of a
teacup—a memento, perhaps, of a quiet
morning at a kitchen table, in the manner
of a traditional still-life. On closer
inspection, however, it unravels and
becomes something else entirely. The flat
tones, sharp contours, and regular shad-
ing suggest that the artist's source for the
drawing was a photograph of a cup
rather than a cup itself. Indeed, no sim-
ple sketch taken from life, *4.6.1999* is an
image of an image. Most likely derived
from one of Richter's own snapshots, the
drawing bears the pictorial imprint of
the impersonal and mechanical language
of the camera. The erased marks that
run across the center of the sheet further
complicate the drawing. Slicing the motif
into strips, these striations disrupt the

"transparency" of the image, calling
special attention to the process of the
drawing's making. Like the use of photo-
graphic source material, these erasures
register the artist's hand negatively, as
something absent or canceled.

The tension between the apparent
simplicity of the motif and the pregnant
implications of the means by which it
was rendered points to the critical
charge in Richter's art, which over the
last four decades has probed the myriad
ways in which images are made and per-
ceived. Working in many different medi-
ums and styles (indeed, this drawing was
executed concurrently with another work
done completely abstractly), Richter has
consistently examined the contingency of
representation, fashioning a body of work
of tremendous variety, versatility, and
import. By underscoring the constructed
nature of illusionism, Richter's work
invites viewers to reflect on how they per-
ceive the world, and, in the process,
invests his personal visions with public
implications.

Lumumba. 2000
Oil on canvas, 24½ × 18" (62 × 46 cm)
Fractional and promised gift of Donald L.
Bryant, Jr.

Tuymans's painting, one of a series of
works related to the history of the
Congo, is based on a photograph of
Patrice Lumumba, the first prime minis-
ter of the former Belgian Congo (now
the Democratic Republic of the Congo).
A visual reminder of an unresolved con-
flict in history that began with Belgian
colonial rule and proceeded to Con-
golese independence and ongoing civil
war, the painting was inspired by a
debate, belatedly begun in Belgium in
2000, about the events surrounding
Lumumba's assassination thirty-nine
years earlier. But this stark portrait tells
us nothing about Lumumba or Africa.
By implication, the portrait leads our
attention to Belgium's unspoken histori-
cal role in colonialism, and to the coun-
try's conflicted consciousness as it
confronts this disputatious past.

If, as Tuymans has said, the subject
of this work is history, then the object is
a vessel of historical memory. Working
from his own visual memory of
Lumumba's photograph rather than
from the photograph itself, the artist re-
created his subject through subtle
changes. Lightening the shade of
Lumumba's skin and altering the look in
his eyes, Tuymans challenges the stereo-
type of the black man as "savage," a
source of threat and apprehension. Is

Lumumba, seen in lighter tones, a more
"civilized" man? Tuymans seems to be
asking us. Here, Lumumba's bemused
gaze seems to question the very myth
that he has become.

Tuymans's selection of this partic-
ular image recalls a mid-nineteenth-cen-
tury European tradition in which vast
archives of documentary photographs
were built up as part of the control and
surveillance of the colonized popula-
tions. Power, secrecy, and control laws
stand at the origin of those archives. It is
this ideological connotation of photog-
raphy that Tuymans subverts by
addressing it so forthrightly. The artist
goes beyond photography's indexical
representation, critiquing and twisting
its original function in order to inter-
twine the representational contents of
history, myth, and memory. Tuymans
inspires the viewer to ponder the cre-
ation of cultural identity through politi-
cal history. Through Lumumba's gaze
we see the artist gazing at history.

Borrowing Your Enemy's Arrows. 1998

Wood boat, canvas sail, arrows, metal, rope, Chinese flag, and electric fan; boat approx. 60" × 23' 7" × 7' 6" (152.4 × 720 × 230 cm), arrows approx. 24" (62 cm) long
Gift of Patricia Phelps de Cisneros in honor of Glenn D. Lowry

Borrowing Your Enemy's Arrows delivers a timeless message rooted in Chinese philosophy and expressed in the Western vocabulary of the readymade. Built on the skeleton of an old fishing boat excavated near Cai's birthplace, the sculpture, suspended aboveground, is pierced with 3,000 made-in-China arrows and flies the national flag.

The title—which alludes to a text from the third century (known as *Sanguozhi*)—refers to an episode in which the general Zhuge Liang, facing an imminent attack from the enemy, manages to replenish a depleted store of arrows. According to legend, Zhuge Liang tricked the enemy by sailing across the Yangtze river through the thick mist of early dawn with a surrogate army made of straw, while his soldiers remained behind yelling and beating on drums. Mistaking the pandemonium for a surprise attack, the enemy showered the decoys with volleys of arrows. Thus the general returned triumphantly with a freshly captured store of weapons.

Surreptitiously gathering strength from one's opponent is also a strategic principle in martial arts. Turning to a militaristic episode and a cultural practice, Cai not only suggests a defensive strategy in the face of foreign intervention, but also creates a poetic metaphor in the image of a wounded body transcending pain and floating in a cloud of feathered arrows.

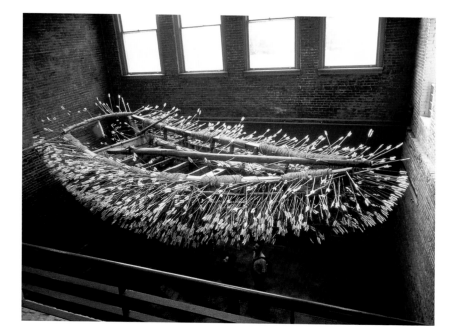

The Cabinet of Baby Fay La Foe. 2000

Polycarbonate honeycomb, cast stainless steel, nylon, solar salt cast in epoxy resin, top hat, and beeswax in nylon and plexiglass vitrine, 59" × 7' 11½" × 38¼" (149.8 × 242.6 × 97.2 cm)
Committee on Painting and Sculpture Funds

The Cabinet of Baby Fay La Foe is a twenty-first-century cabinet of curiosities, a sculpture whose overall form doubles as a display case, yet whose enigmatic contents resist taxonomic classification. Preserved behind plexiglass are a stylized séance table, a stack of barbells cast in solar salt, and a veiled top hat filled to the brim with honeycombed beeswax. A vaguely anthropomorphic recumbent shape made of cast solar salt fixed with epoxy resin seems part body fragment, part crystalline landscape, and appears suspended in a liminal state between becoming and unbecoming. All, with the exception of the barbells, are attributes of Baby Fay La Foe, a real-life clairvoyant as well as a character in Barney's gothic Western *Cremaster 2* (1999), the fourth film in the artist's epic, five-part Cremaster cycle.

Barney's overarching concerns are with the mutability, metamorphosis, and creation of form. Best-known for his feature-length films, he describes himself as a sculptor, insisting that all of his polyglot production—films, photographs, drawings, sculptures, banners, and installations—exists as a series of discrete yet interrelated objects within the multidimensional space of the Cremaster cycle's self-enclosed universe. *The Cabinet of Baby Fay La Foe* recapitulates on a microcosmic level key features of Barney's expansive cosmology. Drawing on Surrealist strategies of fragmentation, uncanny juxtaposition, and fetishistic display, the luminous nylon borders of the cabinet's vitrine are a material manifestation of film's (and photography's) omnipresent invisible frame. Filled with fantasy objects constructed from the artist's signature materials, the work is nominally a symbolic portrait, yet any fixed meanings remain sealed off, subject to transformation and thus tantalizingly out of reach.

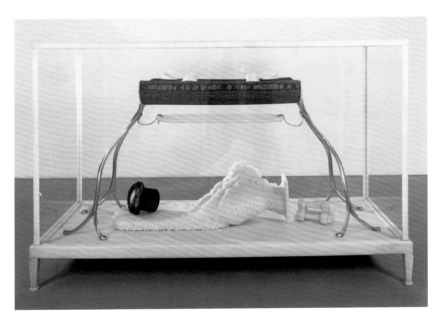

Peacock. 1997
Etching, composition and sheet: 71½" × 6' 4⅜"
(181.6 × 194 cm)
Publisher: unpublished. Printer: Columbia
University, New York. Edition: several known
variants
Lily Auchincloss Fund

Peacock is the most monumental and
commanding example of the many
works by Smith based on sketches made
in natural history museums and then
printed on sheets of textured handmade
paper. After emerging in the 1980s with
confrontational sculptures of human fig-
ures and body parts, Smith shifted her
focus in the mid-1990s to the natural
world, depicting birds, other animals,
and the cosmos in sculptural works as
well as prints and books. For Smith, who
was raised a Catholic, birds have a par-
ticular significance, both as a reference
to the poignant beauty of the environ-
ment and as a symbol of the Holy Spirit.
Here, the authoritative majesty of the
peacock's frontal stance reflects the
artist's appreciation of this rare and
magnificent creature.

Smith considers printmaking a vital
part of her work, and she has become
one of the most innovative and commit-
ted printmakers of the last two decades.
She has said, "I could just make prints
and be satisfied." To date, Smith has
published over 150 prints and books, in
formats ranging from monumental
multimedium prints and elaborate *livres
d'artiste* to screenprinted tattoos and
rubber stamps. When she began working
with imagery of birds and other animals,
Smith discovered the detailed, refined
line available in etching, and found it an
irresistible medium for describing feath-
ers and fur. In *Peacock*, her markings are
so dense as to almost obscure the bird's
face and body and turn the image into
an abstraction. The formal delicacy of
this work is enhanced by Smith's overt
passion for the inherently tactile quali-
ties of paper—a material that she has
explored extensively in sculpture. Smith
likes to work with translucent, skinlike
sheets of handmade paper, folding them,
pasting them together, and otherwise
manipulating them in inventive and
unexpected ways.

Origami Pleat Scarf. 1997

Hand-pleated and heat-transfer-printed
polyester, 17 5/16 × 59 1/16" (43.9 × 150 cm)
Manufacturer: Nuno Corporation, Japan;
also Takekura Co., Ltd., Japan
Gift of the designer

Among The Museum of Modern Art's holdings is a rich collection of contemporary Japanese textiles. Sublime and surprising, solidly anchored in material culture and at the same time representative of the latest technological innovations, these textiles are revolutionary in the way that they alter the habitual relationship between the shape of the body and the light and air around it.

The collection includes the production of several notable designers, from Junichi Arai and Hideko Takahashi to Osamu Mita. None, however, is featured as often as Sudo, a disciple of Arai and a virtuoso in her own right. In 1984,

Arai and Sudo cofounded Nuno Corporation, in Tokyo, and Arai introduced his new partner to the use of scanners and computers, providing her with a fresh palette of artistic possibilities. The Origami Pleat Scarf, which Sudo designed in collaboration with Mizue Okada, is just one example of the company's unique production.

Emulating the Japanese art of folding paper, this delicate-looking scarf is creased repeatedly at sharp angles and then permanently pressed in a special heat-transfer pleating procedure. Its color gradation is achieved by sandwiching colored dye-transfer paper between the fabric and the outer paper during the heat-transfer process. The polyester retains memory of the pleats to such an extent that the three-dimensional scarf folds perfectly flat onto itself when dropped. The scarf represents the ideal balance between functionality, technological innovation, and art that the Museum seeks in its collection of design objects.

Ever Is Over All. 1997

Video installation with two monitors,
dimensions variable
Fractional and promised gift of
Donald L. Bryant, Jr.

Rist's imagery has several foundations,
and invites just as many interpretations.
Culled from resources as rich and varied
as fairy tales, feminism, contemporary
culture, and her own imagination, the
artist's color-saturated, kaleidoscopic
projections are a sophisticated visual
amalgam of wit, humor, and irony.

Ever Is Over All is a video installa-
tion comprising two sharply contrasting
projections on adjacent walls accompa-
nied by a melancholic melody. On the
right is a large field of bright-red long-
stemmed flowers, filmed in close-up with
a roving camera. On the left, filmed
in medium- and long-shot, is a smiling
young woman in a blue dress and red
shoes. Walking toward the viewer in slow
motion along a car-lined sidewalk, she
suddenly raises what appears to be one
of the blooms seen in the projection to
the right, and, in a burst of inexplicable
violence, uses it to smash the window
of a parked vehicle. As she moves down
the sidewalk and shatters another car
window, a policewoman approaches from
behind and offers a friendly salute in
passing. The anarchic young woman
gleefully carries on breaking windows.

Fiction-versus-reality is an impor-
tant theme for Rist, in whose work
an odd combination of nightmare and
magic prevails over the logic of common
sense. In *Ever Is Over All*, the artist jux-
taposes the field and its flowers with
her magically powerful wand, and trans-
poses acts of aggression and annihila-
tion into benevolent and creative ones.

Jim Nutt | American, born 1938

Whisk. 1998
Graphite on gray paper, 13⅛ × 13⅛"
(33.3 × 33.3 cm)
Gift of Jan Christian Braun in honor of
Agnes Gund

Carefully coiffed hair tops a handsome thick-boned face, and two schematic almond-shaped eyes stare warily out into space. This small pencil drawing—a study for a painting, also in The Museum of Modern Art's collection—is a visionary portrait of a woman in which realism and artifice are blended together in a masterful array of fluid lines and abstract patterning. Part absurd and introspective fantasy, *Whisk* is typical of Nutt's art, which evokes the diverse layers—indeed, the disguises—integral to the construction of the individual self.

But as much as *Whisk* pictures someone confronting her own place in the world, it also wittily perverts previous art historical models of portraiture. Knowingly referring to diverse traditions of the genre—from Italian Renaissance and American Colonial to European modernism (as embodied in the work of such artists as Henri Matisse and Joan Miró, for example)—Nutt uses a grotesque style to take aim at the very conventions he identifies by sly emulation. Part of a critical project, *Whisk* offers a pointed challenge to good taste and bourgeois values. Despite this subversive aspect, however, *Whisk* remains primarily a personal vision, part of a deep artistic tradition of drawing on one's imagination.

Joel Coen | American, born 1955
Ethan Coen | American, born 1958

Fargo. 1996
35mm, color, sound, 98 minutes
Acquired from the artists
Frances McDormand

From their very first feature film, *Blood Simple* (1984), the Coens have demonstrated an uncanny ability to find the dark humor in any subject, no matter how tragic or absurd. Whether reimagining Hollywood à la Nathanael West in *Barton Fink* (1991), plumbing the depths of Depression-era noir in *Miller's Crossing* (1990), or adapting Homer for *O Brother, Where Art Thou?* (2000), this brothers duo—Joel directing, Ethan producing, both writing—has consistently managed to draw laughter from material otherwise too sad or hopeless to endure. Conversely, in such outright comedies as *Raising Arizona* (1987) and *The Big Lebowski* (1998), the Coens explored undercurrents of pathos and sadness that other filmmakers might have downplayed or ignored. In every case, they appropriated genres with abandon in order to unveil the complexities of the human psyche.

In *Fargo* the Coens came up with the perfect combination of form and content, creating a black comedy of unusual scope and resonance. Viewed by some as a scathing attack on the Midwest (while defended by the filmmakers as an homage to the region of their birth), *Fargo* deftly integrates the banal and the bizarre, the tender and the horrific. With Marge Gunderson and Jerry Lundegaard (played, respectively, by Frances McDormand and William H. Macy), the Coens created characters of striking depth and emotion while at the same time presenting them as archetypes of midwestern stoicism and reserve. In *Fargo*, as in all of their works, the Coens demonstrate great affection for their characters without shying away from the potent stew of seeming contradictions we humans really are.

Poll. 2001
Chromogenic color print, 71" × 8' 6"
(180.3 × 259.1 cm)
Fractional and promised gift of Sharon Coplan Hurowitz and Richard Hurowitz

Most photographs in the press are consumed at a glance. A few become lasting symbols of famous events. In between lies Demand's raw material: images that might once have seemed to mean a lot, although we cannot quite remember why. Omitting the figures (if any), Demand remakes these scenes in crisp and colorful life-sized constructions of paper and cardboard. Photographing his elegant handiwork, he renders the original image with an uncanny clarity it never before possessed.

Poll applies this strategy to the bizarre flashpoint of the 2000 election for president of the United States: the site at which Florida's contested paper ballots were assembled for intense scrutiny. At once artificial and vivid, Demand's image explains the scene no better than the photograph on which it is based. But perhaps it is less likely to be forgotten.

Prince amongst Thieves. 1999
Synthetic polymer paint, collage, glitter, resin,
map pins, and elephant dung on canvas,
8 × 6' (243.8 × 182.8 cm)
Mimi and Peter Haas Fund

Ofili's intensely worked, vibrant paintings combine a wide range of referents, from African burlesque to Western popular culture. Using a cut-and-mix technique and repetitive patterning, the works evoke the anarchic rhythm of hip-hop lyrics and performance. *Prince amongst Thieves* features the caricatured yet regal profile of a bemused man of African descent, set against a densely ornate background dotted with countless minute collages of the heads of illustrious black figures. The work's shimmering, psychedelic surface of sprayed pigment, synthetic polymer paint, glitter, elephant dung, and splashes of translucent resin produces a ritualistic effect that parodies stereotypes of black culture while celebrating difference. The lacquered clumps of elephant dung on which the canvas rests have become a signature for Ofili, and they confer on the painting a sculptural and perhaps even totemic presence, invoking African tribal art, with which Ofili (who is of Nigerian descent) became familiar during a visit to Zimbabwe, in 1992.

The artist uses elephant droppings for its traditional associations but procures it from the London Zoo, thereby probing his cultural heritage and urban experience in ways that confound identity typecasting. Ofili's mix of hybrid sources culled from popular magazines, music, folk art, and the tough streets around his Kings Cross studio, in London, epitomizes a new form of counter-culture that subtly reworks Western perceptions of blackness.

Sarah Lucas | British, born 1962

Geezer. 2002
Oil, cut-and-pasted printed paper, and pencil on wood, 31⅞ × 29½" (81 × 74.9 cm)
Purchased with funds provided by The Buddy Taub Foundation, Dennis A. Roach, Director

Geezer is part of a large body of work by Lucas dedicated to Charlie George, a star player of one of the top London soccer clubs during the 1970s. Lucas grew up in the same gritty working-class neighborhood as George, who in the artist's youth represented dreams of stardom and escape. Here, in a portrait comprised primarily of collaged pizza-parlor advertisements, Lucas uses her relationship with the soccer star as a touchstone for a complicated investigation of identity, success, and marketing.

While George is the ostensible subject of the portrait, the figure bears an uncanny resemblance to Lucas, whose work typically explores androgyny, the hybridity of personal identity, and double meanings. Indeed, *Geezer* can be understood as a kind of self-portrait connecting the artist's personal history with that of the soccer star's. However, *Geezer* is infused with a biting political critique as well. By rendering the face of the portrait from advertisements—the only legible identifying characteristic in the drawing is the logo of George's team, Arsenal—Lucas seems to speak to the commodification of bodies in sports, and in society generally. Not only are the fans' identities molded by their identification with sports stars, but those models to which they aspire are themselves just blank screens for the projection of logos. In this light, the letters "NANZA," which emblazon the absolute center of the subject's forehead, stand as a poignant symbol for the fragmentary nature of the "BONANZA" of success. For as much as *Geezer* celebrates Charlie George and represents dreams and their realization, it also depicts the underbelly of certain aspects of late-stage capitalism—a stance perfectly attuned to the tradition of political commentary in much collage, to which Lucas knowingly nods with this work.

After "Invisible Man" by Ralph Ellison, the Prologue.

2001
Silver dye bleach transparency (Cibachrome)
on aluminum light box, 7' 2⅝" × 9' 6³⁄₁₆"
(220 × 290 cm)
The Photography Council Fund, Anonymous
Purchase Fund, Gift of Jo Carole and Ronald S.
Lauder, and Gift of Carol and David Appel

After a brief but eventful career that embodies the hopes and humiliations of African Americans at mid-twentieth century, the hero of Ralph Ellison's celebrated 1952 novel *Invisible Man* retreats to a secret basement room on the edge of Harlem. There he patiently composes and reflects upon the story we are about to read. "I am invisible," he explains, "simply because people refuse to see me."

Making pictures out of stories was once the main business of the visual arts.

The rising modernist tradition consigned the practice to the margins of advanced art; for most of the past century, "illustration" has been a term of contempt. In this large, richly detailed and thoroughly absorbing photograph, Wall has all but single-handedly reinvented the challenge.

The novel's eloquent prologue is short on specifics, except one: the 1,369 lightbulbs that cover the ceiling of the underground lair. Starting with this fantastic detail, Wall scrupulously imagined in his Vancouver studio the concrete form of Ellison's metaphorical space. Ambitiously reviving a forgotten art, he made visible the Invisible Man.

Acknowledgments

The following individuals are gratefully
acknowledged for their important contributions
to this volume.

Project managers
Mary Lea Bandy, John Elderfield, Michael
Maegraith

Picture selection
Mary Lea Bandy, John Elderfield, Peter Galassi,
Gary Garrels, Terence Riley, Margit Rowell,
Kirk Varnedoe, Deborah Wye

Picture sequence
Mary Lea Bandy, John Elderfield, Beatrice
Kernan

Authors
Introduction, Glenn D. Lowry; Painting and
Sculpture texts, Fereshteh Daftari, David
Frankel, Claire Henry, Roxana Marcoci, Angela
Meredith-Jones, María José Montalva, Lilian
Tone, Anne Umland; Drawings texts, Mary
Chan, Magdalena Dabrowski, Kristin Helmick-
Brunet, Laura Hoptman, Jordan Kantor, Angela
Meredith-Jones, Margit Rowell, Rachel Warner;
Prints and Illustrated Books texts, Starr Figura,
Carol Smith; Architecture and Design texts,
Paola Antonelli, Bevin Cline, Luisa Lorch,
Matilda McQuaid, Christopher Mount, Peter
Reed, Terence Riley; Photography texts, Peter
Galassi, Susan Kismaric; Film and Media texts,
Mary Lea Bandy, Sally Berger, Mary Corliss,
John Harris, Steven Higgins, Jytte Jensen,
Laurence Kardish, Barbara London, Anne
Morra, Josh Siegel, Charles Silver

Editors
Harriet Schoenholz Bee, Joanne Greenspun,
Cassandra Heliczer, Laura Morris

Photography
David Allison, Mikki Carpenter, Tom Griesel,
Kate Keller, Paige Knight, Erik Landsberg,
Mali Olatunji, John Wronn

Designers
Antony Drobinski, Emsworth Design, Inc.,
Gina Rossi, Amanda Washburn

Production
Christina Grillo, Christopher Zichello

Associates
Dalia Azim, Sharon Dec, Claire Fitzsimmons,
Julia Fuchshuber, Jason Goldman, Steven
Higgins, Jordan Kantor, Nancy Kranz, Joachim
Pissarro, Peter Reed, Marc Sapir, Patterson
Sims, Sarah Suzuki

Photograph Credits

The photographs in this book were taken by the staff photographers of The Museum of Modern Art, with the exception of the following:

Patterson Beckwith, courtesy Pat Hearn Gallery: p. 351
Peter Bellamy, New York: p. 320
Courtesy Stan Brakhage and Anthology Film Archives: p. 352
Courtesy Cai Guo-Qiang: p. 362
Courtesy Joel and Ethan Coen: p. 368
Courtesy Barbara Gladstone Gallery: p. 343
© 2004 Galerie Hauser & Wirth, Zurich, and Luhring Augustine, New York: p. 366
Seth Joel: pp. 83, 128, 149, 151, 292, 297
Larry Lame, courtesy Barbara Gladstone Gallery: p. 312
Luhring Augustine: p. 346
Orcutt & Van Der Putten, courtesy Andrea Rosen Gallery, New York: p. 349
Friedrich Rosenstiel, Cologne: p. 309
© 1998 Tony Smith Estate/Artists Rights Society (ARS), New York. Thomas Powel, courtesy Paula Cooper Gallery and Tony Smith Estate, New York: p. 285
Courtesy Holly Solomon Gallery: p. 313
© 2004 Jeff Wall: p. 372
Sperone Westwater, New York: p. 307
Karen Willis: p. 365
© 1991 Ellen Page Wilson: p. 333
Deborah Wye: p. 334

Individual works of art appearing herein may be protected by copyright in the United States of America or elsewhere, and may thus not be reproduced in any form without the permission of the copyright owners.

Certain credits appear at the request of the artist or the artist's representatives.

The following images are courtesy:
© 2004 Matthew Barney, © 2004 William Kentridge, © 2004 Estate of Roy Lichtenstein, © 2004 Sarah Lucas, © 2004 Boris Mikhailov, © 2004 Vik Muniz, © 2004 Jim Nutt, © 2004 Chris Ofili - Afroco and Victoria Miro Gallery, © 2004 Martin Puryear and Paulson Press, © 2004 Gerhard Richter, © 2004 Kiki Smith, © 2004 Luc Tuymans, © 2004 Steve Wolfe.

Images by the following artists © 2004 Artists Rights Society (ARS), New York, and as noted: Jean (Hans) Arp (VG Bild Kunst, Bonn), Francis Bacon, Balthus (ADAGP, Paris), Max Beckmann (VG Bild Kunst, Bonn), Joseph Beuys (VG Bild Kunst, Bonn), Constantin Brancusi (ADAGP, Paris), Georges Braque (ADAGP, Paris), Marcel Broodthaers (SABAM, Brussels), Marc Chagall (ADAGP, Paris), Giorgio de Chirico (SIAE, Rome), Salvador Dalí (Demart Pro Arte, Paris), Thomas Demand (VG Bild Kunst, Bonn), André Derain (ADAGP, Paris), Otto Dix (VG Bild Kunst, Bonn), Jean Dubuffet (ADAGP, Paris), Marcel Duchamp (ADAGP, Paris), Max Ernst (ADAGP, Paris), Alberto Giacometti (ADAGP, Paris), Julio González (ADAGP, Paris), Arshile Gorky (ADAGP, Paris), George Grosz (ADAGP, Paris), Andreas Gursky (VG Bild Kunst, Bonn), Richard Hamilton (DACS, London), Erich Heckel (VG Bild Kunst, Bonn), Vasily Kandinsky (ADAGP, Paris), Paul Klee (VG Bild Kunst, Bonn), Yves Klein (ADAGP, Paris), Oskar Kokoschka (Pro Litteris, Zurich), Käthe Kollwitz (VG Bild Kunst, Bonn), Alfred Kubin (ADAGP, Paris), Wifredo Lam (ADAGP, Paris), Fernand Léger, René Magritte (ADAGP, Paris), Aristide Maillol (ADAGP, Paris), Man Ray, Piero Manzoni (SIAE, Rome), Henri Matisse, Matta (ADAGP, Paris), Annette Messager (ADAGP, Paris), Joan Miró, László Moholy-Nagy (VG Bild Kunst, Bonn), Bruce Nauman, Meret Oppenheim (Pro Litteris, Zurich), Max Pechstein (VG Bild Kunst, Bonn), Francis Picabia (ADAGP, Paris), Pablo Picasso, Jackson Pollock, August Sander (VG Bild Kunst, Bonn), Kurt Schwitters (VG Bild Kunst, Bonn), Richard Serra (ADAGP, Paris), Gino Severini (ADAGP, Paris), Antoni Tàpies (ADAGP, Paris), Jacques Mahé de la Villeglé (ADAGP, Paris), Édouard Vuillard (ADAGP, Paris), and Andy Warhol.

Images by the following artists are licensed by VAGA, New York, New York:
Louise Bourgeois, Jasper Johns, and David Alfaro Siqueiros.

Index of Illustrations